ARTE PROGRAMMATA

ARTE
PROGRAMMATA

FREEDOM, CONTROL, AND
THE COMPUTER IN 1960s ITALY

LINDSAY CAPLAN

UNIVERSITY OF MINNESOTA PRESS
Minneapolis · London

Publication of this book has been aided by a grant from the Millard Meiss Publication Fund of CAA.

 Advancing
Art&Design

The University of Minnesota Press gratefully acknowledges the financial assistance provided for the publication of this book by Brown University.

Portions of chapter 1 were published in "From Collective Creation to the Creation of Collectives: *Arte programmata* and the Open Work, 1962," *Grey Room* 43 (Fall 2018): 54–81.

Published by the University of Minnesota Press
111 Third Avenue South, Suite 290
Minneapolis, MN 55401-2520
http://www.upress.umn.edu

ISBN 978-1-5179-0993-2 (hc)
ISBN 978-1-5179-0995-6 (pb)

Library of Congress record available at https://lccn.loc.gov/2022015120.

Printed in the United States of America on acid-free paper

The University of Minnesota is an equal-opportunity educator and employer.

31 30 29 28 27 26 25 24 23 22 10 9 8 7 6 5 4 3 2 1

CONTENTS

Between the Programmed and the Free

"The greatest freedom is born from the greatest rigor." This statement comes from poet Paul Valéry's quasi-Socratic dialogue *Eupalinos or the Architect* (1921), which meditates on how all artistic creation in some way stages an inescapable conflict between unrestrained creative expression and the legibility, stability, and validity of form. When Bruno Munari, participating artist and co-organizer of the 1962 exhibition *Arte programmata,* chose this line as an epigraph to the catalog, he used it to signal the essence of what he meant by a "programmed art." As simple geometric compositions with either motorized or movable parts, the kinetic sculptures and interactive assemblages by Munari, Enzo Mari, and the collectives Gruppo T and Gruppo N all illustrated the same foundational principle of computer programs, condensing complex algorithmic functions and scientific speculations about randomness, indeterminacy, and incompleteness into one single precept: a basic procedure, once set into motion, can spawn an unforeseeable number of possible forms. For Munari, the epigraph first and foremost served to describe how the artworks featured in *Arte programmata* were made. But Valéry's dictum points to another dimension of this programmed mode of production: that creativity does not exist in a vacuum; structures can foster spontaneity; and even the sort of unbridled freedom that art appears to offer (freedom from necessity, determination, the limits of medium, tradition, artistic convention) is still bound by material, social, and historical constraints.

Rather than offer a clear definition, therefore, the epigraph points to

how unsettled the locus of freedom is within even the simplest forms of programmed art. These aleatory artworks do seem to disperse—or, better, democratize—the creative process, empowering each viewer to participate or enjoy an entirely singular response. But these works also enact the opposite, incorporating and constraining the activity of both artist and audience within the logic of a mutating but no less predictable machine. Even Munari's own explanations, which continually asserted the liberatory idea of programmed art, were more riven than the artist ever wanted to admit; he extolled the virtues of automation while preserving a romantic notion of the artist as pioneer in the unconditioned construction of new forms. In the *Arte programmata* catalog, the semiotician and philosopher Umberto Eco claimed that programmed artworks were within the category of what he called "open works," artworks comprising changeable, indeterminate structures that grant viewers a larger degree of freedom when interpreting them than ever before. But throughout his essay, Eco's use of the adjective "programmed" slips between qualifying a type of work and describing the processes of perceiving and understanding it. What, then, is being programmed, the artwork or the audience? Whose freedom is being emphasized—that of the artists, the platforms they create, or the people living in or around them? By delegating authorship to a set of rules, chance operations, or moving parts, as the works included in *Arte programmata* propose to do, are these artists withdrawing control or expanding it?

This book centers on these tensions among creativity, freedom, and control in the multimedia practices of the Arte Programmata artists from their initial exhibition in 1962 through the late 1970s.[1] It demonstrates that, decades before computers became ubiquitous in everyday life, and even prior to their becoming an avowed artistic medium, Arte Programmata engaged computers as a conceptual platform to reconceive individual freedom in relation to systematic constraints. Their artworks operated as spaces to experiment with the kinds of freedom available within a program, to posit that subjectivity itself is produced through the contestation and conflict among these different materials and ideas. By reading the artworks themselves as philosophical propositions and probing the historical conditions and political motivations that shaped them, this book argues that the work of Arte

Programmata shows how programming, planning, and control are not categorically antithetical to individual freedom but form the conditions that enable and encourage subjective agency. At the same time, it traces a growing tension between notions of freedom circulating within and among artistic and political contexts. The artists of Arte Programmata foreground the interrelation of freedom and control in artworks at the very moment that these terms were being scrambled and transformed in other arenas. Especially notable for our purposes, the seeds of neoliberalism are evident everywhere in this period, most saliently in the communication technologies that enabled a technocratic logic of management and dispersed mechanisms of control. But as I hope to demonstrate, Arte Programmata's new-media art does not neatly map onto this trajectory, nor can it be reduced to an illustration of (or, worse, capitulation to) technocracy, neoliberalism, or state and corporate surveillance. To the contrary, it is through the disconnects and divergences of what Arte Programmata envisioned with their art and what historically came to pass that we might glimpse visions of alternatives—of how technology might be designed and deployed to resist systems of power, how resistance can be constructive without being complicit, and above all how the continued difficulty of parsing liberatory from complicit forms of collective action is evidence that the terms we have for doing so are inadequate and need to be rethought.

To this end, the book confronts the unavoidable and escalating presence of control in programmed art, especially the manipulation of spectators' experience and action in the immersive environments. This dimension of programmed art was suggested in Munari's choice of epigraph for the eponymous 1962 exhibition, even as it was absent from his own definition. Control is largely a term left out of the writings by the artists as well as the scholarship about Arte Programmata, but it is everywhere in the works. Control is implied in the artists' call for clarity, better communication, and consistency in interpretation, which Mari, Gruppo T, and Gruppo N all demanded over the course of the 1960s. It is there in programmed art's abstract, phenomenological mode of address, which did not merely decenter but dissolved viewers' sense of self as integrated and autonomous. Most of all, the centrality of control to Arte Programmata's notion of freedom—first,

artistic creativity and then individual agency in general—is most evident in how the work of these artists progressed over time. The immersive environments constructed by Mari, Gruppo T, and Gruppo N between 1964 and 1968 intensified, and arguably thematized, the inextricable relationship between control and agency. For these works, the artists drew on cybernetics and mathematical theories of information to design spaces that simultaneously activated and dictated the movements and sensations of their spectators. This same impetus to expand the artwork into the world and affect their audiences in real, material ways motivated most of the artists to abandon art altogether for design by the end of the 1960s. From this point on, they created objects meant to circulate through society and incite its transformation. Design, in other words, became a way for Arte Programmata to put their conception of the program, and attendant conceptions of freedom, control, and collectivity, to work in the service of concrete social change.

This book historicizes and theorizes the Arte Programmata artists' engagement with early computers. Rather than an exhaustive survey of works and influences, therefore, it is the idea of the program, more than a particular author, that structures its organization. I trace Arte Programmata's expansive idea of programming as it manifests in artworks, installations, exhibitions, and design. This makes the study more focused in its theme but more extensive in its time frame than most accounts of programmed art in Italy, which usually end in 1968. In response to the rise of new social movements seeking to curtail the uneven effects of the economic boom, this was the year when Gruppo T made their last collective artwork and many of the participants stopped making art altogether, turning instead to design or teaching. According to most chronologies of the group, the move into extra-artistic practices in 1968 marked the end of Arte Programmata.[2] This narrative of rupture is one propagated by many of the artists themselves. Davide Boriani, one of the artists in Gruppo T, has claimed that 1968 was not only the end of the artist collective but also his own identification as an artist.[3] Exhibitions and scholarly essays that curtail the story of Arte Programmata in 1968 take this narrative of sudden politicization at face value, despite the overwhelming presence of kinetic and programmed art at Documenta 4 (1968) and the 1968 Venice Biennale—the year an immersive

environment by Gianni Colombo of Gruppo T was awarded first prize. To end Arte Programmata in 1968 makes two assumptions about the relationship between art and politics that I hope to problematize. The first assumption is that Arte Programmata's artistic experiments were somehow not political (or not political enough) by virtue of being abstract; the second is that by working as artists, they were operating at one remove from contemporary social life. By contrast, this study argues that Arte Programmata were motivated by political concerns from the beginning, and that they turned to computers because they provided a conceptual platform for rethinking some of the most pressing social and political problems of their time: the role of artists, the political viability of art, and the social necessity of a transparent and flexible mode of communication. The computer program, I contend, was a way the artists could envision and structure relationships within the artwork. In so doing, I take seriously the politics *of* form, rather than conceiving politics as an external referent, subject matter, or content. This focus on form will allow us to recognize the social nature of Arte Programmata's artistic experiments and how their interest in new media is correctly understood as a commitment to understanding people as both subjected to their environment and as agents capable of shaping it.

There is, however, a deep irony to Arte Programmata: as artists who were centrally concerned with clarity of communication, the theoretical and political innovations of their work can be difficult to discern from their appearance alone. They remain unknown to most art historians and have largely languished in provincial obscurity. For those who do know the work, despite the artists' efforts to design aesthetic experiences that wrest viewers outside of their selves and dismantle entrenched assumptions, interpretations are prone to reductive readings that rely on touchstones like "1968" and readymade ideas about art, technology, and politics (seeing their work as illustrations of technocracy, for example, straightforward techno-utopian euphoria, or simply as evidence that Italy had a new-media avant-garde, too). Most of this book is devoted to complicating such readings through close examinations of artworks and their granular, interdisciplinary context, as well as taking seriously the imbrication of histories of art and ideas. It probes the formal dimension of theory and the discursive aspects of art, drawing out

the way that Arte Programmata's artworks, in a singular and specific way, conceive and configure conceptions of freedom and control. However, before we turn to these objects, the specifics of Italy, and the productive pressure that Arte Programmata's work puts on these central ideas, we need to survey the dominant discursive field that Arte Programmata were working with, through, and against.

Programming: Historicizing a Concept

Bifurcated thinking governed most conceptions of emerging computer technology in the 1960s. By 1965, programming spawned visions of the computer as a control mechanism, a machine pitted against the spontaneity and freedom of the individual subject. One of the first cultural representations of this kind, Jean-Luc Godard's 1965 film *Alphaville*, centered on such a dystopian vision of computerized rule.[4] The film follows the protagonist, secret agent Lemmy Caution, as he traipses the streets of a future Paris with the mission of destroying the Alpha 60 computer, a despotic ruler that has outlawed emotions and requires absolute submission and obedience to its rational social program. By envisioning the computer as a program set to systematically eradicate human will and creativity, *Alphaville* collapsed the computer with a more generalized anxiety about (and criticism of) postwar technological rationality—a bureaucratized system of governance as totalitarian as fascism or Stalinism but legitimized (and mythologized) by its association with objective scientific logic. Deemed "the technological society" by Jacques Ellul (1954), the "megamachine" by Lewis Mumford (1964), the "one-dimensional society" by Herbert Marcuse (1964), and "the programmed society" by Alain Touraine (1970), this all-pervasive social system was predicated on "rational" (read: callous, automated, and amoral) methods—the totality of which subsumed individuals under its own operational logic and eradicated any aspect that did not fit (e.g., freedom, desire, creativity, criticality). "Man is caught like a fly in a bottle," Ellul explains. "No human activity is possible except as it is mediated and censored by the technical medium."[5] Or in Mumford's terms, "Man himself is thus losing hold on any personal life that can be called his own . . . being turned into a 'thing' destined to

be processed and reconstructed collectively by the same methods that have produced the atomic pile and the computer."[6]

These conceptions of the computer defined technology in opposition to humans: predictable rather than spontaneous, requiring slavish obedience to necessity instead of fostering creativity and free will. They also conceived computers as an existential threat. For many, this threat was most concertedly and dangerously aimed at individual autonomy.[7] To cite Ellul again, "The mathematical, physical, biological, sociological, and psychological sciences reveal nothing but necessities and determinisms on all sides. . . . Freedom consists in overcoming and transcending these determinisms."[8] Touraine puts it similarly, noting the "contradictions between the impersonal control exercised by technocracy and the revolt in the name of personal and collective creativity."[9] Stanley Kubrick's 1968 film *2001: A Space Odyssey* expressed this trope of human individual versus logical imperative with the character of HAL 9000, a computer that at first seems to share its human counterparts' emotional as well as intellectual intelligence, but whose steadfast, programmed commitment to the operation ultimately left the astronauts no choice: destroy HAL or be destroyed themselves. *2001* made plain what had by 1968 become one widespread premise of the cultural discourse on computers: the opposition between individual freedom and systematic determination.

This same opposition also motivated a diametrically counterposed cultural commonplace: computer enthusiasts imagined utopian digital futures, in which people would be more individually empowered and free because of the increasing rationality made possible by computing. That is, the identical characteristics that made the computer appear as a threat to the likes of Mumford and Ellul made it humanity's greatest hope according to others. For Marshall McLuhan, famously, media's integration with humanity was a liberatory rather than oppressive force, an "extension" that increased the autonomy of individuals and their connectivity with the world. Writing in the book *Understanding Media* (1964), McLuhan navigates this tenuous terrain between integration and autonomy by exploiting the idea that computers are responsive and adaptable systems: "Programming can now include endless changes of program. It is the electric feedback, or dialogue pattern, of

the automatic and computer-programmed 'machine' that marks it off from the older mechanical principle of one-way movement."[10] McLuhan's projection of the computerized age is one in which individuals are connected in a "global village," a vision that is more of a throwback to Romanticism or glorified gesellschaft than projection of a cybernetic future.[11] For him, "the aspiration of our time for wholeness, empathy and depth of awareness is a natural adjunct of electric technology"; and yet "the mark of our time is its revulsion against imposed patterns."[12] McLuhan dismisses others' concerns about computers being conformity-inducing machines as outdated conceptions of the technology.[13]

McLuhan's writing is relatively sensitive to the complexities of technology, especially those pertaining to the tensions between personal freedom and the function and flow of systems. However, contemporaries who picked up on his work were often not so nuanced, and a unilaterally liberationist rhetoric about the new medium has become one of McLuhan's greatest legacies, especially in the realm of art. Expounding on McLuhan, Gene Youngblood projected in 1970 that computers would lead to a social condition of "technoanarchy," where "there is only one real world: that of the individual. There are as many different worlds as there are men. Only through technology is the individual free enough to know himself and thus to know his own reality."[14] A prototype for this world, according to Youngblood, was expanded cinema, an artistic medium that materialized consciousness.[15] To many in the arts, immersive, information-saturated environments manifested a nightmarish Society of the Spectacle, replacing social engagement with alienated, on-screen consumption; yet to others like Youngblood, an environment conditioned by new media like computers and television made self-consciousness and self-determination possible to a heightened degree unrealizable before. A central example of this new sensibility (featured in Youngblood's book) was the WGBH Boston public television program *The Medium Is the Message,* which broadcast a thirty-minute set of six video artworks by artists such as Allan Kaprow, Nam June Paik, and Aldo Tambellini one spring evening in 1968. In contrast to regular programming, these artworks actively engaged their audience, at least perceptually, and presumed to free them from the pacifying effects of the one-way channel normally

enacted by the TV. Paik's psychedelic "Participation TV" makes this plain through its direct address and promise of interactivity (gallery-sited versions altered the video's tangle of technicolor lines in response to participants' voices). Youngblood's framing, these artists' own writing, and the works themselves all emphatically proclaim television's ability to forge connection and collaboration across time and space and produce a deliberately vague sense of community that is as mutable, ephemeral, and unstable as the electric wavelengths themselves.

The same euphoric leap from communication to community pervades countercultural new-media experiments of this period. Another case in point is Stan VanDerBeek's *Movie-Drome* (1965), a repurposed grain silo situated in upstate New York; audiences would lie down on the ground and watch thousands of projected images cut and organized by the artist for display. VanDerBeek imagined *Movie-Drome* as a prototype for an intricate network of satellites that would transmit images across the globe. As Gloria Sutton has articulated, immersive environments like *Movie-Drome* drew on the possibility of transmitting images in real time to assert that these works— even when not yet networked—enacted a global community, intimately and authentically connected but also entirely, uninhibitedly free to pursue desire without limit.[16]

This kind of individualistic, liberationist discourse in the United States swiftly moved from the artistic avant-garde to shape the early internet through the influence of figures such as Stewart Brand and Nicholas Negroponte. As Fred Turner has shown, in contrast to activists among the New Left who were strongly aligned with critiques of technology furthered by Ellul and Marcuse, New Communalists like Brand "saw in cybernetics a vision of a world built not around vertical hierarchies and top-down flows of power, but around looping circuits of energy and information."[17] Brand propagated an idea of technology as a tool for personal liberation in his *Whole Earth Catalog,* founded in 1968. It featured articles by designer Buckminster Fuller and cybernetician Norbert Wiener and advertised desktop calculators and other new gadgets for sale. As Turner explains, "The *Catalog* celebrated small-scale technologies . . . as ways for individuals to improve their lives. But it also offered up these tools—and itself—as prototypes of

a new relationship between the individual, information, and technology."[18] Decades later, in the 1980s, Negroponte advanced the same sentiments of his pre-internet predecessors when he characterized the digital age in four words: decentralizing, globalizing, harmonizing, and empowering.[19] For this wave of cyber-visionaries, the computer was first and foremost a tool for individual liberation, providing its users with a line of flight from the rigid strictures of social conventions and the status quo. Yet these idealized notions of an integrated network of individuals proved to be more neoliberal than communalist, and certainly not communist; these figures and their artistic predecessors circumvent any engagement with the political sphere, to instead focus on technology *as* politics, which obscured its real social effects and interfered with movements for structural change.

For all these thinkers—Mumford and McLuhan, Youngblood and Godard, VanDerBeek and Brand—the computer was more than just a new technology; it posed a theory of the subject and acted as both evidence and instigator of profound shifts in what it meant to be human. And yet in each case, whether as an imprisoned automaton or liberated cyborg, these theorizations relied on and perpetuated the antagonism between individual and system. This gestures toward a crucial similarity among these thinkers, which lies in how the freedom of the individual is defined. In all instances, these theorists, artists, and intellectuals conceived freedom as negative— freedom from constraints, limits, tradition, and the whims and desires of other people—and even those that valorize connection still subsume this under the mandate to be absolutely, individually free. The opposition between these two stances does not lie in their priorities, then, or their desired outcome, but in how, where, and why technology comes to play a part: technology is freedom's condition of possibility for the enthusiasts, its absolute and inescapable obstruction to the critics. Control, likewise, is something everyone wants to avoid; it is just that for some, technology is the antidote, while for others, its antithesis. The issue is more than how this value structure fails to be interrogated, or that these specific notions of freedom and control are assumed to be natural, normal, and right; more than that, this polarized debate shifts the whole question of technology into an ontological register, asserting what technology *is* rather than how it can and should be

deployed. In spite of the motivating ambition to overtly evade politics, this perspective came to have real political effects—most notably, by providing a language and cultural framework for legitimizing deregulation in both corporate and governmental spheres.

While cultural understandings of computers in the 1960s hinged on these stark oppositions and ontological thinking, computer technology of this period was just as capable of confounding them. Algorithms are programs able to mutate and change; cybernetics is a theory of how a system with imperfect, volatile, and wholly unknowable parts can not only function but also adapt and evolve; and information theory examines how communication is possible in the absence of shared expectations, language, or protocols. All presume that the activities of individual nodes, even spontaneous and renegade actions, support and co-determine rather than oppose a system's structural integrity. At the same time, algorithms, cybernetics, and information theory are based on an idea that systems are relatively *un*systematic—operable and functional to be sure, but unpredictable and incomprehensible in their entirety. These same aspects of early computers that led to a bifurcated cultural understanding therefore also point toward a different conceptualization of social systems and their subjects broadly conceived.

In contrast to the visions of new totalitarianism or unbridled freedom being propagated elsewhere, Arte Programmata deployed the notion of the program to unravel these very oppositions that shaped dominant cultural understanding of computers in the 1960s. They did not share Elull's, Mumford's, or Marcuse's worries about a seamlessly programmed authority or an Alpha 60 avatar pulling all the strings. Nor did they rush to romanticize computers as tools for empowering individuals, since individual autonomy was equally something the artists wanted to attack and dismantle. Whether instructing action through algorithms, supporting the feedback mechanisms of cybernetic systems, or forming the basis of the probabilistic logic of transmission in information theory, the artists of Arte Programmata considered computer programs to be the collective codes and conventions that make all activity within a system—however spontaneous and unprogrammatic—possible. The artists designed their works to empower viewers and awaken them to their own sense of agency in the world. But so

too did they intend for these works to integrate viewers, bringing them into conversation—literally and figuratively—with other subjects and the world.

This brought the artists of Arte Programmata to engage directly with the issue and specificity of control, especially in its cybernetic sense. While different theorists have distinct emphases, in all cases control in cybernetics is the adaptive aspect of systems, the outcome of continual reevaluation, flexibility, and feedback.[20] Far from restrictive, cybernetic control enables individuals to act on and affect their environment, and to do so not in isolation but in concert with a network or community. It was Arte Programmata's interest in collectivity, then, that drew them increasingly to confront issues of control—first, in the delimiting of options for how audiences could engage with their relatively "open" mobile works, and then in the disorientation tactics they used in their environments, and eventually in facing issues of political organization and collective identity amid extra-parliamentary social movements in the 1970s. Arte Programmata's objects, environments, and experimental designs from the 1960s to the early '70s evidence an intense attraction and repulsion to control as an inherent problem for any collectivity. Control—as not only the delimiting of discrete options, but more broadly as the organization of the whole environment, through which choices, actions, understanding, and even imagined eventualities come to be conditioned and made possible—stands in the work of Arte Programmata as both the problem to be solved and a crucial part of the solution.

On Control

It is this ambivalent status of control that makes Arte Programmata's approach to new technologies at once refreshing and challenging. But it is in many ways unsurprising, given that the artists were working just as what Gilles Deleuze later described as "the control society" was emerging in its most inchoate form. In a much-cited essay from 1990, Deleuze describes a shift in society's power structures, from an era based on *discipline* to one based on *control*. Whereas disciplinary societies (Deleuze draws on Michel Foucault's theorization) employed bureaucratic and institutionalized modes of domination that take discrete forms (the family, school, prisons, factories,

hospitals), in control societies the mechanisms of power are diffuse and difficult to locate.[21] Control societies are not, however, formless. Deleuze characterizes each type of society—metaphorically and functionally—by association with a machine: if thermodynamic machines powered the industries and institutions of disciplinary societies, then distributed, coded networks of information and communication typify the control society.[22] Using a different moniker, the "network society," to describe the same phenomenon of dispersion, Manuel Castells identifies this era as "a historical period characterized by widespread destructuring of organizations, delegitimization of institutions, fading away of major social movements, and ephemeral cultural expressions."[23] While Deleuze is concerned with how power and domination continue by these elusive means of informational circuits, Castells's project is more diagnostic and descriptive, but both assert the same claim: that starting around the postwar period, and accelerating into the 1970s, the institutional axes of society (and power) apparently begin to dissolve—a dissolution that is given form in both cases by the sprawling communicational networks of computers.

The question of how to resist domination in a control society is therefore an exceptionally contested one, because power works in decentered, dispersed, confounding, and inscrutable ways. Well aware of this dilemma, Deleuze proposes that total refusal is the only way to resist power in a control society. More specifically, since control works via networks of communication, coherence itself becomes something to avoid. Using William Burroughs's schizoid writing style as exemplary, Deleuze claims that "the key thing may be to create vacuoles of noncommunication, circuit breakers, so we can elude control."[24] Reveling in contradiction, embodying and amplifying the schizophrenia of the age, becomes for Deleuze and many in his wake the zenith of critical cultural practice in the control society. A number of artists followed in asserting inoperability as the most effective mode of resistance—most saliently in what David Joselit recognized in Nam June Paik's work as a "viral aesthetics," based on "the twin tactics of diversification and distortion."[25]

By contrast, for Arte Programmata incoherence and the impossibility of communication were as disconcerting a set of problems as didacticism

and domination. As they saw it, the condition described by Deleuze and Castells as characteristic of the control society—withering enclosures, cultural chaos, and an endless stream of meaningless information that amounts to little other than distraction and noise—could not be resisted through non-coherence, non-communication, or absurdist art, because these formless forms had become so central to how power works. Theorists have only further emphasized the importance of such dizzying tactics of disarray in contemporary power regimes, in what Tiziana Terranova calls "a kind of *abstract machine of soft control*," for example, and Alexander Galloway recognizes as the obfuscating operations of "protocols."[26] In her history and theorization of early internet culture, Wendy Chun goes as far as to call these structures of "control-freedom," pointing to "this structure of using while being used" that thrives on a host of other replacements: security for freedom, interactivity for political enfranchisement, and navigation for knowledge.[27] Where the discourse of freedom cannot legitimize domination and exploitation, Chun demonstrates, it serves to obfuscate it—a situation she rightly describes as breeding paranoia, in which power is everywhere and unlocatable all at once.

What generations of theorists grappling with the logistics and mechanics of control have articulated, then, is something that I argue Arte Programmata intuited. Neither the defense of the autonomous subject *nor* its radical dissolution could be viable strategies of resistance for these Italian artists, since these strategies would only reproduce the social problems (anomie, alienation, individualization, the breakdown of institutions and social bonds) they hoped their art could help to solve, or at least clarify and subject to analysis and critique. The intensification of control in Arte Programmata's work therefore needs to be understood in relation to the insidiousness of control societies and their false freedoms, especially how conventional tactics of artistic negation—decentering, dematerialization, deterritorialization—became instrumental to operations of power. But we should also remain sensitive to the ways Arte Programmata's work attempted to bracket this entire discourse and confront what it too often obscures: the question of collectivity, or how one lives with other people. These Italian artists became invested in programs and plans that look a lot like control mechanisms but effectively

operate as platforms for collective creation, experience, and understanding. It was through such technological materials and their attendant metaphors that Arte Programmata experimented with how society can and should be organized, how collective identity can be authorized, and how individual agency can be enacted and understood. The fact that this put them in such close proximity with things that have become synonymous with control—constraints on choices, interactive environmental design, network protocols for communication—should not be cause for condemnation of the artists, but a call to retheorize the relationship between control and, more broadly, conditions for collective life.

Programming: Conceptualizing a History

Arte Programmata's approach to programming, and attendant ideas about freedom and control, must be situated in the economic and cultural context of postwar Italy, in which the term *programmato* had a series of evolving and clashing connotations. From 1948 to 1952, millions of dollars flowed into Italy as part of the European Recovery Program, or "Marshall Plan," a United States–led initiative to aid western European economic regeneration after the devastation wrought by World War II. Thanks to this influx of goods and money, much of which was devoted to developing the industrial sector, along with the formation of the European Economic Community in 1957, which effectively widened the market for Italian goods, Italy experienced a *boom economico,* or economic miracle, that lasted from around 1958 until 1963. Northern Italian industries flourished, the country enjoyed the benefits of free trade accompanied by an increase of wealth, and prosperity among individual citizens grew alongside. During this period of financial buoyancy, the competing parties in the government faced off over the best way to proceed with social and economic reforms. Most agreed that some action on the part of the government—some form of economic planning, or *programmazione*—was necessary. Such a vision contrasted markedly with the laissez-faire economic strategy espoused by the United States; America increasingly distanced itself from the language of planning as any state-led intervention into the economy became associated with Communist rule

in the Soviet Union. In Italy, however, even centrist parties affiliated with the United States embraced *programmazione,* most notably the Democrazia Cristiana (DC, or Christian Democrats). The DC had come into power in 1948, overtaking the Italian Communist Party in that year's election and effectively dismantling the organized political left.[28] In the immediate postwar years, from 1945 to 1953, the leader of the DC and prime minister of government, Alcide De Gasperi, aligned the party with the United States and asserted the party's resolute anti-communism. When De Gasperi's leadership ended, after a few years of uncertainty (with the party wavering from left to right) the DC finally settled on a decisive "opening to the left" in 1958. Under the leadership of Amintore Fanfani and Aldo Moro, the DC forged a coalition with the Partito Socialista Italiano (PSI, or Socialist Party), which reached its climax with Italy's first center-left government in 1963.[29] In the decade prior, from 1953 until 1963, signs of the DC's opening to the left were marked by the party's support for a variety of *programmazioni.* As early as 1954 the DC minister of finance, Ezio Vanoni, had presented an overarching plan for the Italian economy, which was designed to bring about full employment, equity between the northern and southern regions, and an end to the deficit. While the plan was never realized, it asserted the DC's opposition to a laissez-faire approach to the economy.[30] As part of the center-left coalition that developed over the next few years, from 1958 to 1963, the DC-led government did implement a number of top-down government-led economic programs, such as nationalizing the electricity industry, initiating state supervision of the stock exchange, and related social initiatives like making school mandatory for children until the age of fourteen.[31]

The 1962 *Arte programmata* exhibition was staged at the height of optimism about state-led economic reform and the efficacy of a center-left majority, both of which were embraced by the leaders of the Olivetti company that sponsored the show and whose showrooms served as the sites for the exhibition in Italy. Founder Camilio Olivetti and his son Adriano, who took over as director of the company in 1938, were champions of social democracy and advocates of an enlightened corporatism, in which industry leaders benevolently provide social services to their employees.[32] Adriano Olivetti's optimistic stance toward social programming buttressed his en-

thusiasm about new technologies, a position continued by his son Roberto, who assumed the role of CEO after Adriano's death in 1960. The Olivetti company's long-standing and interrelated interest in these two types of programming (technological and social) became clear with the naming and design of Programma 101, the world's first electronic, programmable desktop computer, which commenced its research stage in 1962. The Programma 101 as envisioned by Roberto Olivetti was a radical departure from computers of the time, colossal machines that filled entire rooms and were only accessible by businesses wealthy enough to own or rent them at high cost. The Programmata 101, in contrast, was to be small, user-friendly, and affordable. In 1965 Olivetti unveiled their new machine at the Business Equipment Manufacturers Association meeting in New York. The Programma 101 was essentially a calculator and had no word processing capabilities, but innovative differences between the Programma 101 and large mainframes included the ability to provide a paper printout of the calculated results, its smaller size (due to an entirely new memory apparatus, the precursor to the floppy disk), and its easy programmability.[33] The Programma 101 materialized the Olivetti company's conception of the society they hoped their products would produce: one that was efficiently integrated and egalitarian, comprising empowered and creative individuals. The interest in computer programming taken by the artists included in the *Arte programmata* exhibition only could have been bolstered by their sponsor's hopefulness about both technological and socioeconomic plans.

Olivetti's investment in the connection between technology and society—and not just any society, but a planned society whose government-designed programs aimed at general social welfare—makes Arte Programmata's association with the company distinct from other artistic collaborations with corporations during the 1960s, especially the most canonical examples based in the United States. Most well-known are the Los Angeles County Museum of Art's "Art and Technology Program" that placed the sculptor John Chamberlain at the RAND Corporation and James Lee Byars at the Hudson Institute, both in 1969, and projects by Experiments in Art and Technology, such as their "Technical Service Program" that matched artists with industry giants like Bell Labs and the group's design for the Pepsi

Pavilion in Osaka in 1970.[34] Other notable examples include Charles and Ray Eames's work for IBM for the 1964 World's Fair in New York and Gyorgy Kepes's Center for Advanced Visual Studies at MIT, founded in 1967. A slew of recent scholarship has shown that these collaborations hinged on a set of shared terms (interdisciplinarity, collaboration, creativity) that obscured real political differences, as well as a techno-utopianism that prioritized formal experimentation at the expense of any clear social vision or concrete discussion of broader, social effects of their work. Technology in these cases abstracted and confounded the political uses that the corporations and think tanks made of these artworks, and, as Pamela M. Lee has argued, incubated and advanced their proto-neoliberal agenda.[35] The history of art and technology collaborations in the United States is dominated by these examples and the evidence of artists' complicity with technocracy, but such experiments in Italy present a different set of problems and demand a distinct approach. The enlightened corporatism of Olivetti can and should (and has been) criticized for its own role in innovating operations central to new kinds of technocratic management.[36] However, the company's pro-planning, socialist stance meant that technology was not used to obscure or essentialize the political stakes of art, but rather to make these sociopolitical questions all the more evident—even, and especially, when the political beliefs of the artists differ from their corporate sponsors (as they undoubtedly did). Put simply, in America, technology *replaced* politics, naturalizing and intensifying the laissez-faire status quo—an effect of art and technology collaborations that is most evident in these entanglements with corporations—while in Italy technology was a means to make the political stakes of formal experiments more legible and continuous with actual political debates, even when Arte Programmata were at their most abstract. This highlights that another crucial difference between these artistic collaborations with industry in Italy versus the United States is in the outcomes: reductive geometric abstraction and modest household design dominated the scene in Italy, while in the United States artworks ranged from lo-fi conceptual art (Chamberlain's memos, for example) and elaborate multimedia performance, as in E.A.T.'s seminal *9 Evenings* (1966) and immersive, intricate Pepsi Pavilion at Osaka (1970).

In the years following the 1962 *Arte programmata* exhibition, there was a growing awareness of the uneven effects of the economic boom, which tempered the artists' optimism about technological and social planning alike. Despite profound cultural changes, industrial development, and improvements in many people's everyday lives, the working class suffered, and the plethora of available luxury goods and consumer choices came to mask a growing unrest. Advances among the middle and upper classes were won on the backs of exploited workers, whose conditions only worsened during the years of the boom.[37] In 1962, there were already strikes in the northern factories (staged largely by workers from the relatively poorer South) demanding better benefits and pay. Starting in the second half of the 1960s, therefore, *programmazione* took on an increasingly pejorative connotation associated with unjust and uneven social and economic development. For many on the Italian left, the notion became closely aligned with the mechanics of technocratic domination. In his study of the extra-parliamentary leftist movement of the early 1960s and '70s, namely *operaismo* (workerism) and Autonomia, Steve Wright has shown that while "the call for planning had been central to the left ideology following the Resistance," this younger generation of anti-capitalist Italian intellectuals and activists saw, "on the contrary, [that] planning had become 'the fundamental expression of the law of surplus value,' stretching out from the workplace to assert its command over society as a whole."[38] In other words, the radical left viewed programming as just the next, more sophisticated stage in capitalist exploitation, not its mitigation. Mario Tronti articulated such a leftist critique of planning in his essay "Il piano del capitale" (The Plan of Capital), published in 1962. This landmark publication also developed the important concept of "the social factory," in which capitalist production and exploitation expand outside the workplace to extract surplus value from all activities of everyday life.[39] Tronti argued that economic plans, even those that seemed to help the working class, were simply a way to appease people and strip them of their power to resist.[40] Recently, Pier Vittorio Aureli has reiterated that for Italian activists and intellectuals of this period, the very definition of neocapitalism in Italy included an emphasis on economic planning: "In the 1960s, neocapitalism became the organic link between the capitalist system of accumulation

and the programs of the welfare state."[41] The result of this leftist critique of planning, however, as I will discuss in detail in chapter 4, was not an Italian left based on an anti-*programmazione* liberatory politics, but a left devoted to ever more rigorous attempts to distinguish between revolutionary and reactionary plans. Even the critics of *programmazione* in Italy maintained a belief that the only alternative was still a program in some form.

The work of Arte Programmata, especially when broadly conceived, all took place in the midst of these changing notions of social, political, and economic programming. What remains consistent in all of these notions of the program, artistic and otherwise, is that it is the program that allows a group of disparate individuals to cohere as a collectivity, to understand their own relationship to others and collaboratively enact change in the world. It serves as the condition of possibility for collective engagement and action. The artists of Arte Programmata were not alone in finding in technology a model for rethinking the essence of society and the mechanics of social life. They were part of an international milieu of artists devoted to interrogating the complex relationship between structure and agency who recognized how technologies like computers and cybernetics offered new ways of conceiving these terms. These ambitions are rampant in artists' experiments with technology throughout the 1960s and beyond. They also evidence a concerted effort among artists across the globe to transcend and undermine the association of "freedom" with the individualistic and antisocial stance of Western democracy. Some of these affinities are discussed in detail throughout the chapters that follow—the relationship between Arte Programmata and the network of kinetic artists associated with the New Tendencies in Europe, South America, and Yugoslavia, for example, and the broader genre of "computer art" that emerged around the same time in the United States and United Kingdom. Affinities with other groups like Fluxus and the Independent Group are also clearly evident. Although formally the geometric abstraction of Arte Programmata is far from the pop aesthetic of Richard Hamilton or Edoardo Paolozzi and the outlandish performances of Benjamin Patterson, Yoko Ono, and Charlotte Moorman, the interest in how bodies are determined by systems and structures abounds in all cases. Likewise, there are significant similarities between these Italian artists and

those working in eastern Europe, where the political issues of organization and interest in actually existing communism and socialism were more overt. Polish architect Oskar Hansen's notion of "the open form" has significant resonances with Eco's notion of the "open work"—both are essentially ideas of mutable, generative structures, an attempt to think systematic coherence and flexibility as co-constitutive rather than opposed. And across the Eastern Bloc, many strove to find an alternative to official communism in new technologies and cybernetics, developing a "cybernetic socialism" that Armin Mendosch has also noted in the work of the New Tendencies, including Arte Programmata.[42] Even beyond these explicitly technological works, Eve Melzer has shown that a knowing submission to systems permeated all kinds of post-medium practices, even the most analog conceptual and performance art.[43] Certainly, these artists of Arte Programmata were not alone in their desire to make artworks that created a space where shifting ideas about subjectivity, especially as they were affected by new material and social conditions, could be confronted and made conscious to the audience.[44] This all goes to show that numerous artists not explicitly working with technology and new media were still concertedly thinking through their implications and effects.

By seeing in early computer technology an opportunity to rethink the nature of freedom, the social sphere, and the relationship between the two, Arte Programmata joined a conversation that crossed disciplines and traversed geographic borders. What makes these Italian artists singular is not that they saw technology had these wider implications, but how. One of the most striking dimensions of Arte Programmata is their relationship to leftist political discourse, which was shaped by Italy's particular position within the Cold War (opposed to both Western democratic capitalism and Soviet-style collectivism) as well as the renewed importance of Marxist theory for intellectual, activist, and social movements at the time. Arte Programmata's investment in the dynamic relationship between freedom and control can only be understood in the relation to a larger milieu in Italy committed to thinking through the form, organization, and structure of a free society—not, as Bruno Latour would have it, simply as an assemblage of individual nodes, but as a whole that exceeds and also cannot fully accommodate the sum of its parts.[45]

On Freedom

It is a central argument of this book that Arte Programmata's investigation into the issue of what it means to live with programs was also always a way to understand the conditions for human freedom, rather than conceiving programs as a categorical threat to free will. This dilemma—how to ensure freedom within a social structure, rather than against it—was on the minds of many Italians in the postwar period, following fascism, and those on the front lines of formulating the new constitution and composing the government were faced with the problem of how to create a robust, democratic state without devolving (again) into totalitarianism. This intricate minefield of considerations was further compounded when the Communist Party came under attack following revelations about the repressiveness of the Soviet state in the 1950s, evidencing the reality that any strong centralized government—even when in the hands of "the people"—could still be authoritarian. This posed a challenge to committed leftists, especially, for whom no existing model of political organization would suffice. The question, for those across the spectrum, was this: What form of government would best ensure freedom? Does it arise inevitably from a more equitable distribution of wealth, or does freedom require another kind of organization, protection, or political structure? Significant for our purposes is that in Italy, freedom was always a question of form.

This is clear in the robust public debate about the nature of freedom that took place in Italy in the 1950s between the social democrat Norberto Bobbio and committed Communist Galvano Della Volpe. Their differences hinged on their distinct ideas about the relationship between two different kinds of freedom: economic equality and cultural freedom of expression. In a series of articles in the journal *Nuovi Argomenti* in 1954, Bobbio and Della Volpe laid out their positions on the problem of freedom and the state. The context of their publication is not insignificant: the journal invited contributors to weigh in on the issue of "Communism and the West" by answering a series of questions about political systems and their potential in eastern and western Europe, specifically. The aim was explicitly to refuse the association of communism or socialism (and social equity) with the Soviet Union

and capitalism (and, likewise, freedom) with the United States.[46] For his contribution, "Democracy and Dictatorship," Bobbio criticized the Marxist notion of a "dictatorship of the proletariat," arguing that more important than the issue of *who* dominates is that of *how*. Bobbio's larger concern, continuous with his writing on democracy in the 1940s, was the Italian Communist Party's lack of any clear conception of how to ensure individual freedom within a communist society.[47] He took issue with their assumption that freedom would naturally arise once capitalism was abolished and communism realized, insisting instead that freedom needs an institutional framework and legal protections.[48] Della Volpe's response rejected the separation between individual freedom and a more equitable communist society by pointing to what he saw as Bobbio's confusion between an abstract (liberal) ideal of freedom and a historical materialist (social) one (what he calls "democratic demand materialistically supported").[49] In other words, the writer qualified yet maintained the interrelation between the structure of society and the ability for individuals to be autonomous and free. Della Volpe's critique followed from his 1946 publication *La libertà comunista (Communist Freedom),* which, as Mario Tronti put it in a 2000 edition of the text, attempted to deal with "the contact-contrast of freedom and communism. Not liberalism and socialism. Direct contact and contrast between the problem of freedom and the perspective of communism."[50] Della Volpe took issue with how Bobbio tried to reconcile socialism with liberalism (maintaining a specifically liberal notion of freedom in so doing), while Bobbio contested his interlocutor's refusal to deal explicitly with the problem of democracy as something that cannot be guaranteed, necessarily, by a socialist or communist state.[51]

The intricacies of the debate (and its varying partisan interpretations, at the time and at future flashpoints) are of less concern for our purposes than the fact that even in the wake of fascism and the continued specter of totalitarianism in the Soviet Union, Italian intellectuals did not rely on a wholly negative notion of freedom, and instead focused their discussions on the structure of the state. Their conversation centered on qualified notions of freedom grounded in concrete conceptions of social organization. Indeed, both Bobbio and Della Volpe accuse one another of wrongfully prioritizing "negative" freedom: freedom *from* institutions, *from* social attachments, *from*

channels of communication, even freedom *from* coherency and meaning itself. Bobbio might value the right of individuals to enjoy non-coercion and freedom of choice, but he believed this needed a robust infrastructure of protection. And Della Volpe may have confused liberty with autonomy, but he too understood the state to be a condition of freedom, not antithetical to it. Despite their differences and disagreements, both saw freedom arising from structure, rather than considering them to be essentially opposed.

This perspective on freedom was not confined to this particular 1954 debate or these two figures. When protests and strikes erupted in Italy in the late 1960s, it prompted a whole generation of Marxist thinkers—many profoundly influenced by Della Volpe—to reexamine the role of the state, the party, and the importance of political organizations writ large. And the movement that followed in the 1970s was not defined by eruptive action but by the concerted organization of new institutions (social centers, radio broadcasts, alternative universities, networks of care). This emphasis arguably continues to structure the nature of Italian activism today, even in the art world, evident in what Marco Baravalle has recognized as an impetus toward *alteristituzioni* or alter-institutions, in contrast to the more conventional institutional critique or anti-institutionalism.[52]

The debate between Bobbio and Della Volpe is the most local example of what was a broader investment among intellectuals of the time to parse *negative* freedom from *positive* freedom—what Erich Fromm in 1965 crystallized as the distinction between "freedom from" versus "freedom to."[53] In his 1965 book *Escape from Freedom,* Fromm argued that liberty needs certain economic, social, and political conditions to exist. Freedom does not exist a priori, innate to the individual, something one needs only to strip away structural barriers to unleash—a presumption inherent to any formulation of freedom *from* (and also rampant in liberal and neoliberal notions of the term). Freedom *to* presumes that "society has not only a suppressing function—although it has that too—but it has also a creative function."[54] Fromm's central aim was to explain the rise of fascism: What psychological conditions had to be in place for people so easily and willingly to submit themselves to a dictator? But he found an equally disturbing reality in the human submission to machines and technocracy.[55] Fromm's multifac-

eted analysis, as well as his committed Marxist position (Fromm was part of the Frankfurt School), led him to make the striking argument that positive freedom requires a robust infrastructure to exist. Freedom in the positive sense, for Fromm, in fact relies on clear protocols and more transparent and cogent plans: "The irrational and planless character of society must be replaced by a planned economy that represents the planned and concerted effort of society as such," Fromm concluded.[56] But not just any plan will suffice: "Unless planning from the top is blended with active participation from below, unless the stream of social life continuously flows from below upwards, a planned economy will lead to renewed manipulation of the people. To solve this problem of combining centralization with decentralization is one of the major tasks of society."[57] Fromm's notion of *freedom to* therefore rejects the opposition between freedom and programming, as well as communism and liberalism, at the same time that it suggests why the two have never successfully been bridged (as all scholars of the Bobbio / Della Volpe debate, regardless of their sympathies, admit).[58]

The appeal and necessity of a notion of positive *freedom to* remains. Today's societal structures proliferate negative freedoms all the time—freedom from monotony at work (freelancing, precarious labor) and freedom from the state (a demand that welfare and other social programs shrink to the point of disappearance belied by the simultaneous call for expanding police and the military), to name a few of the most salient examples. From this standpoint, it becomes difficult to justify any position—artistic, technological, or social—based on the idea of negative freedom. Negative freedom reproduces both the individualism that comprises the dominant ideology of capitalism and the contemporary conditions of domination and control. No wonder that Arte Programmata, well aware of the limits of the Cold War discourse and conditions of a society of control, rejected it, and sought a pathway for modeling a more positive, constructive ideal. But this ideal was equally distinct from a technologically deterministic notion of freedom, in which technology is the *only* condition of subjective free will. Arte Programmata's practice demonstrates that they were thinking through freedom as something that arises in and among the relationship between technological and social programs.

The political context, spanning the postwar to today, is crucial. But it is not incidental that Arte Programmata's interrogation of freedom occurred in the realm of *art*. Art, at this historical juncture, was a realm where individual freedom, creativity, agency, and subjectivity were all being experimented with, reexamined, figured forth, and newly understood. But here too, dichotomies abound: understandings of freedom in art, be it the freedom of artistic expression or a nondeterministic, free-from-necessity aesthetic experience, oscillate between existing beyond and even against society (as in the legacies of Romanticism and art for art's sake) or unilaterally instrumentalized by it (as in, most important for this context, the Cold War discourse of artistic "freedom" as a cipher for Western capitalist individualism). Looking at the issue from the other direction, Juliane Rebentisch has recently shown how central theories of democracy, from Plato to Rousseau, rely on "the ethical–political rejection of the aesthetic" and the subjective freedom associated with it.[59] Rebentisch shows how entrenched a negative notion of freedom is within a history of aesthetics. This can make it seem that art is the antithesis of society, or that a project of protecting artistic freedom has to be, inherently, against one aimed toward establishing a more just state. There is a plethora of counterexamples—André Breton and Leon Trotsky's 1938 "Manifesto for an Independent Revolutionary Art" comes most immediately to mind—and most, like this one, are lodged in a history of alternative communisms. Arte Programmata are aligned with this broader history of artists who understood their explorations of artistic freedom to be part of—rather than beyond, against, or (alternately) subservient to or equivalent with—a broader reckoning with political and social forms.

Organization of the Book

This Introduction has sought to provide a sense of both local and international discursive frameworks that shaped the central terms of this study. It stems from my methodological approach, which situates art history within and among technological and intellectual histories and focuses on the theoretical and political implications of form. To this end, I have been fortunate that many of Arte Programmata's artworks have been recently reinstalled at

museums in Italy; a good number of the environments discussed are on display in the permanent collections of the Museo del Novecento in Milan and La Galleria Nazionale d'Arte Moderna e Contemporanea in Rome. Various programmed objects have made appearances in exhibitions since the start of my research, at the New Museum and MoMA, for example, in New York. It was only after seeing these objects and environments in person that the more controlling dimensions of Arte Programmata became uncontestable, as it became readily apparent that the things were saying something different than their makers. That said, as is the case with so many ephemeral installations, exhibitions, and artworks of this period, I have also relied a great deal on diagrams, photographs, firsthand accounts, and contemporaneous reviews. When describing works throughout the book, I note whether the actual thing was available and when I am working from secondary sources.

In the chapters that follow, I trace an expansive idea of programming as it mutates in shape, scale, ambition, and effect. In some cases, the program served as an actual (albeit highly simplified) principle for artistic production; in others, it was a conceptual metaphor for envisioning how the audience might be incorporated or activated by the work. In all cases, the artwork served as a model for subjectivity and social relations. Chapter 1 establishes "programmed art" as a theory of artistic production and historicizes its connection to Umberto Eco's idea of the open work. It charts how and why in 1962 the artists included in *Arte programmata* embraced a strategy of dispersed authorship modeled on computer programs. This chapter focuses on the program as a model for artistic labor, which was precisely how the artists understood the term and the aims of their work. Two of the artists are collectives (Gruppo T and Gruppo N), and the literal collectivization of their creativity was a crucial way they thought they were undermining any individualism in both the creation and meaning of the work. But the larger aim of this chapter is to demonstrate that the fantasy that programmed, collectivized production would create a more open, inclusive, activating, and participatory experience for their viewers obscured another element to the work: the simultaneous attempt to enclose and control the viewer and articulate—indeed, insist on—the collective conditions for individual agency.

Chapter 2 historicizes and theorizes the intensification of control in the

immersive, interactive *ambienti* as they develop between 1964 and 1967. I show that the artists' move from object to environment was a response to changing ideas in Italy about the nature of individual freedom, and with it, the political aims of art. The objects of the early 1960s delight in endless alteration and indeterminacy as a means to draw the audience into the creative process, making them a part of the work. But what became immediately apparent as their works traveled and were misunderstood (most famously in the 1965 MoMA exhibition *The Responsive Eye*) was the extent to which such values as open-endedness, audience participation, and abstraction too comfortably fit into the individualistic ideology of Western capitalism. This chapter suggests that the environments were a response to the failures of the objects to sufficiently collectivize the space of spectatorship in a way that could unsettle and undermine the Cold War binaries. The seeds for this idea were already in the 1962 exhibition, but they were further fostered by the 1964 Milan Triennale, organized by, among others, Umberto Eco, which included a work by Enzo Mari and Gruppo T. "Tempo libero" (Free Time) sought to dismantle the semblance of the free individual in capitalist culture by critiquing a central part of this myth: the idea of self-directed, desire-driven, free leisure time. Constructed as a series of sensorially stimulating, cinematic rooms, the 1964 Triennale put forth an unequivocal argument: it attacked the idea that personal taste was indeed personal by sending message after message that desires are determined by the social and historical situation in which one lives. Similarly, with their use of surveys, switchboards, motion sensors, psychedelic effects (rotating mirrors, blinking lights), and other interactive elements, Arte Programmata's programmed environments sought to activate the viewer in a way that also demonstrated, on a visceral level, how all activity is contingent on context, environment, and the formal constraints of the work. But unlike the Triennale, which was modeled on the strategy of ideological critique, the *ambienti* draw on cybernetics and rejected criticality. This distinction between a critical model for art and a cybernetic one is an important thread and is further teased out in the final "scene": the 1967 exhibition of environments, *Lo spazio dell'immagine* (The Space of the Image), which exhibited Arte Programmata alongside artists affiliated with the burgeoning Arte Povera movement.

Chapter 3 places Arte Programmata on the international stage of early computer art to assess the genre's political stakes. I focus on how the Italian artists' use (and misuse) of computers differed from others operating in the United States, United Kingdom, and eastern Europe and argue that underlying the different notions of computers were disparate political theories of art. By 1970 the terms of understanding computer art were split between the aesthetic and the political, the formal and communicational, as epitomized by two exhibitions: *Cybernetic Serendipity* at the ICA in London (1968) and the *Information* show at MoMA in New York (1970). On the one hand, computers were an inspiring new medium prompting formal innovation (the goal being aesthetic novelty); on the other, computers were a communicational medium, in which art (be it computer based or not) serves as a message-delivery system (the goal being explicitly political, be it as propaganda or critique). Arte Programmata's work was unrecognizable if viewed through these terms, as the purpose was to assert the collective nature of individual experience—to find, that is, the political in the aesthetic, and vice versa.

The fourth and final chapter looks at the artists of Arte Programmata during the surge of protests starting in the late 1960s and early 1970s. It confronts two issues percolating in the book thus far: (1) the role of design—almost all of the Arte Programmata artists also were designers, most famously Bruno Munari and Enzo Mari; and (2) the uncomfortable "end" of Arte Programmata—their cybernetics-inspired art effectively positions the artist as a social engineer capable of shaping and manipulating their audience. The book thus far stresses how this aspect of control in the work should be seen as a critique of an untethered ideal of individual freedom and an attempt to locate the basis for subjectivity in a common material and technological world. This chapter elaborates what diagnostic power this role has historically and what it might offer us today. The last chapter ventures that by looking at what the artists of Arte Programmata go on to do gives us one answer. It shows that after 1968, design is where these debates about social and political programming play out in Italy. To unpack these intricate politics of design, I examine a number of projects by Enzo Mari, Giovanni Anceschi, Davide Boriani, and Gabriele Devecchi, as well as the pedagogical strategies and visual theories of Gruppo N's Manfredo

Massironi. I argue that these works anticipate a contemporary perspective: that there is no outside or beyond with capitalism, because there is an inexorable identity between the system and ourselves.

This perspective appears to stand in great contrast to Arte Programmata's contemporaries, namely the activist milieu associated with *operaismo* and Autonomia, which emphasized (among other things) political strategies of refusal, exodus, and sabotage. This chapter contends that these leftist activists and intellectuals share much more with Arte Programmata than first appears. Looking at political theories and activist debates, it becomes clear that these movements, while incredibly diverse, were not based on an *antiprogrammatic* liberatory politics. Autonomy for most of Autonomia and their predecessors was not freedom *from* structures, but rather relies on the creation (the design) of better ones. A case in point is the journal *Contropiano*— "counterplan" in Italian—active from 1968 to 1971, which published cultural analyses aimed at dismantling not only capitalist plans but also ineffective leftist agendas and sought to develop a radical program that could supplant both. Looking at Arte Programmata alongside this broader intellectual milieu, we see a shared commitment to developing alternative institutions, in contrast to contemporaneous assertions of the eruptive, dismantling role of critique or spontaneous events.

The Conclusion continues this discussion of collectivity and elaborates the implications of these efforts for understanding Italy in the late 1970s and our conditions today. Chapter 4's study of *operaismo* and Arte Programmata charts how both movements worked to develop new forms of collective action, organization, and representation. In the late 1970s, activists increasingly appropriated the language of the historical avant-gardes like futurism, Dada, and surrealism. They romanticized absurdity and rejected conventional politics, writ large, presuming any kind of representation to be a totalizing (even tyrannical) endeavor. The Conclusion argues that Arte Programmata offer another way of conceiving representation, and with it, the relationship between politics and art. Rejecting the rhetoric of "collapsing" art and life, and the fantasy of immediacy and post-political strategy it served to further among this 1970s activist milieu, Arte Programmata

help us to see that the connecting tissue across art and politics is an investment and continual interrogation of collectivity and form.

This book seeks to underscore the idea that both art and technology are ways of visualizing and structuring social interaction. From this perspective, to conceive of a programmed subject is not to posit society as inevitably constricting, something that individuals must begrudgingly submit to or escape, but rather to locate the basis for subjectivity and society in the material, physical, and practical world that we share. The aim of the present study is not to overstate the applicability of Arte Programmata's model or argue that we adopt it as our own, but to use the artists' experiments with computers to evaluate what is lost and what is gained, both conceptually and politically, when we presume to work with or against the program. It seeks to interrogate what art might have to offer in the ever-more pressing project of reimagining the social field. The challenges of our moment, which can only be described as an utter and devastating failure of the state—a failure that has unleashed a slew of economic and ecological disasters on all but a rarified and elite privileged few—has put this question of collectivity, society, social constraints, and their relationship to equality and social justice front and center in cultural and political discourse. Part of the task is to parse what each arena can accomplish, and to chart actions according to these specific possibilities and constraints. Politics is where actual programs can and should be—and are being—articulated and fought for. But the terms of these battles also need to be radically rethought, starting with what we mean by society, the social, as well as the state. Art, then, might be a place to work toward a new way of experiencing and describing these collective bodies. At the very least, the renewed appeal of the social as a category in our current moment of failure and crisis points to why it is worth examining the reasons that Arte Programmata found the program so appealing, and to complicate the fantasies of individual liberation and optimization and apocalyptic visions of control that dictate and arguably stagnate conceptions of art, technology, and society in our contemporary milieu.

COLLECTIVIZING AUTHORSHIP

Arte Programmata and the Open Work,
1962

When the 1962 exhibition *Arte programmata: Arte cinetica, opere moltiplicate, opera aperta* (Programmed Art: Kinetic Art, Multiple Works, Open Work) opened at the Olivetti Showroom in Milan, it might not have been immediately apparent what a room filled with mesmerizing kinetic sculptures and optically stimulating objects had to do with a company dedicated to electronics and communications technologies. None of the artworks used computers, typewriters, or calculators as a medium, nor did this dizzying array of plastic and metal abstract assemblages seem to offer practical design possibilities for future Olivetti products. Yet the structural and conceptual foundations of computers, Olivetti's most recent interest and investment, were everywhere. Key features of the computer—the delegation of creative tasks to automated mechanisms and the communication between human beings and machines—simultaneously constituted *how* the works were made and *what* spectators were asked to observe in action. Gruppo T member Gianni Colombo's *Strutturazione fluida* (Fluid Structure, 1960), for example, was a transparent box containing a clear plastic ribbon that, thanks to a motorized pulley hidden in the base, appeared to snake itself in and around the frame. Gruppo N's *Rilievo ottico-dinamico* (Dynamic-Optical Relief, 1962)

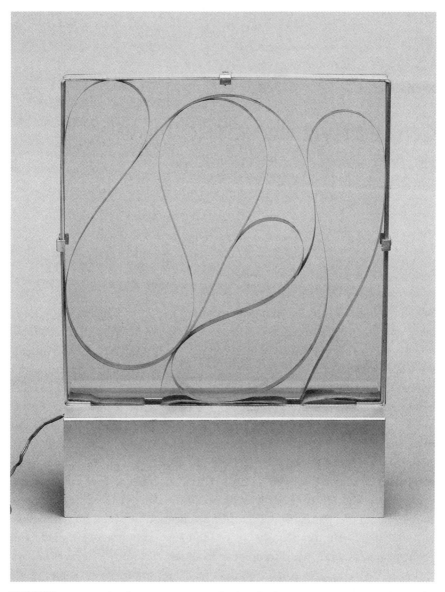

FIGURE 1 Gianni Colombo, *Strutturazione fluida* (Fluid Structure), 1960. Courtesy of
Archivio Gianni Colombo, Milan, Italy.

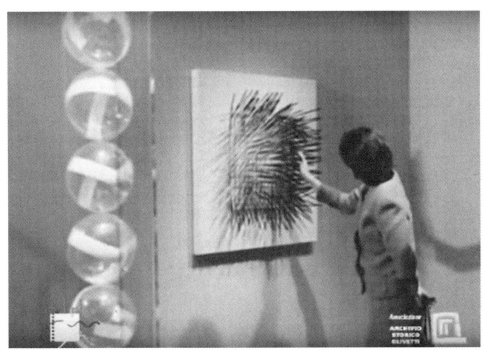

FIGURE 2 Gruppo N, *Rilievo ottico-dinamico* (Dynamic-Optical Relief), 1962; as displayed in the 1962 *Arte programmata* exhibition at the Olivetti Showroom in Milan. Frame enlargement from Enzo Monachesi, dir., *Arte programmata* (1963).

was a white square pierced with rotatable metal rods, organized into a grid that viewers were invited to twist into new configurations. And in the collective's *Interferenza geometrica* (Geometric Interference, 1962), five sliding panels, adorned with a stack of either horizontally, vertically, or diagonally dashed lines, enabled the audience to create unique designs from the work's constituent parts. The idea of "programming" underlying *Arte programmata* therefore condensed complex and seemingly competing notions such as algorithmic functions, stochastic processes, and mathematician Kurt Gödel's incompleteness theorem into a single operating principle: a simple, logical structure can generate an unforeseeable number of possible forms.

For the contributing essayists to the *Arte programmata* catalog, this notion

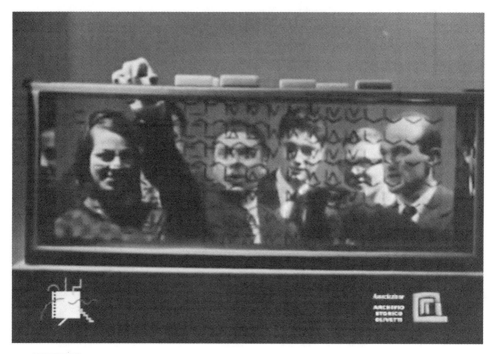

FIGURE 3 Gruppo N, *Interferenza geometrica* (Geometric Interference), 1962; as displayed in the 1962 *Arte programmata* exhibition at the Olivetti Showroom in Milan. Frame enlargement from Enzo Monachesi, dir., *Arte programmata* (1963).

of the program articulated a broader and interconnected set of cultural and epistemological transformations that these artworks interrogated and engaged. Organizer and participating artist Bruno Munari posited that programming was primarily an artistic method to generate formally innovative compositions, explaining that "in these works of programmed art, the fundamental elements . . . are arranged objectively in geometrically ordered systems so as to create the greatest number of combinations, often unpredictable in their mutations but all programmed in accordance with the system planned by the artist."[1] The philosopher Umberto Eco claimed that the greatest contribution of *Arte programmata* was how it demonstrated that "following precise, predisposed formative patterns . . . do[es] not negate spon-

taneity, but rather enlarge[s] its boundaries and possible directions."[2] He defined *programmed art* in terms of a "singular dialectic between chance and program":

> Contemporary art is generally recognized by two categories of artists: on the one hand those who devote themselves to the search for new forms, faithful to an almost Pythagorean ideal of mathematical harmony. . . . On the other hand those who have realized the richness of chance and disorder, certainly not unaware of the reevaluation—made by scientific disciplines—of random processes. . . . But is it really true that mathematical rule excludes chance? . . . Would it not be possible, therefore, to delineate, with the linear purity of a mathematical program, "fields of events" where random processes can happen?[3]

For Eco, the works in *Arte programmata* demonstrate that such a synthesis is possible. The forms are finite, logical, and clear, but their instantiation in space and time, as moving, physical objects, renders them infinite, unpredictable, approaching (Eco contends) utter randomness. Both Eco and Munari assert this singular reading that *Arte programmata* illustrates the tensile oppositions constitutive of contemporary life: chaos and order, fragment and whole, planning and spontaneous action.

The computer program, however, served as more than just the interpretive key behind the exhibition *Arte programmata*. It also operated as a working methodology, one that ran counter to programmed art having a set or single message. The participants (Munari, Enzo Mari, and the collectives Gruppo T and Gruppo N) hoped to avoid creating singular artworks and instead sought to provide their audience with a material platform that could include them as co-creators of the work. By automating the realization of their artworks and demanding concrete activity on the part of viewers—who would have to move their bodies to see all sides of a kinetic sculpture or continually refocus their eyes to keep up with rippling geometric patterns or motorized compositions—Munari, Mari, Gruppo T, and Gruppo N imagined they were alienating the authorial operation, objectifying it in the program, and dispersing it equally across all elements of the work. From

this perspective, the most radical ambition of an *arte programmata* was to generate a multiply authored, horizontally organized, and endlessly mutating composition—a leveling, even democratizing, of the creative process that included and activated the audience.

How and why the program was seen by the artists of *Arte programmata* as a means for collectivizing authorship relied in large part on its relationship with another term in the Olivetti exhibition's title: the *open work,* which Eco had defined in a series of essays compiled and published, also in 1962, as *Opera aperta: Forma e indeterminazione nelle poetiche contemporanee* (The Open Work: Form and Indeterminacy in Contemporary Poetics).[4] In *Opera aperta,* Eco draws on information theory, a field foundational to the development of computers, to describe open artworks as those that contain a multiplicity of possible interpretations. From kinetic "works-in-movement," to musical compositions reconfigured for every performance, to novels with ambiguous signifiers, many understood the genre of *arte programmata* to espouse the same model of authorship as Eco's notion of the open work. While "programmed art" stresses the openness of forms and Eco's "open work" emphasizes the plurality of meaning, in both terms the author spawns a "field of possibilities" rather than a definitive work of art. Where the two coincide most comfortably is in their theory of artistic labor. Both terms describe a process for delegating authorship to the chance operations of the work, and both presume that the space of labor will encompass the sphere of reception; that, through the mediating term of the programmed open artwork, the creative agency renounced by the author will in turn be assumed by the audience, which will interact with and interpret the work with greater freedom than ever before.

However, another dimension of the program operating in the 1962 Olivetti exhibition is based not on authorship or labor (and its projected expansion) but in the distinct, delineated space of reception.[5] This element of *Arte programmata* exceeds, or at least deviates from, the contemporaneous theorizations typified by Eco's "open work." From this other perspective, "programmed art" does not create an indeterminate, infinitely mutating space, in and around which the viewer may meander and indefinitely explore. The stark, geometric simplicity of the artworks is striking, their

"algorithmic" logic so reduced as to be almost infantilizing. Faced with the oscillation between finite and infinite in these metamorphosing, mutating works, one experiences expansiveness and enclosure simultaneously—not, as the artists and Eco posit, in progression as a gradual opening out. The experience is not one of unbounded liberation but of control, of restraint, of limits. These works demonstrate how our presumably free and spontaneous actions—whether physical movement or the process of interpretation—rely on rather than defy our given, material constraints. Embedded in all the rhetorical assertions about openness and freedom and inclusion is therefore a more complex and historically provocative assertion: for any kind of social engagement—artistic or otherwise—to take place, one needs a commonly held platform, a set of protocols, a program. This assertion is obfuscated by the collapse of "programmed art" with the "open work." When we un-couple the two terms and tease out their differences, however, it becomes clear that the most compelling aspect of the 1962 *Arte programmata* exhibi-tion is how the works sought to generate aesthetic experiences that resist individuation and stage the inextricable connection between spontaneous, free action and an operable social sphere.

Ideological *Impegno* and the Politics of Authorship in Postwar Italy

In the late 1950s and early 1960s, young practitioners in the vibrant north-ern Italian art scene were rethinking the role of the artist and, with it, the location of creative agency, as defined in the work of art. Fatigued by the immediate postwar debates about the political efficacy of figuration versus abstraction, artists wanted to eschew the ideas about authorship these styles espoused: on the one hand, the artist of social realism, who is subservient to a predetermined ideology, political project, and party; on the other hand, that of *arte informale,* in which access to and expression of an authentic in-dividuality is paramount. *Arte programmata* was staged at a time when both paradigms were in crisis, their underlying assumptions being challenged on multiple fronts.

The Italian Communist Party (PCI) thrived in Italy right after World War II as leaders of the antifascist resistance. It was the party of a wide range

of left-leaning artists and intellectuals who, for a while, were able to deploy a diversity of artistic styles to express the idea of *impegno,* or commitment to the revolutionary communist cause. But pressure from Moscow and the growing popularity of American art and values among Italians caused the PCI to adhere more rigidly to an ideology and aesthetic, thereby dissolving the alliance between the PCI and more moderate factions of the Italian left. In November 1948, following the PCI's disastrous defeat in the most recent election, party leader Palmiro Togliatti publicly condemned abstract art and asserted figurative realism as the only real expression of *impegno.* From that point on, many artists, including Renato Guttuso, abandoned any semblance of abstraction and began to make art that was more straightforwardly an expression of political content. Others refused Togliatti's mandate and continued to defend the importance of stylistic experimentation as a part of any *arte impegnata,* such as the artists of Forma 1, who staunchly defended their claim to be "both formalists and Marxists," a position they had asserted since their founding manifesto in April 1947.[6] Similarly, the painter (and PCI member) Emilio Vedova understood his thickly scrawled abstract paintings from the late 1940s and early 1950s as no less politically committed than socialist realism, since they wrested the expression of the individual from the self-effacing political imperative of fascism.[7] Togliatti's 1948 proclamation led to a bifurcation of artists along the lines of abstraction and figuration. Realist artists such as Guttuso contended that their position was the true representative of an international, revolutionary project, while abstract artists who held fast to formal experimentation heralded themselves as the progeny of the Italian Resistance with their antitotalitarian assertions of individual autonomy and uncensored expression.[8] However, the distinct styles and values to which figurative and abstract artists adhered obscure what the two sides held in common. So long as communism was a viable ideological position, committed artists could rely on their association with it to bring political relevance to their art. Therefore, whether deployed by PCI-affiliated realist artists or those defending abstraction against party policy, in both cases the notion of *impegno* carried with it a specific authorial operation. Artworks, whatever their form, were expressions of the artist's commitment to an already-existing political program. As Guttuso explained, "if

he is a man *impegnato* . . . it can be seen in all that he does," and the artists of Forma 1 asserted their own identity as a means of claiming a politics for their art.[9] Each of these politically committed artists affixed themselves to a stable political project, and it was this equation of the author with a political agenda that propelled the creation, form, and meaning of their work.

The communist project was thrown into crisis over the course of the 1950s in Italy. The Soviet invasion of Hungary in 1956 delivered a final devastating blow to the viability of official Communist ideology and aesthetics. The invasion, seen by many as revealing the inadequacies of de-Stalinization, spurred widespread disenchantment with the PCI and tainted orthodox Marxism among most leftist artistic circles in Italy.[10] This launched a flurry of writing that sought to unsettle a notion of *impegno* based on official variants of Communism or party affiliation. The disparate positions and opinions about this problem of where to locate the politics of art confronted one another in the pages of literary journals such as *Officina* (founded in 1955), *Il verri* (founded in 1956), and *Il Menabò* (founded in 1959).[11] The debates that unfolded reflected a crisis not only about the political content to be expressed by a work of art but about the very possibility of shared meaning. Among visual artists there was a drive to circumvent the question of politics entirely. For this reason, the same unstructured, abstract styles that had invoked an antifascist freedom of the individual in the late 1940s and 1950s now appealed to those seeking an apolitical, immediate, personal, and antirepresentational art. Artists who came to be affiliated with *arte informale* rose to prominence in Italy due to this drive toward a nonideological art.[12] Epitomized by Alberto Burri's assemblages of frayed fabric swatches and tacky globs of paint, *arte informale* claimed to capture the uncensored authenticity of individual artists struggling to express themselves without relying on mediating terms such as *politics, narrative,* or *figuration.* As Burri wrote, his paintings are unmediated demonstrations of "freedom attained."[13] Many practitioners of *arte informale,* like its French counterpart *art informel,* presumed that a stable subject (the author) was capable of expressing a universal human condition but that it was a condition in and of crisis, something the historian and critic Giulio Carlo Argan noted in 1961: "Informale is universally considered a phenomenon of revolt. The objective

of the revolt is not traditional or conservative art, but art that moves from a revolutionary ideology, which can be criticized for not having achieved its program and reached its end."[14] Many artists believed that, in an attempt to escape the debates about the politics of art, however, *arte informale* replaced one universalism with another, positing the unmediated expression of individual anguish as the only viable aim for art. The genre suffered criticism by leftist artists and intellectuals in Italy as its perceived individualism increasingly appeared to work in favor of Western consumer capitalist values. This affinity had already been recognized in 1957, when a group of artists from across Europe (Enrico Baj, Piero Manzoni, and Yves Klein, among others) issued the statement "Against Style," which charged that emotive gestural painting had fallen prey to the capitalist market and claimed that "every new invention is now at risk of becoming the object of stereotyped repetitions of a purely mercantile character."[15] Just a year later, in 1958, the exhibition of Jackson Pollock's drip paintings throughout Italy further ingrained the association of gestural abstraction with the unbridled individualism being championed by the capitalist West.

The early work of the artists included in *Arte programmata* developed as a concerted reaction against the two dominant aesthetic paradigms, *arte informale* and socialist realism. Each of the participants in the 1962 exhibition sought to navigate toward an aesthetic and ideological alternative that converged in the perception-oriented and participation-inviting works on view at the Olivetti exhibition. Munari (1907–1988), the oldest of the artists in Arte Programmata, was active as an artist beginning in the 1930s, when he joined the futurists and became known for his "useless machines," which began his experimentation with the multifarious implications of mechanization in art.[16] Emerging entirely unscathed by his association with futurism (and the fascism many of its artists espoused), in the postwar period Munari was a prolific artist, designer, design theorist, and children's book author, familiar to the public for this work in the cultural field. He worked concertedly against both *arte informale* and socialist realism through his involvement in Movimento Arte Concreta (MAC).[17] Founded by Munari with artists Gianni Monnet, Atanasio Soldati, and the critic Gillo Dorfles in 1948, MAC objected to the way gestural abstraction remained subservient to referentiality (of the

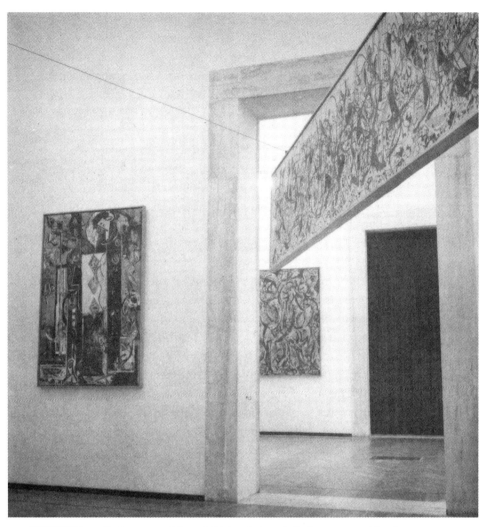

FIGURE 4 Installation view of the exhibition *Jackson Pollock, 1912–1956*, March 1–30, 1958. La Galleria Nazionale d'Arte Moderna e Contemporanea, Rome, by permission of the Ministry for Cultural and Environmental Heritage and Tourism.

artist's subjectivity) and debased art and the artist as such.[18] MAC sought to distinguish these expressive *abstract* works from what they designated "concrete." The aim was to generate forms that were real—concrete—but not referential, insofar as referential works were insufficient shadows of a more robust reality. As Dorfles put it, concrete art is "that tendency to the abstract that comes closest to pure constructivism, rather than falling back on the abstraction of forms borrowed from nature."[19] A series of small paintings by Munari titled *Negative-Positives* (1951) embodies this mandate. Black-and-white blocks of interlocking rectangles and canvases of squares in primary colors, the *Negative-Positives* are stark compositions that assert there is nothing to be gleaned from these works outside the experience of viewing them. In his engagement with MAC, Munari aimed at making works that were not only non-referential but also a non-hierarchical in their organization of space and color, with no one element more important than another. This formal horizontality had an ethical charge. As Paolo Fossati wrote about MAC, "Concrete art is the destruction of illusory representational values, of pictures, in the painting of a self-organized *[autorganizzata]* reality."[20] Munari imagined that his concrete works necessitated no prior experience or education for their enjoyment or comprehension; he envisioned them as both models of and catalysts for a more equitable world.

This idealistic notion of art as a universally accessible language capable of generating better social realities runs throughout Munari's oeuvre, and nowhere is it more evident than in his activities as a designer. Prior to the *Arte programmata* exhibition, Munari had been working for Olivetti intermittently for almost three decades. He joined the advertising and development office in 1931, consulting on the company's graphic design. In the 1940s, Munari designed most of the company's graphic material as well as a number of commercial products. In 1958 he created a melamine "desk tidy" (small modular cubes that held pens, paper clips, and other supplies), one of the company's most successful products, which "became a status symbol on desks all over the world."[21] There is a family resemblance between objects like the desk tidy and his *Negative-Positives,* and his designs put his formal experiments to direct use. In the fields of both art and design, Munari strove to produce forms that were readily appealing, be it in the playful, aesthetic

experiences of the useless machines, the concrete compositions of the 1940s and 1950s, or the object and graphic designs for companies like Olivetti. He saw a direct correlation between how works were produced and the breadth of their audience. Artworks that were movable, multiple, or motorized would both reach and resonate with a wider public, due to the combination of simplicity and dynamism in their form.

The early work by Enzo Mari (1932–2020) from the 1950s was also driven by a search for a non-expressive mode of production that could engender a clearly legible form. But Mari framed his practice in more concretely political terms than did Munari. Reflecting on the differences between their approaches, Mari stressed that "[Munari] is an idealist, I am a materialist."[22] This distinction is most notable in how the two define the relationship between audience and artist. Whereas Munari wanted to generate a universal language and then disseminate it, Mari wanted to disperse authorship and dismantle individual autonomy on both sides of the work.[23] Between 1952 and 1956, while studying at the Brera Art Academy in Milan, Mari recounts, he went to see exhibitions of the most popular styles, *arte informale* and realism, and was "disturbed that the values of the left . . . were painted in such a poor manner"—a formal poverty that Mari saw as stemming from any art based on the (variable and inconsistent) expression of individuals.[24] To find an alternative method for making work (and grounding meaning), the artist took inspiration from Renaissance artists who used mathematical principles to design their compositions and experimented with semiautomated, logical procedures for producing simple geometric compositions. He spent days studying the Sistine Chapel, which he praised for representing an absolute (in this case, God) through so many variable means.[25] Two works of encaustic on wood, executed in 1952, are plays on one-point perspective, divided and disrupted according to a logic Mari derived from the golden ratio. The fact that a simple rule could generate an infinite number of forms was for Mari analogous to how each person's experience (of art as much as of the world) might vary but still be grounded in the same reality. Through a scientific, and presumptively transparent, method of creation, Mari posited, works of art could demonstrate this concrete, common reality to viewers. As Mari has explained, he was drawn to scientific, rational modes of artistic

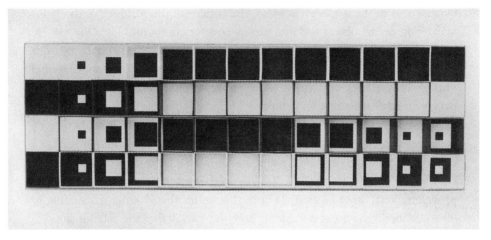

Enzo Mari, *Struttura 301* (Structure 301), 1956. Courtesy of CASVA Gli Archivi del Progetto a Milano, Comune di Milano.

production as "the only true existing democracy," due to their basis in verifiable facts and reproducible methods.[26]

The legibility of these works, however, was a problem. As Max Bill wrote in 1959 of Mari's black-and-white serial compositions, "The probability that Enzo Mari will make a work of art is very great, [but] the probability that these will be perceived as works of art is minimal."[27] The artist's goal to be formally innovative conflicted with the aim to be unambiguous and universally legible; as we shall see over the course of this study, this tension between novelty and clarity would continue to drive the development of Mari's work for years to come. Mari found some respite from these tensions in the field of design, where his formal experiments could be put to use, and the simplicity of their composition was an asset rather than an anti-aesthetic assertion. In 1959 Mari designed his first objects for the Danese company, a set of products fashioned out of sheet metal, such as the multiuse tray he called the "Putrella." From this year onward, Mari employed the same method—what would become the "programmed" means of producing forms—within these distinct arenas: making art that explored the basis for human perception all the while creating objects of household design. What

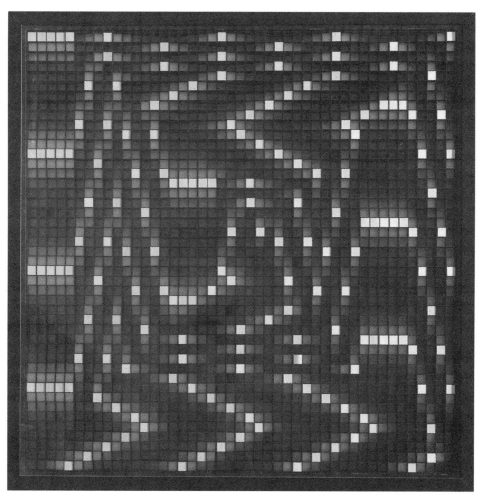

FIGURE 6 Enzo Mari, *Progetto 1059 B,* 1964–2001. Courtesy of VAF-Stiftung.

united these two endeavors, even at this early stage in his career, was the important insight that collectives need a material platform to cohere.

The decision by both Gruppo T and Gruppo N to work collaboratively was initially intended as an overt act of opposition to the figure of the *informale* artist. Gruppo T launched in the fall of 1959, when Giovanni Anceschi

(b. 1939), Davide Boriani (b. 1936), Gianni Colombo (1933–1993), and Gabriele Devecchi (b. 1938) decided to jointly devote themselves to investigating how to formally manifest the mutability and fluctuation they believed characterized the world. (Grazia Varisco, b. 1937, joined the group a year later.) Boriani and Colombo were students at the Brera Art Academy when they first met Anceschi, a philosophy student who was auditing a decorative arts course, in 1957. Devecchi was working at his father's silver design firm at the time, but he had been friends with Boriani since high school.[28] The foursome began going to see exhibitions together, watching with great interest as alternatives to *informale* begin to take root. When Yves Klein exhibited his IKB monochromes in 1957 at Galleria Apollinaire in Milan, the absence of the artist's hand and the repetitiveness of forms in Klein's monochromes were a revelation. Over the next two years, all four young artists moved from creating gestural, abstract paintings to monochromes and mixed-media assemblages.

This change in style was accompanied by a commitment to a new mode of working and the formation of their collective. They chose "T" for their name to designate this interest in temporality *(tempo)* and flux. The official start of Gruppo T came after penning their first Miriorama declaration, in 1959. The manifesto claimed that since the nature of reality was to be in constant movement, their artworks must follow suit (generating "a thousand images," or *miriorama*). As they put it, "We consider then reality as a constant becoming of phenomena which we perceive in variation . . . considering the artwork as a reality made with the same elements that constitute that which surrounds us and therefore rendering necessary the artwork itself be in constant variation."[29] To emphasize change, they began to create works whose creation and composition were at least partially delegated to a changing material. *Ossidazioni decorative* (Decorative Oxidations, 1960), for example, was a copper plate that, when subjected to heat, altered in color. *Pittura in fumo* (Picture in Smoke, 1960) was a long, rectangular, clear plastic case (approximately eight feet wide) hung to a wall at eye level with cigarette smoke pumping through it. Little straws protruded out from the case and dangled from the structure, so that audience members could blow or suck air in or out of the piece, varying the size, shape, and speed

of the misty, vaporous patterns inside. Gruppo T understood these works, featured at the group's first exhibition at Galleria Pater in January 1960, to be expressions of a shared reality rather than a singular author. Working as a collective further ensured that these works would not be understood as expressions of individual subjectivity, biography, or intent. Unlike the pieces in the *Arte programmata* exhibition, however, there was no system or structure underlying this early work by Gruppo T. These works are subject to deterioration, decay, or the whims of individual audience members. These qualities made Gruppo T's early works more playful and anarchic than the programmed pieces they would begin to make the next year.

Nevertheless, like Mari, Gruppo T strove to create works that transcended the subjective, volatile expressions of an artist to express a material reality presumed to be objective, or at least shared. Gruppo N was also founded on an interest in making art with a common basis. The group initially formed as Gruppo Ennea, named for many things, among them the nine participants, all enrollees in the Department of Architecture at the University of Venice (*ennea* means "nine" in ancient Greek). Ennea swiftly disbanded and reformed in 1960 as Gruppo N, with Manfredo Massironi (1937–2011), Alberto Biasi (b. 1937), Ennio Chiggio (b. 1938), Toni Costa (1935–2013), and Edoardo Landi (b. 1937). Gruppo N's early work combined the artists' shared interest in design and urban planning (one exhibition organized by the group featured Cornelis van Eesteren's visionary 1929 plan for the expansion of Amsterdam). In a 1961 statement, Gruppo N asserted their identity as experimental designers, a designation that they hoped would distance them from the rarified realm of art and put them in direct engagement with life. From 1960 to 1963 in the university town of Padua, Gruppo N ran a group studio and gallery space committed to the ethics of collective life. They worked together, lived together, and organized exhibitions together, and considered their activities in each register as integrally related to every other.

Gruppo N's earliest exhibitions were irreverent and nihilistic; for example, *A porta chiusa* (Closed Door) spanned just three days, September 11–13, 1960, and comprised a locked gallery door and a sign declaring "NESSUNO È INVITATO A INTERVENIRE" (No one is invited to participate). In contrast

to Klein's *Le vide* (The Void, 1958), a clear precedent and influence on the group, which invited people into an empty gallery in order to sensitize them to the aesthetic possibilities of space itself, *A porta chiusa* was a defiant act of refusal, halting artistic production and denying the audience the aesthetic experience of space and sensation. The door to the gallery on Via San Pietro offered a peephole to peer through, although the interior remained empty throughout the show. Another Gruppo N exhibition, *Arte è pane, pane è arte* (Art Is Bread, Bread Is Art), held for one day in March 1961 at their studio, both enacted and undermined the avant-garde ambition to dissolve art and life. The show exhibited all types of bread, hung from the ceiling and left to dangle, like one of Alexander Calder's mobiles or Munari's useless machines. The invitation to *Arte è pane* explained that the objects on display "do not express any interior personality, but serve a social function," and a caption to an installation shot reads, "Against the cult of personality and against the myth of artistic creation."[30]

Arte è pane and *A porta chiusa* reflected the Gruppo N's affinity with the artist Piero Manzoni, whose works, such as *Achromes,* some of which also used bread, were meant to ironize painting by using found objects and to unsettle the earnest expressionism of *informale.* Manzoni was an important influence on the early Gruppo N.[31] Following a strategy employed by Yves Klein, Manzoni signed people (including Eco) and random things, rendering them artworks simply through this authorial action. Clearly interested in the process of "framing"—how context and discourse produce the work of art—Manzoni understood his spectacular performances of authorship as displays of depersonalization. Gruppo N at first adopted Manzoni's absurdist strategies; however, they soon turned away from them as yet another manifestation of singular authorship. Just prior to the *Arte è pane* show, in 1961, Gruppo N member Alberto Biasi wrote an impassioned letter on behalf of the collective which criticized Manzoni's *Achromes* for their failure to achieve "indifference," as Manzoni had claimed they did. Biasi argued that the repetition of the *Achromes*—their gridded structure, their use of ready-made materials—was actually "a derivation of gestural painting."[32] To Biasi, Manzoni failed to eliminate authorship; his stunts like signing people as works of art relied on his aura as a singular author, even as they

denied the ideal of artist as meaning-maker and replaced it with a vacuous parody.

Gruppo N's critique of Manzoni shows that they wanted "to eliminate art as a category . . . [and] demystify art of all those idealistic and transcendental values, such as the unique and unrepeatable work, the inimitable masterpiece, the individual creator, superior and brilliant," as they put it in a 1961 statement.[33] While more politically militant than Gruppo T, Gruppo N joined them in their fascination with uncertainty, something they too viewed as uniting art with reality, and one's ability to perceive and influence it. Both collectives designed their works to materialize a dynamic interplay between an unpredictable subject and an equally mutable world. However, it was not enough to work against individual authorship, whether encapsulated in the earnest forms of *arte informale* or the ironic performances by Manzoni. These young artists yearned for a positive model of an anti-individualistic art and authorship to put in its place. In 1961, Gruppo N issued another statement that gestured toward the group's next direction:

> We propose a dialectical synthesis of two positions—the rational and sentimental. . . . On the one hand we find reason and its constant preoccupation with building a new world that makes people afraid to lose their interior lives in favor of a mechanism that would turn them into complete automata. And on the other we find an emotional reaction response which, in order not to allow itself to be caught up in the gears of a mechanical system, reacts by rejecting all forms of rigor, all structure, and by valuing anything and everything that is free, natural, and immediate, or even rejected, denied, and abandoned.[34]

Gruppo N seems to be rejecting both a technologically deterministic notion of agency (in which one is unilaterally programmed) *and* a romanticized, individual, subjective one. This statement coincides with the start of Gruppo N's practice of kinetic art and strikingly patterned, abstract works, which would be featured in *Arte programmata*—suggesting that this style was associated with their quest for another way of understanding artistic

creation. They designed and executed these works in partnerships, with Landi and Chiggio as one duo and Biasi and Massironi the other. Biasi's *Visual Dynamics* series, for example, rejected the stark monochrome in favor of a vivid color palette and vibrating patterned design.

For all the artists of Arte Programmata, before the language of programming took hold, there was a concerted desire for their art to generate a platform for collective creation, shared experience, and a communicable ideal. This was due to the fact that many among the left were experiencing a political vacuum. Although there was a plethora of economic plans in Italy during the late 1950s and early '60s, the state of the political left and their progressive programs was more tenuous. The banishment of the Communist Party from the Italian government and the Socialists' alliance with the Christian Democrats, coupled with growing disenchantment with the actual Communist project unfolding in the Soviet Union, confined these politically committed artists to a liminal ideological holding pattern, finding faults with every progressive dogma of the time and respite in none. As their political landscape shifted, progressive (and, in the case of Mari, Massironi, and Boriani, militant and Marxist) artists like those in Arte Programmata were left with no political program, party, or even far-fetched utopian social vision to which they could adhere. Mari especially expressed profound doubts as to the possibility of a shared leftist agenda, which he saw as undermining the legibility of the social project he hoped to engender with his experimental artistic forms. In response, Mari framed his artworks as investigations into new models for communication, which he understood as a precondition for both creativity and collective life. Munari shared Mari's understanding of art as an experimental mode of communication, one that could unite and empower his audience. In 1966 Munari wrote that with "the programmed art of today . . . what really counts is the information which a work of art can convey, and to get down to this we have to abandon all our preconceived notions and make a new object that will get its message across by using the tools of our time."[35] Gruppo T and Gruppo N each designed works meant to empower viewers and awaken them to their own sense of agency in the world. So too did they intend for these works to integrate viewers, bringing them into conversation—literally and figuratively—with

other subjects and the world. In all cases, Mari, Munari, and the collectives Gruppo T and Gruppo N struggled to imagine how their artworks could provide a platform for social engagement, a way to methodically move from engaging a formal program to collectively creating a social or political one.

By the time of the *Arte programmata* exhibition, the participating artists understood themselves to be facing an audience for which no basic common language, much less a shared political project, could be assumed as given. Many other Italian artists, writers, and intellectuals recognized this condition, and reframed their work accordingly. Eco's idea of the open work was based on his argument that society had entered a new age in which social conventions and linguistic codes altered constantly. The writer Italo Calvino asserted in a 1967 lecture titled "Cybernetics and Ghosts" that "faced with the vertigo of what is countless, unclassifiable, in a state of flux, I feel reassured by what is finite, 'discrete,' and reduced to a system."[36] Years prior to this statement, Arte Programmata also saw in this cultural disarray not some triumphal eradication of hegemonic cohesion, but the dissolution of any and all social fabric and collective life. Each of the artists featured in *Arte programmata* had been struggling with this sense of intensified anomie—what Calvino goes on to call "intellectual agoraphobia"—for years before they came together in the Olivetti exhibition. All found a solution in the same mechanism: the computer program.

The Artist as Programmer: The *Arte programmata* Exhibition (1962)

"Also in Italy, the future has already begun," the popular periodical *Epoca* proclaimed on October 15, 1959.[37] Illustrating this enthusiastic headline was a bright color photograph of an orange computer chip woven with blue, black, and yellow coated wires. The chip was an integrated circuit belonging to the first computer produced in Italy, the ELEA 9003 (Elaboratore Elettronico Aritmetico, or Arithmetical Electronic Computer). Able to process hundreds of thousands of bits of information per second, ELEA promised a new future for Italy with implications beyond a more efficient workplace. As the *Epoca* article anticipated, ELEA "effectively open[ed] a new epoch of fascinating problems and responsibilities in the field of labor relations,

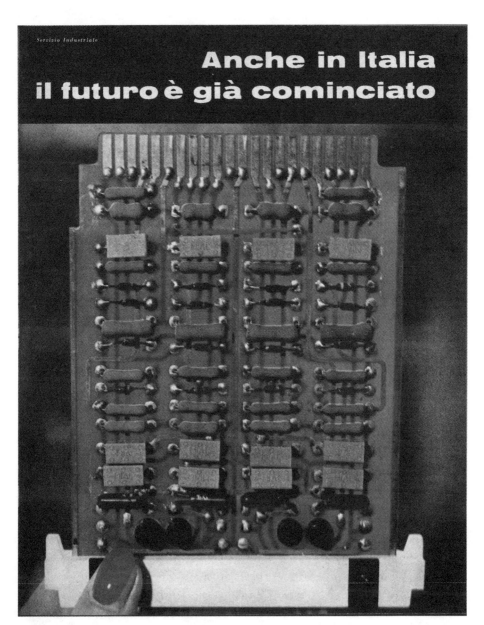

FIGURE 7 An integrated circuit from the first computer produced in Italy, the Olivetti ELEA 9003. *Epoca* (October 1959).

creating new responsibilities in those fields of social organization, education, and school."[38] This rhetoric was continuous with Adriano Olivetti's socially conscious mission to make objects capable of engendering better lifestyles and practices with their use.[39] Olivetti considered mechanization as a pathway not only for a more efficient but a more equitable world. The industrialist wrote prolifically about ideal forms of government, especially what he called "managerialism," which applied scientific principles of management to politics, following utopian socialists like Charles Fourier more than Henry Ford. Olivetti's vision included a highly integrated social system in which each of the parts also had a degree of autonomy. Technologies held out models for new forms of this kind of integrated, efficient social organization. Olivetti's son, Roberto, ran the company according to this same ethos after his father's death in 1960, and in 1962 he established a small research team to develop the company's first personal computer, the Programma 101, which was unveiled in 1965 to critical acclaim. Roberto Olivetti was also one of the first industrialists to integrate the cybernetic principle of feedback into the organization of factories. This made Olivetti a controversial case study for a group of activists and radical sociologists associated with the journal *Quaderni rossi,* and one, Romano Alquati, published a study of Olivetti in 1962 to make a case about how computers and information theory were changing the terms of working class struggles within the factories.[40] Whereas Olivetti saw computers and cybernetics as models for more liberatory and participatory modes of organizing a factory, Alquati saw this same sort of participation as further entrenching workers' bodies and subjectivities within the capitalist mode of production—more cooperation leads to more refined and even invisible exploitation (prefiguring today's "cognitive capitalism," in which minds, knowledge, and creativity are the primary sites for profit exploitation).[41] Whether early computers were capable of realizing utopian socialism or a cyborg–capitalist nightmare, for Italians they pointed more to questions about social organization, liberation, and power than to technological efficiencies.

At the heart of these social questions was the various ways computers prompted a rethinking of human–machine relationships. While some believed computers would ensure a more efficient, easy, and even egalitarian

future, for many the computer provoked anxiety about the extent to which human beings were like machines, and vice versa. Tensions between these two perspectives roil throughout the publication that was the precursor for the *Arte programmata* show: the *Bompiani Almanac*. Founded and funded by the Bompiani publishing company, the almanac compiled the news coverage about major historical events from the year. A large portion of the *Bompiani Almanac* was dedicated to a particular theme that focused on arts and culture and speculated about their future. In the 1962 edition, this themed section was dedicated to current and potential uses of the computer in the human sciences and the arts. Cosponsored by Olivetti and IBM Italia, the articles, artworks, and illustrations that made up this section sought to develop a comprehensive discourse about the aesthetic and intellectual changes prompted by the advent of computers, grappling with the ways the computer would—or should—transform conceptions of human creativity.

All the articles in the 1962 "Computers and the Arts" section touch on the idea of programming, or the translation of all activity and information into a standardized code. The problem for theorists and practitioners to consider was what such quantification did to creative expression. Did programming fatally restrict artistic expression, or did it open entirely new forms of creation and thought? Many of the almanac's authors celebrated the ability of computers to mechanize processes that were for the most part already mechanical, such as computation, data analysis, and even prediction (insofar as it is a statistical operation). Computer programs from this perspective liberated human beings from having to perform menial tasks. Others considered the computer's application in fields such as linguistic analysis, archival research, and language translation.[42] For example, the information analyst and author Stanislao Valsesia proposed a digital library, noting how much scholarship would benefit from a digitized, searchable collection.[43] And an illustrated section (with no listed author) traced the idea of automated art and autopoiesis historically, highlighting the literature, art, and philosophy, from the golem to Fritz Lang's film *Metropolis* (1926), that prefigured the concept of a programmable art.[44] The publication also includes some of the earliest examples of computer-generated art. Nanni Balestrini contributed *Tape Mark 1* (1961), which deploys an algorithm to assemble a poem com-

posed entirely of fragments the artist selected from previously written texts by other authors.[45] Whether demonstrating that computers are accurate models for human beings or humanity's antithesis, excellent artistic corollaries or evidence of art's demise, the essays and artworks in the "Computer and the Arts" section of the 1962 *Almanac* also indicate that alongside the development of computer technologies was an evolving discourse about the nature of individual agency and creativity.

The *Almanac* was the first occasion in which Eco, Munari, and the artists of Gruppo T collaborated. Reproductions of sketches and drawings by the artists were published alongside an essay by Eco titled "The Form of Disorder," which establishes the terms that defined and developed the genre of programmed art: a multiplicity of points of view and a diverse array of perceptual experiences, all generated by a predetermined principle or operation.[46] Just after the almanac's release in December 1961, Munari began to organize the exhibition that introduced the broader public to this idea of *un'arte programmata*. Working with Giorgio Soavi and Riccardo Musatti, the heads of Olivetti's advertising department, Munari invited Gruppo T, Gruppo N, and Mari to participate. *Arte programmata: Arte cinetica, opere moltiplicate, opera aperta* opened on May 15 at the Olivetti store in the Galleria Vittorio Emmanuelle, the main shopping mall in the center of Milan, presenting, for the first time in Italy, a vision of the computer program as an essential collaborator in the making of art.

Visitors to *Arte programmata* were confronted with eleven artwork-generating machines in process. A ten-minute film of the exhibition made by Enzo Monachesi with Munari and Soavi, accompanied by a high-pitch, staccato score by experimental composer Luciano Berio, captures the jerky, automated movements of the contraptions on display. After panning the room, the camera zooms in on viewers' mesmerized faces as they watch red, yellow, and orange liquid being pumped through thin plastic tubes in Gruppo T member Giovanni Anceschi's *Percorsi fluidi orizzontali* (Horizontal Fluid Paths), creating colorful pulsating stripes across the black cubic frame. Another scene shows spectators gazing at the iron filings in Davide Boriani's *Superficie magnetica* (Magnetic Surface) as the metal dust clumps together into little clusters that creep around the rotating plastic case. Mari's *Opera*

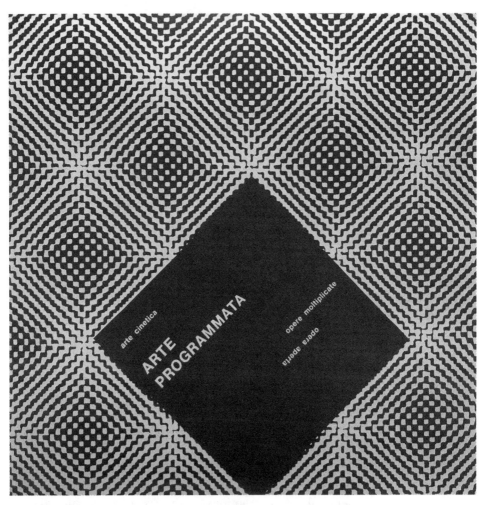

FIGURE 8 *Arte programmata,* cover of the catalog for the 1962 exhibition.

n. 649 flickers rainbow-colored cubes of light into the eyes of a sole viewer sitting in a darkened room. And in the final moments of the film, a little girl gazes up at Munari's *Nove sfere in colonna* (Nine Spheres in a Column) while transparent orbs with thick white stripes glisten as they perpetually turn.

On the one hand, the specific articulation of the exhibition on film high-

FIGURE 9 Giovanni Anceschi, *Percorsi fluidi orizzontali* (Horizontal Fluid Paths), 1962; as displayed in the 1962 *Arte programmata* exhibition at the Olivetti Showroom in Milan. Frame enlargement from Enzo Monachesi, dir., *Arte programmata* (1963).

lights how the programmed mode of production can instigate audience participation. The footage centers on visitors interacting with and marveling at these abstract assemblages and delighting in their aleatory movements. On the other hand, the film cannot help but capture the rigid choreography dictated by the works, as the people appear to function in comparably programmed ways: their movements, too, are determined not only by the formal qualities of the work but by the organization of space and by societal conventions and pressure (at one point the film shows people patiently waiting in line to view Anceschi's *Percorsi fluidi orizzontali*). The encompassing nature of the program is amplified in the film by the experimental score,

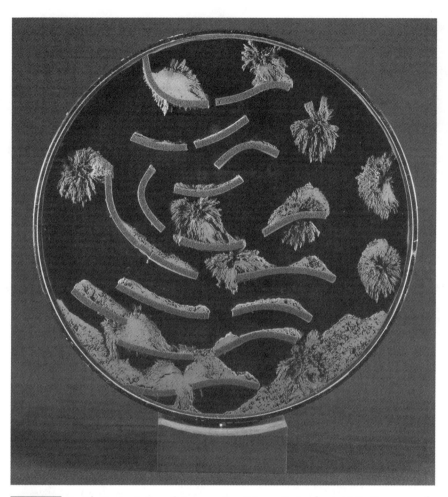

FIGURE 10 Davide Boriani, *Superficie magnetica* (Magnetic Surface), 1960. Courtesy of the artist.

whose arrhythmic bleeping aligns with the movements of both artworks and audience in such a way as to materialize the "field of possibilities" as a space of confinement and control. The audience is included according to carefully delimited terms.

The works in *Arte programmata* therefore aligned with the participants'

FIGURE 11 Davide Boriani, *Superficie magnetica* (Magnetic Surface), 1960; as displayed in the 1962 *Arte programmata* exhibition at the Olivetti Showroom in Milan. Frame enlargement from Enzo Monachesi, dir., *Arte programmata* (1963).

investment in dismantling the fantasy of unmediated individual expression at the heart of *informale*. The program ensured that the artists' creative and expressive possibilities were firmly grounded in the material confines of the medium they chose—whether the magnetic possibilities of iron filings, the undulating effects of geometric abstraction, or the curvatures of an encased and motorized plastic ribbon. The Italian critic, curator, and historian Umbro Apollonio recognized this essential characteristic of these programmed works, writing in 1963 that with *arte programmata* "the interiority of the individual is gradually transforming into a communitarian field."[47] But by expanding this field to encompass the audience, rather than just the artists and their creative methods, the film asserts the inextricability of participation and control.

The artists avoided articulating this dimension of their art by stressing the similarities between artist and audience—notably, their shared creative labor. As Gruppo N explained in a letter to Munari dated January 12, 1962, "We consider the title *arte programmata* to be the most appropriate to define our experiments, because the majority of our works will be to specify that the programmer *[programmatore]* of the work is the very same as the spectator, who chooses one view rather than another, or decides on one of an infinity of variations seizing the object in the movement of his vision."[48] Gruppo T understood their art similarly, emphasizing the formal, physical freedom these works grant to the viewer. As Boriani explained, "The interaction between two dynamic processes, that of the work and that of the perception of the spectator, could augment the communicative potential of visual art; and in a manner more consonant to the concept of a reality that is not fixed and immutable but in continual mutation."[49] In all instances, the artists of *Arte programmata* insisted that variations in the audience's experiences were, like the artist's expressive capabilities, derived from the common, objectified structure of the work. But for them, this was a method to achieve a distinctly different result: open-endedness and indeterminacy. They wanted to instigate a collective experience, not convey one based on a predetermined identity or ideology. In addition to dismantling the individualized and individuating ideal of *arte informale,* the program was also a way to circumvent the model of the *artista impegnato,* in which an artist commits himself to the expression of an already established political agenda or revolutionary plan. The *artista impegnato* wants to activate the audience, either to amplify the commitment they already have to the cause or to inspire them to join. For the *artista programmato,* however, the program was a way to invite the audience to participate without determining the end result. For the politically committed artist, the program is the ends rather than the means of the work of art. For the *programmed artist,* in contrast, the program is a logical, procedural platform on which artist and audience can meet and engage. Like the rules of a game, it sets the condition of possibility for interaction, while leaving the outcome open.

But once set into motion, asserting itself in real space, the works in *Arte programmata* betray how the program as a mode of production does not

generate an entirely indeterminate artwork. Rather, as a process the program displaces the site of determination from ends to means. The audience chooses, participates, interacts, but always from a series of options designed for them. But this is not a prefiguration of Alquati's nightmare of cybernetically managed participation; the lesson of *Arte programmata* is not this unfortunate yet inevitable reversal, a dystopian disgrace of the artists' utopian dream. Such an analysis would maintain the very dichotomy—individual against system—that the works are designed to dismantle. Rather, *Arte programmata* demonstrates the programmed nature of all experience, insofar as our individual perceptions, actions, and interactions are (however apparently spontaneous) determined by our environment. This significance of *Arte programmata* and programmed art more generally is obscured by its association with another term in the exhibition's title: the "open work." The association allowed the artists and art historians to circumvent and even temper the more controlling aspects of the work, leaving the most challenging aspects of this exhibition unacknowledged. Examining the genesis of the "open work" before it was paired with *Arte programmata* in 1962 will help to uncouple these terms and tease out their differences.

From Authorship to Interpretation: Eco and the Open Work

Eco began writing on the concept of the open work in 1958. He published *Opera aperta,* a collection of essays about the concept, in 1962, just a few months before *Arte programmata* opened. Citing artists as diverse as Munari, James Joyce, Bertolt Brecht, Karlheinz Stockhausen, and Alexander Calder, Eco defines open works as having multiple interpretations and lacking any sort of conclusiveness. By virtue of their formal and conceptual open-endedness, Eco contends, open works are symptomatic of the end of universal narratives and the instability of truth that had defined modernism since the late nineteenth century, when poets such as Stéphane Mallarmé began to question the capacity of language and words to carry any stable or coherent meaning. Drawing on his research into the medieval period, when interpretations were limited to the literal, moral, allegorical, and anagogical, Eco explains that an open work, by contrast, "remains inexhaustible insofar

as it is 'open,' because in it an ordered world based on universally acknowledged laws is being replaced by a world based on ambiguity, both in the negative sense that directional centers are missing and in a positive sense, because values and dogma are constantly being placed into question."[50] Eco is thinking as much of the laws of physics as of the state of contemporary politics when he claims the modern world is essentially unstable. At a microscopic level, matter disintegrates into energy and the effects of relativity become more severe. At the macro level of geopolitics, ideologies and political theories are either tainted or undifferentiated. Open works convey this perpetual state of instability that defines the contemporary context, laying it bare for audiences to contend with and to try to understand. They are, Eco argues, epistemological metaphors, expressions of the world and how we come to know it: in a state of constant change and disarray. However, Eco's notion of the open work is neither a dejected resignation that meaning and truth are impossible, nor a celebration of relativism: "The *possibilities* which the work's openness make available always work within a given *field of relations*. . . . We may well deny that there is a single prescribed point of view. But this does not mean complete chaos in its internal relations. Therefore . . . the 'work in movement' is the possibility of numerous different personal interventions, but it is not an amorphous invitation to indiscriminate participation."[51] Open works represent a shared, material condition of indeterminacy; they do not succumb to it. However multiple, the meanings of open works are dependent on the mechanics of the work, how it positions the audience, and how it enables them to act and think within this discrete field. The work's form allows for an openness that is circumscribed.[52]

To describe the limits of the open work, Eco utilizes insights gleaned from information theory, a field that was foundational to the development of computers. Information theory was launched by the American engineer and mathematician Claude Shannon in "The Mathematical Theory of Communication," published in 1948 in the *Bell System Technical Journal*.[53] Working as a cryptographer during World War II, Shannon wanted to mitigate two undesirable outcomes: that the wrong person (e.g., an enemy interceptor) could decode a message and that the right person might fail to do so correctly. Shannon's crucial innovation was to approach the problem quanti-

tatively, defining information as what was unpredictable in a message and therefore the most likely to be missed or misunderstood. In Shannon's theory, information is defined as a statistical measure of the probability that a signal will be accurately reproduced after traversing a channel. Such a measure does not pertain to the precise meaning of the message but instead diagrams the outer limits of the types of signals that can be accurately received.[54]

Shannon's definition of information provided Eco with a concrete visualization for how open works produce what Eco calls "fields of possibilities" when it comes to meaning. Information theory tries to discern the outer limits of what is possible to communicate; open works, Eco argues, do the same. For Eco, open works are like information theory: both are metalinguistic commentaries on the conditions of possibility for meaning, not an interpretation of a work in and of itself. But there are important differences in emphasis. Shannon wanted to reduce the variability of meaning so as to ensure the accurate transmission of a message in wartime. Eco, writing about art, deploys information theory to explain how a work's meaning is tied to the composition of the work and not the whims of the spectator, however variable the meaning might be. Because of this disparity, Eco takes more inspiration from the French theorist Abraham Moles, who applies information theory to art in *Information Theory and Esthetic Perception* (1958). Moles stresses information theory's probability structure and the relatively open field of possible interpretations that artworks (uniquely) allow. "What is transmitted [by art] is *complexity*," Moles asserts.[55] Moles outlines how complexity is always relative, contingent not only on the form of other artworks (i.e., aesthetic conventions) but on the form of the audience—their expectations, predilections, and a slew of other unpredictable but material, social factors. The best artworks, Moles explains, occupy the outer edges of what is expected, pushing the boundaries of the audience while not straying so far afield as to be illegible or ugly. In *Opera aperta,* Eco echoes Moles when he writes, "Even an art that upholds the values of vitality, action, movement, brute matter, and chance rests on the dialectics between the work itself and the 'openness' of the 'readings' it invites. A work of art can be open only insofar as it remains a work; beyond a certain boundary, it

becomes mere noise."[56] Moles allows Eco to emphasize novelty and innovation without relying on a mythical notion of creativity as generating forth, ex nihilo, from the individual artist. Moles's aesthetic information theory also supports Eco's claim that these experimental works are not absurd gestures proclaiming the impossibility of meaning but statements about the simultaneously chaotic yet ordered state of the world. From Moles (arguably more than anywhere else) Eco derives his political theory of art: "One might say that rather than imposing a new system, contemporary art constantly oscillates between the rejection of the traditional linguistic system and its preservation—for if contemporary art imposed a totally new linguistic system, then its discourse would cease to be communicable. The dialectic between *form* and the *possibility* of multiple meanings, which constitutes the very essence of the 'open work,' takes place in this oscillation."[57] But the two differ in one important way. Moles reduces art's purpose to its ability to communicate formal complexity, always seen (even calculable) in statistical relation to given conventions. Complexity, for Moles, is therefore narrowly defined. For Eco, complexity is analogical and expansive; it describes a societal condition, a creative methodology, and a property of artistic form. Most important, it places these registers (social, aesthetic, political) into direct relation, which allows art to comment on and even reshape the others.

Eco expands on these sociopolitical implications of the open work (and further departs from Moles) in his essay "Del modo di formare come impegno sulla realtà" (Form as Social Commitment), written just a few months after the publication of *Opera aperta*.[58] By using the term *impegno* in his title, Eco means to directly address the official left (the PCI and party-affiliated artists and writers) and its critique of experimental art as elitist and out of touch.[59] In "Del modo," which was published in *Il Menabò*, Eco argues that open works are instances of formal protest, more politically effective and truthful than, most notably, neorealism.[60] He explains that, by refusing meaning, contemporary artists are rejecting a social model, one in which the world is ordered and coherent. Formal protest is, for Eco, the most effective way to enact a political protest because forms are the means by which we understand the world and communicate this understanding to one another. At the time, Eco was writing not only against realism but against a more pro-

active, pedagogical method whereby art advances a predetermined revolutionary project. Eco could not have been clearer: with open works, "the artist does not provide a solution. As [Elémire] Zolla points out, thought must understand. Its task is not to provide remedies."[61] "When [art's] discourse is unclear, it is because things themselves, and our relationship to them, are still very unclear," Eco concludes, defending the apparent "noncommunication" of avant-garde art as the most truthful communication that could be.[62]

Open-endedness operates on many levels in Eco's notion of the open work: as a formal characteristic (movement), a message about reality, a metaphor for epistemology, and a model for the political function of art. It is also a quality of aesthetic experience, which Eco ties to the structural composition of the work. This is most apparent in the chapter on the open work and visual arts, where Eco surprisingly discusses *arte informale* as his central example. He argues that *arte informale* is open because it rejects a formal system: "The sign becomes imprecise, ambiguous. . . . Informal art calls into question the principle of causality, bivalent logics, univocal relationships, and the principle of contradiction."[63] *Arte informale* becomes for him a primary example of how a lack of clarity is the most precise way to represent the state of the world. To then explain how this effects the audience, Eco turns to the example of Jackson Pollock's drip paintings: "The disorder of the signs, the disintegration of the outlines, the explosion of the figures incite the viewer to create his own network of connections."[64] This pleasurable, even empowering, experience of infinite possibility is the open work's raison d'être: "The 'reader' is excited by the new freedom of the work, by its infinite potential for proliferation, by its inner wealth and the unconscious projections that it inspires."[65] "Openness," he concludes, "is the guarantee of a particularly rich kind of pleasure that our civilization pursues as one of its most precious values, since every aspect of our culture invites us to conceive, feel, and thus see the world as possibility."[66]

For Eco, then, production is quite separate from reception. While both the artistic process and the resulting form are best understood as a discrete field, open yet contained, the type of aesthetic experience triggered by open works is wholly individuating—albeit an individuation deliberately designed by the artist, rather than something inherent to the audience (and

thus to all forms of art). As Eco contends, "We still live in a culture in which our desire to abandon ourselves to the free pursuit of visual and imaginative associations must be artificially induced by means of an intentionally suggestive construct."[67] The programmatic model, for Eco, is one such means of advancing individuation, of inspiring freedom in the viewers of art. The expressive gesture of *arte informale* is another. That Eco could posit *arte informale* and Arte Programmata as analogous in their open-endedness, working as similar metaphors for the same epistemology, protesting the same formal conventions and artistic styles, points to the disparity between Arte Programmata and Eco's ideas about the social function of art. Arte Programmata is not a material articulation of chaos or a meditation on noncommunication in everyday life. Its geometric, algorithmic operations are an active intervention into this condition, an attempt to reconstitute a collective signal, to reject noise and its alienating effects. If, as Eco claims, the complex web of Pollock's paint splatters invites the viewer to "create his own network" each and every time the work is viewed, then the motorized plastic strip snaking its way around the square frame in Colombo's *Strutturazione fluida* achieves the opposite: it delineates its own network and entices viewers on its own mechanistic, albeit mutable, terms. The fact that the artists of Arte Programmata did not recognize this crucial disparity suggests a critical fallacy in what they imagined their programmed artworks were designed to do. This distinction ultimately continued to crumble in observations of real audience responses, forcing the artists to rethink the program of Arte Programmata.

From Collective Creation to Creating Collectives

In one important way, information theory appealed to Eco as a theory of interpretation for the same reason programming appealed to the artists of Arte Programmata as a mode of production: each offered a way to conceive the activity of individuals (artists or audience members) as stemming from shared material, social conditions rather than a uniquely subjective or metaphysical state. The artists of Arte Programmata were excited by Eco's theory of the open work precisely because of how it presumed an active, engaged

FIGURE 12 Gianni Colombo, *Strutturazione fluida* (Fluid Structure), 1960. Photograph of the artist in his studio by Ugo Mulas. Copyright Archivio Ugo Mulas Heirs.

spectator who, although acting with unprecedented freedom, is nevertheless bounded by the form of the work and the shape of the channel or context.

But in their understanding of "participation," Mari, Gruppo T, and Gruppo N diverged from Eco. Although Eco argues that open works stem from a collectively held reality, he does not posit that even the most programmatic open works are a means for creating a sense of collectivity. To the contrary, Eco celebrates the amplified sense of freedom that open works impart to their viewers. Rather than collectivizing authorship, and far from creating collectivities, Eco's notion of the open work is more precisely understood as a type of delegated authorship: artists make works in which their audience (or performers) can enjoy the freedom romantically

understood to be the freedom (from determination, from instrumentality, etc.) of the artist, too. Within an open work's field of possible interpretations, each spectator stands alone. By contrast, the artists of Arte Programmata understood the program as a means for probing the possibilities of common, communal experience and action at a time when such a thing seemed all but impossible. The programming of their art was therefore an answer to a historically specific problem: how to engender a collective subject without a preexisting ideology or identity. This attempt to have it both ways—to generate a collective aesthetic experience that also affirmed the spectator's individual creative capacity or agency, as defined by the work of art—also led them to posit the inevitable element of control for any collectivity, however provisional, temporary, or inoperative, to exist.

Some contemporaries took issue with what they perceived to be this controlling element, or hyper-rationalism, in the art of Arte Programmata. In 1963, Italo Calvino referred to their intense mechanization of art production when he wrote of a "rationalist" trend in contemporary art that might successfully integrate art with industry, except that it had "paid with a weakening of creative and combative forces."[68] The critic, curator, and historian Enrico Crispolti issued a similar critique in an essay also penned in 1963. Crispolti was largely sympathetic to the movement, especially the young collectives Gruppo T and Gruppo N (Crispolti had curated an early exhibition of the Gruppo T artists in 1958; and he would go on to include them in exhibitions in the later 1960s, as we shall see in chapter 4). But in taking stock of the political effects of the artists' early work, Crispolti concluded that Arte Programmata failed to transcend the negative effects of mechanization: automated art in turn automated (and stultified) its audiences. If the artists attempted to avoid this devastating effect, the resultant works, for Crispolti, did so not by creating a sense of collectivity but by embracing "a sort of playful visual design [progettazione]"—which, he continued, was far from a sociological or political interrogation of collective production or experience.[69] Crispolti lamented that Arte Programmata were too individualizing, while Calvino lambasted them for not being individualizing enough (and thus falling into step with the most dehumanizing effects of industrialization). Both Crispolti's and Calvino's criticisms of Arte Programmata,

however, fail to account for or adequately theorize the anti-individualist ambitions and controlling effects of these works.

By attacking the integrity of individuals and situating their sense of self within (rather than against) a programmatic system, the works of Arte Programmata not only refuse to see programming as stultifying to creativity; they also displace the locus of freedom from individuals to the site of engagement with a system—abstracted and analogized in the artwork—itself. In so doing, the objects included in the *Arte programmata* exhibition gesture toward an understanding of programs as foundational to social relations rather than as inextricably linked to their prediction, domination, and control. Historically, the artists developed the idea of programmed production as a means to dismantle the untethered ideal of individual freedom and locate the basis for subjectivity and society in the material, physical structures we share. That they refused to recognize their own subjectivity in this formula only further complicates the challenges the works raise. However, this uninterrogated position of the author in programmed art did not remain so for long. In the years following the 1962 exhibition, the more militant, politically ambitious participants (Mari, Gruppo T, and Gruppo N) began to construct immersive, disorienting, and sensorially assaulting environments, increasing their authorial control over the audience. In these expansive works, the program progressively becomes a social mechanism, in which freedom is not just circumscribed but secondary to participation in a common—that is, programmed—activity. As we shall see, the aim of the environments was not just to instigate phenomenological experience or physical action but to provoke a retheorization of the subject, furthering Arte Programmata's interrogation of the relationship between individuals and systems that began with these early works.

PROGRAMMING THE SPECTATOR

Environments and Control,
 1964–1967

In 1962, the artists of Arte Programmata celebrated the power of dispersed authorship to engender collectivity, but the next few years unleashed a slew of doubts about this strategy. By partially delegating the design of their compositions to programmatic media—motorized moving parts, chance operations, and the logic of generative structures—the artists hoped to eschew the instrumental aims of party-affiliated artists and the individualistic expressionism of *arte informale*. But the conflicting and often contentious reception of Arte Programmata, both in Italy and abroad, laid bare the limits of programmed authorship and prompted Gruppo T, Gruppo N, and Enzo Mari to alter both their artistic practice and political horizon.

The most vexing misunderstanding of Arte Programmata's work took place at the Museum of Modern Art's 1965 exhibition *The Responsive Eye*. The occasion was so traumatic that Gruppo N's Manfredo Massironi recounted it as "an ostentatious funerary celebration."[1] Curated by William Seitz, *The Responsive Eye* included Mari and Gruppo N as well as other abstract artists such as Victor Vasarely, François Morellet, Heinz Mack, Bridget Riley, Robert Irwin, Kenneth Noland, and Agnes Martin. While many of these artists worked with nontraditional media, the pieces selected for *The*

Responsive Eye were mostly paintings, sharp, geometric compositions that used vivid contrasts and intricate patterns to create the illusion of movement and depth on their still, flat surfaces. Seitz conceived the MoMA show as a survey of works that, due to their tendency to trick the eye, had been grouped under the moniker "Op"—as in optical—in a 1964 *Time* magazine article.[2] In his essay for the exhibition catalog, Seitz described how in these paintings forms imprint themselves directly on the viewer's retina without any conceptual filter, bypassing cognition and provoking new feelings and sensations in their audience as a result. In his words, "[Op] exists primarily for its impact on perception rather than for conceptual examination."[3] The curator ended the essay with an open but optimistic prompt: "Can an advanced understanding and application of functional images open a new path from retinal excitation to emotions and ideas?"[4]

Yet audience responses, critical reviews, and even Seitz's own terms belied his claim that by stimulating audiences perceptually and not conceptually op artworks "refer to nothing outside themselves."[5] In New York, op's vertiginous geometric patterns were already rampant, adorning everything from cutting-edge clothing to corporate interiors. In his review of the show, Lawrence Alloway noted the ubiquity of the op aesthetic in fashion, humor, and youth magazines at the time, including a London-based teen monthly that stressed to its readers, "Remember—Black and White is THE colour."[6] *ARTnews* magazine writer Thomas Hess went as far as to claim that for op (like pop) "the content . . . is advertising."[7] Seitz's own catalog essay entrenched the exhibition deep within popular culture, relating the works' compositions to the moiré patterns prevalent in contemporary textiles. The curator even wrote a preview of *The Responsive Eye* for the fashion magazine *Vogue*.[8]

To many, the similarities between op and consumer culture were more than stylistic. Op also seemed to mimic consumer culture's stultifying mode of address. According to the critic Barbara Rose, op art "provided exactly the 'nouveau frisson' to engage the jaded sensibilities of today's museum audiences. It is more immediate than the movies, more brutal than TV, and takes less time and thought to experience than the theatre."[9] For her, the sensual titillation provoked by the artworks in *The Responsive Eye* was no dif-

ferent from that of a gripping Hollywood film or compelling commercial. In all cases, these media reduced their audience to an assemblage of nerves, reflexes, and unthinking motor responses. Viewers might be activated to think differently, even to desire something new (this was Seitz's conclusion). Yet on the whole, critics tended to view op's emphasis on perceptual stimulation as detaching spectators from reality, reveling in trickery instead of revealing the perceptual or representational device. For this reason, both Rosalind Krauss and Lucy Lippard lambasted *The Responsive Eye* for celebrating illusionism—and its associated escapism—at the very moment that many painters and sculptors were critically dismantling this same artistic operation.[10] They considered op not only basely sensual and mystifying (detaching viewers from reality rather than more firmly entrenching them within it), but also individuating. These abstract compositions might dissolve the distinction between an active and contemplative mode of viewing art—as many of the artists, and Seitz, claimed—but they were ultimately grounded in the personal, ineffable nature of the spectator's experience. The officials at MoMA would seem to agree; as the press release issued by the museum explained, "Each observer sees and responds somewhat differently."[11]

This individualized response to op art was dramatized in a CBS television program about the MoMA show, the existence of which indicated that the museum considered *The Responsive Eye* appropriate for, and thus contiguous with, popular media. There are some striking similarities between this film and the one produced for the *Arte programmata* exhibition in 1962: both featured disjointed, experimental scores (jazz musician Specs Powell composed the music for the CBS program) and depict these works in motion to an audience unable to attend the show. But the film for *The Responsive Eye* is more narrative than demonstrative, relying on talking heads more than footage of the works. Emceed by the popular journalist Mike Wallace, the first portion of *The Responsive Eye* program presents interviews with the audience describing what they thought of the exhibition.[12] Whether expressing approval or discontent, pleasure or displeasure, all of the interviewees expressed their opinion in terms of personal taste. Another film for *The Responsive Eye* directed by Brian De Palma features experts such as Seitz, perceptual psychologist Rudolf Arnheim, and fashion designer Larry

Aldrich explaining the effects of the work and their historical and cultural import.[13] The dominance of talking heads in both films solidifies the connection between perceptual instability and the vicissitudes of subjective judgment. Between Seitz's own framing, the two documentaries, and the exhibition's popular and critical reception, *The Responsive Eye*'s appeal to sensory experience aligned it with the individualistic sensibility of capitalist consumer culture.

This affiliation with consumerism was devastating for the Italians. Manfredo Massironi of Gruppo N claimed that *The Responsive Eye* subjected their works to the "imperialism of the American art market."[14] On the tail of the show's closing, Mari expressed similar concerns that Arte Programmata's works were too easily incorporated into consumer culture.[15] The artists abhorred individualism, whether implicit in the single authorship of *arte informale* or personal judgments of taste. By tempering their creativity with programmatic methods such as automation and chance, the artists of Arte Programmata had imagined that they could democratize the production process and—by extension—collectivize art. But when transported to the United States, only the work's open-endedness was recognizable, while its collective dimensions were subsumed by the dominant ideology of capitalism. Seitz even went as far as to single out the Italians, stating that Gruppo N and Mari "are not revolutionaries; they aspire to full cooperation with the modern world and are open to almost any application of their creativity."[16] The curator misinterpreted the artworks' movements as routinizing, rather than empowering, and their use of technology as aligned with the logic of capitalist industry, rather than inciting new collective experiences in their audience.

As Massironi had intuited, *The Responsive Eye* was a funeral indeed, which gave birth to a new way of working for these artists: the immersive environment. This change in strategy reflects the artists' shifting political and social concerns, from the struggles of the Cold War as they manifest in competing aesthetic trends to the challenges posed by media-saturated mass culture. However, although the *ambienti*—which incorporated motion sensors, motorized moving walls, mirrors, viewer surveys, and other collaborative media—increased audience participation, they also intensified autho-

rial control. A central question then becomes: How and why did immersive environments become the antidote to the perceived threat of an absorbing capitalist culture? They did so, we shall see, because the artists did not take issue with the fact that the media influenced spectators and directed experience, but rather with how and to what end. Mass media, like television, radio, and cinema, worked in conjunction with consumerism, promoting the myth of self-sufficiency and unique individuality. Arte Programmata's environments were an attempt to extricate this constructive power of media— its socializing power—from the individualistic values of capitalist culture. The artists rerouted the same media in order to explode the myth of individual autonomy and highlight the degree to which individuals are always embedded in a system. The mass media's power to interconnect its spectators with their environment and one another, which many considered its gravest threat, was for Arte Programmata its most promising aspect, a platform for producing a more functional, transparent, even ethical mode of collective engagement and action.

To unleash this political potential of media, the artists needed another way of conceptualizing how their broader technological environment produces subjects, to move beyond demonstrating the variability of perception and ground the viewer's body and being in the program of the work. Arte Programmata found such a new model in cybernetics, specifically its notions of feedback and control. Feedback presumes that the subject and environment are mutually constituted. The result of their constant interaction and co-construction is what in cybernetics is deemed control. In cybernetics, therefore, control is not the antithesis of freedom, the unequivocally dictatorial determination of all subjects everywhere. Rather, cybernetics defines control as a collaborative, fluid, creative, and continual process necessary for the components of any system not only to survive but also adapt and improve. There are, of course, crucial disparities across cyberneticians as to the idea and implications of control.[17] And as artists, these figures could interpret the idea with substantial (and arguably, productive) abandon. Cybernetics offered Arte Programmata a language and a conceptual platform for designing their work and envisioning their spectators. What interests us here is less their fidelity to cybernetic theory, but rather what

the artists saw in this scientific field. Cybernetics inspired their use of light, space, and constant motion, all of which put spectators in dialogue with the environment, emphasizing the very materials that constitute their experience and connects them to others and their world. Equipped with a distinctly cybernetic notion of control, Arte Programmata designed their *ambienti* to attack the autonomy of spectators so that when they emerge from the work, they do so with an acute sense of their own contingency and the collective dimensions of subjectivity.

Looking back, this emphasis on audience manipulation may seem to align the *ambienti* with a technocratic form of domination, in which the environment and all possibilities for action within it are constrained by design, all life ultimately determined by a team of experts. Indeed, it is difficult to parse these distinct dimensions of control. Coordination does require constraints, which can swiftly be deployed for domination; and mediation demands codes and protocols, which impose limits and render certain kinds of expression invisible, even impossible.[18] But in 1960s Italy there were other, equally pressing problems: namely, the challenges of clear communication and the potential that comes with it for a collective imagination and social life. These challenges, as they manifest in art as much as in everyday life and the political sphere, became progressively evident over the course of the 1960s. As an idea, cybernetic control was meant to mitigate problems of entropy, noise, and systemic failure. For the most exuberant, it promised a perfect system, the seamless integration of freedom and functionality. For those more wary, control was always and absolutely to be avoided, an analytical path that collapses the distinctions between operability and oppression and forecloses how agency might be understood as interrelated with these forces rather than opposed. The effect of cybernetics on the *ambienti* was to foster a way of putting all these problems together into the same discursive, and experiential, space. What appears in these disorienting, immersive, and at times aggressive *ambienti* as the dissolution of the subject was Arte Programmata's attempt to confront the inextricability of control and collectivity. In a way, the ends are devastating, for what these environments bring forth is the scale and complexity of this endeavor, a feeling of impos-

sibility for any subject, now or then, to construct a common foundation for communication, collective action, or social sense.

Mass Media Debates in Italy

The Responsive Eye was the pinnacle of a crisis that had been mounting for years among Italian artists and intellectuals concerning the relationship between art, mass media, and capitalist consumer culture. The postwar economic boom had raised the per capita income and doubled the country's GDP between 1950 and 1963. This financial stimulus sparked sweeping cultural shifts, one of which was the exponential growth of the television industry. Between 1958 and 1963, the number of RAI (Radiotelevisione italiana) subscribers grew from 1.0 to 4.3 million, increasing the audience of the nation's public broadcasting system from 12 percent to 49 percent of the population.[19] This had conflicting outcomes. Television unified the country, giving more Italians access to the same cultural content and a standardized form of the Italian language than ever before. Yet the expansion of television, radio, and cinema meant that artists were now competing with a more cacophonous cultural landscape. Crowding and competition for attention were part of the problem; content was an issue as well. RAI funded some very experimental programming in the 1950s and 1960s. (Luciano Berio's music studio, where Umberto Eco worked before writing *Opera aperta,* was a prime example.) However, television was also the central means of fostering consumerist attitudes, a process some referred to as Americanization.[20] This effect was due to the structure of Italian television, whose programming was controlled by the state, or more accurately, the ruling party. Throughout the period in question, this was the Christian Democratic Party (DC), and their programming had a split personality. On the one hand, the DC was invested in ensuring that the mass media not erode the country's conventional (Catholic) mores. On the other, during RAI's rise the DC party was aligned with the United States in the Cold War and sought to forge cultural links with the country through the promotion of U.S. culture. While Hollywood movies and other products were inevitably tied to the country's capitalist and individualist values, for the DC advertisements posed the greatest threat of

corrupting Italians since they explicitly promoted decadence rather than thrift, consumption rather than conservation. The solution concocted by the DC government to handle commercial advertisements on Italian television was an attempt to reconcile the party's competing objectives. Advertisements were condensed into one daily program called *Carosello,* shown at nine every evening before the nightly news. The show ran for thirty minutes, and each advertiser was allotted 110 seconds, during which it could focus on its product once at the beginning and for five additional seconds at the end. The interim period had to be filled with something else, which usually took the form of child-friendly cartoons or fairytales. Therefore, rather than limiting consumerism, *Carosello* had the opposite effect of entrenching it within Italian culture, since now the most popular children's program in Italy was tied to U.S. advertising. This led Pier Paolo Pasolini to criticize the program as indicative of contemporary culture's most insidious vices: "The Vatican . . . should have censored *Carosello* because it is in the all-powerful *Carosello* that the new type of life which the Italians 'must' lead explodes onto our screens with absolute, peremptory clarity."[21] For better or worse, Western consumer culture was rapidly becoming one of the country's most powerful agents of socialization. Less than two decades before, in a visit to Italy in 1947, Marshall McLuhan had noted that, in contrast to the United States, "the Italians can tell you the names of the ministers in the government but not the names of the favorite products of the celebrities of their country. In addition, the walls of the Italian cities are plastered more with political slogans than with commercial ones."[22] Progressively, however, the construction of Italian identity—who the Italian people were, but even more so, who they wanted to become—was being dictated by a burgeoning mass media and the values of consumerism.

Pasolini was not unique among Italian intellectuals in his analysis of mass culture's socializing power. The novelist Alberto Moravia, filmmaker Roberto Rossellini, and the leaders of the Communist Party (PCI) all chimed in to denounce Hollywood cinema and *Carosello* for producing nightmarishly unified Italian subjects.[23] From the perspective espoused by these prominent figures, the problem of the mass media was homogenization. The media theorist and journalist Cesare Mannucci crystallized this

analysis in his 1962 book *Lo spettatore senza libertà: Radio-televisione e comunicazione di massa* (The Spectator without Freedom: Radio, Television, and Mass Communication).[24] Mannucci was more disturbed by the government control of the media than by its consumerist content, but his critique of the mass media was the same as these other intellectuals, namely that it effectively led to "the 'robotization' of the masses."[25] In an attempt to bring further critical attention to this phenomenon, in 1963 Mannucci translated Walter Lippmann's book *Public Opinion* (1922), a seminal study of how easily people can be manipulated by media "spin." (Mannucci worked with the support of Olivetti's public relations manager, Renzo Zorzi, to publish this volume.)[26] By the early 1960s, there was a sense among many intellectuals, artists, and even socially conscious heads of industry that Italian television was an instrument used to integrate people into a consumerist, capitalist way of life and manufacture passive, consenting citizens.

Not everyone shared this same concern about centralized mass media and its unifying effects. For some, the instantaneous, integrated nature of mass media such as television was its most promising feature. Back in 1952, Lucio Fontana and seventeen other artists (almost all abstract, *informale* painters) claimed a revolutionary potential for the medium in the Manifesto of the Spatialist Movement for Television. The artists championed television for its immediacy and scope, its capacity to both transform what art could be and unify the audience by expanding distribution: "For the first time anywhere, we Spatialists are broadcasting, through the medium of television, our new forms of art . . . the triumphs of technology are now in the service of the art we profess."[27] The same year, Fontana developed a new artwork to showcase the artistic power of this new medium. His plan was to broadcast two of his works to cities like New York, Berlin, and Milan. The works were punctured canvases, backlit so that rays of light projected through the holes and cast twisting lines onto the dark surrounding walls.[28] While Fontana's televisual art was never realized, the resonances between the 1952 manifesto and the artist's later writing make clear that television epitomized the artist's view of what art should do: operate like a mass medium. His utopian understanding of the integrating power of television was both preempted and developed by his lifelong pursuit of a "spatial art," in which the idea

of synthesis was primary, the goal of his art being at once to dissolve the boundaries of traditional media (sculpture, architecture, painting) and to unify spectators to one another and the world.[29]

Fontana's idealistic interpretation of the mass (and massifying) medium of television was written before RAI had the capacity to realize the broadcast that was intended to accompany the manifesto.[30] He also developed his idea before Italian television had the association with U.S. capitalism that so troubled Mannucci and Pasolini. The painter, critic, and essayist Gillo Dorfles expanded Fontana's optimistic understanding of the medium's unifying capacity in light of these criticisms of capitalist culture in his *Simbolo, comunicazione, consumo* (Symbol, Communication, Consumption, 1962). This current epoch, Dorfles argues, is characterized by a resurgence of the centrality of symbolic, or visual, communication, evident in the accelerated production of advertising, design, architecture, and art in the modern period. Along with the advancement of symbols, Dorfles describes the proliferation of channels—an expansive communication network—due largely to the development of mass media. Both *simbolo* and *comunicazione,* Dorfles maintains, are collectivizing forces: the former establishes a shared cultural language and the latter ensures that it is accessed and understood by all. The range of communication is as important, even more so, than its content: "Communication—understood as the growth of the *mass media,* of communication that is written, spoken, sung, recited, visual, audial, figurative, etc.—is without a doubt at the base of our intersubjective relations, and forms the true and proper fulcrum of all of our active thinking."[31] Dorfles is unequivocally buoyant about the positive outcomes wrought by mass communication, arguing that it is the planned obsolescence of consumer society that undermines the connectivity, sociality, and activating power of *comunicazione* and *simbolo*. The constant turnover of styles and conventions, as well as goods and services, inherent to *consumo*'s logic, "slowly commits and degrades the symbolic elements and the network of communication."[32] Dorfles considers the mass media's networking function to be its greatest promise; the problem was its subsumption by the logic and values of *consumo*.

Dorfles carefully negotiates a balance between what Eco argues is a deadlock between two opposing but equally useless positions on mass cul-

ture and media. In *Apocalittici e integrati* (Apocalyptic and Integrated, 1964), Eco outlines the two sides: "apocalyptic" critiques, exemplified by Mannucci and others like Theodor Adorno, condemn popular culture for producing docile, obedient subjects, while "integrated" analyses, like those forged by Marshall McLuhan, leap to celebrate it as the democratization of culture. Both, Eco contends, are ahistorical and ideological, determined by an a priori position: "The image of the Apocalyptic is found by reading texts *about* mass culture; the image of integration emerges from texts *of* mass culture."[33] This assumed place in relation to mass culture (either purely outside or entrenched within), Eco argues, determines the author's verdict from the start, shaping what they are able to see when they look at a given cultural object. By contrast, Eco refuses to consider mass media a monolithic entity to be dismissed or endorsed wholesale. Instead, he advocates taking mass culture seriously as a subject of study, to be analyzed as both a social agent and symptom. Eco not only theorized this position but embodied it as a strategy, publishing widely on phenomena from *Superman* comics to television game shows and subjecting them to rigorous theorization and critique.[34]

Whether for or against, polemical or circumspect, underlying these analyses of mass media was the reconceptualization of the relationship between the individual and society in light of technological and cultural change. Therefore, in Italy as in elsewhere in Europe, from the early to mid-1960s the problem of the mass media increasingly determined how artists understood their art and what it might accomplish in the world: Should art liberate or educate? Collectivize and connect their audiences? Or wrest them from the mass media's controlling, homogenizing grip? This was no simple or straightforward matter, and opinions differed depending on which side of the equation was seen to be at greatest risk: individual autonomy or social cohesion.[35] Many at the time recognized the complex and contradictory way that mass media operated in postwar Italy. Eco pointed to the conceptual impasses produced by moralizing and binary thinking about mass media, Fontana tried to redirect the integrating power of television from consumerism to (an admittedly far-fetched, abstract, and utopian) humanitarian globalism, and Dorfles saw mass media's potential to connect people, if only it could be divorced from the values of consumerism. Yet most held fast to

one side or another: either the problem was integration and the solution was an art that could provide individuation through critical distancing, or the issue was disintegration and the solution was art that could highlight the integrative power of the media. It was in this context of heightened debate about the politics of art in the age of mass media that Arte Programmata developed their understanding of both, expanding the scale and scope of programmed art to more assertively unsettle the dichotomies (individual and collective, art and media) that structured the analyses of and artistic responses to the broader visual landscape.

Theories of Spectatorship: The 1963 San Marino Biennale and the 1964 Milan Triennale

One of the first public occasions for the artists of Arte Programmata to articulate their own ideas about how artists should engage the mass media environment was the international congress of artists, critics, and art scholars held in 1963 in the Italian town of Verucchio. The congress was held in conjunction with the nearby San Marino Biennale, *Oltre l'informale* (Beyond *Informale*), organized by Giulio Carlo Argan. As an art historian and critic with strong Marxist leanings, Argan was particularly interested in modern art's historical position within capitalism. For example, his 1957 monograph on Walter Gropius situated the Bauhaus figure as a proponent of design's rationalizing, progressive capacity in society.[36] In his organization of the 1963 San Marino exhibition, Argan put his political ideas about contemporary art to work. This edition of the Biennale showcased three dominant artistic trends: gestalt art, the central example of which was Arte Programmata; neo-figuration, exemplified by the Dutch painter Asger Jorn; and neo-Dada, inclusive of artists such as Jasper Johns and Robert Rauschenberg. Argan used the Biennale to highlight art that, in his view, combated the homogenization of subjects in the contemporary mass media environment. In a series of articles leading up to the exhibition, Argan described the challenge of artists working within a mass culture: the overwhelming barrage of images that flow through the cultural landscape, and the endless stream of brief, staccato signals pumped out by film, photography, television, and news,

which "threaten to suffocate or paralyze the image-poetic potential of the individual."[37]

Of the three tendencies included in the San Marino Biennale, Argan privileged gestalt art and awarded Gruppo N and the German Zero Group first prize.[38] Gestalt art, Argan argued, functioned as an antidote to the mass media's stifling of individuals' creative and critical capacities by attuning spectators to the active role they had in shaping their own perception of the world. To make this claim, Argan relied on gestalt psychology's theory of perception, in which "the mind gives form to things, [and] structures experience, isolating a certain unitary entity within a muddle of phenomena."[39] Because of the instability of gestalt art's forms, it was up to the perceiver to create a whole out of these indeterminately moving parts. Argan favored gestalt art for how it appealed directly to this creative capacity of viewers, making visible the viewer's active role in producing the work.

Argan's moralizing tone was clear. While the critics of gestalt art charged these works with succumbing to the unthinking, sensational stimulation of popular entertainment, Argan saw these two types of stimuli as radically different in kind. In his terms, the constant sensory stimulation perpetuated by mass media congealed spectators into an indistinct mass, disconnecting them from any sense of their own agency. This was an effect of mass culture that could not be countered easily, and Argan criticized pop art for merely reproducing the iconography of capitalism and entrenching its viewers within its ideological grip. In contrast to both the mass media and pop, Argan argued, gestalt galvanized its viewers, attuning them to the productive activity of their own perception. Gestalt art reconstituted viewers' sense of self in contrast to a mass media that dissolved it. Against the pacifying de-individuation bred by mass media, gestalt art reminded its viewers of their own power to understand and shape the world.

Argan's ideas about gestalt art resonated with Arte Programmata's initial rhetoric about their work, especially their desire to activate their viewers and include them in the creative process. Arte Programmata's contribution to the Verucchio Congress, however, indicated a shift in the artists' priorities. Gruppo T, Gruppo N, and Mari read a collaboratively written statement titled "Art and Freedom: Ideological Commitment [impegno] in

Contemporary Artistic Currents," which explained their idea of how art should relate to its spectators: "Our research, realized across all the possibilities of visual communication (objects, films, graphic works, etc.) must be submitted to specific media (visual perception) used with maximum economy . . . to stabilize contact with the spectator . . . that is to ensure the least possible individual interpretive ambiguity (culture, humor, geographic contingencies, taste, etc.)."[40] In a total reversal of Argan's model, the artists' statement suggests that the spectator's individuality was not the solution to the stultifying effects of media but another part of the problem, something that art needed to mitigate and control. For the 1962 *Arte programmata* exhibition, Gruppo T, Gruppo N, and Mari all made moving objects that invited spectators to experience multiple perceptual phenomena and interpret them just as openly. But in their Verucchio statement, the idea of a more constricted spectator begins to emerge: the openness of interpretation becomes an obstacle that art must overcome, rather than its objective, since it can too easily invite a wholly subjective reading of artworks. In contrast to the rhetoric of openness so rampant in 1962, in their 1963 Verucchio statement Gruppo N, Gruppo T, and Mari explicitly argue that art should organize experience for the spectator. It should provoke not only a new experience but also a consistent one, capable of being reliably communicated and collectively shared.

The artists' desire for consistency continued, driving a rift between them and some of their contemporaries. The conflict came to a head over the course of a series of exhibitions called *New Tendencies*. A group with this name had formed in 1961, exhibiting works by an international set of European and Yugoslavian post-*informale* artists—Enrico Castellani and Piero Manzoni, the collectives Gruppo N, GRAV (Groupe de recherche d'art visuel), and Zero, to name a few—with a total of thirty participants from six countries. The curator of the first exhibition, the Yugoslavian critic and historian Matko Meštrović, chose the title *New Tendencies* because of how it stressed the artists' shared orientation toward the future, and his catalog essay underlined their pursuit of formal experimentalism free from any preoccupation with the past. The second exhibition, also organized by Meštrović in 1963 and held, like its precursor, in Zagreb, included Gruppo T and Mari as well. Across the board, the artists' catalog essays took

on a heightened political tone. In particular (and despite the inclusion of so many artists from Socialist Yugoslavia and the show's siting in Zagreb), the participants in *New Tendencies 2* were consumed above all by the problem of eschewing the capitalist market. Many of the artists focused on production rather than consumption, working collectively on sustained "research."[41] By being anti-individual and anti-object, the artists in the second *New Tendencies* exhibition imagined they could counter the logic of capitalism. This shared belief was reflected in the artists' statements for the exhibition catalog and the debates that took place at a conference held in conjunction with the show. For example, in their catalog essay titled "For a Progressive Abstract Art," François Molnar and GRAV artist François Morellet framed their light sculptures and abstract, mostly black-and-white constructions in the language of historical materialism, claiming that these structures typified "the dialectical richness" of reality, namely class struggle.[42] Gruppo N explicitly raised the problem of the market in their statement for the catalog: "Is it or is it not increasingly clear that the way the relationship between artists and society is dependent on the art market is imposing on the groups within New Tendencies limits that are almost insuperable when trying to achieve real freedom for research?"[43] The works in the first and second *New Tendencies* exhibitions were almost exactly the same—abstract paintings, light sculptures, and objects that, with their glimmering surfaces and tightly composed patterns of contrasting colors or hues, flickered and mutated over time. But the difference in rhetoric between these two exhibitions indicates that only in 1963 did anxieties about the marketplace, especially worries about the ease with which the meaning of abstract art could be mistaken, take hold.

At this point, in 1963, those among New Tendencies who failed to assert any social or political mission in their work began to lose the respect of the group. Shortly after the second *New Tendencies* exhibition opened, a faction of artists, which included Mari and the members of GRAV, Gruppo T, and Gruppo N, issued a bulletin calling for the expulsion of certain members, such as Otto Piene and Heinz Mack of the Zero Group in Germany, due to their "lack of clarity" and narrow focus on the entirely "formal problem of constructive art."[44] The artists signed the bulletin with the name "Nouvelle

Tendance—recherche continuelle" (New Tendency—continuous research) to reflect the change in the group's composition and goals. The bulletin outlined the dangers of keeping artists like Piene and Mack in the group: that "continuous research may be absorbed into the art scene," "the risk of members becoming stars (behaving like 'artists')," and "the risk of a facile repetition of formulas."[45] The language of the bulletin resonated with Arte Programmata's Verucchio statement, with its emphasis on clear communication and concerns about ambiguity and misinterpretation.

Together, the San Marino Biennale, the second *New Tendencies* exhibition, and its ensuing critique prompted Gruppo T, Gruppo N, and Mari to reevaluate the political implications of their programmed mode of production and to begin to redress its limitations. By the start of 1964, Gruppo N and Gruppo T took two different paths of action. The artists of Gruppo N (at this point, Manfredo Massironi, Alberto Biasi, Edoardo Landi, Toni Costa, and Ennio Chiggio) threw themselves into working collectively, a strategy they asserted in another statement read aloud at Verucchio, in which they articulated their identity as workers in explicitly Marxist terms.[46] Gruppo N then signed a renewed "commitment to collectivization" late in 1963. Theirs was a common strategy among artists and intellectuals at the time: since there is no place outside capitalism from which to critique (or create), one must begin with one's identity within this system as a producer. Jacopo Galimberti has shown that Gruppo N's embrace of their identity as workers reflected the influence of new Italian social movements of the time, namely the group of thinkers associated with the journals *Quaderni rossi* and *Classe operaia,* who by 1963 were developing the idea of *operaismo,* or "workerism." *Operaismo* insisted on the centrality of the agency of the working class in the transformations of capitalism. Gruppo N's sustained faith in the revolutionary potential of collective labor was inspired by the worker-centrism of *operaismo,* but the group's focus on production proved inadequate. They could not eschew the larger system of capitalism nor its effects on the significance of their work and their sense of self. Citing their inability to truly work collectively (despite their efforts, they retained too much of their own individual practice) and the persistent danger of being incorporated into the art market, the group temporarily dissolved ten months

later, in the fall of 1964. An open letter published by Massironi in the literary journal *Marcatrè* expressed their profound despair and nihilism: "Our achievements risk representing the artistic equivalent of Neo-capitalism and the centre-left. . . . [Our objects oppose] the art market and could represent a critique of Capitalism . . . but this attitude alone is useless and it is ultimately harmful, for this criticism is made within a new, more encompassing form of Capitalism."[47] The disbanding came at the tail end of Gruppo N's participation in the 1964 Venice Biennale, where pop art reigned supreme, and the radical disruption of capitalism they desired appeared not only impossible but also unpopular. Sensing the influence of capitalism and individualism to be absolute, Gruppo N retreated and regrouped (without Costa or Chiggio) as a result. Gruppo T (Boriani, Anceschi, Colombo, and Devecchi), on the other hand, saw art as a more powerful terrain of struggle precisely because mass media images were growing more pervasive every day. While in 1963 Gruppo N had affirmed their identity as *workers,* Gruppo T and Mari had asserted their identity as *programmers,* broadening the scope of this term from programming art to programming their audience. In contrast to Gruppo N's sustained focus on production, Gruppo T and Mari directed their next efforts toward restructuring the idea of the spectator in their work.

The 1964 Milan Triennale provided Gruppo T and Mari a crucible for rethinking the effect an exhibition could have on its spectators. The themed introductory section "Tempo libero" (Free Time) sought to dismantle the semblance of the free individual in capitalist culture by critiquing a central part of this myth: the idea of self-directed, desire-driven, free leisure time. Constructed as a series of sensorially stimulating, immersive rooms, the 1964 Triennale put forth an unequivocal argument: it attacked the idea that personal taste was indeed personal by sending message after message that desires and personal taste are determined by the social and historical situation in which one lives.

The main introductory section of the exhibition, which presented this argument and provided the national sections with their theme and framework, was organized by the architect Vittorio Gregotti and Eco, and this pair brought in a team of contributors that included the artists Mari, Lucio Fontana, Enrico Baj, and the members of Gruppo T; the poet Nanni

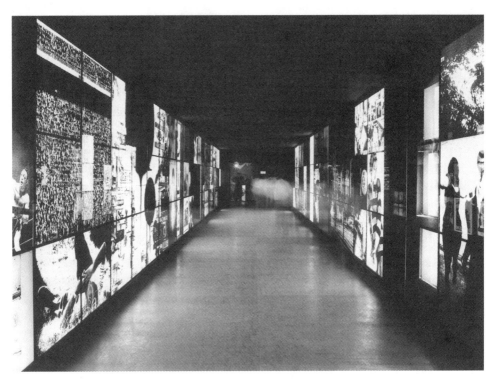

FIGURE 13 Tredicesima Triennale di Milano, "Tempo libero / Free Time" introductory section, "Exaltation," 1964. Design: Massimo Vignelli. Photograph: Ugo Mulas. Copyright Triennale Milano–Archivio Fotografico.

Balestrini; and the filmmaker Tinto Brass. In her comprehensive history of the Milan Triennale, the design historian Anty Pansera placed this as the last Triennale of the postwar economic boom.[48] But its content also represented the very negation of this boom, as it was steeped in the criticism of Western consumer capitalism that had been developing among Italian artists and intellectuals for the past few years. A book published by *L'Unità* journalist Gianni Toti, *Il tempo libero* (1961), demonstrates that by the early 1960s, "free time" was an intensely contested term.[49] Toti claims that in capitalism, no time can in fact be free, and that leisure time is only the other face of work, and just as alienating. Many other leftist intellectuals shared the idea that

the very activities (sports, cinema, holidays, etc.) that proclaimed to give people respite from their work only further entrenched them within capitalism's productive forces.[50]

Certainly, Gregotti and the other organizers of the Triennale would have been even more acutely aware of the relation between postwar capitalism and the instrumentalization of free time because it was through design exhibitions (among other things like cinema and television) that this connection was articulated and advanced. Most famous were the multiscreen environments designed by Charles and Ray Eames first for the Moscow World's Fair of 1959 (site of Nixon and Khrushchev's Kitchen Debate), and then for the New York World's Fair of 1964. The Eameses' contribution to the 1959 fair in Moscow, a seven-screen installation of their film *Glimpses of the USA,* exemplified the American Cold War culture offensive strategy of depicting material abundance as evidence for capitalism's superiority over communism.[51] The Eameses designed a similar structure for the IBM "information machine" in 1964; it included more screens (almost twenty) of different shapes and sizes, completely enveloping the viewer. The Eero Saarinen–designed room seated five hundred people for a screening of the film *Think,* which used montage to demonstrate the structural similarities between human and computer behavior, organization, and decision-making. The Eameses' film installations differ in content but not form: both transmitted overwhelming image montages to an immobilized and engrossed audience, in order to transmit clear, predetermined, and unambiguous messages—capitalism's superiority, on the one hand, and the anthropomorphic qualities (and thus marketability) of computers, on the other. Beatriz Colomina has commented on the unsettling way that the Eameses tightly designed and controlled the flow of information to create the sort of image-saturated environments that have become so commonplace today. In so doing, Colomina argues, the Eameses were the architects, first and foremost, of a new form of technocratic power, in which the façade of individual freedom is maintained by providing a discrete, carefully chosen array of choices within a rigidly controlled environment. In fact, this critique was already a part of the design of the Milan Triennale, which worked in opposition to the Eameses' model in two ways: the organizers sought to

undo the American valorization of individual freedom to show that the very idea was historically and ideologically determined, and they deployed their multimedia environment to engage and inspire audiences to think critically rather than direct their thinking as if the environment were an instrument of mind control.

The 1964 Triennale organizers made this critical argument the structuring principle of the introductory exhibition. Their goal was to illustrate that "free time" was a historically constructed concept, thereby denaturalizing the equation of personal choice with individual freedom. Since the aim was to unsettle the autonomy of the spectator, the organizers exercised a great deal of curatorial control, evacuating the spaces of objects and filling them instead with images, film projections, and text. As Pansera wrote, in contrast to prior Triennales, in 1964 "design as a discipline disappeared altogether in the presentation of a theme."[52] The introductory section unfolded like an expository essay, divided into four parts. The first was "dialectically connected to the remaining three parts of the exhibition. Its central theme [wa]s the discussion on the quality of our 'leisure,' in its historical formation and stratification, whereas the rest of the exhibition present[ed], substantially . . . positive solutions."[53] While later sections represented options for leisure such as dance, experimental cinema, hobbies, and parks, the introductory rooms (six in total) visually and aurally assaulted viewers in order to first eradicate traditional understandings of the term. Upon entering, visitors walked through a "terminal of praise," a long hallway with moving images picturing leisure-time activities—cinema, bike riding, driving a car in the open country on holiday—projected onto both walls. As they passed through, they heard a recording that encouraged them not only to enjoy their leisure time but also to revel in the endless choice of how to spend it. The catalog explained that this room asked spectators to delight in "all the possibilities made possible today by the industry of free time. A gesture of confident abandon is asked for, which will be symbolically frustrated when [they enter] the second hall."[54] The second room then negated the first: the "decompression room" was comparatively sparse, a smaller, squatter, space meant to re-create the experience of "empty time" after work when a person is too tired even for leisurely fun. The decompression room, however, was

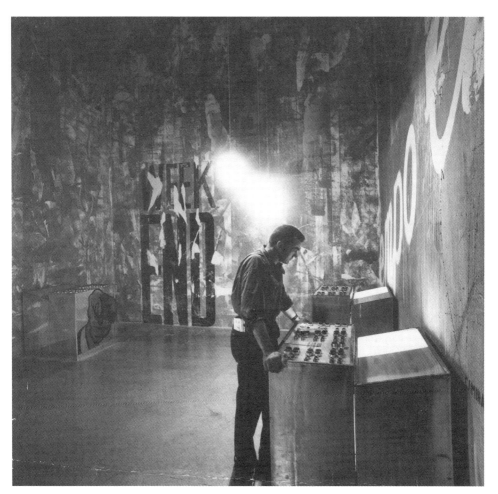

FIGURE 14 Tredicesima Triennale di Milano, "Tempo libero / Free Time," introductory section, "Decompression Room," 1964. Design: Massimo Vignelli. Photograph: Ugo Mulas. Copyright Triennale Milano–Archivio Fotografico.

not actually empty. On display was a set of five aluminum information-processing machines. Visitors were invited to input their age, gender, profession, and favorite free-time activities. The machines then dispensed a ticket giving participants "tailored" interpretations of the preceding and

subsequent rooms. The machines put forward somewhat heavy-handedly the idea that one's choices are not free but rather determined, predictable, and programmable outcomes of quantifiable demographic facts such as age, class, and vocation. However, the audience was meant to read a critical message behind the programmed media; as the organizers explained, "The relationship between the entered data and the obtained recommendations is naturally false, just as it is false to believe, in our conditions, that we have free choice as to our use of free time."[55] The wall text at the end of this introductory section stressed the opposite perspective, that one was never outside: "Enjoying oneself means integration."[56]

What appears to be freedom, the exhibition argued, is in fact a relatively small repertoire of choices, and even among these, one's selections are likely to be determined by demographic realities, as the computers in the decompression rooms made clear. Enjoyment is integration, participation is submission, and nowhere are we more securely in chains than when we think ourselves to be free. The multimedia format of the show conspired to obliterate the viewer's sense of autonomy, sensually stimulating viewers only to manipulate them, juxtaposing image and text to undermine one another, leaving the audience with no secure place—physically or logically—to stand. The American poet John Ashbery, in his *New York Herald Tribune* review, explained that "the effect is extraordinary and brilliantly suggests the individual's isolation and bewilderment amid today's mass-produced distractions."[57] Another reviewer, Paolo Portoghesi, lauded the Triennale's criticality as an important turning point in the history of the exhibition: "If the old Triennales promoted a diffusion of taste, an expansion of the sphere of influence of culturally produced objects, this new Triennale proposed, more directly, to propagate within its viewers a critical self-consciousness *[autocoscienza critica]*, to help them reconsider some of the particularly upsetting aspects of the ways in which modern man spends his time, and especially, his time that is not directly devoted to work."[58]

The goal of the Triennale, however, was not only to critique contemporary culture. The organizers also wanted to historicize leisure in order to improve it, not declare its bankruptcy.[59] Therefore, the "Tempo Libero" section was followed by "Moments of Free Time," a section that promoted

new and better ideas of what free time could be. The section surveyed topics such as green zones in residential areas, experimental cinema, sports, and dancing. The purpose of this section was not to counter these "good" leisure-time activities with the bad ones in the prior section, but to look at arenas where practical solutions could improve the quality and expand the quantity of free time. For example, a section on transport explained that faster, more rational and comfortable transportation would have the effect of delivering to commuters more time for actual leisure, since less of their day would be consumed by traveling to and from work.

It was here that Mari, Boriani and Colombo of Gruppo T, together with the artist Dadamaino, constructed a room called *Lo Spettacolo* (Performance). The artists wrapped seven long canvases printed with photographs around three poles, and then arranged them to create a snaking, storyboard structure that occupied the center of the room. The pictures were all black and white. Some straightforwardly depicted leisure-time performances, such as a marching band, a boxing match, Liz Taylor as Cleopatra (from the 1963 film), and a still from the opening of *Carosello*. Others were more enigmatic— a crying baby from an advertisement, a close-up of a woman with closed eyes. The artists attached motors to the canvases so that they circulated around the poles, creating different image combinations as they moved and overlapped. Individually, the images were nonsensical, their juxtapositions absurd. If the rapid-fire editing of the Eameses epitomized what Marshall McLuhan called the "hot" medium of film, *Lo Spettacolo*'s slowed-down montage was a "cooled off" version, inviting more sustained engagement with both the whole and each of its moving parts. The strategy of comparatively lo-fi motorized montage (to say nothing of the use of canvas) denaturalized the images from their original siting in television and film, directing viewers to be critical and contemplate the content and its contingency in this context. The artists' catalog text read, "Television, cinema, sports, light [pop] music, strip-tease, advertising, cultural events, folklore. The myths of middle-class mediocrity, arrivism, violence, condition thousands of leisure hours."[60] But critical negation was not the end goal of this work. Writing in 1970, Mari noted that, by viewing recognizable activities spliced together with confusing images, "the spectator . . . has the possibility of perceiving

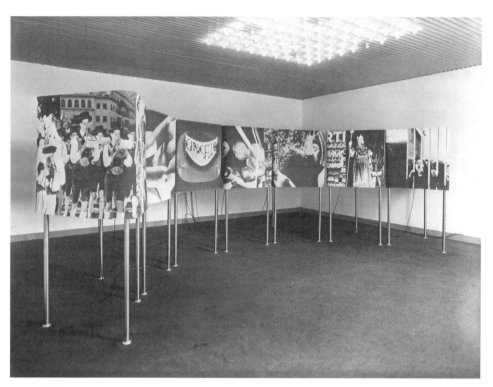

FIGURE 15 Tredicesima Triennale di Milano, Gruppo T, Dadamaino, and Enzo Mari, *Lo Spettacolo* (Performance), 1964. Photograph: Ancillotti. Copyright Triennale Milano–Archivio Fotografico.

the becoming of an 'other' image determined by the successive integration of self-sufficient images."[61] The work was meant to operate like a generative structure, prompting new ideas about entertainment after the critique had set in. In contrast to the introductory section of the Triennale, in which the environment immersed its audience in projected images only to reveal, afterward, the dangers of immersion, *Lo Spettacolo* was an attempt to have it both ways, to suggest that being inside, invested, and even enjoying an image or experience was a support for—rather than the antithesis to—further analysis or critique.

In a 1964 interview, expressing sentiments shared among Gruppo T, Anceschi articulated this new direction in which the artists were rethinking their media and its relation to spectators: "Those who want to influence the way of seeing the world of their contemporaries will have to deal with this phenomenon [of the mass media]," or succumb to a position "without hope" that Anceschi associates with the critical, anarchic stance of so many around him.[62] After calling for a tempered engagement with the mass media, the artist went on to specify that "perhaps it is now the moment to start the process of transformation of this sphere [the mass media] from a vague set of personal knowledge to an *operable interpersonal structure*."[63] Reminiscent of Dorfles's distinction between *comunicazione* and *consumo,* Anceschi made a crucial distinction between technological platforms in general and those structured according to capitalist logic; Anceschi posited art as a kind of laboratory for experimenting with the radical redirecting and collectivizing potential of new communicational forms.

For most of Gruppo T and Mari's contemporaries, the challenge of making art in the age of mass media crystallized around the opposition between social determination and individual empowerment. These terms then determined how an artist, intellectual, or curator would imagine that a work could or should engage its spectators. Argan's argument about the politics of gestalt art presumed that individual viewers, with their a priori ability to structure the work, arrived at the artwork ready to oppose the paralysis brought on by the barrage of images in the contemporary cultural field. Art need only stimulate that inherent capacity. The Triennale, on the other hand, supposed instead that individual freedom was in fact a byproduct of that culture. Argan's model presumed that activating the spectator was a radical blow to the stultifying effects of mass media, while for the Triennale activation was first and foremost another form of submission, requiring remedy by radical redesign and critique. This central problem of the mass media for both Argan and the organizers of the Triennale—the way it confounded the distinction between programming and participation—became the motivating logic behind the artists' *ambienti* (environments) beginning in 1964.

Gruppo T's Environments, 1964–65

Gruppo T's first environments—*Spazio + Linee luce + Spettatori* (Space + Light Lines + Spectators) and *Ambiente a shock luminosi* (Light Shock Environment)—appeared as part of the *Nouvelle tendance* (New Tendency) exhibition that took place just prior to the Triennale's opening, in April and May of 1964 at the Musée des Arts Decoratifs in Paris. This exhibition came on the tail end of the eponymous movement's restructuring, and the use of the singular "New Tendency" as the title was meant to reflect this change. The invitation to organize an exhibition of the group gave the New Tendency a chance to translate into artworks the ambitions advocated by their 1963 bulletin, such as "depersonalization," "collective work," "a need for clarity," and "the active engagement of the spectator."[64] The predominance of interactive installations at the exhibition pointed to the importance of audience engagement in this endeavor, but differences among the installations suggest that the artists of the New Tendency were inciting participation to divergent ends. The works in *Nouvelle tendance* indicated that there was tension between the demand for consistency and the call for participation—two criteria so important that they were the central reasons cited in the bulletin for asking artists in the group to leave, and yet hard to reconcile. Karl Gerstner's essay for the exhibition catalog, for example, placed strong emphasis on audience engagement at the expense of consistency:

> Our aim is to make you a partner. Our art is based on reciprocity. It does not aspire to perfection. It is not definitive, *always leaves the field open between you and the work.* More precisely, our art depends on your active participation. What we are trying to achieve is for your joy before the work of art to be no longer that of an admirer but of a partner. Moreover art does not interest us as such. It is, for us, a means of procuring visual sensations, a material which brings out your gifts. As everyone is gifted, everyone can become a partner.[65]

Gerstner's language was similar to Seitz's, who also used the word "partner" in his description of Gruppo N in his essay for the *Responsive Eye* exhibition

catalog; both groups defined active participation in terms of physiological stimulation and, more important, imagined (implicitly or explicitly) that this made the artwork more collaborative, even democratic. The works in the *Nouvelle tendance* exhibition in Paris split along these lines—either underscoring the liberation of spectators or accentuating its limits.

The French collective Groupe de Recherche d'Art Visuel produced an installation that aspired to activate spectators and turn them into partners in the manner described by Gerstner. Together Gerstner and GRAV were the prime organizers of the show and did the most to shape its catalog and curatorial frame. GRAV's environment was a work titled *Labyrinth,* a guided pathway directing viewers through a series of sixteen steps, or moments, each meant to provoke a distinct perceptual experience. A hand-drawn plan for *Labyrinth* illustrated the order and arrangement of these sixteen stages, which included three kaleidoscopes, four light sculptures, an "uneven area," a projection of Leonardo da Vinci's *Mona Lisa* (the original hung close by in the Louvre), a cut-out window allowing the audience to see people's feet on the grass outside the museum, and a prismatic window through which spectators could view the Tuileries Gardens. Inside this pathway, visitors encountered light sculptures by GRAV members Julio Le Parc, Morellet, and Joël Stein, were directed to look out on the city of Paris, and even guided to meditate on the instability of the ground on which they trod. While viewer participation in *Labyrinth* was highly choreographed, since the audience was funneled through a set of predetermined pathways, the artists stuck to the language of liberation when it came to interpretation.[66] And as Lily Woodruff reminds us, "The figure of the labyrinth itself multiplied across disciplines and ideological dispositions during the 1950s and 1960s, symbolizing play, discovery, and freedom."[67] GRAV's *Labyrinth* was therefore meant to function more like a springboard than a maze, launching spectators into a more active, conscious, and self-directed existence rather than leading them toward a determinate end. The group intended the playful guidance provided by *Labyrinth* to contrast with the ideological battlefields of the market, economy, and city. In their manifesto, the artists explained, "To the best of our abilities we want to free the viewer from his apathetic dependence that

makes him passively accept, not only what one imposes on him as art, but a whole system of life."[68]

Although *Labyrinth* seemed to point to the contrary, GRAV maintained that in the field of reception, predetermined programming was antithetical to participation. This left them open to harsh criticism, most notably by Guy Debord and the Situationist International (SI). A 1963 article by the SI, "The Avant-Garde of Presence," mocked GRAV member Le Parc's claim that one can achieve "real participation" only by means of "the manipulation of elements." This, the SI points out, makes "the notion of programming" always a submission to "cyberneticians of power."[69] The SI's alignment of programming with power is illustrative. Programming was something to battle against, a control over others that can only be wielded to treacherous ends. (By contrast, the SI's "situations" were aleatory and unprogrammed.) GRAV did employ the notion of programming in their artistic production—they wanted to temper their authorial role through automation and chance as much as the rest of the New Tendency—but when it came to the participation and activity of their spectators, the artists dropped the metaphor.[70] In a model that should by now sound familiar, *Labyrinth* showed that GRAV pitted the programmed subject of culture against the liberated, activated, and free spectator of art, without critical attention to the mythical dimension (and ideological exploitability) of this autonomous subject.

Gruppo T, on the other hand, gave the relation between programming and participation pride of place in their environments. Boriani's *Spazio + Linee luce + Spettatori* was an immersive environment in which visitors were made to feel a great deal of ambiguity as to who or what was in control. As evident from a series of diagrams and photographs, the artist hung thirty-two spotlights attached to motion sensors from the four walls and ceiling of a small, dark, square room. As viewers moved through the space, they activated the sensors, triggering bright beams of light to illuminate the spot where they stood. While Boriani designed the lights to follow the spectator, the actual experience was less than clear. Even in a 2005 reconstruction, there was a conspicuous delay between the moment the sensors were tripped and the lights switched on.[71] Add to this the loud clunking sounds emitted by the fixtures as they flashed, and the effect was more disorient-

FIGURE 16 Davide Boriani, *Spazio + Linee luce + Spettatori* (Space + Light Lines + Spectators), 1964. Courtesy of the artist.

ing than empowering. In some instances, viewers could feel that they were in control; in others, the environment seemed to be operating of its own volition, as the spotlights effectively blinded the audience rather than illuminated their way. As the sensors tripped and the lights crisscrossed, making loud sounds that filled the space, viewers were encouraged to feel the porosity of their bodies and the manipulability of their movement by their environment.

Spazio + Linee luce + Spettatori therefore propagated a different mode of spectatorship from the "open field" described by Gerstner and aimed at by GRAV. In *Labyrinth,* the artwork functioned like a springboard, inviting participation, creativity, even critical consciousness; *Spazio + Linee luce*

+ *Spettatori* was structured like a tightly organized network of binary commands (on/off) that enabled the communication between machines and spectators. This logic was evident in Boriani's choice to include *Spettatori* as one of the "materials" in his title, along with space and light. Boriani did as much as possible to confine the spectator's activity to the few basic actions that could be communicated and physically, materially manifest in the work. Boriani's diagram for *Spazio* only further emphasized the confinement and control of the spectator: a grid of hanging spotlights completely surrounds a single viewer. Lights that intersect with the figure's position are switched on, portrayed by intersecting lines that encage the spectator. The viewer is trapped, an effect amplified in the diagram by the way Boriani represents the walls and ceilings, detached at the edges, hovering above and around and appearing to be ominously closing in around the viewer.

In Anceschi's contribution, *Ambiente a shock luminosi,* the immersive, mutating space produced the same experience of overstimulation and control. Anceschi bisected a thin, rectangular, hallway-like space to create two narrow corridors connected by a pathway at the far end. Long stretches of fabric hung loosely from the ceiling of each hallway to diffuse the light from the spotlights hanging overhead. The artist set two timers to flash the lights according to discordant rhythms. As the lights flash, the fabric vibrates and all the components pulsate loudly and in sync. The sound is aggressive, and the beams of light make the demarcations of the room (ceiling, walls, floor) appear to dissolve. As the use of "shock" in the title suggests, *Ambiente a shock luminosi* is meant to saturate the room and the spectator's senses with light and overwhelming sound. Anceschi provides some respite from this immersive experience by keeping the entryway to the work wide open so that viewers can stand outside and look in from afar, a perspective that flattens the *ambiente* and accentuates the viewer's distance from it. However, from outside the lights are just as distorting, obfuscating one's ability to discern the depths and perspective of the room. (Standing far enough away, one might be forgiven for thinking it is a large canvas.) Therefore, neither position—inside or out, distanced or immersed—offers a more accurate insight into the operations of this metamorphosing work.[72]

Beyond their use of literally interactive media, *Spazio + Linee luce +*

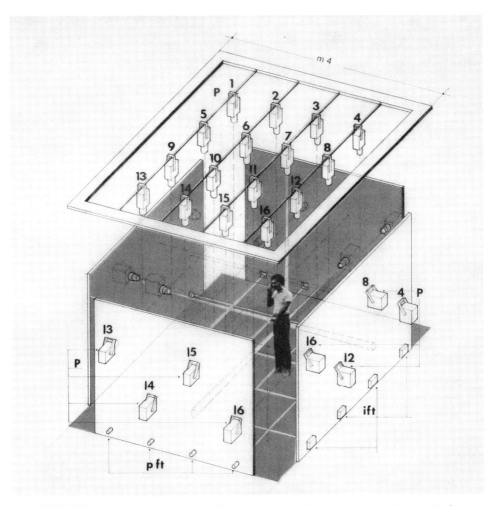

FIGURE 17 Davide Boriani, diagram for *Spazio + Linee luce + Spettatori* (Space + Light Lines + Spectators), 1964. Courtesy of the artist.

Spettatori and *Ambiente a shock luminosi* both positioned their spectators in relation to the environment such that interactivity functions not only as a new quality of art but a notion of subjectivity itself. In Boriani's environment, the movements of the lights are determined by the spectators, but

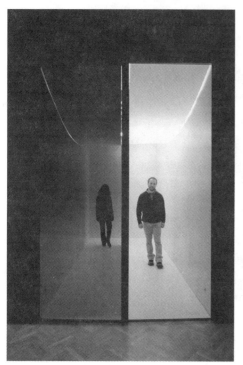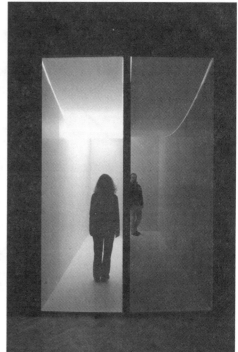

FIGURE 18 Giovanni Anceschi, *Ambiente a shock luminosi* (Light Shock Environment), 1964. La Galleria Nazionale d'Arte Moderna e Contemporanea, Rome, by permission of the Ministry for Cultural and Environmental Heritage and Tourism.

the ability of spectators to move and see is continually undermined by the lights; Anceschi confounds the distinction between environment and self through oversaturation, filling the space and spectator's senses with light and sound to the point of blurring all distinction between oneself and the surrounding space.[73] Both works emphasize what is common among viewers (the contents and motion of the artworks) and suppress what is unique, unpredictable, individual, or singular (personality, prior experience, history, education, and the like).[74] All activity becomes interactivity, the very structure of the space laying bare how subjects are shaped by their environment, and vice versa. To invoke Anceschi's term, the works function as an "opera-

ble interpersonal structure," obliterating the spectators' sense of their selves as autonomous from the space that surrounds them. In direct opposition to the individuating nature of GRAV's participatory work, *Spazio + Linee luce + Spettatori* and *Ambiente a shock luminosi* convey the collective dimensions of subjectivity, showing viewers that their individual agency is part of, rather than opposed to, the material structure of the work and the world.

The interactive environments created by Gruppo T for *Nouvelle tendance* comprise the first attempts by Arte Programmata to collectivize spectatorship, in opposition to both the de-individuating effects of the mass media and the solution (to re-individuate) espoused by their fellow New Tendency artists. As was already clear in their rhetoric, Arte Programmata's problem with the mass media was not its power to integrate them within a system (thereby structuring their desires and determining their actions), but the way it alienated people from one another. The first environments gesture, then, toward how integration might be deployed differently to convey the collective dimensions of individual subjectivity. The 1965 debacle of *The Responsive Eye* only intensified the artists' desire to exercise more authorial control. As discussed above, the lesson from the MoMA exhibition was two-fold: first, its critical reception highlighted the power of the cultural context (in this case, the United States and New York) to determine the meaning of their work; and second, the particular values (escapist entertainment, individualism) that consequently became attached to Arte Programmata revealed the insufficiency of the artists' fantasy that collectivized authorship would automatically engender a collective mode of spectatorship. The inexorability of these two problems—that their programmed objects did not adequately control their spectators and that capitalist consumer culture did—demanded a commensurate response.

New Tendency 3, the Zagreb-based exhibition and conference organized in 1965 in the wake of *The Responsive Eye,* raised yet again the possibility (or impossibility) of evading the market, and discussions among the participants centered primarily on whether art was critical of or complicit with capitalist values. Cocurator Matko Meštrović pronounced at the conference that took place upon the exhibition's opening on August 8, 1965, "As the fate of the object in contemporary society is defined largely by market factors, we are

now faced with the question, 'In what sense is research possible that would be independent of this dependency?'"[75] Massironi, in his catalog essay, reprimanded the New Tendency for being reformist (rather than revolutionary) and concluded that now "we realize that we can achieve very little with our work."[76] Finally, Mari, working as a co-organizer of *New Tendency 3,* noted that one danger of working with technology was that "the industrial world is dominated by commercial problems and by competition. . . . It is very likely that concessions will be made to the mediocre taste of the public and research will be copied," by which he means aestheticized and abstracted from their intention as investigations rather than artworks.[77]

But interwoven with this theme—and employed by artists to varying ends—was the language of cybernetics. Developed by the U.S.-based engineer and theorist Norbert Wiener in the late 1940s and 1950s, cybernetics is a theory of how dynamic systems can remain systems at all, rather than devolving into chaos and dysfunction.[78] In his defining book *Cybernetics: Or Control and Communication in the Animal and the Machine* (1946), Wiener characterized the field as the scientific study of adaptable systems. The book begins with the idea, inherent to thermodynamics, that all systems tend toward entropy: as entities expend energy, they grow increasingly disordered. Incorporating insights from information theory about how communication is possible between humans and machines, Wiener argued that systems survive because they are able to learn and adapt through a process called feedback. He described feedback in his later elaboration of this theory, *The Human Use of Human Beings: Cybernetics and Society* (1950), as "the property of being able to adjust future conduct by past performance."[79] According to cybernetics, then, and contrary to Newtonian physics, systems function not because they remain static and adhere to timeless rules but because they are able to change and operate within a situation of absolute uncertainty. In this ontologically unstable context, feedback would mitigate the entropy inherent to systems by allowing them to continually adapt, reorganize, and reconstitute themselves. Feedback is therefore integrally linked to a cybernetic notion of control. In Wiener's theory, control is not synonymous with domination or the suppression of difference. Rather, cybernetic control signifies the dispersal of agency across a system; it is the result of feedback,

the collaborative efforts of diverse nodes within a system to coexist, adapt, and thrive. As the subtitle of Wiener's second book, *Cybernetics and Society,* suggests, cybernetic principles like feedback and control have enormous implications for how systems—as well as society and individuals—are conceptualized. Wiener writes, "I repeat, to be alive is to participate in a continuous stream of influences from the outer world and acts on the outer world, in which we are merely the transitional stage. In the figurative sense, to be alive to what is happening in the world, means to participate in a continual development of knowledge and its unhampered exchange."[80] Principles like feedback and control presume that all beings are networked beings, and that all activity—biological, mechanical, psychological—is interactivity. For anyone searching for a way to imagine the power of a system to shape its subjects in a generative rather than constrictive manner, cybernetics offered a promising model.

By the time of *New Tendency 3,* Wiener's ideas had been percolating among Arte Programmata and other New Tendency artists for a few years.[81] In *Opera aperta,* Eco cited Wiener to make the case that the disorderly form of open works reflects the conditions for communication in a context of endless flux.[82] The artists of Gruppo T came to Wiener through an even more direct route, when Anceschi enrolled at the Ulm School of Design in 1962 to study visual communication. Headed by Max Bill, the school employed two central figures responsible for bringing cybernetics to the study and creation of art, Abraham Moles and Max Bense, both of whom synthesized information theory and cybernetics to develop a quantitative theory of artistic production and reception. For Bense, good art was a question of programming; for Moles, aesthetic experience could be anticipated and measured through statistical means.[83] The Ulm School certainly influenced Anceschi's idea that art should function like an operative interpersonal structure rather than promoting individualized activity (however "active" or participatory); such language is clearly derived from the school's visual communication curriculum, designed by Bense.[84] Mari's investments led him to also take an interest in cybernetics' theorization of communication. A shared investment in integrating art and science led the artists of the New Tendency, Arte Programmata included, to familiarize themselves with the work of Bense,

Moles, and Wiener. The organizers of *New Tendency 3* invited Bense and Moles to participate in their conferences and exhibitions. Bense contributed writings to the *New Tendency* exhibition catalogs starting in 1968 (when they reverted to being called *New Tendencies* again). Moles took part in the 1965 events, participating in the conference and contributing a catalog essay titled "Cybernetics and the Work of Art" that described how adaptable cybernetically designed machines could help artists to rationally and methodically introduce new forms into the world.[85]

For the most part, however, the introduction of cybernetics did not cause a change in the practices of the New Tendency artists; it only served to add to the rhetoric around mechanizing the making of art and delegating authorship. For Gruppo T, however, *New Tendency 3* featured their new practice of making environments. Rather than just reconceive artistic production, cybernetics enabled the Italians to reimagine reception as well—a shift evident in the structure of these expanded, immersive works. *New Tendency 3* included a special section organized by Mari that featured three *ambienti* by artists from Arte Programmata: Boriani and Anceschi's *Ambiente sperimentale* (Experimental Environment), Devecchi's *Spazio in strutturazione plasticocromatica* (Space in Plastic–Chromatic Structure), and Colombo's *Strutturazione cinevisuale ambientale* (Environmental Cinevisual Structure).[86] All the works were immersive environments designed to submerge the spectator in a continually metamorphosing space. For *Ambiente sperimentale*, Boriani and Anceschi programmed colored lights hanging across the ceiling to cast a cycle of twelve different patterns on the walls of a small interior. They also added the unique element of a viewer survey that, following Moles and Bense, tried to quantify the quality of the aesthetic experience generated by the work. The survey listed seven adjectives to rank on a scale of intensity from zero to four: Was the work modern, banal, serious, active, terrible, fascinating, or poor? Additional lines were provided for the audience to add any further comments or thoughts. The survey might appear an odd addition, but it functioned like the environments' other amalgam of new media (motion sensors, mirrors, and rotating walls, to name a few). It also follows from GRAV, who used surveys in their work as early as 1962, when their exhibition *Instability* included a questionnaire (this also offered

a list of descriptors, such as rational, emotional, visual, or nonexistent). Just like these other mutable materials, the survey ensured that spectators become part of a collaborative process of creation, at the same time as it made clear that this collaboration hinged entirely on a mediating term.

For Colombo's work, *Strutturazione cinevisuale ambientale,* the only documentation that has survived is a diagram and description in the exhibition catalog. These indicate that visitors were placed in a room with motorized spotlights that crisscrossed as they cycled, creating an ever-changing, illuminated pathway for the audience to follow. *Strutturazione cinevisuale ambientale* was therefore a predecessor of Colombo's later environmental artworks, such as *Topoestesia (Tre zone contigue—Itinerario programmato)* (Topoesthesia: Three Contiguous Zones—Programmed Itinerary, 1965–70) and *Spazio elastico* (Elastic Space, 1967), constructed for the exhibition *Trigon 67,* held at the Neue Gallerie am Landesmuseum in Graz, Austria, in 1967 (and repeated for the 1968 Venice Biennale, where it was awarded first prize). *Spazio elastico* is exemplary of the artist's delight in showing that new experiential possibilities can be unleashed within a programmed space. It has been reproduced multiple times in recent years—for example, at the 2012 *Ghosts in the Machine* exhibition at the New Museum in New York.[87] For *Spazio elastico,* the artist strung elastic cords from wall to wall and ceiling to floor, weaving and knotting them together to create a gridded walkway. The strings are then connected to rotating motors, so that the shape of the pathway continually mutates, and black lights cast the whole apparatus in an otherworldly glow. Yet the strings move slowly and deliberately, giving time for spectators to adjust their route. *Spazio elastico* and likely *Strutturazione cinevisuale ambientale* as well revel in the mutability of the system, generating an experience that offers the audience time and space to learn, adapt, and ultimately predict how their environment might behave and proceed accordingly.

Devecchi's *ambiente* for *New Tendency 3,* only available in a set of diagrams and plans, appears less playful and more assaulting. Viewers were thrust into a pitch-black space while a single light source flashed alternating red and green beams into their eyes. Because of the contrast between darkened room and blinding light, the artist assumed that the flashes would linger and the afterimages of red and green would mix and move. Devecchi's

diagram for *Spazio in strutturazione plasticocromatica* shows a viewer absorbing the "input" of red and green light, the output pictured in a thought bubble as a mixed-up array of scattered dashes of red, green, and—surprisingly, because it was not present in the work—blue. In the exhibition catalog, Devecchi explained that his environment was meant to disrupt the idea (key for gestalt psychology) that the human mind organizes perceptual data to create a totality from the chaos, since the afterimage would "construct an initial hostility to comprehension."[88] Devecchi designed this *Spazio* to deny rather than affirm the spectator as the primary organizing force. His environment positioned the viewer as one medium among others, a dynamic already present in Boriani's *Spazio + Linee luce + Spettatori*. As implicit in Boriani's work, Devecchi envisioned the spectator as a programmable medium, but one that is generative, creative, and active as a result. In his earlier objects like the ones featured in the *Arte programmata* exhibition, Devecchi programmed the work to generate a series of compositions—a series that was in theory endless. In *Spazio in strutturazione plasticocromatica,* the artist tried to program the spectator to operate in precisely the same way. The artist deliberately linked what might in another instance be considered personal differences or subjective associations to the work's own material conditions; for Devecchi, experience is unpredictable, open, but part of the program.

Each of the environments in *New Tendency 3* confounded the distinction between the programmed activity of the environments and the free activity of the audience, figuring forth a conception of freedom as inextricably linked to materiality and infrastructure. Light was instrumental in enabling the works to confound the distinctions between subject and environment in this way; light was what viewers were supposed to see and the condition of sight itself. The effect was utter destabilization. By shining bright beams at spectators in a darkened space, the artists tried to disorient their spectators and created afterimages that would linger even as new lights begin to shine, flash, or emerge. Anceschi and Boriani even programmed the light patterns to increase in complexity. Over time, spectators did not find their experiences simplified or synthesized, but rather evolved and multiplied. Even when the means for responsive feedback were absent, Gruppo T's environments used interactive elements and control mechanisms to situate

their viewers and dissolve their sense of autonomy.[89] Sound was also instrumental in sensorially stimulating a porous and ever-mutating sense of self. Gruppo T wanted to activate their spectators, but for them this meant creating an experience that showed viewers on a visceral level that all activity is contingent on one's context—or more immediately, the formal constraints of the work. On the level of intensity, these works also vary, and so they oscillate from being fun, beautiful, disorienting, and downright dizzying. In the ricochets of light and sound, and the blurring of body and space, Gruppo T's *ambienti* implemented a cybernetic notion of subjectivity as their structuring principle and mode of address, one in which recognizing that one is part of a system is an initial step toward imagining the capacity for being an active participant in the world.

From Subject to Network: *Ambienti* and *Lo spazio dell'immagine,* 1967

Gruppo T's *ambienti* relied on feedback between subject and environment and focused on the generative aspects of control, in the cybernetic sense. A number of *ambienti* created by Gruppo N in 1967 were concerned with the same problem: how to imagine human agency as something that exists by virtue of, rather than in spite of, systems, and shows that unpredictability is part of even the most programmed setting. Mari's definition of "the environment" for a 1967 exhibition emphasizes the implications for an understanding of the subject; most of all "an *ambiente* refers to the coexistence of a contained and a container. . . . One will analyze only the strength of influence stemming from the container and not from the contained, how *the softness of the observer* would function."[90] For the exhibition for which he wrote this, *Trigon 67,* Mari contributed a work comprised of thirteen identical containers, each with their interior patterned differently so that these uniform structures appeared to be different sizes and shapes. The *ambienti* by Gruppo N and Gruppo T take the disorientation of the spectator further, as their works were more immersive, manipulative, and confusing. Still, for all these artists, the aim with their *ambienti* was not to create a pleasurable, harmonious balance—something the term "softness" would seem to suggest. Rather, the environments emphasize the porosity of the subject; they

refuse to give the audience a secure place to stand. They force visitors into a condition of *not knowing* and yet demand that they "act" nevertheless. These tensions pervade the environments, in all their forms. As such, the *ambienti* suggest that individual freedom is not found in the experience of mastery but its opposite—arising from the acknowledgment of one's contingency on others and the obliteration of the subject as a privileged site. This position, this understanding of the viewer and with it, subjective agency, is cast into relief, we shall see, as Arte Programmata's environments are staged in exhibitions among other 1960s environmental art.

While Gruppo T's environments, like *Spazio + Linee luce + Spettatori* and *Spazio elastico,* used ambient light to integrate spectators into their programmed environs, Gruppo N designed inflexibly structured labyrinths that were either literally or perceptually set into motion. None of Gruppo N's environments survive; nor have they been re-created—something that might be due to them being relatively lo-fi. (Gruppo T's environments have been re-created amid the recent enthusiasm for early histories of new media art.) For example, Manfredo Massironi's *Ambiente cinetico programmato* (Programmed Kinetic Environment) subjected its audience to a metamorphosing space by plunging them into a motorized maze. Thin plywood walls with large, semicircular and rectangular cutouts were hung in a grid and then set to rotate, so that visitors had to weave through the negative spaces as they moved. Similarly, Gruppo N's collectively constructed *Ambiente struttura* (Structured Environment) was, according to Italo Mussa, a "forest of colorful moving shingles," hanging poles that viewers had to anticipate and dodge as they moved through the space.[91] As evident in the diagrams and photographs that remain, Gruppo N's environments were more sculptural than Gruppo T's; rather than dissolving boundaries through the immaterial medium of light, Gruppo N staged encounters between spectators and blunt objects and walls. Closer to an obstacle course than a discotheque in design, Gruppo N's environments were more rigid in their programming as a result. Subjects were not dissolved through ambient media but scattered as they tried to avoid collision. Writing in his 1977 monographic study of the group, Mussa described this aspect of Gruppo N's environments in almost ethical terms. For him, the works conveyed the promissory note that "the

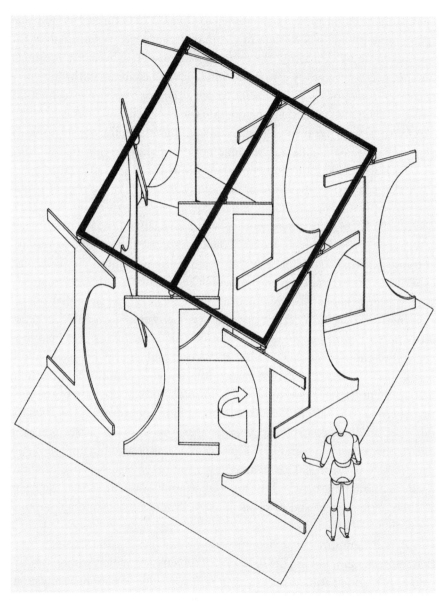

FIGURE 19 Manfredo Massironi, *Ambiente cinetico programmata* (Kinetic Programmed Environment), 1967; diagram, in *Il Gruppo Enne: La situazione dei gruppi in Europa negli anni 60,* ed. Italo Mussa (Rome: Bulzoni, 1976). Courtesy of Michele Massironi.

environment ought to be a habitable space, even if structured by visual and spatial ambiguity."[92] The effect of Gruppo N's *ambienti* was ultimately the same as those by Gruppo T: the environments oscillate between annihilating the spectator's agency (through confusion) and enabling it (through programmed movement), not in order to reify the opposition but to imagine the contingency of individual freedom on the experience of giving in.

With their programmed environments, therefore, the artists not only aligned themselves with a cybernetic notion of subjectivity, maintaining that entities and identities come into being only through continual relation. They also enacted a cybernetic epistemology, in which knowledge of a total system is always imperfect and partial due to the system being in flux. As Andrew Pickering has shown, with its focus on adaptability, indeterminacy, and change, cybernetics confronts "how to get along in a world that was not enframeable, that could not be subjugated to human designs."[93] To his mind, cybernetics "tries to address the problematic of getting along performatively with systems that can always surprise us."[94] Pickering is clear that not all cyberneticians accommodated uncertainty; many transformed cybernetics into a science aimed at totally eliminating risk, anticipating it as best they could. But the figures that interest Pickering, and inform his understanding of the field, developed cybernetics differently—using it to imagine self-management (rather than top-down administration), in the case of the British cybernetician Stafford Beer, to cite one important example. And even for the most anxious, controlling cybernetician, this arguably arises precisely due to how cybernetics stages this problem of unknowability and, in fact, a decided *lack* of control. This dynamic ricochet between acknowledging the limits of human mastery and the anxious attempt to restore it is at the heart of cybernetic control and rampant in Arte Programmata's mobilization of the notion in their art.[95]

Arte Programmata's environments were designed by the artists to function unpredictably, forcing the spectator to traverse a situation without understanding or anticipating what exactly it is. Knowledge, if it exists in any comprehensive form, is scattered throughout the system rather than contained in or possessed by any single entity. As such, the programmed environments refuse to position the individual spectator as a privileged site of knowledge, com-

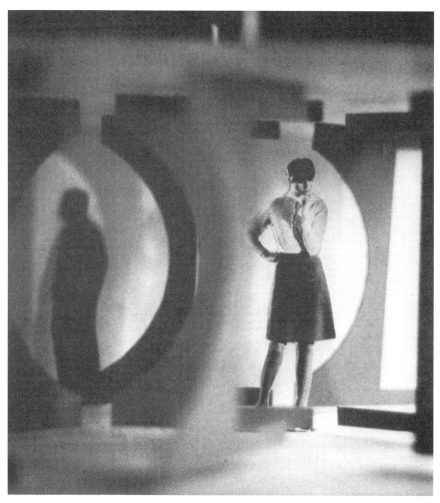

FIGURE 20 Manfredo Massironi, *Ambiente cinetico programmata* (Kinetic Programmed Environment), 1967; in *Il Gruppo Enne,* ed. Mussa. Courtesy of Michele Massironi.

prehension, and understanding. The result is an experience of ambiguity and confusion as the spectator circumnavigates these works. This epistemological stance is a crucial underlying aspect of the environment's inchoate idea of freedom: individual will and agency stem from one's interaction with a system;

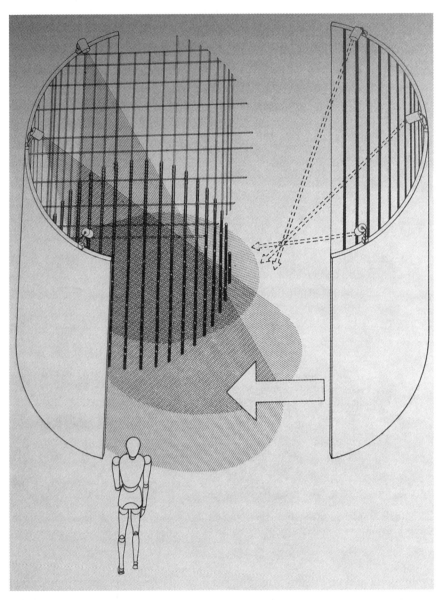

FIGURE 21 Gruppo N (Ennio Chiggio, Edoardo Landi, Manfredo Massironi), *Ambiente struttura* (Structured Environment), 1967; in *Ill Gruppo Enne,* ed. Mussa. Courtesy of Michele Massironi.

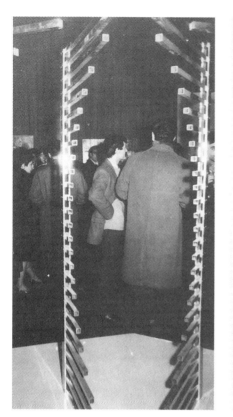
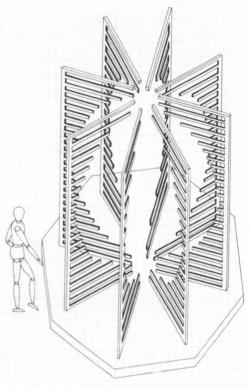

FIGURE 22 Manfredo Massironi, *Negativo,* 1967; realized for Paris Biennale V, Musée d'Art Moderne de la Ville de Paris. Photograph in *Il Gruppo Enne,* ed. Mussa. Courtesy of Michele Massironi.

and in both cases, individual and environment are unpredictable, unknowable entities. It is the interaction of erratic subjects in a volatile environment—and not perfect knowledge or total control—that constitutes a system's organizing principle and makes possible agency and spontaneity within. As such, it is through action and not understanding that programmed spectators interact with, are affected by, and affect their surroundings. This conception of individual agency is what appears in the works as disorientation and manipulation—all part of the premise that the subject is not the locus of control.

Given these effects of the environments, it is no surprise that some misinterpreted these programmed environments as intending to obliterate, rather than situate, the autonomy and agency of their spectators. This was Germano Celant's assessment of Gruppo T and Gruppo N's *ambienti*, which he formulated in his essay for the exhibition *Lo spazio dell'immagine* (The Space of the Image), held in Foligno in 1967. In addition to Gruppo T and Gruppo N, *Lo spazio dell'immagine* included major Italian figures of the postwar period such as Lucio Fontana, Enrico Castellani, Pino Pascali, and Michelangelo Pistoletto. All the artists shared a central concern about, in the words of Celant, "the problem of how to act in relation to the environmental system."[96] Almost every contributor to the catalog—including Celant, Dorfles, and Umbro Apollonio—agreed that the system of interest to the artists was not nature, but culture, in particular capitalist consumer culture and its image-saturated world.[97] Every participant of *Lo spazio dell'immagine*, whether an artist, curator, or critic, was grappling with the same thing: the conception of subjectivity in a context where mass media images played a powerful socializing role, and the possibilities for action in such strongly mediated environs.

The exhibition was held at the sixteenth-century Palazzo Trinci, and the artists of *Lo spazio dell'immagine* did everything they could to undermine the Renaissance order rooted in the building's structure by forcing spectators to constantly move around to observe and interact with the work. Experience in this exhibition was about experience in space, at once a public encounter with the objective world and an encounter of one's self in public. The dominance of mirrors, shiny surfaces, and labyrinthine rooms exemplified this tendency. The artworks ranged from Getulio Alviani's *Interrelazione speculare* (Reflecting Interrelation, 1965), which filled one space with light-reflective plastic containers, whose undulating convex and concave surfaces stretched from ceiling to floor; to Pascali's tiling of an entire room's floor with shallow rectangular basins filled with colored water; to *Ambiente stroboscopico programmato* (Programmed Stroboscopic Environment, 1966) by Gruppo MID (a newer collective experimenting with programmed art), which had flickering red, green, and blue lights to distort the viewers' perception of themselves moving in space.[98]

In his catalog essay, Celant divided these environmental explorations into two categories, according to two distinct ways the works positioned individuals: immersive, programmed environments, made by the artist collectives Gruppo T and Gruppo N, which prioritized the power of space to determine subjects; and works that encouraged the unbridled free associative play of meaning in their spectators, made by artists who would soon be associated with Arte Povera (namely, Pascali and Pistoletto).[99] Celant denounced the former for submitting the audience to the control of their program, writing that in these *ambienti* "the basis of every creative work is design, understood as total control of production. This research proposes the creation of a programmed, defined 'im-space' [image-space] which surrounds the spectator . . . and aims at filling the need to coordinate 'a priori' the perceptive and behavioristic system of the spectator, who thus finds himself 'inextricably involved.' This plan, therefore, aims at a concrete structure of the space of existence, leaving nothing to immediate decision."[100] Celant saw in these works the annihilation of the figure, and with it, the spectator's capacity for spontaneous action and distanced analysis. Rather than controlling their spectators—working "centripetally"—Celant argued that artworks by Pascali and Pistoletto operated "centrifugally," using the environment of art to trigger in their viewers a freedom otherwise absent in the wider environment of nature and culture. These artists transported objects and images from everyday life, and for Celant this de-contextualization effectively deprogramed the spectator, creating a "'field' [that] is disarticulated and undefined. . . . It tends to enlarge."[101] Celant was not the only one to charge Gruppo T and Gruppo N with making works that were too controlling. In a review of the show in *Studio International,* Gillo Dorfles praised their aesthetic quality but ultimately supported Celant's charge that Gruppo T and Gruppo N obliterated the autonomy of the viewer, calling them "visual manipulators" whose work "provided us with few surprises or unexpected techniques."[102] Another reviewer of *Lo spazio dell'immagine,* the art historian and critic Maurizio Fagiolo dell'Arco, was even more dismissive, writing that "from the splendid environments of [Enrico] Castellani and [Pino] Pascali one passes to the weak realizations of the Groups."[103]

Underlying these critiques was an unease, even incomprehension, with

the notion of subjectivity operating within Gruppo T's and Gruppo N's work. For Celant, the programmed environments operate centripetally, but the effect on the spectators is the converse: they are dissolved, dispossessed of their agency, with nothing left up to chance. By contrast, artists like Pascali and Pistoletto reconstitute the spectator as an empowered and autonomous subject in opposition to a context that overdetermines them—the centrifugal power of the environment is what allows the subject to cohere. The difference is not just theoretical, but experiential: Does the figure stand against ground, the subject contemplating from a distance an (equally distinct) object? Or do the environments assert the porosity of such boundaries, and blur categorical distinctions and the source of agency in turn? The distinction is evident in the distinct use of mirrors among works in *Lo spazio dell'immagine*. Boriani's *Camera stroboscopica multidimensionale* (Multi-Dimensional Stroboscopic Room) was typical of his programmed environments. The walls of this room were covered with mirrors, with an additional double-sided mirror bisecting the space, and the floor was lined with highly reflective resin. In this mirrored room he hung nine stroboscopic spotlights from the ceiling, which flickered red and green lights downward to be reflected on the floor. According to the artist's description, "The spotlights are controlled by a 'planner' working according to a cycle of forty-six different combinations. . . . The spectator moving inside the room finds himself in a condition of 'perceptive uncertainty.' . . . He will see himself in the center of an unlimited space, the perceptive, illusory structure of which varies with the variations of his own position within the room."[104] A black-and-white photograph of the installation featured in the catalog shows a woman in the room, her reflection repeated through what appears to be an indefinite space. It is difficult to discern where the "real" woman is, given the many reflections both in front and behind her. This photograph represents from the outside the dispersal experienced from within. This environment was recreated at the Museo del Novecento in Milan, in 2005, where visitors had to sign a permissions letter before entering, since it was so sensorially assaulting. The rotating mirrors and flashing lights all conspire to displace one's sense of rootedness from within themselves to the space around them; one is continually looking around to see where they are, turning a corner only

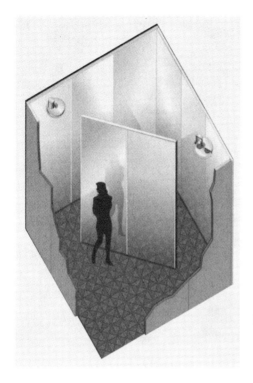

FIGURE 23 Davide Boriani, plan for
Camera stroboscopica multidimensionale
(Multi-Dimensional Stroboscopic
Room), 1967. Courtesy of the artist.

to confront their reflected image again. The subject is turned inside out, liter-
ally and figuratively projected into the environment, and it becomes a space
all but impossible to navigate.

While Boriani used mirrors to dissipate spectators' sense of self and
their surrounding space, Pistoletto's mirrors reflected viewers in order to po-
sition them more firmly within their iconographical environment of print
media and consumer culture. For the mirror paintings Pistoletto reproduced
photographs of figures (often friends) on thin tissue paper, affixing them to
shiny stainless steel. Viewers came to see themselves within the frame, al-
though the contrast between affixed tissue-paper figure and live viewer
maintained the separation between real and imagined space. Pistoletto's
other work for *Lo spazio* comprised a set of identical white basins with mir-
rored bases, so that when visitors peered in, they saw themselves reflected

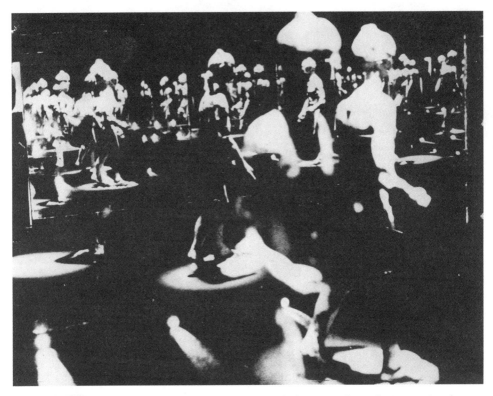

Davide Boriani, *Camera stroboscopica multidimensionale* (Multi-Dimensional Stroboscopic Room), 1967. Courtesy of the artist.

against the frescoed ceiling. In both the mirror paintings and mirrored cylinders, the spectator's reflected image remains whole, an entity that exists within the world of the simulacrum but is perceived as detached from it. Whether this detachment was, as Claire Gilman has argued, a means for "true comprehension . . . a detachment that shifts the individual's relationship with the world from one of control and consumption to one of distanced reception in which he or she is equally viewer and viewed" or, as Romy Golan has insisted, a noncommunicative alienation of figures in a mise en abîme, Pistoletto's mirrors reflect in order to isolate, prompting temporary respite from immersion.[105] In the *Lo spazio* catalog, Pistoletto described the

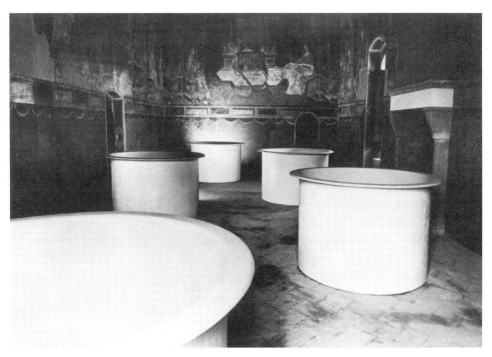

FIGURE 25 Michelangelo Pistoletto, *Cinque pozzi* (Five Wells), 1967; installed at *Lo spazio dell'immagine*. Courtesy of Archivio Pistoletto, Biella, Italy.

works in terms of this kind of relief: "I think that man's first real figurative experience is recognizing his own image in the mirror, the fiction which is most similar to reality. But immediately afterwards, the reflection from the mirror will begin to send back the same uncertainties, the same questions, the same problems, posed by reality: uncertainties and questions which man tries to illustrate in his paintings."[106] Pistoletto and Boriani dealt with the same historical conditions: the proliferation of images at the expense of meaning, a mass-mediated consumer image culture, and an equally contradictory sense of one's agency in the world (empowered as a consumer and annihilated as any other kind of agent). The artists' responses to these conditions, as Celant intuited, could not be more distinct. Pistoletto's mirrors created a measured dialogue between the figure and itself, while Boriani's

refracted and projected the figure into the environment. Boriani mobilized his mirrors to posit the environment (artistic, cultural, or otherwise) as an agent of socialization, a totality that includes us all. Pistoletto used the mirror to offer temporary respite from a totality through isolation, using the mirror to cleave art from life.

Celant's distinction between centripetal and centrifugal works therefore not only described two ways of understanding the relationship between the subject and environment, but also the political capacity of art in an era of mass culture. Celant's idea of art's agency is based on an understanding of popular culture as a monolithic force that is not just totalizing but verges on totalitarian. In response, art must provide relief by reconstituting the individual—which is what Celant argued the works of Arte Povera achieved. Later in 1967 when Celant wrote his manifesto for Arte Povera, "Notes for a Guerilla War," he made this same argument in even more militant terms: Arte Povera carried the banner of the individual against the system, "a world dominated by inventions and technological imitations."[107] In the face of this totalizing abyss, in which "no one is permitted to be free," Celant argued that artists must aim for "the free self-projection of human activity. . . . *an identity* between man and action, between man and behavior, and thus eliminat[ing] the two levels of existence."[108] He goes on to declare that in art, "man is the message," sabotaging media theorist Marshall McLuhan's idea that "the medium is the message" by replacing the medium with man—a categorical collapse that (echoing with Pistoletto's description of the mirror) brings Celant to lay claim to the positive effects of solipsism. ("The artist rejects all labels and identifies solely with himself.")[109] Against a world in which humanity is dominated by technological systems, alienated from self, society, and nature, art can and should resist not only the media but all mediation. With a romantic notion of the spectator-as-inchoate-species-being resonating everywhere in his writing at this time, Celant argues that art can restore the individual's sense of being in the world, feet steeped in the muck of experience in all its contingent and unpredictable—unprogrammed—magnificence.[110]

In addition to disparities in understandings of subjectivity, then, the programmed artists differed from Celant in how they understood the broader

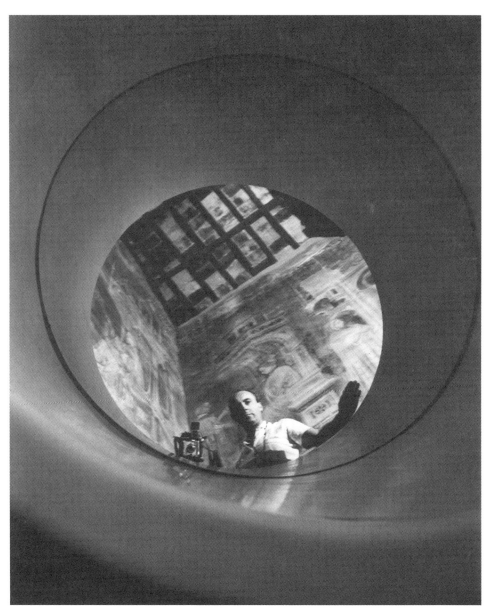

FIGURE 26 Michelangelo Pistoletto, the artist with *Cinque pozzi* (Five Wells), 1967. Courtesy of Archivio Pistoletto, Biella, Italy.

context of the mass-mediated environment in which their artworks existed. Celant understood a central problem of the mass media to be its control of spectators. The programmed environments, for Celant, simply reproduced this same problem. Good, political, even morally acceptable art must offer a respite from control and remind viewers of their incipient freedom. For Mari, Gruppo T, and Gruppo N, by contrast, the power of media to construct subjects was neutral and unavoidable. What is more, this aspect of media provided its own antidote to another problem of mass culture: how it disintegrated the ties that bound individuals together and dissolved any sense of a shared context. Gruppo T's and Gruppo N's environments were therefore objectionable to Celant because they did more than disperse, decenter, or multiply the spectator's position vis-à-vis the work; such verbs imply the very distinction between subject and object that the *ambienti* sought to unsettle. The programmed environments assail the viewer, generating an experience of one's self breaking down—spectators are disoriented, thrust into chaos, forced to wrestle with the unpredictability of their surroundings. The effect is a feeling of being controlled by the environment, as well as confounded by it. Confusion is the byproduct of feedback, the accumulation of entropy, the "hostility to comprehension" that Devecchi ascribed to his *ambiente* in 1965. But confusion is also exactly what the *ambienti* convey to spectators—a confusion that experientially attests to the contingent status of subjectivity. These works shock, stun, and mystify such that, upon emerging, spectators reconstitute themselves with an acute sense of their own interrelationship with the environment.

With this in mind, one can discern a social mission behind Arte Programmata's environments. Intimately connected to cybernetic notions of feedback and control is the problem of commonality and how it might be possible within a chaotic, unpredictable world. Cybernetics, after all, was developed as a theory of how systems could operate in a hostile context, and how communication could occur in an environment plagued by noise. Ultimately, what appeared in the programmed *ambienti* as the breakdown of the subject was in fact the artists' attempt to create a network, one that is held in common, but that escapes the comprehension of any single part. Evident in statements as early as 1963, Gruppo T, Gruppo N, and Mari

framed the idea of a social, communal ground in terms of communication, another cybernetic concept, arising from the field's roots in mathematical theories of information. As we shall see, the programmed environments not only materialized this chaos to reconceptualize subjectivity and human agency, but also tried to mitigate this chaos by discerning the necessary conditions for communication, and with it, communal life. In pursuit of this goal, the next chapter will show, the artists turned mathematical theories of information into a theory of art's political work.

CHAPTER 3

THE POLITICS OF INFORMATION
Arte Programmata and International Computer Art,
 1965–1970

By the end of the 1960s, the artists of Arte Programmata had all but abandoned computers. This chapter interrogates how and why this happened. At first the reasons may seem obvious. The latter half of the decade saw the formation of new social movements in Italy that launched a wave of protests and unrest. This reached its climax in the Autunno caldo (Hot Autumn) of 1969, but the aftereffects continued to reverberate for almost a decade. Given the rise of visible conflict in the 1970s, many Italian artists were moved to reevaluate the political stakes of their art. In light of this situation, one might venture that Arte Programmata's abstract formal and spatial experiments began to appear ill-equipped to face the new challenges of contemporary life. But this answer is not only inadequate, it is also misleading. I have argued that Arte Programmata's experiments with technology were politically motivated all along; any change to their practice therefore should not be attributed to a sudden ethical or moral awakening.

Moreover, when seen within the international history of computer art, the timing of Arte Programmata's "end" appears incongruous. The Italian artists stopped working with computers just as the technology's popularity reached new heights among artists in the United States and Europe, where

social unrest and protest culture were just as strong. As the computer lost traction in Italy, it gained currency in almost every other center of the art world. The first exhibitions of computer art took place in New York and Stuttgart in 1965, featuring computer-generated compositions created by telecommunications engineers. This same year, also in New York, engineer Billy Klüver and artists John Cage and Robert Rauschenberg initiated what would become the amalgamation of multi- and new-media performances titled "9 Evenings: Theatre and Engineering." "9 Evenings" (1966) was the start of Experiments in Art and Technology (E.A.T.), the loose affiliation of artists led by Klüver devoted to working with information technologies (and, just as centrally, corporate sponsors). If 1965 saw the beginning of computer-based practices, 1968 was a definitive high point. The Museum of Modern Art's exhibition *The Machine as Seen at the End of the Mechanical Age* sought to distinguish the prior generation of machine artists of the industrial age from those in the contemporary scene working with computers. Just a few months later *Cybernetic Serendipity,* curated by Jasia Reichardt, opened at the Institute of Contemporary Art (ICA) in London, gathering a decade's worth of dispersed artistic experiments with cybernetics and computational technologies under one rubric and roof. In 1970, Kynaston McShine organized the *Information* exhibition at MoMA, which brought together a diverse selection of conceptual and multimedia practices that all shared an interest in the cultural politics of information. Later that same year *Software* opened at the Jewish Museum in New York. The curator, Jack Burnham, was able to claim that the exhibition did not just display how artists used computers but "address[ed] itself to the personal and social sensibilities altered by this [technological] revolution."[1] This spate of exhibitions captured a range of competing ideas about the cultural implications and sociopolitical significance of computers, but together they make one thing clear: the period between 1965 and 1970 saw an exponential increase in the use of computer technologies in the arts.

The question is therefore not just why Arte Programmata abandoned computers, but why they did so at the exact moment that their appeal among artists was growing across Europe and North America? I argue that the two phenomena are related: Arte Programmata distanced themselves from the

explicit language of technological programs, algorithms, cybernetics, and information theory because of how these platforms were understood by artists elsewhere. That is, the dominant ways that artists in other parts of the world articulated the political stakes of computer art rendered the technology unviable as a medium for Arte Programmata by the 1970s. Politics did figure into the reasons that Mari, Gruppo T, and Gruppo N chose to stop working directly with computers, but the political stakes arose from *within* the field of computer art. This chapter therefore telescopes out from Italy to evaluate Arte Programmata in comparison to the development of computer art internationally, with a particular focus on how computer technology engendered distinct political theories of art. To do so, it narrows in on one of computer art's most contested, mutable, and socially relevant issues: the meaning of information.

"Information" was a term mobilized by many artists in the 1960s, but for multifarious and conflicting reasons. My analysis concentrates on two central and seemingly opposed uses of the term within the history of computer art. In the first case, technicians such as Georg Nees, Frieder Nake, and A. Michael Noll, based in research institutions in Germany and the United States, drew on mathematical definitions of information in the making of their computer-generated graphics. As noted in prior chapters, Claude Shannon developed information theory in the United States during the late 1940s. In his 1948 essay in the *Bell System Technical Journal*, "The Mathematical Theory of Communication," Shannon defines information as the ratio between signal and noise. This ratio describes, in entirely quantitative terms, the difference between a message and the interference it will inevitably encounter as it moves. Two theorists simultaneously seized on Shannon's theory of information and applied it to art in the late 1950s: Max Bense in Germany and Abraham Moles in France. Both adapted Shannon's theory to apply to works of art, defining what they each called "aesthetic information" by transforming Shannon's ratio between signal and noise into the ratio between innovation and convention. Artworks were to be analyzed as numerical distributions of banality and originality. As Moles laid out, "The measure of the quantity of information then boils down to the measure of unforeseeability."[2] For early practitioners like Nees, Nake, and

Noll (in contrast to Umberto Eco's use of Moles), aesthetic information was meant to provide an objective index of the boundary-pushing capacity of an artwork, insofar as it calculated the extent to which a given work deviated from expectations or norms while also remaining intelligible to the audience. Its appeal was that it promised to provide a consistent method for generating inventive artistic forms and calculating their efficacy at inciting aesthetic (loosely understood as physiologically stimulating) responses in the most consistent way to a majority of people.

The second and equally prevalent understanding of information arose in a different context and out of a different set of influences, as artists in the United States became concerned with the skewing of meaning and truth in the media by political agendas, as well as issues of transparency and access. Rather than the mathematical approach described above, information in this instance signified all the circulating messages that pertained to the political and social realm, as well as the means for distributing them. This understanding of information buttressed a widespread belief in art's political potential to generate better information than the mainstream media, be it more widely disseminated or more clearly or truthfully conveyed. Artists worked not only with computers but also with entire communications and information-processing systems—radio, television, telephones, and print media, as well as cybernetic notions such as feedback and interactivity. Information, in other words, was not just a medium or source material but a way to conceptualize the environment as a network of channels, flows, and discrete signals into which artists could directly intervene. For curators like Burnham and McShine as well as artists such as Hans Haacke, information stood in contrast to propagandistic or politically skewed *mis*information. Information in this case was a message with such potent descriptive power that it was capable of cracking the all-too-smooth, controlled circuits of ideology and dismantling its myths.

These two notions of information propelled parallel trajectories of computer art and engendered distinct ideas about what art should do in the world. The separate trajectories were epitomized by the exhibitions *Cybernetic Serendipity* (1968) and *Information* (1970), the former's experimental use of technology contrasting remarkably with the sociopolitical ambitions of

the latter. On the one hand, information technologies were a new medium for generating novel forms that could alter the audience's perception and provide perceptually stimulating, unique experiences. On the other, information pitted truth against power and gauged the politics of art according to the quality and clarity of messages. But in both cases, the opposition between novelty and clarity functioned as the central way that artists defined the social role of their art. One emphasized the transformative potential of formal experimentation with no foreseeable use value (novelty) while the other strove to deliver accurate representations of social life (clarity). In contrast, as we shall see, Arte Programmata's understanding of information was based on the inextricability of these two theories of art.

Arte Programmata took the mathematical theories of aesthetic information and mobilized them to rethink the sociopolitical dynamics of both art and information, distinguishing their use of these ideas from early CGI practitioners. The problem, as Arte Programmata saw it, was both the clarity of their messages and the capacity for audiences to receive and understand them. Even if they could conceive of a politically potent message, they knew there still existed a danger that it would fail to be read as intended, if it was received at all. Information theory, like the field of cybernetics with which it is so intertwined, foregrounds this problem of sending signals in a changeable, unstable cultural context. Defined mathematically, information does not signify a particular message or presumed meaning, but pertains to the conditions, possibilities, and limits of communication of any signal— that is, the situation as a whole. This concept took the Italians to a unique place politically, since to them, the "situation" included the relationships between people, the composition of their audience, and the networks and codes that connect them. The political significance of Arte Programmata's computer art hinged on their understanding of the two-pronged pursuit of novelty and clarity: to clarify the ground for collective creativity and clear communication, starting from a (potentially transformative, potentially devastating) position of not knowing yet what this ground was or could be. However, as we shall see, as computer art became defined by opposing the very terms Arte Programmata sought to reconcile, the Italians left the technology behind.

Computer-Generated Art in the United States and Germany, 1965

The first two exhibitions to explicitly use the term "computer art" took place within months of each other in 1965 and went on to determine the shape and contours of the category and discourse for years to come. Both were based on interpretations of the same mathematical theories of information that inspired Arte Programmata, and it was these theories that formed the earliest notions of computer art's distinct role in the world. The first exhibition, *Generative Computergrafik,* opened in February at the art gallery of the Technische Hochschule in Stuttgart, where Max Bense chaired the philosophy department. The show exhibited graphic works on paper by a young engineer, Georg Nees. Employed by the Siemens corporation in Erlangen, Nees had used the company's Graphomat Z64, a punch card–controlled flatbed drawing machine, to generate what he called *statistiche graphik,* or probabilistic graphics. Nees was inspired by Bense's ideas even before meeting him; only after Nees encountered the philosopher's theories of digitized artistic production in the journal *Grundlagenstudien aus Kybernetik und Geisteswissenschaft* (Fundamental Studies in Cybernetics and the Humanities) did he begin to experiment with making computer-generated art.[3] For the works that were eventually exhibited in the Stuttgart show, Nees used the programing language ALGOL 60 to code a set of instructions and imprint them on a punch card; the card directed the Graphomat's pen-adorned mechanical arms to draw designs. The artwork *8-corner graphic,* for example, was produced using the following instruction: "Distribute eight dots inside the figure-square and connect them with a closed straight edge line."[4] The result was a page full of line-drawn polygons, each one twisted in a slightly different way. Similar designs constructed using these sorts of procedures— variations on a given theme—made up the majority of works in the show. A special issue of the school's journal of experimental philosophy and poetry, *rot 19,* functioned as part catalog, part manifesto. The fifteen-page pamphlet included six of the exhibited graphics and a text by Nees, as well as an essay by Bense on what he called "generative aesthetics."

As Bense explained, generative aesthetics was the part of his theory of aesthetic information. It combined Claude Shannon's theories of informa-

tion with the mathematician George Birkhoff's 1933 notion of aesthetic measurement, which defined aesthetics as the ratio between order and complexity. Synthesizing these sources, Bense imagined the artwork as a network of signals and signs. Aesthetic information was the unexpected element in this circuit. Generative aesthetics was centrally concerned with how this novelty—the definition of aesthetic information—was produced. As Bense wrote in the 1965 essay, "Aesthetic structures contain aesthetic information only insofar as they manifest innovations, or rather innovations of probable reality. The aim of generative aesthetics is the artificial production of probabilities, differing from the norm using theorems and programs. Hence generative aesthetics is an 'aesthetics of production.' . . . The 'aesthetics of production' is concerned with bringing about 'orderly arrangements.'"[5] In his theory of generative aesthetics, Bense conceives creativity through the logic of algorithms, or generative structures, and equates aesthetic information with the amount of novelty it formally contains. For Bense, a successful artwork pushes the boundaries of communication but is still legible—insofar as it is results in a pleasing form. For Bense, art *is* this balance of order and disorder, novelty, and pleasure. All of this intellectual armature, however, delivers a relatively traditional idea of art, especially (and most surprisingly, given Bense's focus on computerized production) when it comes to authorship. Bense's theory maintains the idea that art is valuable insofar as it remains an arena for unfettered experimentation. It is a rationalized avant-gardism, stripped of any explicit social or political aim: artists aim to create pleasurable perceptual experience of forms, where pleasure is stimulation that comes from experiencing something just beyond the bounds of convention. Generative aesthetics may subvert a uniquely human notion of genius by rendering the creative process transparent and categorizing computers as "creative," but it nevertheless constricts formal innovation to the only acceptable aim for art. The conservatism of Bense's theory was recognized by Jack Burnham in *Beyond Modern Sculpture,* his 1968 book on "the effects of science and technology on the sculpture of this century." After briefly mentioning the importance of Moles's *Theory of Information and Aesthetic Perception* and Bense's *Programming the Beautiful* for experimental European

music (only, not art), Burnham explains that "Bense also does not attempt a new art form."[6] For Burnham, there is barely any discernable impact of these mathematical theories on contemporary art.

There is, however, a political significance to this purging of political content. Bense's whole project is propelled by a belief that rationality is humanity's first defense against the irrationality of fascism—an irrationality that continues in the form of extreme subjectivism in art. In the postwar, post-fascist period, Bense became an adamant and vocal critic of what he perceived as the persistence of mythical, irrational currents in German culture. Fascism might have been over, but its epistemological seeds could be found everywhere. Bense's generative aesthetics endeavored to remove subjectivity from artistic production and aesthetic judgment and imbue both with the transparency and clarity of science, to, in his words, "transform the metaphysical discipline into a technological one."[7] Claus Pias has shown how and why Bense's work wrested aesthetics from the contingency of subjective associations and the whimsy of taste, making it a methodical investigation of the possibilities and limits of creativity within a system.[8] Underlying all the technical language of information, complexity, redundancy, and signs was an attempt to salvage meaning in an increasingly dispersed and confused information age while at the same time navigating an anti-totalitarian skepticism about whether such shared meaning was possible or desirable.

Much of this historical context has been lost, however, in the translation of computer art into a stylistic genre or medium. In effect, Nees's 1965 Stuttgart exhibition established a number of equivalences that came to define a major trajectory for early computer art. First, computer art became synonymous with computer-generated graphics that achieved a balance between structure and randomness, especially the sort of glitchy, line-drawn geometric abstraction found in Nees's work; and second, aesthetic information became a theory of algorithmic artistic production. Other exhibitions followed suit. Just months after *Generative Computergrafik,* an exhibition of works by Nees and Frieder Nake, another Bense student, opened at the Niedlichs Galerie in Stuttgart. Nake's graphics were also made using the programming language ALGOL 60, which generated punch cards that controlled the movements of a Graphomat machine to make simple, geometric

designs. Nake had seen Nees's show, recognized a kindred spirit, and asked a mutual friend for an introduction. Their meeting resulted in this show of computer art in Germany a few months later, where Nees's patterns of variations in a series were hung next to Nake's more chaotic sketches determined by random-number generators. Nake therefore shared with Nees and Bense not only the interest in production and the pursuit of mathematical balance, but also their ethos of formal and technological experimentation unfettered by concerns about politics or use. As Nake put it years later, "Digital art is experimental by nature. The experiment here appears as more than a method to derive a result (the work). The experiment has a tendency to become part of the work."[9] By focusing on production at the expense of any other arena, the creation of computer-generated forms became an end in itself.

Nothing defines this period of computer art more than this commonly held value of experimentation for experimentation's sake, and this principle shaped the first self-declared exhibition of computer art in the United States. *Computer-Generated Pictures* opened at the Howard Wise Gallery in New York on April 6, 1965. The show was funded by the American Telephone and Telegraph Company and featured images created by AT&T's Bell Laboratories engineers A. Michael Noll and Béla Julesz. Noll's venture into art began serendipitously several years earlier with a glitch in information mapping. Employed by Bell Labs to investigate the sound wave frequencies most common to human speech, Noll operated a Stromberg-Carlson S-C 4020 that could plot his data for him. In his memoir, Noll described the day when a coworker came to him with "a computer-generated plot of data that had gone astray because of some programming error. Lines went every which way all over his plots. We joked about the abstract computer art that he had inadvertently generated."[10] Noll's experiments proceeded from his recognition of the machine's ability to mimic the artistic process and mechanically generate aesthetically pleasing forms. He hit on his first self-proclaimed successful piece, which he titled *Gaussian-Quadratic* (1963), when he produced something he thought resembled Pablo Picasso's analytic cubist painting *Ma Jolie*. A stack of thin zigzagging lines that look like they were drawn with an Etch A Sketch, *Gaussian-Quadratic* is characteristic of the sparse aesthetic of Noll's computer-generated works. It also shows that for Noll, formal innovation

was tied to the pursuit of beauty (a notion Noll modeled on early modern abstract paintings). In 1964, Noll wrote the first programs allowing computers to make works resembling those by Piet Mondrian and Bridget Riley. The decisive proof of success, according to Noll, was when his colleagues at Bell could not tell the difference between the Mondrian original and the computer-generated copy. This artistic Turing test—asking people to differentiate between art made by a human and that by a machine—provided evidence of the general tendency among viewers of art "to associate randomness with creativity."[11] Thus Noll's idea of computer art developed according to the same values as that of Nees and Nake: experimentation in the pursuit of perceptually interesting, balanced, pleasing, and beautiful forms.

For the Howard Wise show, the line drawings Noll had programmed with the Stromberg hung next to Julesz's pixelated designs. Yet despite Noll's enthusiastic embrace of the term "art," the Howard Wise exhibition organizers deliberately refused to describe the included works as such. Noll never shied away from the term, nor did he think that the computer was the artist; he still saw himself as the creator. On the other hand, Julesz had been using computers to create abstract stereograms to aid his analyses of human perception. Because of his articulated and overtly scientific goals, Julesz rejected the idea that his works were art. He resisted the term for the very reason Noll embraced it, because Julesz used his images in his investigations into perception and psychology and so did not want them to be seen only in aesthetic terms. There were added concerns among those at Bell Labs that calling these works art would trivialize their worthiness as scientific research, and with it degrade their whole research department.[12] The fact that the exhibition did not frame the works as art demonstrates the extent to which art was seen in opposition to the rigor and use of actual science. These works might be temporarily appreciated as art, but for Julesz at least, they had a more determinate use.

Critical reviews of the Howard Wise show convey that the art world was just as uncomfortable with this meeting of two cultures, but for different reasons. The show opened to scathing reviews and apocalyptic predictions of a future art "ex machina." As Grant D. Taylor has shown in his history of the contested reception of the genre, "computer art received a uni-

form response across the world, which was both apathetic and dismissive."[13] Because the Howard Wise show collapsed "computer art" with "computer-generated forms," Taylor claims, the idea that the genre signaled the death of the artist, and with it, creativity, agency, humanity, and meaning, pervaded much of the critical responses: "Computer art was more an act of war than a birth of a new medium."[14] But Noll steeped his work in the language of pure experimentation and a romantic notion of the lone artist working with no end or goal in sight. It is clear that for him, computer art was far from a threat to already existing values. The fact that he celebrated the computer's ability to "make" a "Mondrian" shows that for Noll, computers were a way to continue making traditional art by other means. As Noll wrote in the journal *IEEE Spectrum,* "The aesthetic experience will be highly individualistic, involving only the individual artist and his interactions with the computer. . . . The artist's role as master creator will remain. . . . We might even be tempted to say that the current developments and devices in the field of man–machine communication, which were primarily intended to give insight into scientific problems, might in the end prove to be far more fruitful, or at least equally fruitful, in the arts."[15] The clash between Noll and his critics was therefore not between an anti-humanist and humanist perspective on art. It was between Noll, who saw in the computer the possibility of making art based on the timeless pursuit of novelty and beauty, and his critics, for whom computer art seemed to be operating according to dated criteria.

Buttressing all of these early experiments with computer art was an idea of information as synonymous with innovation. As Nees explained in a 1967 essay for the journal *Bit International,* "What from the point of view of information theory was disruptive noise before, is now interesting information."[16] Herbert Franke, a mathematician and pioneer of computer-generated art in his own right, asserted similarly that "since chance processes are clearly the only information-generating events, the computer linked with a random number generator, and composing music and producing graphics, appears in a fresh perspective—namely as a simulation model for creative processes."[17] For the Stuttgart school and Bell Labs researchers—the two major progenitors of computer art in 1965—information theory and its focus on

formal experimentation enabled computer art to fulfill otherwise compet-ing aims. On the one hand, computer art stood in contrast to other areas of science and industry because of its open-endedness; these early research-ers in computer art were able to carve out the space for unencumbered in-quiry thanks to the language of art. But since computer art was entrenched in both science and industry, not only because its funding came from these arenas but also because engineers were the primary creators of these works, advocates of computer art could claim potential uses for their works. Art and science could coexist in this way only because essentially nothing was at stake; the language of experimentation meant that everything made by these practitioners was potentially valuable, but nothing carried the burden to be actually so. All the results—successes as well as failures—were seen as positive steps toward a future where computers could execute innumerable and as yet unforeseeable tasks.

Cybernetic Serendipity at the ICA, London, 1968

The optimism surrounding early computer art reached a notable and con-tentious peak with the 1968 exhibition at the Institute of Contemporary Arts in London, Cybernetic Serendipity. Like the exhibitions of computer graph-ics a few years earlier, it reconciled competing visions of computers and art through the language of indeterminate experimentation. While the works on display varied considerably, from computer graphics to conceptual art to experimental music to actual computers, all the accompanying texts, artists' statements, and institutional framing espoused this same exuberant rheto-ric of potentially purposive purposelessness. As Jasia Reichardt, the curator, explained in the catalog (published as a special issue of the journal Studio International), "Cybernetic serendipity deals with possibilities rather than achievements, and in this sense it is prematurely optimistic."[18]

According to Reichardt, it was Bense who planted the seed of the idea for Cybernetic Serendipity when he visited the ICA in 1965 to see an exhibi-tion of concrete poetry and urged her to "look into computers."[19] The re-sulting show, which took over three years to organize, shared with Bense's own 1965 exhibitions of computer art a focus on computerized produc-

tion and reveled in how machines could be creative. As an ICA press release explained, "The idea behind this venture is to show creative forms engendered by technology."[20] The title, *Cybernetic Serendipity,* suggests that creativity meant the same thing to Reichardt as it did to Noll, Nake, and Nees: a balance between order and randomness. While cybernetics "refers to systems of communication and control in complex electronic devices like computers," she explained in the show's press release, serendipity is a term "describ[ing] the faculty of making happy chance discoveries."[21] Like the other early exhibitions of computer art, most works in *Cybernetic Serendipity* achieved this balance on the level of composition and form.

After a struggle to secure the funding and machines needed to display the works, *Cybernetic Serendipity* opened on August 2, 1968. Reichardt organized the exhibition into three sections: computer generated graphics, computer animated films, computer composed and played music, and computer verse and text; cybernetic devices as works of art, cybernetic environments, remote control robots, and painting machines; and finally, machines demonstrating the uses of computers and an environment dealing with the history of cybernetics. Over 120 objects were exhibited, accompanied by a comprehensive program of public lectures, performances, and musical events. A lecture by Moles, for example, titled "The Social Implications of Art with Computers," promised to discuss the applications of information theory to music, and another by the psychologist and professor John Cohen addressed "Varieties of Information."[22] Artists in the show ranged from well-known figures such as John Cage, Nam June Paik, and Bridget Riley, to technicians such as Noll, Nake, and Nees. Following the show's mandate, most of the works in the show, such as Jean Tinguely's *Metamatic* painting machines (1955–59) or the many computer-generated graphics on display, illustrated how computers and machines could be used as a tool in making artworks. Additionally, viewers were presented with computer-created choreography by Jeanne H. Beaman and musical compositions by figures like John Cage, Peter Zinovieff, T. H. O'Beirne, and Iannis Xenakis (compositions created for this exhibition were released separately as a vinyl record). In some areas, computers were displayed as artistic achievements in their own right. The show was heavily indebted to corporate sponsors, including IBM,

Boeing, General Motors, Bell Labs, and the U.S. Air Force, which provided the necessary money and machines. Some works focused on creativity and verged on interactive environments, most notably *Colloquy of Mobiles* by Gordon Pask. For this work, which illustrated his idea of an "aesthetic potential environment," Pask constructed five mobiles—three bulbous fiberglass "females" and two flat, geometric "males"—which could communicate with one another by means of light and mirrors. Viewers could join in the conversation by using flashlights, altering the mobiles' "behavior" or movements. Despite the suggestion of social allegory in the work, *Colloquy* was primarily an operational investigation into the logistics of feedback and physical interactivity. Like Noll's *Gaussian-Quadratic, Colloquy* used the most advanced technology but the most conventional (gendered) forms.[23] Other works, like Charles Csuri's *Random War,* betrayed the emphasis on formal experimentation with an unsettling choice of content. Picked to be one of the works reproduced as an artist's edition print, and thereby granted greater circulation, this lithograph was generated by an algorithm. Csuri began by drawing one image of a soldier, and then used a random number generator to determine how he would scale and position a group of soldiers across the page. The generator also assigned each soldier a "side" (red or black) and determined which would die, which would be wounded, and which would survive unscathed. As Csuri explained in an interview published in the show's catalog, *Random War* illustrated how computers could be used both to make art and to predict the outcome of war. It is troubling but indicative of the spirit of the moment that Csuri—a painter and decorated veteran of World War II—moved seamlessly from discussing these two possible uses for computers.

Although it was difficult to garner financial support for the show from the art world, all in all more than forty thousand people reportedly visited the exhibition and its critical reception was overwhelmingly enthusiastic. While some responses expressed concerns about the end of art due to its automation and mechanization, most critics celebrated *Cybernetic Serendipity* as a cheerful survey of the creative, constructive, and ludic uses of computers.[24] A commentator for a BBC show noted that "at first sight, it's much more like a fun fair or going into the science museum with children running about

pressing knobs and with robot machines wandering around and squawking or gesticulating."[25] However, many critics noted that the show had not commented on social aspects of computer art, especially those related to the economic conditions for computer technology and the exhibition's financial sponsors. A review in *New Society* issued a scathing critique of *Cybernetic Serendipity*'s fun-fair attitude: "When we ignore the total social context in which they work, and begin to accept the after-hours fun and games of IBM technicians as art, we are not all that far from admiring the aesthetic surface of thermonuclear mushroom clouds and ballistic missiles."[26] These blind spots only appear more striking with time. In his analysis of the exhibition and its reception over forty years later, Rainer Usselman lamented how the show disregarded the computers' strong connection to military pursuits, both past and present. He made the case that the unabashed celebration of technology in *Cybernetic Serendipity* reflected the ICA's connection to Britain's Labour Party and their "modernization programme," of which the National Computing Centre was a crucial part: "Rather than focus on the technocratic, threatening or plainly vacuous elements in [Labour prime minister Harold] Wilson's vision, the exhibition merged science and technology with great entertainment and a dash of art."[27]

By 1968, to many the optimistic stance of *Cybernetic Serendipity* appeared irresponsibly out of touch with the realities driving computer development. It continued what had begun as computer art's singular mission: to display the current achievements in computer technology in order to instigate continued experimentation with the applicability of the technology in all arenas of life. Furthermore, the exhibition positioned artists as uniquely capable of innovating with computers. That this echoed the missions of Boeing, IBM, the U.S. Air Force, as well as the British Labour Party was not so much an indication that the ICA adopted the values of these entities, but instead shows that the experimental ethos associated with art pervaded so much of the early computer development at the time. Together, the majority of artworks, the discursive framework, and the critical reception of *Cybernetic Serendipity* show that the pursuit of novelty, when it came to computers, had become widely adopted as a social good unto itself, at the expense of others.

Triangulating the Politics of Computer Art: *Tendencies 4,* Zagreb, 1968–69

Among other computer artists, the politics—or apparent lack thereof—adopted by these early creators of computer-generated images and the *Cybernetic Serendipity* exhibition were divisive. These divisions roiled throughout the fourth *New Tendencies* exhibition, which was the first of the exhibitions to include Nake, Nees, and Noll, as well as other pioneers of CGI like Charles Csuri. The "show" in fact comprised multiple events that spanned almost two years from its initial planning stages in December 1967 to the opening of the final exhibition in August 1969. The exhibition was postponed numerous times due to disagreements about its contents and discursive frame, but this period of continuous delay was nevertheless productive: the final event, *Tendencies 4,* included two colloquia, two publications, and no fewer than five smaller exhibitions. The first colloquium and smaller-scale exhibition, held in August 1968, served as both trial run and preparatory meeting. This same year, out of the discussions surrounding the planning of *Tendencies 4,* the Yugoslavian organizers launched a new journal, *Bit International* (the first publication to come out of the show's planning stages). The final exhibition, held in 1969, was actually four separate shows: a historical section surveying work by the New Tendencies group since 1961, a display of current works of visual research (these two parts included works by members of Gruppo T and Gruppo N, but not Mari); an exhibition of CGI graphics by Csuri, Nake, Nees, Noll, and about forty others; and an exhibition of books and publications on computers, indicative of how important the discursive framework was for understanding the show.

Albeit sprawling in its format, *Tendencies 4* crystallized the changing stakes of computer art in 1968. In great contrast to *Cybernetic Serendipity,* all the contributors, even staunch defenders of the experimental ethos of CGI, framed their work in explicitly political terms. In his introduction to the August 1968 colloquium, held at the Center for Culture and Information in Zagreb, Abraham Moles laid out a threefold plan for the future direction of the New Tendencies: to be the most modern, to work across disciplines, and to tackle the problem of the relationship between art and society.[28] It

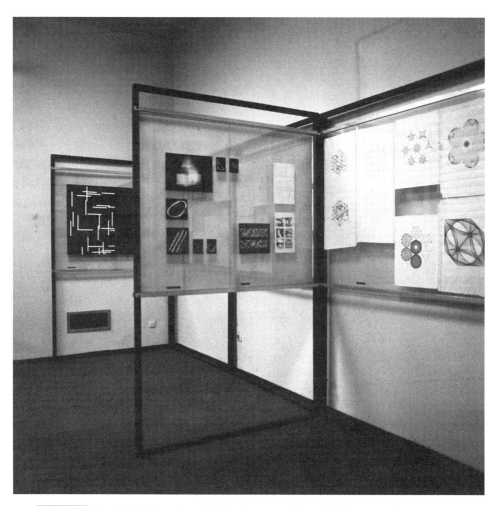

FIGURE 27 *New Tendencies 4,* installation shot, 1968, Zagreb. Courtesy of Muzej Suvremene Umjetnosti Archive Zagreb, Croatia.

quickly became clear, however, that for Moles these three goals were interrelated, and the second (to integrate science and art) eclipsed the other two. To be the most modern meant integrating science with art, and this was the way to transform the public, contemporary culture, and society at large.[29]

Indeed, Moles's equation of progress with science signaled what was in *Tendencies 4* a more general narrowing of political scope. As Margit Rosen has shown, the focus of these Zagreb exhibitions became the computer itself at the expense of its political implications: "The whole process of integration of a new technology [starting in 1967] implied a revision of New Tendencies' history by the organizers: it was a version of the movement's history focused primarily on aspects of the 'programming' of artworks and inquiry into the creative process. Inquiry into optical effects and the 'democratization' of art through observer participation were abandoned."[30] Likewise, *Tendencies 4* emphasized the computerized production of art at the expense of all other concerns, such as audience activation and participation as well as collectivity and communication. Moreover, by deemphasizing communication and highlighting algorithmic production, the show minimized the broader social and theoretical implications of computers, cybernetics, and information theory that interested Arte Programmata. The Italian artists' frustrations with these changes in the composition and meaning of computer art in *Tendencies 4* was most evident in their absence from the events. Almost no one from the Arte Programmata milieu participated in the colloquia, although works by almost everyone in Gruppo T and Gruppo N were exhibited at some point, in the "historical" section of the 1969 show that was also included, as a set of images, in the *New Tendencies 4* catalog. The few Italian voices in the debates were therefore all the more resonant and capture a growing unease. A presentation delivered by Alberto Biasi at the 1968 colloquium and the catalog essay by Mari were both disparaging, not only of *Tendencies 4* but of the CGI trajectory of computer art as a whole.

Biasi's intervention was nothing short of despondent. Speaking to an audience of almost exclusively CGI practitioners, he condemned the New Tendencies for taking science and technology for granted as ideologically neutral. Looking at this and previous Zagreb shows, Biasi noted a "disturbing fact": "a desire that traditional theories of art should be replaced by a mode of understanding and working that would be more in line with new scientific thinking about nature and human life."[31] Biasi took issue with how interdisciplinarity (in this case, artists working with scientific methods) had replaced—even effaced—the avant-garde ambition to integrate art and poli-

tics.[32] While this might be appropriate for those working in the socialist East, Biasi conceded, such an optimistic stance toward science and technology was not possible for artists in western Europe, given that computerization, mechanization, and most of all innovation were inseparable from the dominant values of capitalism, the exploitation of workers, and the perpetuation of war. For him, any engagement with computer research and development—artistic or otherwise—must be "accompanied by a revolution, a root and branch struggle against capitalism at the ideological, political, and cultural levels."[33] A lack of such a wider purview, Biasi ventured, might explain the reason why he was the only Italian to come to Zagreb for this symposium.

Frieder Nake was scheduled to present an article on computer-generated images at the 1968 colloquium, but he was moved to respond to Biasi's critique instead. He launched an impassioned defense of *Tendencies 4,* especially the political implications of its efforts to bridge art and science: "We shouldn't demonize automata. Computers exist, and we would be making a great mistake if we ran away from them. I think it would be much better if we brought as many 'leftists' as possible together with computers. . . . We must, for example, stick to the following program: rationality in the service of humankind."[34] Nake recognized some of Biasi's objections, namely the way that automation has amplified rather than alleviated the exploitation of workers. Technology is not so much neutral in Nake's response as it is malleable enough that artists can intervene and direct it toward different goals. In the end, for Nake the political stakes of computer art hinged on the issue of authorship, or intentionality.[35] His solution was to limit the participation of *Tendencies 4* to those who were "committed to a certain social idea" (presumably socialism).[36] Once the participants were carefully selected, he believed, the goal of *Tendencies 4* could remain the same: to showcase the collaborations, achieved and potential, between artists and scientists in the realm of computer research and development. Nake concluded his remarks by distancing the Zagreb exhibition from the ICA's contemporaneous show: "The London exhibition *Cybernetic Serendipity* addresses mainly the individual's instinct to play. Why shouldn't the Zagreb Tendencies address the social consciousness?"[37] However, the difference between the two shows for

Nake amounted not to what artists *do* or how the technology is *designed or deployed* but who the artists *are*. Nake saw politics as external to the work of art, something to be referenced by the work or embodied by an artist's intentions (or not, as in the case of the ICA show). This stance epitomized a widespread sentiment at *Tendencies 4:* that the avant-garde of that moment was made up of those working with computers on the borders of science and art, reconciling a rationalized rigor of method with a human-centered awareness of social and political needs. This perspective hinged on a particular interpretation of information theory that equated information with novelty, and politics with the actions of the producer alone. The audience was irrelevant, and the social and political agenda decidedly abstract, a simple gesturing toward the "expanded field" of artists collaborating with scientists and industry.

A short but incisive essay by Mari published in the *Tendencies 4* catalog, "Nouvelle tendance: Éthique ou poétique" (New Tendencies: Ethic or Poetics), was targeted at not only the technology enthusiasts but also the socially conscious computer artists like Nake. Mari's critique even encompassed his own earlier artistic production. The strand he identified as addressing poetics derived from the more recent, engineer-driven experimentation with computers in the making of graphic works, while the ethical position included those who sought to demystify art by grounding it in procedures as rigorous and verifiable as science in order to investigate perception and even teach their viewers to see the world anew—what Mari called "engag[ing] in a didactic action."[38] After taking stock of these two distinct approaches, Mari launched into his critique. For him, poetics confused the means with the ends, focusing so much on method that it effaced all other concerns. The ethical position, however, equally abstracted from social and political reality, mystifying the very phenomena it set out to interrogate and change. The ethical, then, falls into the same trap as the poetic of confusing the means with the ends—or, we might say, substituting technology for society itself. Here, Mari echoes Biasi's concern with how interdisciplinarity fosters the replacement of social questions with scientific models, and isolated, idealized experimental contexts with actual sociopolitical ones.

Mari's conclusion then goes on to advance the same political theory of art

he had been advocating for years, in which clarity is not a precondition but a problem that the work of art should solve: "If we do not seek first to define clearly . . . the socioeconomic reality of our situation, we will never reach the necessary conditions for research pursued in non-mystified terms."[39] Mari would seem to be rejecting any engagement with hard science (and he even explicitly calls for art to draw more on sociology and social psychology). However, when Mari calls for clarity, he is not rejecting the mathematical theories of information espoused by CGI artists like Nake or theorists like Bense; rather, he is redirecting his understanding and subsequent use of them. A common assumption shaping both Mari and Biasi's critiques of *Tendencies 4* is that art should clarify and make visible the situation for communication. To them, however, and in contrast to other computer artists at the time, this situation includes the whole field of reception—a field presumed to be difficult to predict or model at all. In the hands of these artists, information theory—especially its conception of "context" as by definition uncertain and always in flux—became a way of understanding how art might elaborate the sociological and technological conditions for clear communication, prompting the artists to draw on information theory to reconceive art's "context" in new terms.

Between Novelty and Clarity: Arte Programmata's Political Theory of Art

Information theory has been intertwined with Arte Programmata's practice from its inception in the early 1960s. Moles's writing helped Umberto Eco to model his theory of the "open work," especially the idea that forms give rise to their own discrete "field" of possible meanings. The earliest programmed artworks relied on this idea of a field, manifest in the endless mutations of kinetic sculptures and the flickering effects of intricate geometric patterns. The artists marshaled formal instability as a productive force to displace and disperse creativity across artist, audience, and machine. In their attempt to collectivize authorship, however, these works succumbed to the uncertainty of meaning. By 1965, with their own work being appraised as kitschy op art in the United States and the crowding of the cultural field increasingly being

felt at home, many of the Arte Programmata artists changed their practice in order to rein in the variability of interpretation. The environments forced this reckoning with spectatorship—and thus the mess of art's "situation" as a whole. Rather than delighting in uncertainty, the *ambienti* assert it as an unavoidable condition—of the environment, of subjectivity, and of the communicational network. Although they disoriented and confused their audience, Gruppo T, Gruppo N, and Mari continually claimed they wanted to achieve clarity. This would seem to contradict their aim to attack the autonomy of the spectator and assert the uncertainty of the communal sphere. But this was precisely the point of the environments: to function as experimental inquiries into the possibility of communication between unpredictable subjects in a situation that is equally erratic and unknown.

Information theory is particularly poised to address this question. While artists utilized it as a theory of artistic production for their programmed art, it was only with the environments that its social and political implications came to the fore. Information theory was developed in the context of World War II when cryptographers like Claude Shannon worked to ascertain the extent to which communication is possible in an environment plagued by distortion, be it due to the instability of the channel or the variability of interpretations on the other end. By calculating the ratio between signal and noise, information theory promises to quantify the probability of communicating a message. "The concept of information applies not to the individual messages (as the concept of meaning would), but rather to the situation as a whole," wrote Warren Weaver in his 1949 introduction to Shannon's *Mathematical Theory of Communication*.[40] Information is not the message, therefore, but the statistical delineation of the boundaries of what is communicable at all. We have seen numerous ways of interpreting this idea of the "situation" as posited by information theory. Moles and Bense seized on how Shannon mitigated the volatility of the communicational context, in order to rationally and objectively predict and measure the innovation in a work of art. Both agreed that balance was key; the aesthetic signal (in other words, the artwork) should be complex enough to stimulate and provoke, but not so complex that it would be lost in transmission by being misunderstood or disliked and thereby dismissed. As Moles wrote,

"The ontological goal pursued by the work of art is always to give the receptor 'a little too much' information, a little too much originality; this 'too much' is what is called the perceptual richness of the work of art, but the excess must be moderate."[41] Scholars have noted that the drive to quantify art's production and reception among Bense, Moles, and their milieu was motivated by their desire to avoid appealing to people's visceral and irrational responses—a mode of address they associated with fascist aesthetics. Rationalizing art's production and evaluation was also appealing to artists in this period because it seemed to avoid the individualism of *arte informale*. In all cases, the aim was to engender a discernable, logical, and transparent mode of communication, first in art but by extension into arenas beyond. However, progressively these theories of aesthetic information seemed to deflect further and further away from this focus. Any inquiry into the limits of communication was displaced by an abstracted measure of artistic "appeal" or pleasure—in a sense, Moles's and Bense's theories replaced politics with aesthetics and eclipsed the social implications of both.

Arte Programmata used information theory to probe the collective (in contrast to the scientific) dimension of aesthetic experience. This politicized use of information theory was most explicit in artworks that interrogate the field of reception through viewer surveys. One such work was *Ambiente sperimentale*, constructed by Giovanni Anceschi and Davide Boriani for the 1965 *New Tendencies 3* exhibition in Zagreb. As discussed in the previous chapter, *New Tendencies 3* had two important, intertwined components: a section devoted just to new works of visual research, organized by Mari and comprising three environments by artists of Gruppo T; and an emphasis on cybernetics, with Moles standing as the exhibitions' main theoretician. These intertwined developments—the environment as a medium and cybernetics as a structuring idea—emerged out of the political situation felt to be of greatest concern to the artists by the mid-1960s: the power of media to produce subjects, and the imperative to find a way to direct this power to collectivize, rather than individualize, their spectators. Like the other environments by Gruppo T members, *Ambiente sperimentale* immersed viewers in a space that was equal parts regulated and disorienting, with colorful spotlights projecting twelve algorithmically programmed patterns onto the

Giovanni Anceschi and Davide Boriani, *Ambiente sperimentale* (Experimental Environment), 1965, program. Courtesy of Davide Boriani.

surrounding walls. To their light environment, Anceschi and Boriani added a questionnaire handed to audience members upon leaving the work that asked them to judge the piece's aesthetic value. As Anceschi and Boriani explained in the exhibition catalog, "Our intention is to highlight and evaluate statistically, using tests, the aesthetic information content of a programmed visual message."[42] The survey seems to be enacting Moles's and Bense's theories by setting out to measure whether the artwork achieved a balance between originality and convention or whether it failed to register with audiences because it was too complex (in other words, so incoherent that it prompted little relatable affect or emotion). The adjectives of the survey posit novelty and clarity as antipodes on a continuum, with the goal of the artwork to fall somewhere in between.

However, the technical language of the artists' statement masks a more politically charged goal. In the struggle to articulate an entirely abstract experience, each visitor is forced to confront the necessity and challenges of communication—they are asked to search (and inevitably settle) for the terms that make one's unique experience shareable, transparent, open to articulation, circulation, discussion, and debate. Visitors feel, on a visceral level, the clash between individual and collective—which is the terrain that traditional surveys, after all, were meant to map. Unlike conventional so-

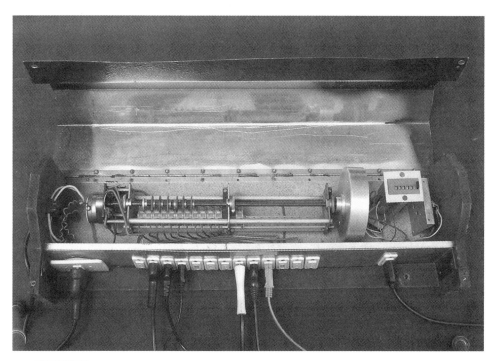

FIGURE 29 Giovanni Anceschi and Davide Boriani, *Ambiente sperimentale* (Experimental Environment), 1965, programmer. Courtesy of Davide Boriani.

ciological surveys, however, Anceschi and Boriani's questionnaire does not presume collective experience or the social field exists already, waiting to be related through the neutral medium of the questionnaire. Instead, collectivity exists in *Ambiente sperimentale* as an open-ended question, a potentiality rather than a precondition of the work of art. The questionnaire, in other words, was made in earnest: the artists really wanted to know what, if anything, was communicated by their work.

True to Shannon's definition, therefore, the information sought by the survey does not pertain to the artwork or to a particular message or meaning. Information in *Ambiente sperimentale* probes the artwork's capacity to communicate; it attempts to discern a field of possibilities—for collectivity, as much as communication. Unlike with Bense or Moles, Anceschi

and Boriani's goal was not consistency (a single signal spread to everyone equally); rather, the artwork was designed to generate a picture of the channel (here made up of people as much as material media), the limits of the field of communication rather than the content or signal itself. Information in Anceschi and Boriani's work discerns the border between novelty and clarity, charting the edges of what can be communicated by their artwork and the moment when communication starts to break down. The results of their survey were intended for the artists, in order to make them more skilled visual communicators capable of producing messages that could traverse a crowded and hostile context. The survey would better equip them with knowledge of this context—not only the proclivities of a sample audience, but also the effectiveness of certain materials and styles of art.

Anceschi and Boriani's turn to mathematical theories of information was therefore motivated by a set of social problems. The challenge of making art in information-saturated age, as the artists saw it, was two-pronged. The mass media produced subjects, but so too did it produce a cultural chaos in which there was no guarantee that a message could or would be accurately understood. The subject might be socially determined, that is, but the social field was in chaos—social codes, conventions, and economic realities in constant flux. For this reason, the very notion of communication needed a thorough reevaluation if it were to be effective. The issue was not that their context worked against the artists, that their work was overdetermined by ideology or personal taste, or that these codes would always lead to incorrect readings of the works. Rather, the problem was both more profound and more inscrutable. Anceschi and Boriani's notion of information reflected their understanding of their context as chaotic and unruly, unpredictable and largely unknown. They turned to information theory to reimagine this problem, which the theory was designed to address. By separating out questions of transmission from signification, information theory allowed the artists to circumvent issues of content and meaning and address their chaotic context, to separate the "what" of communication from the "how." *Ambiente sperimentale* showed that intertwined with the environments' cybernetic epistemology of uncertainty was an "informational" theory of art: to decipher and develop new requirements for

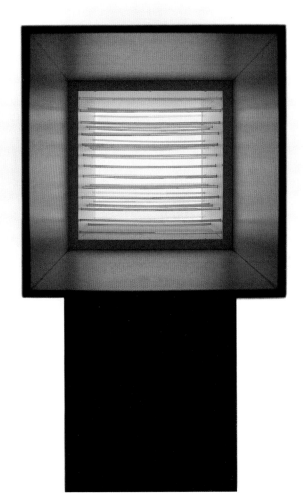

PLATE 1 Giovanni Anceschi, *Percorsi fluidi orizzontali* (Horizontal Fluid Paths), 1962. Courtesy of the artist and Galleria d'arte Niccoli, Parma.

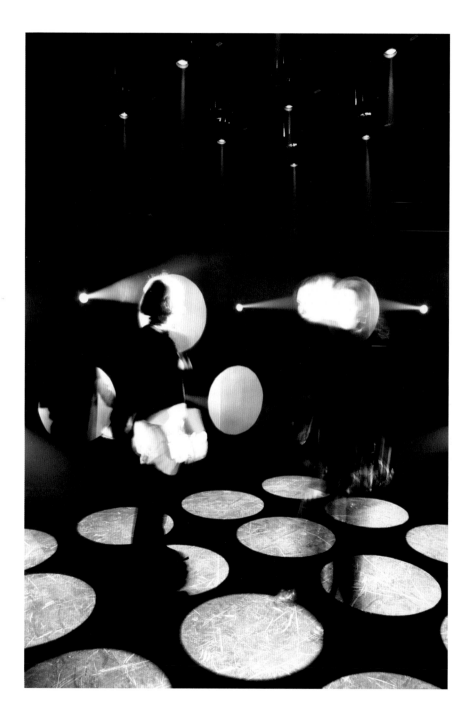

PLATE 2 Davide Boriani, *Spazio + Linee luce + Spettatori* (Space + Light Lines + Spectators), 1964; reconstruction 2006. La Galleria Nazionale d'Arte Moderna e Contemporanea, Rome, by permission of the Ministry for Cultural and Environmental Heritage and Tourism.

PLATE 3 Gianni Colombo, *Spazio elastico* (Elastic Space), 1968; reconstruction for La Galleria Nazionale d'Arte Moderna e Contemporanea, Rome, 2005. Photograph: Giorgio Pizzagalli. Courtesy of Archivio Gianni Colombo, Milan.

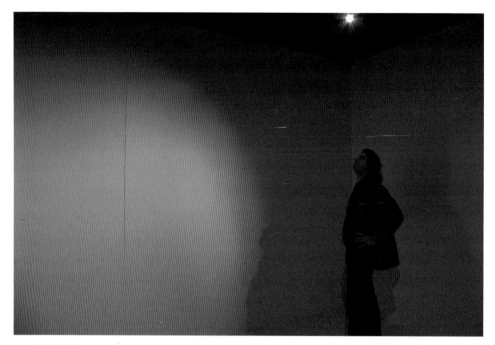

PLATE 4 Giovanni Anceschi and Davide Boriani, *Ambiente sperimentale* (Experimental Environment), 1965; reconstruction 2006. La Galleria Nazionale d'Arte Moderna e Contemporanea, Rome, by permission of the Ministry for Cultural and Environmental Heritage and Tourism.

PLATE 5 Giovanni Anceschi and Davide Boriani, diagram of *Ambiente sperimentale* (Experimental Environment), 1965. Courtesy of Davide Boriani.

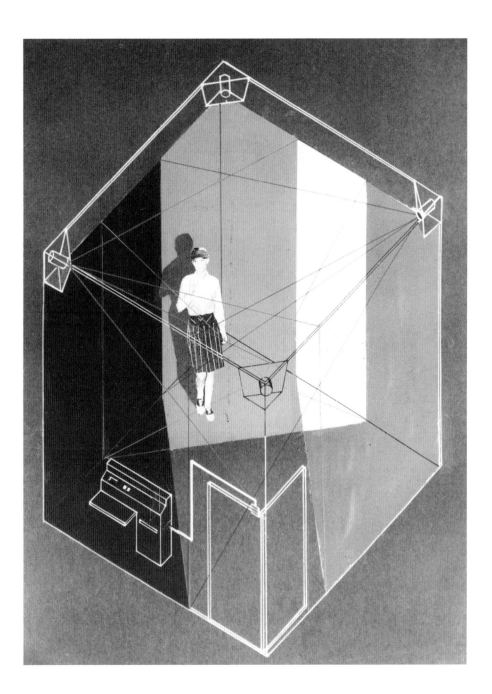

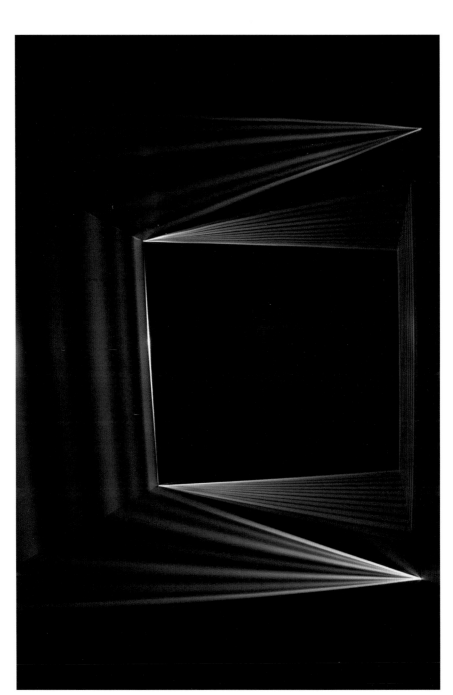

PLATE 6 Gabriele Devecchi, *Strutturazione
a parametri virtuali (Virtual Parameters
Structure),* 1969; reconstruction 2006.
La Galleria Nazionale d'Arte Moderna e
Contemporanea, Rome, by permission
of the Ministry for Cultural and
Environmental Heritage and Tourism.

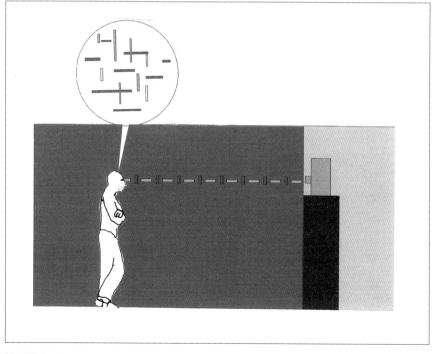

PLATE 7 Gabriele Devecchi, diagram for *Spazio in strutturazione plasticocromatica* (Space in Plastic–Chromatic Structure), 1965. Courtesy of Archivio Gabriele Devecchi.

PLATE 8 Enzo Mari, "Social Map," *Atlante secondo Lenin* (Atlas According to Lenin), 1976. Courtesy of CASVA Gli Archivi del Progetto a Milano, Comune di Milano.

communication—and with it, social and communal life—in a world over-run by noise.

Mathematical theories of information, then, reinforced what we might call Arte Programmata's sociological conception of technology, acknowledging the ways that media structure what society is and can be imagined to be. This approach does not subsume technology (or art, for that matter) to a readymade idea of the social. Rather, it recognizes that the social is shaped by the terms we have for communicating, by the kinds of collective action and meaning these shared platforms make possible. Mari invoked this idea when he called for those in the New Tendencies "to define clearly . . . the socioeconomic reality of our situation."[43] Mari wanted to find new ways of envisioning and modeling the social field; and he saw artists—as innovators of form—as uniquely poised to do this. Mari reiterated this theory of art explicitly in 1970, claiming that the purpose of his works lay not in choosing what to communicate—a politically effective message or critical stance—but in confronting the problem as follows:

> As the analysis of the evolution of the profession of artist should reveal, there are obviously two phases to every research. One is the determination to communicate something, the other, the "how" to communicate it. Obviously the "determination to communicate" entails, besides the indispensability of the message, its comprehensibility: the "how" implies the determination to find other means of communicating more effectively or more faithfully to the new media, to the cognitive evolution, to the new social context. . . . It is clear that of these two phases only that of "how" involves the concept of the research which we have already defined.[44]

Discerning the "how" of communication meant deciphering the necessary requirements for clear communication but also assessing its limits—something that the experimental arena of art might, Mari wagered, be able to do.

This conception of art and its political agency materialized most readily in a work by Mari that also featured a survey: *Modulo 856,* constructed for the

1967 San Marino Biennale. *Modulo 856* was a container shaped like the number 7—a short pedestal that supported a long, outstretched cantilevered arm (approximately eight feet in length). The artist positioned this structure outside the entrance of the exhibition space, the Palazzo dei Congressi. A small, square opening on the underside of the overhanging limb allowed viewers to insert their heads inside and peer through the container to the other end. Mari lined the interior with mirrors so that spectators were confronted with their own image. As Mari described, he wanted viewers to confront themselves as an object, a thing to contemplate.[45] After exiting the structure, visitors were prompted to further externalize when they were given a survey written by Mari in collaboration with Eco. The survey began by asking its audience "Is it art?" followed by three optional answers: yes, no, or "It is a machine for psychological experiments." The reference to psychology gestures toward Mari's roots in what Argan had called in 1963 "gestalt art" and attendant ideas about the variability of perception and its relation to the formation of the self. Furthermore, in 1965 Mari had designed book covers for Italian editions of works by Sigmund Freud and Carl Jung, for which he used a gridded pattern of repeated portrait busts to signify psychoanalysis's split subject. *Modulo*'s mirror rendered viewers in this same form (the bust) and manifests an analogous split in the viewer, who is rendered both subject and object of the gaze. As Francesco Leonetti observed at the time, "We see our presence as it is registered by others. And that displaces the subject from the sphere of his own interior existence. . . . He is forced to remember his external identity, and he finds that identity confirmed within the very strict limits of the sphere of appearances: there you are, always the very same imbecile, rendered an object by the institutions that surround you."[46] Rather than stabilizing the subject, as we saw in Pistoletto's mirror paintings, or dispersing it, as Boriani did with his environments, Mari's mirrors stage the tensions between internal experience and the act of communicating (or externalizing) it—a tension that is further concretized when visitors are confronted by the survey and made to feel both possibility and inadequacy when trying to put their experience into words.[47]

The survey intensified this tension, bringing in competing commentaries on culture, art history, literature, and aesthetic judgment. After the first

CHE COSA HA FATTO MARI PER LA BIENNALE DI SAN MARINO

presentazione di Umberto Eco

« Enzo Mari presenta in questa Biennale Internazionale d'Arte di San Marino un oggetto tridimensionale, di altezza data, da essere disposto sul pavimento, elevantesi ad altezza d'uomo, e tale da disporre il visitatore a due scelte alternative.
Egli può infatti limitarsi a contemplarlo come forma piena, traendone le soddisfazioni del caso, che non coincidono peraltro con quelle previste dall'Autore. Oppure, scorta nell'oggetto, a un punto determinato, una cavità — indice dell'esistenza di uno spazio interno — può essere indotto a un certo comportamento motorio.
Se compitato correttamente, questo comportamento porterà il visitatore a trovarsi con una porzione della propria persona all'interno dell'oggetto stesso e qui avrà la possibilità di fruire di una determinata esperienza visiva — che, pur essendo tra le più banali, è fra quelle che più frequentemente si incontrano nel corso di una giornata, a casa propria o per strada — potrebbe non mancare di suscitare nel percipiente — vuoi per l'inusitatezza dell'occasione, vuoi per la modestia della proposta — alcune reazioni d'ordine concettuale o emotivo, che l'Autore (assistito da amici devoti) ha catalogato a un massimo di informatività a un minimo di noncuranza.
L'Autore, che era partito ritenendo che la sua comunicazione potesse aspirare a una certa univocità, ha dovuto convincersi, via via che le sottoponeva amici e conoscenti a esperimenti, che la comunicazione era invece assai ambigua; altrimenti detto, che la risposta di fronte alla esperienza in questione poteva essere di vario tipo, e i tipi di risposta potevano essere addirittura catalogati riferendosi a correnti critiche

attualmente in voga (non trascurando le risposte anomale, innovatrici, illuminanti o risibili). Ha pertanto stabilito di non offrire al visitatore la chiave onde interpretare l'oggetto e l'esperienza che consente, ma di farsela dare da lui: e di sottoporre pertanto chi avesse fruito del suo oggetto a un rapido test, invitandolo a scegliere su una scheda una tra le possibili risposte anticipate, o ad aggiungere una risposta non prevista. Si è preoccupato, così, non tanto di offrire un oggetto da

contemplare ma una modesta macchina per sperimentare le reazioni di un visitatore di mostra d'arte contemporanea, ed è riuscito a sfuggire, nel contempo, alla jattura di quelle presentazioni critiche che inscatolano l'opera presentata in una rete di riferimenti filosofici e ottenebrano in partenza la spontaneità del visitatore ». Umberto Eco

P.S. L'Autore, e i suoi amici, si propongono poi di rendere di pubblica ragione i risultati del loro esperimento.

Inchiesta su « Modulo 856 » (in laminato plastico Print; cm 203 × 84 × 240) progettato da Enzo Mari in occasione della VI Biennale di San Marino (Scheda a cura di Umberto Eco).

Si prega di sottolineare la risposta con cui si concorda. Le conclusioni dell'inchiesta verranno pubblicate: il materiale potrà essere consultato dagli interessati. Le schede possono anche essere firmate.

Cos'è questo oggetto?

a) è un'opera d'arte
b) non è un'opera d'arte
c) è una macchina per esperimenti psicologici

Vi piace?

x) mi piace
y) non mi piace
z) mi irrita

Cosa significa?

1) è il punto massimo della pop art: a furia di isolare oggetti reali ed esporli come opera, ora il visitatore è indotto a considerare se stesso, a mezzo busto, come quadro.
2) è il punto massimo della op art: ora lo spettatore è totalmente libero di determinare i movimenti dell'opera che guarda, e con l'appoggio della più classica delle illusioni ottiche, quella data dalla immagine speculare.
3) è la più completa fusione di op e di pop: viene esposto un oggetto reale, il visitatore, dotato del massimo di mobilità.
4) è un ritorno totale alla figurazione.
5) è un invito a riconsiderare l'uomo.
6) è un invito a rivalutare la soggettività.
7) irride, prendendoli in parola, a coloro che si lamentano che dall'arte contemporanea è assente l'uomo.
8) ripropone il mito di Narciso.
9) ripropone il motto del tempio di Delfi, « conosci te stesso ».
10) vuole provocare il visitatore riconducendolo a se stesso, dopo la « distrazione » in cui si è trovato di fronte alle altre opere.
11) è un atto di protesta contro le mostre d'arte.
12) vuole mettere a disagio lo spettatore.
13) è il « divertissement » di chi accetta le mostre d'arte così come sono.
14) altra risposta a scelta

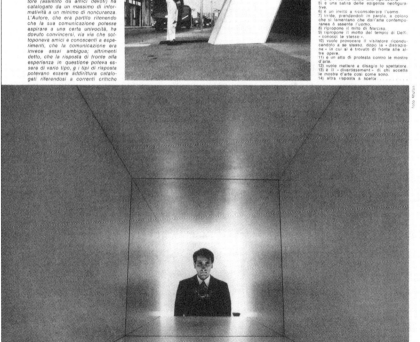

FIGURE 30 Enzo Mari, *Modulo 856*, 1967, with text by Umberto Eco, from *Domus* 453 (August 1967). Copyright Editoriale Domus S.p.A.

question, "Is it art?," it proceeded to ask visitors if they liked the work, again offering three answers to what would intuitively be a yes-or-no question: the third option this time was "It irritates me." Then, in the last segment of this short survey, Mari and Eco provided thirteen choices as to what the work could mean: Is this a work of pop? Op? Does it fuse pop and op? Is the spectator free to determine the movement of the work? Is the spectator a "bust," like in the fine art of painting or sculpture? Is the work repeating the myth of Narcissus? Or is it repeating the motto of the Temple of Delphi to "know thyself"? Is the work a return to figuration? Satirizing the neo-figurative? A protest? Does it strive to make the viewer uncomfortable? Does it reconnect viewers to their selves in the midst of a culture of distraction? Is it mere entertainment? Or, finally, is the work mocking the meaning of "Man"?

The survey appears to parody the very act of interpretation by presenting an array of incompatible meanings as so many reductive aphorisms, a slew of outsized statements of significance, each more inflated than the other. Like *Ambiente sperimentale,* then, the survey was not meant to discern what the work definitively means. It operated more like a game, one that thematizes and points beyond its own limits as such. Viewers were invited to participate *within* these limits (the structure, the questions) at the same time they were prompted, through its self-conscious absurdity, to move *beyond* them. However, this was not meant to liberate the subject from the system—as if such a thing were possible. Rather, as Leonetti correctly surmised, *Modulo* attacks viewers' sense of interiority (both the mirror and the survey insist on externalization). But Leonetti is too quick to see this as delivering spectators directly into the hands of institutional or governmental power. His mistake is to interpret the controlling aspects of *Modulo* in such negative terms. Mari, after all, was interested in demonstrating the "how" of communication, which, following information theory, required an understanding of the situation (its limits and possibilities) in which interpretation takes place. The mirrored container shifts the meaning of the work from where it is conventionally located (the individual spectator) to the operations of the channel, the codes of interpretation, the activity of projection and feedback as enacted by mirror. *Modulo* stages an encounter—an inescapable clash, we might say—between experience and its exteriorization, in

which one's sense of self and one's communicable self never quite match up. Feedback is necessary but imperfect, Mari seems to be saying; this is not an end but a beginning, however, as spectators are asked to engage with and also challenge the bounds determined by the questionnaire's terms. Like *Ambiente sperimentale, Modulo* thematizes the dynamic interplay of social and individual that constitutes the act of communication.

It is worth noting, then, how Mari's perspective differs from Eco's own discussion of the "how" of communication in "Towards a Semiological Guerrilla Warfare," an essay presented at a cultural conference in New York in October 1967.[48] In this much-cited work, Eco describes a new regime of power in Italy, in which those who control the means of communication control the channel, dictating the path through which a message travels in order to reach its destination. Power resides with those who are able to ensure that their message gets through despite the noise. Drawing on information theory, Eco goes on to distinguish between channel and code. The channel and those who control it are impossible to evade, but codes are far more slippery; much can be lost or gained in their execution. This leads Eco to point to what he called a "residual freedom" of the receiver, "a freedom to read it [the signal] in a *different* way."[49] Eco called for a concerted, socially conscious effort to mobilize such "critical reception," because "the battle for the survival of man as a responsible being in the Communications Era is not to be won where the communication originates, but where it arrives."[50] Eco considers the individual receiver the locus of art's political stakes—art trains them to be critical readers. Mari, by contrast, considers this freedom of interpretation at once a problem and a potential solution; he recognizes the liberatory potential of freedom as Eco describes it, but he also sees freedom as a barrier to communication. Works like *Modulo* attempt to take stock of this situation by mapping the limits of personal interpretation while also confronting its effects. What arises from Mari and Eco's collaboration, then, is a sense of the various ways that information theory can engender a political understanding of artistic practice. Both consider communication as a social problem, one that is inextricably intertwined with technology—how it is structured, and who controls its design and use. Despite their differences, Mari and Eco each mobilize information theory to analyze the

pragmatics of communication, which leads them each in their own way to address the limits and possibilities for agency (be it individual or collective) within a network.

All of Arte Programmata's programmed environments interrogated these issues. Most did not produce information in the literal way that the survey works did, but all reflect the influence of information theory, especially its conception of even the most programmed situation as unknowable and always in flux. It was due to this insight that the environments sought to attack the spectator's autonomy, foreground control mechanisms, and investigate the intersecting and conflicting tensions between agency and structure, freedom and control. The artists also drew on the language of information theory as it was deployed by others, oscillating between calls for unfettered formal experimentation (novelty) and consistent communication (clarity).

This emphasis on clarity brings Arte Programmata (especially Gruppo T and Mari) into conversation with the second major trajectory of computer art: conceptual artists working with communications media, for whom information signified the meaning or content of a message. This trajectory was propelled by the question of what it meant for art to be political, and it underscored an ideal of artists as processors of information, capable of delivering clearer and more potent messages to their audience. Two New York–based exhibitions—*Information* and *Software*—epitomized this understanding of computer art and its social significance, and therefore also bring to light why, by the start of the 1970s, most artists associated with Arte Programmata abandoned not only computers but also art.

Clear Messages: The Politics of Information in *Information* and *Software,* 1970

In a letter to Joseph Beuys a few months prior to the opening of his exhibition, *Information,* at the Museum of Modern Art in New York on July 2, 1970, curator Kynaston McShine described what he meant by the exhibition's title: "The exhibition, which I am calling INFORMATION, is devoted to work that is more conceptual than objective in the traditional sense of making specific

objects. It will take a look at the various activities of artists who are more directly involved with the natural and artificial environment and more with situations than with objects."[51] With over 150 participating artists and works ranging from cerebral meditations on language, such as Joseph Kosuth's *Three Chairs* (1965), to political posters, such as the Art Workers Coalition poster *And Babies* (1969); from Cildo Morales's *Insertions into Ideological Circuits: Coca-Cola Project* (1970) to an Earth Day poster by Robert Rauschenberg, *Information* took stock of artists working not only with nontraditional media (video, television, ideas, language) but with entire communication networks (radio, broadcast, telephones, transport, telex). As McShine explained, "[The artists] represented are part of a culture that has been considerably altered by communications systems. . . . Therefore, photographs, documents, films, and ideas, which are rapidly transmitted, have become an important part of this new work."[52] A focus on networks of information circulation characterized the works in *Information* as much as did their overt political content. Vito Acconci's *Service Area* (1970) enlisted the U.S. Postal Service to have his mail forwarded to the museum for the duration of the show, while John Giorno's *Dial-a-Poem* (1968) gave visitors a phone number to call in order to hear one of over fifty audio recordings of works by contemporary writers such as William Burroughs, Frank O'Hara, Abbie Hoffman, Bobby Seale, and Emmett Williams. The Argentinian Group Frontera built a recording booth in which audience members were interviewed about such topics as their daily routine and their views on God, love, sex, and politics as visitors watched on a set of external monitors. One of the exhibition's more imposing components drove home its expanded idea of "media." The "visual jukebox," funded by Olivetti and designed by Ettore Sottsass Jr., was a large, black, elliptical orb resembling a UFO, which supported individual viewing stations for watching the exhibition's program of experimental and structuralist films.

As McShine's letter to Beuys suggests, in the *Information* exhibition "information" was communications media expanded to such a scale and scope that it constituted the environment. Information alluded to everything: politics, biology, culture, ideology, community, society. McShine reiterated the idea that information was synonymous with reality in his catalog essay: the

artists have "attempted to extend themselves into their environment"; the films, "like so much of the other work in the show, [are] simply a method of distributing the visual information that interests the artists."[53] Information was the stuff "out there" that artists, concerned with the state of their world, channeled, redirected, and presented as works of art. McShine's installation mirrored his idea of information as the environment. Information overload was a glaring difficulty that plagued aspects of the show: the hours, even days, of film included in the cinema program, and the long list of recommended readings in the catalog that could make any viewer, then and now, cringe at the time commitment involved. One of the most dominant meanings of information operating in the exhibition was the collapse of medium and message; with so much content, sometimes the only discernable meaning was that information was a constant stream.

The imprint of media theorist Marshall McLuhan was everywhere. He was cited in McShine's catalog, his writing made up a large part of the curator's preparatory materials, and copies of the theorist's *DEW-Line* newsletters were even exhibited in the show. Yet *Information* expanded rather than exemplified McLuhan's famous dictum that the medium is the message. For McLuhan, this was true because media structure reality. In *Information,* however, information was such a pervasive societal presence that it lacked any structure whatsoever. Nebulousness was a characteristic of information that McLuhan himself came to acknowledge over time. Whereas in *Understanding Media* (1964) he called electric light "pure information" because it "shapes and controls the scale and form of human association and action," in a 1970 essay McLuhan wrote that *"information itself* becomes the chief environmental component."[54] McShine took this idea further to use the term to encompass almost anything, thus insinuating that information is too expansive and too ubiquitous to constitute a medium.[55]

This conception of information *as the environment* was central to the political ambitions of the show, which put artists front and center in the struggle to grapple with contemporary culture as well as social and political life. Artists recombined, reorganized, and redirected flows of information from the culture at large into the space of art, irrevocably changing the information, altering how it looked and what it meant. This was how the

show defined its political goal: art, in contrast to life, generated information that was clearer, more potent, and easier to consume than the indiscernible, unfiltered flows of information pervading everyday life. All the artists were leftists, and overtly against the Vietnam War, corporate power, inequality, and oppression; even those whose works were not political in content espoused the idea that art could provoke critical reflection on one's self and position in the world. For every work where the medium was the message, there were two in which the opposite was true: the message was the message, medium notwithstanding. McShine's curatorial strategy—information overload—therefore contrasted with most of the works included, which all struggled to produce clear, politically relevant information. Pieces like the Art Workers Coalition's My Lai poster, *And Babies,* which disseminated a photograph with a caption to make a clear anti-war statement, and Giorno's *Dial-a-Poem,* which put the audience in touch with the vibrant discourse constitutive of the countercultural movement (one reviewer mistitled it *Dial-a-Revolution*), typified how the artists captured, organized, and delivered information to their audiences. In so doing, the works in *Information* not only expanded the notion of what art could be, they also shared a particular model for how art could affect the world: by delivering thought-provoking, rousing messages to audiences, either by exploiting the relatively quiet space of art to convey a complex critical idea, or by constructing a coherent, pointed commentary about the world at large.

The political stakes that McShine articulated were overwhelming. In his terms, the works in *Information* formed the most compelling answer to the question of how to make art in a world beleaguered by war, oppression, inequality, violence, and fear. In the last analysis, this was the problem that *Information* set out to answer, rather than the issue of noise or an oversaturated image economy. For a better world, information needed to be organized toward direct, political ends. As McShine wrote in the catalog, in a passage that was quoted endlessly by reviewers:

> If you are an artist in Brazil, you know of at least one friend who is being tortured; if you are one in Argentina, you probably have had a neighbor who has been in jail for having long hair, or for not being

dressed properly; and if you are living in the United States, you may fear that you will be shot at, either in the universities, in your bed, or more formally in Indochina. It may seem too inappropriate, if not absurd, to get up in the morning, walk into a room, and apply dabs of paint from a little tube to a square canvas. What can you as a young artist do that seems relevant and meaningful?[56]

The answer: work with information, because this meant engaging directly in the world and shaping it for the better. With all the materials and messages circulating throughout, *Information* underlined how, in the face of information overload, information processing was itself a political intervention.

While seeming to foreground the technical aspects of information rather than the sociopolitical ones, *Software,* which opened in September 1970 at the Jewish Museum in New York, adopted the same idea of information and its attendant political theory of art. Curated by the art historian and critic Jack Burnham, the show—which was aptly subtitled *Information Technology: Its New Meaning for Art*—employed the language of computers and cybernetics more readily than did *Information* and included gadget-driven, tech-heavy works. The Architecture Machine Group from the Massachusetts Institute of Technology created a miniature version of a self-regulating environment that epitomized for them the purpose of computer research: "The goal is humanism through machines. . . . We are talking about a symbiosis that is the cohabitation of two intelligent species."[57] SEEK (1969–70) was a large, five-by-eight-foot terrarium that held a community of gerbils, a set of uniform square building blocks with which they could construct their habitat, and a computerized machine that intervened to help with the assemblage. *Software* also featured other research institution-funded projects, like the *Tactile Vision Substitution System* for the blind, designed by the Smith–Kettlewell Eye Research Institute. There was a selection of new-media artists, such as Les Levine, whose work *A.I.R.* (1968–70) featured a set of televisions screening previously recorded video footage of the artist working in his studio. But there were many overlaps across the two shows as well: Acconci, John Baldessari, Hans Haacke, and Robert Barry, to name a few. Some even included related works in each show, like John Giorno, who

set up a guerilla radio station to broadcast a program of recorded poems. *Guerrilla Radio* (1968) used the maximum amount of power (one hundred milliwatts) allowed without an FCC license, reinforcing *Dial-a-Poem*'s message that the media can be expanded and distributed to democratic ends.

Burnham had to work hard to distance *Software* from "tech art," even making a direct contrast to *Cybernetic Serendipity* in his catalog essay. Whereas the ICA show was a survey of works that "used" computers, Burnham explained, "*Software* is not technological art; rather it points to the information technologies as a pervasive environment badly in need of the sensitivity traditionally associated with art."[58] In *Software,* information technologies were not just a fancy new medium for artists to use, but a contemporary societal situation to which artists could and should attend. In his framework for *Software,* Burnham brought the show closer to *Information;* and like McShine, he saw artists who worked with information technologies as working with the world, rather than making art about it. In this regard, *Software* expanded the thesis Burnham first put forth in his 1968 article "System Aesthetics": "We are now in transition from an *object-oriented* to a *systems-oriented culture.* Here change emanates, not from *things,* but from *the way things are done.*"[59] Drawing on the theorist Ludwig von Bertalanffy's idea of a system as a set of relationships, Burnham defined systems as "material, energy, and information in various degrees of organization"—an expansive category that included art as well as the work (labor) of artists and the audience.[60] Burnham's choice of title for the Jewish Museum show reflected this idea. He selected "software" because it designated those aspects of a system that can be transformed by new plans and designs: "Software is the part of the system, which is more easily changeable."[61] Ted Nelson, a media theorist, computer scientist, and sociologist who coined the term "hypermedia" in 1963, who was also a contributing essayist, consultant, and featured artist for *Software,* was exuberant about the radical potential such artistic activity held: "The human environment can now be wholly, wonderfully redesigned. What do we want? What do we want?? What do we want??? . . . Creating media that are *organized,* then, clear and easily related to the human mind, is our task."[62] Therefore, the same contrast between the unruly state of reality—be it technological or political—and the central

role that artists were now taking by organizing and intervening into this context structured both *Software* and *Information*. Information in *Software* pertained more directly to information-processing systems than to political problems, but the meaning of the term was nevertheless the same as it was in *Information*: better, clearer messages through more efficient means and meaning.

The overlapping meaning of information in *Software* and *Information*, and the vision of art's (and the artist's) amplified social significance, were most salient in the work of Hans Haacke, an artist featured in both exhibitions. Haacke established a friendship with Burnham when he was first visiting the United States as a Fulbright fellow in 1962. It was at this early stage in Haacke's career that Burnham introduced the artist to systems theory, prompting him to begin making sculptures out of "real-time systems."[63] For Haacke as with Burnham and McShine, working with materials and media that interacted with the environment disintegrated the distinction between art and life before it had even been made.[64] In his contributions to *Information* and *Software*, Haacke not only showed the interconnectedness of art with its environment, but also emphasized how, in doing so, artists were able to transform the world. Haacke, therefore, adhered to the idea of the artists as information processor, wholly embracing the political implications of the idea. As he said in an interview in 1972 about his work of the previous decade, "Information presented at the right time and in the right place can potentially be very powerful. It can affect the general social fabric."[65]

Haacke's works in *Information* and *Software* intervened in the contemporary information environment in two distinct and important ways: his viewer polls, one of which was featured in each show, exposed how ideology not only structures the audience's direct political actions (how they might vote, for example) but also their identity and sense of self. On the other hand, his artwork *News*, which compiled reporting from local, national, and international sources and printed it out on teletype machines placed in the gallery, redirected and reshaped what would otherwise be a dizzying stream of unprocessed, even inaccessible, information. While the reams of printed paper in *News* might seem to mimic the flood of information experienced in the outside world, it compiled all these disparate news sources (the foreign

press included) into one place, for a single reader, and on a more manageable scale (human, rather than dispersed environmental). *News* demonstrated both the problems and promise of gaining access to so much information. But it is important to remember that at that time, bringing all these news sources together into one place would have seemed like a democratization of the media more than saturation to the point of absurdity. *News* embodied the idea of the artist as information processor, a concept advocated by both *Software* and *Information,* and an attendant theory of art as aimed toward delivering better information to its audiences—if not better for its clarity, then at least for a complexity that could better represent the truth.

Haacke's viewer polls adhered to a similar politics of information but wielded this as an instrument of ideological critique. Haacke conducted his first audience survey in 1969 at the Howard Wise Gallery in New York, inquiring into the residence and birthplace of the show's attendees. Haacke's next few polls expanded the questions in number and scope. For *Software,* Haacke created *Visitors' Profile,* which asked questions about viewers' age, sex, education, and income and elicited their opinions on a range of political and social matters. Haacke also utilized the assistance of an engineer and a PDP-8 computer, so that the answers could be compiled, compared, and aggregated into a set of statistical results. The data were projected in real time on a screen in the gallery, displaying the correlation between the demographics of the audience and their political leanings for all to see. For *Information,* Haacke took a less technological route (since his works in *Software* had suffered from grave technical difficulties) but the point was the same. The bluntly titled *MoMA Poll* asked the audience a single yes-or-no question: Would the fact that Governor Rockefeller has not denounced President Nixon's Indochina policy be a reason for you not to vote for him in November? Haacke constructed two clear plastic boxes to hold the answers, which audiences wrote on color-coded slips of paper distributed by the museum's guards. As the responses piled up, the audience could see if there was any association between the type of people that went to museums and their electoral leanings.

Haacke's polls framed the resulting information as a message meant to attack the autonomy of both individuals and art. In both *Visitors' Profile*

and *MoMA Poll,* the surveys generated a picture of the art-going audience as subjects produced by the driving motors of ideology and privilege. They were, in the artist's words, "statistical self-portraits" of his audience.[66] Such a picture conveyed to viewers that they were the product of social structures, not least ideological ones, and that their very sense of self was implicated in the political struggles that surround them. As Fredric Jameson argued of Haacke's surveys, "Since in these installations, no preexisting aesthetic 'pleasure' is present to be demystified, the focus shifts from the destruction of categories of 'taste' and 'art' . . . to the attempt to graph and 'map' the social system that subtends them."[67] But Haacke surely knew the map of the system before he even began. It is doubtful that the artist learned anything new about his audience, and even if the results swung in an unexpected direction (pro-Rockefeller and pro-war), the point he wanted to make was already clear: that despite the anti-ideological rhetoric of the Cold War United States, ideology was everywhere determining subjects and their environment.

While Haacke's survey questions appealed to viewers as products, however, the results engendered a different mode of address: they spoke to a position outside the machine of socialization, to rational, humane, ethically concerned, and notionally re-individualized subjects able to see themselves as the outcome of a situation and as active agents of change. In the end, the structure of Haacke's surveys was optimistic, even if their message was unsettling. For Haacke, the information generated by his surveys was a tool for unveiling already existing attitudes, in order to break the smooth facade of ideology in a critical gesture.[68] In Haacke's work, institutional critique eclipsed systems theory: the disturbing revelation that we are all implicated in networks of power was redeemed by the assumption that through this knowledge, individuals can become armed to affect and change the world.

Despite many similarities, therefore, Haacke's surveys worked differently than those constructed by Boriani and Anceschi and Mari, and these differences indicate the distinctions between the politics of information—and art—in the United States and Italy. Haacke's surveys were structured around well-formed assumptions about how society and subjectivity operate. The artist knew the message he wanted to send, and this message—

which Haacke intended from the start—subsumed the particulars of the survey results. For Haacke, to produce information meant elaborating an invisible reality, bringing it to light. The social, then, insofar as it was the system that Haacke wanted to expose, was given and assumed; it is, essentially, the force of demographic determination. Moreover, underlying Haacke's work was a secure critical position buttressed not only by critical art discourse but also by the web of social movements that, by the time he began his polls in 1969, were well underway. Anceschi, Boriani, and Mari's surveys worked in the other direction. Rather than unearth a reality that the artists knew was there, the Italian artists' surveys were an earnest inquiry into a world they did not presume to understand. This clarifies an important difference between Haacke and Arte Programmata's ideas of information and the notion of context that they assumed: for Haacke, context was a given, to be imported into the work of art to give it political meaning, while for Arte Programmata, context was uncertain and unknown. Arte Programmata's idea of information reflected this sense of instability and doubt: they drew on mathematics rather than politics, deploying technical theories of information that brokered in probabilities rather than certainties. But they did so for political reasons. For the Italians, information described the logistics of transmission, the limits and possibilities for any message—regardless of its meaning—to get through. From these two different ideas of information arose two distinct ideas about the political purpose of art: Haacke's polls delivered a clear message meant to inspire critique and arguably a change in behavior and even action, whereas Arte Programmata's surveys were directed toward deciphering the new requirements for communication in a world overrun by noise, to establish the conditions for a collectivity from the ground up.

The Ends of Information

However different in their definition, Haacke and Arte Programmata converged in an ethics of information. They shared the position that not just more, but more accurate information is the pathway to the betterment of society. Although the Italians' idea of information derived from the same

mathematical theories of information that inspired Nake, Nees, and the more technical strand of computer art, the Italians did not accept their indeterminate experimental approach, nor their optimism. To Arte Programmata, the goal of art was not to provoke aesthetic experiences but to interrogate the possibilities for communal ones. But while Mari, Anceschi and Boriani, and all the artists of Arte Programmata shared Haacke's, McShine's, and Burnham's desire for a more socially relevant art, they could not adopt their method. They could not mobilize art to send messages, having seen, by the mid-1960s, how slippery meaning could be, despite one's best intentions. The problem in Italy was not ideological overdetermination—otherwise, Haacke's strategy might have sufficed. Arte Programmata also doubted the adequacy of critique, and with it the power to decode the world that it bestows on those who wield it. Arte Programmata's idea of information, therefore, synthesized the concern with formal innovation at the heart of early computer art with the directed political purpose of the "new media" art in *Information* and *Software*. Their environments established conditions of uncertainty in order to experiment with the possibilities of communication in this context. Ultimately, they tried to reconcile the pursuit of novelty with that of clarity in order to combine an experimental and instrumental theory of art.

As the 1960s progressed, these two trajectories of computer art became more and more distinct, crystalizing into diametrically opposed ideas about the purpose and function of art in society. The opposition is clear in two publications of the early 1970s that take stock of the relationship between art and computer technology: Herbert Franke's *Computer Graphics–Computer Art* (1971) and Jonathan Benthall's *Science and Technology in Art Today* (1972).[69] Franke's book narrowly defines computer art, as the title indicates, as computer-generated imagery, and for him the value of CGI is the way in which it incorporates chance and can appear to "create" forms spontaneously. His publication shares the enthusiasm for formal innovation (and its basis in information theory) that propelled so much of early computer-generated art, although his conclusion gestures toward wider ambitions: "We now approach the fundamental questions: how did organized life first establish itself on earth; does the human brain have the capacity to create the fundamentally new?"[70] However, by 1971 the notion that art

could be a protected space for expanding—not to mention humanizing and democratizing—what computers could do had largely disintegrated, since it became clear that, in the words of Gustav Metzger, "there is little doubt that in computer art, the true *avantgarde* is the military."[71] Rather than offering a chance to rethink what it meant to do computer research, beyond these dubious institutional bounds, computer art became one of the last bastions of art for art's sake. This caused even a passionate devotee like Nake to proclaim his abandonment of computer art in 1970, even though he continued for decades to experiment with making artistic forms using algorithms and information theory under the mantle of "visual research." Only those who held fast to the idea of formal innovation as an end in itself continued to work under the mantle of computer-generated art. Nowhere was this clearer than at the 1970 Venice Biennale, which featured for the first time a section devoted solely to computer art. Only two-dimensional graphic works by Franke, Nees, and even Nake (despite his renunciation of the term) were shown. No Italians were included; rather, Boriani collaborated on a special section of the Biennale devoted to experimental research.[72]

Jeremy Benthall's book *Science and Technology in Art Today,* published with many of these criticisms of computer art in mind, presents a more expanded vision of the computer's cultural relevance by including chapters on photography, kinetic art, and ecological art. Even his section on computer art proper includes examples ranging from work by Nake to pieces by conceptual artists like the Art & Language group.[73] To Benthall, the prevalence of new media art demanded that art and art criticism be placed under the broader category of media studies; in other words, art must be considered as only one among many ways of communicating information. In each chapter, Benthall discusses different media, each as a different "technique used for the transmission of information from person to person."[74] When discussing the computer in particular, he writes, "If the camera extends our ability to recognize or *match* visual images such as faces, it may be speculated that the computer extends our ability to structure or organize information."[75] From this perspective, Benthall continues, the computer is most revolutionary not as a new medium but because it ushered in an interdisciplinary and ecological *consciousness* (Haacke, Negroponte, and

Pask are all exemplary of this tendency)—anything that has to do with "life-processes, energy transformations, the utilization of resources and the satisfaction of needs at a superorganismic level. . . . Ecology is thus related to the social sciences and also to the humanities."[76] Artists used technology to expand not only their methods, but also the applicability and scope of the art, forging new practices that brought art closer to science, sociology, and politics. Importantly, Benthall's expanded idea of computer art (as information processing) and its social significance allowed it to be easily uncoupled from the technology that inspired it; as Burnham himself claimed, the most important art of the 1970s was the a-technological (or even anti-technological) ethos of conceptual art, body art, and live performance.[77] Gradually, then, what began as two ideas about the politics of computer art—experimental and instrumental—overwhelmed the technology and debates about it: one could work with computers or one could be political, but increasingly artists could not sustain both stances.

Over this same period in Italy the problems of uncertainty and distortion in communication that compelled Arte Programmata to turn to information theory and reconcile these two ideas of art in the first place only worsened. Indicative of this was the controversial and revelatory media response to the bombing at the Piazza Fontana in Milan on December 12, 1969. After almost eight weeks of escalating protests in the city streets, and months of factory strikes across the country, a bomb went off at the Banca Nazionale dell'Agricoltura, killing seventeen people and wounding almost ninety others.[78] Initially, police attributed the bombing to anarchists, and the media swiftly jumped at the chance to use the tragedy to delegitimize burgeoning social movements on the left. But as arrest after arrest was made (over eighty people in total), many of whom were held (some for years) despite airtight alibis—and one, Giuseppe Pinelli, died while in custody under suspicious circumstances—severe doubts began to circulate as to who was behind the bombings. As it was later revealed through the investigatory efforts of activists, the Piazza Fontana bombing was the start of the state-led "strategy of tension," organized by the far right and sponsored by the government, intended to escalate violence in the hopes that the left would succumb to either fear or fatigue.

While Piazza Fontana was a political calamity, the advent of a cata-strophic government strategy that bred public distrust and fueled the flames of terrorists on both the right and left, it was also a media disaster. The distortion that already plagued the communication channels was now decidedly being wielded as a weapon by the state. This not only degraded the means of communication, weakening infrastructure necessary for de-mocracy in the process, but it also made painfully clear that the police and government were not working in the interests of the peace or the people. Rather, the state was breeding *disorder as a mechanism of control*, and much of the mainstream media followed its lead, propagating misinformation rather than truth.[79] But this moment of Italy's Autunno caldo of 1969 had the opposite effect that the government intended, for it only strengthened leftist social movements and provoked them to advance their strategies and tighten their bonds. In response to Piazza Fontana, a group of investigative journalists published the book *La strage di stato* (The State Massacre), expos-ing the right-wing origins of the bombing and the government support of the action.[80] As Massimo Veneziani has shown, *La strage di stato* launched a concerted counter-informational strategy that would come to characterize activist culture in Italy for the next decade.[81] It also, we shall see, made the question of organization all the more important to new social movements, especially as disorder became so blatantly a control mechanism of the state.

With the explosion of protests and new social movements across Italy, the artists of Arte Programmata were increasingly reevaluating the politi-cal efficacy of their art. Yet their concern remained fixed on the problem of communication. One of the last environments constructed by Arte Pro-grammata, Boriani and Devecchi's *Camera distorta abitabile* (Distorted Liv-ing Room, 1970), demonstrated, more aggressively than any other envi-ronment before, the ease with which information could be skewed. The work was designed for the exhibition *Vitalità del negativo* (The Vitality of the Negative), which opened at the Palazzo delle Esposizioni in November 1970. Boriani and Devecchi positioned their audience outside of a small rect-angular room, which was equipped with unadorned, stark white furni-ture: a table, two chairs, a couch, and low, long dresser. The surrounding walls were painted white with thin black lines forming a wide grid, shaped

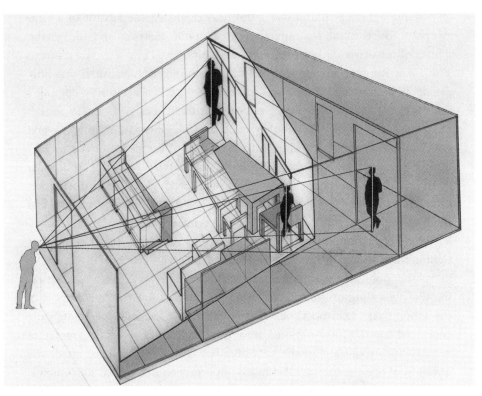

FIGURE 31 Davide Boriani and Gabriele Devecchi, *Camera distorta abitabile* (Distorted Living Room), 1970. Courtesy of the artists.

to match the black-and-white, square-tiled floor. The whole space looked entirely ordinary, which made the position of the viewer, who peered in through a peephole, all the more unsettling. This position was uncharacteristic for Arte Programmata's environments. Rarely was the audience afforded this privileged position of viewing an environment as a whole, and from the outside. But this position was immediately undermined by *Camera distorta*. The space was designed according to the principles of an Ames room, so that what onlookers saw was different from what actually existed.[82] The irregular polygon–shaped table looked like a perfect rectangle, while the couch made of only right angles appeared bent and skewed. In

addition to the furniture, the room contained a television set and a mounted copy of the famous painting by Giorgione, *Sleeping Venus,* which referred equally to Renaissance perspective and the voyeuristic gaze mimicked and then undermined by the work. There were also (usually) two people standing in the room, revealing its most extreme distortion: when two people of similar height stood across from one another, they appeared drastically different in size. *Camera distorta abitabile* not only pitted viewers against their own perceptual apparatus, showing them that they could not trust what they saw, but the work also established a relationship in which the position of presumed power—the outside, omnipotent spectator—was in fact the one being most thoroughly deceived.

Camera distorta abitabile illustrated how masterfully Boriani and Devecchi could manipulate reality and control their audience by wielding mathematical principles, but this *ambienti* also highlighted the absurdity of doing so within the hermetic situation of art. Rather than seek to solve or circumvent distortion, the work exacerbated it, and in so doing became a swan song to the programmed environments and their informational theory of art. Sustaining the tension between mathematics and politics and experimenting with modes of communication that could withstand both novelty and clarity became untenable in a situation in which the politics of computers and art were defined by these oppositions. In the end, Arte Programmata did not abandon their concerns with communication and social life, even as they put their more explicit engagement with computers aside. But they did need to find a way to put their skills and insights into the nature of communication to use, to intervene more actively and directly into the crises of the present. The amplification of authorship and the intensification of control in *Camera distorta abitabile* intimated the artists' next step: reshaping the world through design.

AUTONOMY AND ORGANIZATION

Progettazione and the Ends of Programmed Art,
 1970s

When the 1968 Milan Triennale opened on May 30, 1968, students and art-ists immediately occupied the exhibition in protest. While only four years before, Gregotti and Eco were able to orchestrate an experimental design of the Triennale to critical ends, by 1968 the exhibition was seen as nothing less than an ossified relic of bourgeois culture to be vandalized and dispensed with.[1] The hope that an exhibition could provide a space of contemplation and critique was deteriorating in the face of student-led social movements seeking to undermine the very structures that embodied traditional hierar-chies and authority—schools, factories, parliamentary politics. The rapidity with which an anti-institutional ethos was taking hold was evident in the fact that participants in the 1968 Triennale—Boriani and Mari included—spearheaded the demonstration, which included destroying some of the ex-hibition spaces.[2] Only a few weeks after protesters ransacked the Triennale, rallies against the Venice Biennale consumed its opening on June 18. Many artists had already refused to participate in their national pavilions (for example, over twenty artists from the United States boycotted the exhibi-tion to show their solidarity with movements against the war in Vietnam). Demonstrators at the Biennale's opening aimed their critique directly at the

exhibition's architecture and art by blockading pavilions and turning artworks around to face the wall. Photographs of the ravaged halls of the Triennale and arrests of protesters at the opening of the Biennale overwhelmed the media coverage of both shows, attesting to how the anti-authoritarian spirit of 1968 engendered an atmosphere where the most compelling and politically relevant gestures for artists to make were swiftly becoming negative ones.[3]

In conjunction with the protests, Mari, Massironi, Biasi, Boriani, and fellow artist Enrico Castellani composed a political statement titled "Un rifiuto possibile" (A Possible Refusal).[4] The statement charts their shared diagnosis of critical art and exhibition practices as broken beyond repair. Art, they claimed, is too mired in mystifying and circuitous language to make any consequential intervention or contribution to understanding the world. Likewise, they said, the spaces and discourses surrounding art, not to mention the economic structures that support it, overdetermine the meaning of any single work, rendering it complicit with existing systems of exploitation. With its emphasis on critique, refusal, and lack of specific program or discrete demands, the statement seems to resonate with the protester's emphasis on dismantling existing systems. But "A Possible Refusal" was published alongside another statement by many of the same artists (Mari, Massironi, Biasi) written just weeks before: "Proposta politica dei progettatori" (A Political Proposal of Designers) rejected strategies based on negation, even as it scorned the instrumentalization of art in the service of a predetermined political agenda. "The student movement and the occupation of the Triennale has shown with urgency the necessity of a more precise definition of the functions and role of the cultural professional," the proposal began. It continued: "Therefore we would like to underline that the cultural professional is only someone who discovers and communicates what was at first not known, rather than limited to the simple repetition or explanation of what is already known. . . . To avoid any misunderstanding, we would like to define the cultural professional with the term *ricercatore* (researcher) or *progettatore* (designer/planner): this last term is our preferred of the moment, as it accents the pragmatic aspect of cultural activity."[5] This statement puts forth a notion of the *progettatore* as a transitional figure, someone who inter-

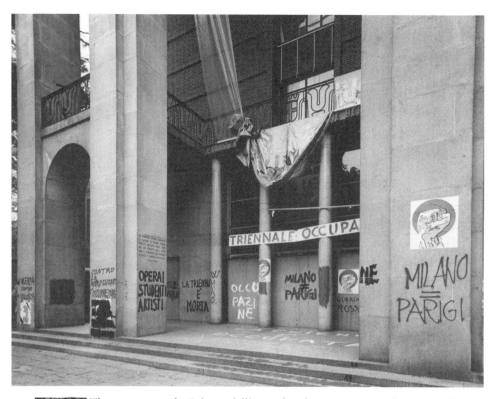

FIGURE 32 The entrance to the Palazzo dell'Arte after the occupation. Milan Triennale, 1968. Photograph: Publifoto. Copyright Triennale Milano-Archivio Fotografico.

rogates and describes the present as a crucial step toward its transformation. Armed with new understanding, designers could create objects and arrange encounters capable of disrupting given systems and laying the groundwork for new modes of communication and collective action. As understood here, refusal in one arena required continued research and experimental production in another—which meant to some extent "descending into a pact with the current social system," to understand how it works and can be undermined and altered.[6]

The authors of the "Proposta politica dei progettatori" went on to outline the contours of this proposal, listing the particular characteristics of the

current system that *progettatori* can and should confront: the rapid growth and mobility of the global population, and the cultural clashes that resulted; and the acceleration of production, especially of "useless goods," and with it, environmental degradation. Constant migration, new forms of capitalist exploitation and alienation, and the simultaneously homogenizing and in-dividualizing effects of mass culture had led to a situation in which the codes and channels of communication were so confused that, as the artists put it in the statement, it had become "impossible to receive a message in a clear and universal mode."[7] In other words, *uncertainty* and *lack of clarity* were still cen-tral problems that the artists wanted to articulate, interrogate, and attempt to solve. "Descending into a pact" was how the artists could generate new terms for understanding the problems of the present; as a strategy, it posited the inextricable connection between knowledge and action. Moreover, it connected the production of art and knowledge with the structures of social reproduction that support those that create both. The authors' sensitivity to the broader ecology of resistance is evident in how the statement con-cluded: with a plan to create a new design school that could support collec-tive experimental inquiry into new forms of communication, align design-ers explicitly with the burgeoning new social movements of workers and students, and serve as "a platform of autonomous organization."[8]

This juxtaposition of radical refusal with a pragmatic proposal for a new institution might seem paradoxical at first, but for these artists they were two sides of the same strategy. Institutional spaces and monumental, historic architecture could remain the site for spectacular gestures of pro-test, since they embodied well-defined loci of control. But given the con-tinued problem of instability in the realms of culture and meaning, not to mention work and labor, a more constructive approach was also required. New forms of both knowledge and organization were necessary for any po-litical subject and collective social movement to not only make a singular gesture or statement but also sustain itself and thrive. This is why Mari, Biasi, Massironi, and their collaborators rejected both critique and instru-mentalization and issued *progettazione* as their model for resistance—a term that means both to design and plan. To be a *progettatore* was not to have a clear-cut program and autocratically implement it, but to decipher the pres-

ent conditions as the first step toward organizing collective intervention and implementing change. As such, the twinned statements of refusal and *progettazione* not only reimagine the very concept of planning; they also assert that critique is insufficient when it stands alone. Refusal is only possible when paired with a sustained project of inquiry and redefinition—of subjects, systems, as well as organization.

In this regard, the notion of *progettazione* continued these artists' work as programmed artists by other means. Their central concerns remained the same: the relationship between structures and agency, the impact of systems on the subjects and objects that constitute them, and the ability of these discrete nodes to affect the system in turn. *Progettazione* and *arte programmata* are each based on the presumption that subjectivity and agency are inextricably tied to the technologies that both connect and control us.[9] However, the shift from *arte programmata* to *progettazione* marked a significant reorientation of Arte Programmata's practice away from experimental models toward pragmatic, political action. Looking at a number of design projects by Enzo Mari, Davide Boriani, Gabriele Devecchi, Giovanni Anceschi, as well as Manfredo Massironi's theories of visual perception, this chapter argues that these experiments with *progettazione* offer a model of resistance not as something that happens autonomously from or decidedly against a given structure but within and through it. Engaged with personal behavior, habits of vision, modes of communication, and local economies, their varied projects all evidence a struggle to catalyze new collectivities and engender an alternative program or plan for organizing everyday life.

This constructive perspective appears to stand in great contrast to the new social movements developing in Italy, especially the multifaceted precursors to what came to be known as Autonomia, which emphasized (among other things) political strategies of refusal, exodus, and sabotage. In the design arena, these intellectual and political developments influenced the work of the radical Italian counter-design movement like Archizoom and Superstudio, and the writing of Manfredo Tafuri. However, these leftist artists and intellectuals share much more with Arte Programmata than first appears, when considered in their complexity. The protests of 1968–69 inspired the creation of a variety of organizations to the left of the Italian

Communist Party (PCI), most notably Lotta Continua, Avanguardia operaia, and Potere Operaio. This period also gave rise to the journal *Contropiano*—or "counter-plan"—active from 1968 to 1971, which published cultural analyses aimed at dismantling not only capitalist plans but also ineffective leftist agendas and sought to develop a radical program that could supplant both. These groups grew out of those associated with *Quaderni Rossi* (such as Mario Tronti and Antonio Negri), and the debates that propelled their development morphed into Autonomia in 1973. As we shall see, the relationship between autonomy and organization was at the center of the movements' theories and practices, albeit also one of the most divisive, controversial issues. The anti-institutional appearance of the 1968–69 protests in Italy, then, masked a longer, varied reimagining of collective action and institutions. Despite many differences, for the decade following the 1968 protests one of the most central questions for those involved in Autonomia and its precedents was not *if* but *what kind* of mediating structure or system could best accommodate a diverse array of political subjectivities and engender the greatest degree of autonomy for all.

This chapter situates the Arte Programmata artists' practice of *progettazione* within the broader landscape of political debate and action in Italy after 1968 and argues that the artworks offer a productive conceptualization of its key terms: planning, organization, and autonomy. Contextualizing Arte Programmata within this milieu, especially Autonomia and its precursor, *operaismo,* will demonstrate how the artists' interest in platforms and programs was tied to the radical reimagining of subjectivity, political organization, and collective action that consumed the extra-parliamentary Italian left. Far from an inevitable submission to one-sided techno-determinism or technocracy, Arte Programmata's investigation of platforms and programs should be seen as an important contribution to wider discussions about the relationship between autonomy and organization, as well as attendant ideas of individuality, collectivity, knowledge, and action. This is one "end" of Arte Programmata: an elaboration of the idea of autonomy based not on a freedom *from* structures but the creation (the design) of better ones. As we shall see, the integral relationship between art and politics in this period was most evident among those invested in creating alternative institutional and organizational forms.

The Question of Organization in Italy, circa 1969

The 1968 protests in Italy that prompted Mari, Boriani, Massironi, and others to assert their identity as *progettatori* intensified over the following year, climaxing with the Autunno caldo of 1969 and the state-led escalation of violence (discussed in the last chapter as the *strategia della tensione*). A key characteristic of the movement, across its sprawling, multifarious instantiations, was its rejection of traditional political strategies, institutions, and party structures. Many protesters were unemployed youth, and even those protesting within the factories (notably Fiat in Turin and the petrochemical plant in Porto Marghera, near Venice) were at times acting without the assistance of traditional unions or affiliation with the PCI.[10] These industrial centers in particular (Fiat and Porto Marghera) had been the site of strikes and protests for years, but these actions were now growing in size and inclusivity, drawing in specialized craftspeople and white-collar laborers who, due to technological change, were now seeing their work automized and conditions worsen.[11] Massive protests were also taking place among students at both universities and high schools, who occupied their institutions and rallied against their rigid, hierarchical structure as well as constrained content—understood to be, in the words of Nanni Balestrini and Primo Moroni, "an instrument of ideological and political manipulation."[12] Unwilling to question the systemic problems with capitalism, unions and schools were now often seen as aiding processes of exploitation and immiseration, means for deescalating struggle and further entrenching participants within elaborate systems of discipline and control.

Within and beyond the factories, at universities, and in the streets, the antagonism between the PCI and broader leftist landscape, which had been ongoing since at least the 1950s, intensified. Demonstrations were directed explicitly against the reformism of the official left and the PCI (rather than, say, capitalist bosses or the Italian state). The novelty of the late 1960s was as much in what the movement opposed, then, as who it drew into the opposition. The participants of the protests of 1968 expanded and exploded notions of "the worker" and "working class" to include the unemployed and students; they also reframed seemingly unproductive activities as capital-producing,

and therefore sites of exploitation, including education, leisure, and housework. In 1969, a meeting was held in Turin to bring together the students and factory workers and draw explicit connections between their struggles, clear acknowledgment that a new kind of political subject—or perhaps more precisely, network of subjects—was emerging.[13] The meeting went beyond recognition of a shared enemy and outrage. The problem for many, including those at in attendance at Turin, was how to organize this explosion of activity into a coherent program aimed at achieving sustained political and social change.[14]

The tension between spontaneity and organization was therefore a key dimension of the struggles in the late 1960s in Italy. But it was a not a new concern. It consumed the intellectuals and activists at the center of the tradition (or more precisely, trajectory) of political theory that began in the earlier part of the decade and came to be known as *operaismo,* or workerism, for its centering of worker agency. Since the early 1960s, militant researchers and activist sociologists had been writing about the actions taking place in factories that appeared erratic, recognizing them not just as seeds of rebellion but as evidence of an emergent revolutionary subject, inchoate experiments in alternative collective organization and political action. This groundbreaking workerist writing appeared in the journals *Quaderni rossi* (Red Notebooks), where Romano Alquati also published his analysis of Olivetti in 1962, and then *Classe operaia* (Working Class), founded by Mario Tronti and Alberto Asor Rosa. In a 1964 essay, Alquati argued that the 1962 protests at Fiat defied any simple opposition between organization and spontaneity: they appeared disorganized only because they did not use unions or take conventional forms.[15] (He notes the same apparently chaotic, "wildcat strikes" at Olivetti.)[16] In "Lenin in England," the first editorial for *Classe operaia* in 1964, Tronti wrestled with the perceived passivity of workers, famously pointing to strategies of refusal—"planned non-collaboration, organised passivity, stoppages, political refusal and a continuity of permanent struggles"—as evidence of struggle in need of new forms of organization.[17] Watching workers organize without unions, in ways that are unrecognizable in terms of traditional politics, enabled Tronti and Alquati to enact *operaismo's* "Copernican Revolution," prioritizing the working class as the primary agent of historical

transformation. This stood is stark opposition to analyses that presume that capitalists (technological innovation, factory management, capitalist plans for development) were the most significant agents of social and structural change. As Tronti put it, "We too saw capitalist development first and the workers second. This is a mistake. . . . Capitalist development is subordinate to working-class struggles; not only does it come after them, but it must make the political mechanism of capitalist production respond to them."[18] The same went for revolutionary theory as practiced by *operaismo:* it could only be accurate and effective if developed in explicit conversation with the worker struggles on the ground.

Importantly, the activist intellectuals involved in *operaismo* saw worker agency as both a practical and theoretical problem. It was not as simple as exalting workers' struggles, discovering within them an a priori collective subject and strategizing how they might continue to act on their own. After all, the very concept of work—even in its most expansive manifestation—makes this impossible. One cannot be nor conceive of a "worker" without acknowledging the capitalist conditions that produce this identity. How, then, can anyone assert the revolutionary nature, much less the autonomy, of the working class? One of the most innovative contributions of *operaismo* was how it confronted this apparent contradiction, making it the focus of their notion of class and class struggle—encapsulated by the concept of class composition. The term "class composition" (in contrast to "class" alone) was meant to dynamize and historicize the understanding of class struggle, centering the subjectivity of what it means to be a worker (i.e., its historical contingency). As Steve Wright puts it, class composition is "understood as the various forms of behavior which arise when particular forms of labourpower are inserted in specific processes of production," with "stress upon the relationship between material conditions and subjectivity, being and consciousness."[19] Class composition—the historical form of workers' struggle for autonomy against capital—is the result of a dynamic interrelation between technical composition of capitalism and the political composition of the working class.

This assertion of a dynamic interrelation between the technical organization of the factory—where workers are subjected to capital—and the

political organization of struggle—which constitutes worker solidary, organization, and action (in essence, their self-valorizing will)—percolate much of the workerist writings (in Alquati's writing on workers at Fiat and Olivetti, for example). From an economic perspective, workers are entirely produced by capital and subsumed by its exploitative logic. Their subjectivity and identity as workers render them inextricably part of this system. But politically, workers are a force against capital, capable of organizing against, and beyond, the current system. These processes are not separate, but mutually constitutive. Gigi Roggero explains this dynamic: "Technical composition is not simply a photograph of the structure of exploitation, nor is political composition an indication of an autonomous subject already created. The articulation and hierarchization of labor power are set in motion by worker behavior, while the political formation of the class lives in permanent tension between autonomy and subsumption."[20]

For *operaismo,* then, workers operate both "within and against" capitalism. This stance was most clearly articulated in Tronti's seminal 1965 essay, "Marx, forza-lavoro, classe operaia" (Marx, Labor Power, Working Class), reprinted in the widely read and circulated essay collection *Operai e capitale* in 1966. In the essay, Tronti describes this complex relationship of workers to capital: "When it comes to the working class within the system of capital, the same productive force can really be counted twice: one time as a force that *produces* capital, another time as a force that *refuses* to produce it; one time *within* capital, another time *against* capital."[21] The claim that workers are both "within and against" capitalism was important for this whole generation of activists and intellectuals. It provided an analytical way out of a perceived impasse (how to resist the very structures of power that produce subjectivity), as well as a conceptual toolkit for conceiving of practical action by asserting that "against" is in fact a creative, productive activity. For *operaismo,* the struggle for worker autonomy and self-realization has to take place as much through the constructive organization of alternatives as antagonistic, destructive action. As Roggero demonstrates, this put the question of organization front and center: "The *operaisti* wanted to break the static dichotomy [between spontaneity and organization] and place the problem of organization inside the materiality of class composition and the form of struggle."[22]

The integral relationship between spontaneity and organization and the contradictory positionality of the working class are foundational to Tronti's early *operaisti* writings. In his essay on "The Plan of Capital" (1964), for example, Tronti demonstrated that plans were equally essential to the capitalist exploitation of the workforce, reformist attempts to mitigate intense economic inequality (most notably in Keynesianism), as well as socialist societies, both real and imagined. Workers, he writes, "will not move unless they have a plan for revolution which is also explicitly organised. . . . The demand for power must precede everything else."[23] Again and again, Tronti contends that a particular form (or in the case of spontaneous action, formlessness) does not ensure its political impact. Rather, one has to account for the whole situation in all its complexity and then, enabled by this understanding, generate a method for organizing an effective and sustained oppositional force—one that includes a confrontation with the inner workings of power.

The protests and new kinds of class composition that they evidenced offered a unique chance for activists and *operaisti* intellectuals to experiment with creating these new forms of organization, explicitly and in practice. By 1969, a staggering number of alternative organizations had formed—all in opposition to the PCI and trade unions, and many influenced directly by *operaismo*'s ideas. This year saw the start of Lotta Continua (a Turin-based student–worker alliance that published a daily paper), Avanguardia operaia (centered in Milan and arising out of the movement in the state university), and Potere Operaio (a national network of regional activist associations with strength in Turin, Rome, and Venice—the latter founded in part by Antonio Negri—that also published a newspaper under the same name).[24] These organizations struggled with maintaining a focus on worker power while also negotiating the real political terrain, still dominated by unions. Moreover, the relationship between students and workers became increasingly fraught; with all the excitement around new political subjects, this variety remained difficult to maintain. The challenge, as one anonymous author put it in an issue of *Potere Operaio* in November 1969, continued to be the need to "maintain *a continuous relation between new forms of organization and mass struggles*"—which required new ways of conceiving and enacting both, lest they devolve back into the status quo.[25]

The activist groups and their publications were therefore only a few arenas where the issue of organization played out. Another center for discussion and debate was the journal *Contropiano,* started by Asor Rosa, Antonio Negri, and Massimo Cacciari, with Tronti as a frequent contributor. The first issue appeared just prior to May 1968 and was intended to be a site for theorizing and historicizing the relationship between working-class composition and political organization. As the name suggests, the aim was not to dismiss all plans but to generate a "counter-plan," a revolutionary organizational form capable of realizing the emancipation of workers and the end of capitalist social relations. The first issue included an essay on Keynesianism by Negri; Tronti's critique of both "extremism and reformism"; Asor Rosa on Georg Lukacs's "theory of bourgeois art" (the Frankfurt School is a continual reference for the writer); as well as essays on architecture, film, and literature. A large part of this project, then, involved interrogating the politics of form, broadly conceived: artistic forms, but also political ones. Negri's essay in the first issue, for example, outlined the increasing instrumentalization of crisis by the state, describing how the "planner-state" and the "crisis-state" were effectively two aspects of the same strategy—that is, the state's plan *became* that of permanent revolution.[26] This claim—that capitalism could render the negative positive, integrate the challenges made by the working class into its own plan, and redirect this antagonistic energy to effectively make itself stronger—pervaded the essays published in *Contropiano* and challenged any simplistic and essential opposition between capitalist development and revolutionary destruction. This same unraveling of oppositions pervaded Manfredo Tafuri's seminal essay on the artistic and architectural avant-gardes, published the following year in the journal as "Per una critica dell'ideologia architettonica" (Towards a Critique of Architectural Ideology).[27] As Pier Vittorio Aureli explains in his examination of the intersections between *operaismo* and architecture, "Their [the editors and writers of *Contropiano*] great discovery consisted in the fact that what made capitalist development strong was not its continuity, but its discontinuity: its ability to absorb the negative, that which at first seemed to be its opposite or its collateral effects."[28] This insight applied as much to political analyses as the artistic and cultural ones. Given this realization that capitalism could so ef-

fectively recuperate the negative, the journal sought to go beyond critique and put forth a theory of working-class revolution, one that confronted the mechanics of power and the need for organized action, and included meditations on the role of art, design, architecture, and urban plans, as well as political organizational forms.[29] For many involved this also gave them license to think strategically, interrogating bourgeois models to see what might be of use. For others, however, the analyses presented in *Contropiano* effectively drew a line in the sand against any collaboration with powers understood to be within capitalism.

Theoretically, 1968 marked a turning—and a breaking—point among these *operaisti* thinkers on the question of political organization and what a struggle "within and against" capitalism looked like in practice. Much of this discussion centered on the role of the party, namely the PCI, and how and to what ends the party should be engaged, expanded, worked with, or dismissed. Significant disagreement about this preceded *Contropiano*. Tronti rejoined the PCI in 1967, the same year that Negri participated in the formation of the Potere Operaio group in Venice, which was resolutely opposed to any collaboration with the PCI. The rift also structured the essays that appeared in the journal's first issue: Tronti called for the strategic use of the PCI by the working class, while Negri outlined the dangers of any sort of collaboration, emphasizing that insurrectionary work first needs to be done.[30] Given the journal's continued focus on questions of organization and the party as central to the continued struggle, Negri left the editorial board of *Contropiano* before its second issue.[31]

The tragedy of *Contropiano* is that the initial impulse in *operaismo* to foreground the complex and contingent relationship between spontaneity and organization devolved into diametrically opposed theoretical and political positions.[32] Increasingly, Negri exalted spontaneous action (even insurrection) while Tronti insisted on the strategic use of the PCI by the working class. Negri was quick to support novel, eruptive actions for their own sake, while Tronti advocated for the use of old forms in new ways.[33] This had implications for how the two intellectuals view the relationship between organization and autonomy, which too became starkly opposed and rigid: For Tronti, worker autonomy was realized in and through organization, in the

assertion of their political will for self-determination and democracy. For Negri autonomy was inherent to the positionality of workers and so the aim of action is to destroy capitalism and assert worker power.[34] In later writings, this immediatism appeared in Negri's stark distinction between constituted power (of the state) and constituent power (worker power, without mediation).[35] By contrast, over the course of the 1970s Tronti developed an idea of "the autonomy of the political," in which the sphere of political action (shaped by organizations and the pursuit of power in the political arena) is uncoupled from the shape and structure of the working class. And so, underlying this apparent distinction between "revolutionary" and "reformist" politics was a fundamental disagreement about the role of organizational forms.

To summarize the stakes of this overview of *operaismo* and organization for understanding the politics of art at this same time: organization was not considered antithetical to autonomy. Although disagreeing about models, workerist intellectuals all assumed that organization was essential, and moreover, that it was already inchoate in the most apparently spontaneous eruptions of collective protest. This is a robust intellectual history that gets glossed over and obfuscated by the focus, especially in the United States, on Negri's post-*operaismo* work and writing.[36] When artists and designers asked how they could relate to the social movements of this period, it is essential to recognize that they were not simply trying to connect to a stable political field. Furthermore, by the late 1960s, when the protests erupted, activists, intellectuals, as well as artists, were all aware they faced capital's ability to recuperate crisis and oppositional energy—an assumption encapsulated by Tronti's notion of "within and against," which for many captured the spirit of the age with its call for simultaneous creation and critique. Thus, the anti-institutional stance of the protests in Italy masked a much longer complex intellectual issue (of which many of the participants were aware). If capitalism's modus operandi was deterritorialization and crisis, then the same could not be true for the strategy of the left. Struggles had to be carefully staged and strategically planned if they were not to be co-opted by the crisis machine of capital. (Although, as Tronti even admitted, anger could be a good

starting point, capable of indicating a crack in the edifice or point of contention as a start.) Finally, there are significant assumptions about the limits and possibilities of representation strewn throughout these varied attempts to articulate—and enact—a mutually constitutive, productive relationship between organization and autonomy. Tronti became overly confident in old forms of mediation, and Negri too exuberantly anti-representational, but in all cases questions of representation were at the heart of revolutionary political theory in the 1970s in much the same way that it occupied artists at the same time. The same core question motivated innovations in both fields: the extent to which programs, plans, and other mediating organizational forms might produce autonomy and the kinds of autonomy this would entail. The refusal of simple dichotomies might have devolved in theory, but they continued in practice—as we shall see—in both art and activist innovations for the rest of the decade.

Arte Programmata's *Progettazioni*

Galvanized by the protests of 1968, Arte Programmata put their conception of the program, and attendant notions of freedom and autonomy, to concerted use in the field of design. Spanning a range of media—from graphic designs and site-specific, socially engaged art, to theories of visual communication and concrete programs for self-constructed household objects—Anceschi, Boriani, Devecchi, Massironi, and Mari all conceived of objects (as well as the artist and designer) as a network, enmeshed in systems that both compromise and make them meaningful. Their experimental practices (or, *progettazioni*) offer a model of resistance not as something that happens ex nihilo, in exile, or decidedly against a given structure but within and through it. As with *operaismo,* the issue of language and labor and forms of collective organization were particular centers of concern. This shared arsenal of ideas, however, did not mean that all the artists agreed about how to implement or enact them. The projects explored in this chapter diverge in significant ways, illustrating at once the promise and pitfalls of engaging with *progettazione* (planning/designing) as a method and conceptual conceit.

Within and Against: Anceschi's Graphic Designs in Algeria and Rome

Anceschi's work with the Algerian state-run petrol company Sonatrach is perhaps the closest, and earliest, example of an Arte Programmata artist embodying the strategy of "within and against": collaborating with a nation-state to combat neo-capitalist (and in this case, neo-colonial) forces. Algeria formally won independence from France in 1962, but negotiations and compromises securing French access to Algerian oil and hydrocarbons continued. Sonatrach was first established by the Algerian government in 1963; it was expanded under Houari Boumédiène, who took power in a coup d'état, in 1965. During these early years, Sonatrach progressively took control of the country's oil resources from foreign companies, such as the U.S. companies Esso and Mobil and the UK outfit British Petroleum (BP), in 1967. The process of nationalization was finally completed in 1971, around the same time that a trans-Mediterranean pipeline from Algeria to Italy began its preliminary research stage.[37] Anceschi arrived in Algeria in 1966, during a time of extreme optimism about Algerian national identity and autonomy, effectively standing as a symbol of anti-imperialism to those in the country and also around the world.

Anceschi moved to Algeria with his friend Anne Preiss, whom he had met while studying at the Ulm Bauhaus in the early 1960s. Both were committed communists, and Preiss had served as a "suitcase carrier" for Algeria's National Liberation Front prior to arriving at Ulm.[38] The Algerian government sponsored Preiss's studies, and subsequently invited her back to help with Sonatrach's company design. Anceschi came with her, and the two joined a team of designers. They worked with Sonatrach to redesign the company's brand identity to better reflect its new, centralized role in the Algerian economy and explicitly connect the company to anti-colonial movements. As Anceschi put it, they two oversaw "the creation of a complete coordinated image program" that consisted of "all typographical material, vehicle coloring, service station staff uniforms, exhibition design, press, and international advertising."[39] Anceschi and Preiss spearheaded a new design for petrol stations, changing them to all white with a black stripe. They also streamlined the logo to a simplified black "SH" with orange background.

The stark simplicity of the style was meant to better convey the company's logo (a name that by then had strong political and nationalist connotations) as well as contrast with the colorful logos of the foreign companies such as Esso, BP, and Mobil. In his study of Anceschi and Preiss's work with Sonatrach, Jacopo Galimberti stresses this aesthetic strategy of simplicity and contrast: "Choice to use a single color . . . was then necessary to quickly make the logo of this foreign company [BP] invisible while maintaining the principle of a highly recognizable, coordinated image."[40]

Anceschi's approach to Sonatrach's design identity prioritized legibility, a characteristic of visual communication that he saw as crucial to engendering a sense of community, and in this case, national sovereignty and self-determination. It is also a reminder that such displays of counter-hegemonic power, even by nation-states, were a threat to global capitalism, and perceived by the international left to be so at the time.[41] During the late 1960s, while Anceschi was working in Algeria, the anti-colonial struggles of the nation were linked to anti-capitalism and an explicitly socialist project. At the same time, as Galimberti demonstrates, the upper echelon of the Algerian government (including the design team at Sonatrach) was monopolized by elites, many of whom had much more conservative political positions and some of whom even harbored fascist sympathies.[42] In 1969, when Anceschi was asked by Argan and Filiberto Menna to return to Italy to teach design at the ISIA (Higher Institute for Artistic Industries), he took the opportunity to leave. At ISIA he developed courses in "basic design" and "communication design," some of the first in Italy to frame design in terms of communication systems and information theory.[43]

Living in Rome and working at ISIA, Anceschi actively participated in the social movements erupting all around the country in the late 1960s. And like his fellow Arte Programmata artists, he too engaged with the movements *as a designer*; mobilizing these skills was an integral part of how Anceschi engaged with the struggle for social justice. Anceschi had been friends with the poet Nanni Balestrini from his early days as an art student in Milan, and it was through Balestrini that Anceschi met Antonio Negri and became involved in the local chapter of Potere Operaio. Specifically,

Anceschi collaborated on designing the group's weekly newspaper, which was a central part of the group's activities. Whereas Anceschi's aims in Algeria were to make a simple logo that could assert the power and stability of an emerging postcolonial nation-state (as well as formally manifest its control of natural resources and economic self-determination), in the case of Potere Operaio, he strove for typographical disruption. Anceschi worked with Fabio Bonzi, whom he described as an "anarchist comrade," on designing the header for the newspaper. They chose a "bold condensed" rather than elongated font; this, they felt, made the text assertive, even aggressive, and overtly "industrial." At the same time, however, they wanted the text to be "user-oriented" and more open-ended. This required a different set of typographical strategies. Anceschi explains that in the resulting layout there was "no hierarchy and a seductive variety of characters: the idea was that it was not ethical to manipulate and direct the reader's attention." This graphically translated to the use of a sans serif font (Grotesk), a nonjustified right margin (a "flag" rather than a "block," an "irregularity" that is, to Anceschi, more visually pleasant), and a leveling of textual organization—no headline was larger, no article prioritized in the layout. Anceschi also speaks about the "freedom" he felt using offset printing rather than a printing press, which meant they could crowd the letters and lessen the space between words—a typographical "compression" that the artist associated with "a militant graphics."[44]

Altogether, Anceschi's description of his design for the Potere Operaio newspaper emphasizes the formal, nonhierarchical nature of his layout and how it levels the articles, leaving it up to readers to designate importance and affording them relative freedom in reading. At the same time, the imperative of the newspaper was the rapid dissemination of information, and so Anceschi had to consider legibility as much as, if not more than, anything else. Significantly, for the designer these two demands were mutually constitutive: the same formal strategies that invited user participation also allowed for the most intelligible text. Anceschi's militant design practice therefore contrasted with an avant-garde aesthetics (of montage, for example) in that it prioritized and propagated signals rather than noise.[45] Moreover, his approach points to the ambition among the extra-parliamentary left in Italy

FIGURE 33 Cover of *Potere Operaio*, November 1968. Courtesy of Giovanni Anceschi.

to forge an intelligible collective identity while allowing for a great deal of agency, as well as accommodating differences among individual participants across the movement and within its various groups. The medium of the newspaper itself was a way of navigating this tension between coherence and difference, as the density and intricacy of the articles attest. The graphic layout, as developed by Anceschi, thus engaged in an analogous struggle and formally manifested this desire for a movement whose revolutionary aims could be both clear and complex.

Between Intervention and Interruption: Boriani and Devecchi at *Volterra '73*

Boriani and Devecchi's collaborative project for the exhibition *Volterra '73* was also a concerted attempt by the designers to intervene directly into a specific economy of cultural production, to leap beyond the object and transform a

system of production, circulation, and consumption, and in so doing, restore to this community a modicum of their regional autonomy and control. Boriani and Devecchi had worked together on their 1970 environment (discussed in chapter 3) *Camera distorta abitabile* (Distorted Living Room) for the *Vitalità del negativo* exhibition in Rome; in this case, they came together for a more elaborate, site-specific collaboration that also drew on their distinct strengths and disparate political positions.

Boriani was committed activist who wrote treatises about the political effects of art and was determined to work in noncommercial realms. By the early 1970s, most of his time and energy was focused on teaching and crafting interventions into public space. In his pedagogical approach, Boriani experimented with process, transforming his classroom into a collective laboratory for design research. For his 1971 class "Technology of Material" at the Brera Academy in Milan, for example, Boriani worked with his students to create "Spazio e verde attrezzato," a green space in the municipality of Pizzighettone. Their process included a preliminary assembly, which opened up the design of the space to public input and debate. "Spazio e verde attrezzato" was the first of many course projects that Boriani structured as interventions into the city's infrastructure and architecture.[46] Boriani's classroom operated at the interstice between a protected space for disinterested inquiry and a workshop aimed at solving social ills. In 1973, he taught a course "Gli adetti ai lavori" (Those in Charge of Work), in which the class forged a systematic investigation into the composition of the workforce in the Milan art scene. The group interviewed fifty representatives—artists, critics, gallerists, and collectors—and recorded the conversations and photographed the participants. They presented their findings at the Galleria San Fedele in 1974 in the form of an installation: they filled a room with life-sized cutouts of the photographs of participants, each equipped with a speaker playing the recorded interview. It was, effectively, a collective self-portrait of the Milan art world—closer to one of Hans Haacke's surveys than what Boriani applied to *Ambiente sperimentale* in 1965. But in "Gli adetti ai lavori," in contrast to these precedents, the survey and subsequent social "portrait" was the product of a collective social research project meant to unearth and

give form to the kinds of labor that go unnoticed in the construction, circulation, and appreciation of artwork.

Devecchi is more difficult to situate in relation to the contemporary protests and political shifts, as he fit more comfortably into a conventional conception of design as the creation of objects (rather than behavioral and political systems). In the late 1960s and '70s he was a prolific professional designer, having taken over his father's *argenteria* (silverware company) in 1962. He was generally motivated by political concerns—he worked to design relatively inexpensive objects that actively challenged the material's associations with antiquated ideals of aristocracy and wealth—but this only shows the limits of an object's agency in relation to ossified systems of symbolic and monetary value.[47] His silver designs might boast stylistic breakthroughs, like his 1971 "new forms" series of organically shaped instruments whose reflective surfaces seem to liquify and reconstitute in relation to the surrounding light and space; but when it came to the systems in which they circulated and became meaningful, no amount of aesthetic mutability could affect it or enact change. Devecchi's less militant stance (in comparison with Boriani) is also evident in his distinct approach to teaching. Devecchi's course in "Visual Perception," taught at Milan's Brera Academy from 1972 to 1977, was structured around finding pragmatic solutions to design problems; even the designer acknowledged that his "effort to stick to what is feasible can give rise . . . to some rigidity in the creative process."[48] In Devecchi's collaborations with Boriani, however, one can glimpse a glimmer of another kind of design, and with it, a different kind of productive and creative circuit.

In many ways, the mandate of *Volterra '73* synthesized the seemingly opposed strengths of Boriani's and Devecchi's distinct positions within the field. It helped that the exhibition itself was already strongly framed by the curator, Enrico Crispolti, as politically and socially engaged. An art historian and critic as well as seasoned curator, Crispolti conceived *Volterra '73* as a sustained, creative, and critical engagement between cultural professionals and town residents. He explicitly fled city centers like Milan, Rome, and Turin, where artistic and curatorial freedom was far more restricted, regulated, and subject to state bureaucracies and even fascist-era organizational

decrees. But Crispolti also organized the Volterra exhibition against an important precursor, also located in a peripheral Italian locale: *Campo Urbano*, in which forty artists, architects, musicians, and intellectuals were invited to stage creative interventions into the historical town center of Como for a single day in 1969. Crispolti considered *Campo Urbano* a fleeting imposition onto the city from the outside. It only took place for one day, and most of the artworks were aesthetic impositions rather than sustained engagements meant to enact structural and lasting change. The superficiality of *Campo Urbano* was something criticized by the artists already at the time (and soon after by one of the curators, Luciano Caramel), including Boriani and Devecchi. They contributed a collaborative work, with Gianni Colombo, that thematized the emphasis on ephemerality and its implied valuing of instability, disorder, and chaos. *Tempo libero: Strutturazione temporale in uno spazio urbano* (Free Time: Temporal Structure in an Urban Space) installed an artificial rainstorm in the center Piazza Duomo for a single night (September 21, 1969). Employing hoses hooked to the firehouse supply, electric flashes of light to simulate lightning, artificially induced thunder, and spotlights flashing on and off, the "storm" was a sea of disorienting effects meant to index what Boriani described in the catalog as the limits of such artistic involvements, even their complicity with perpetuating class differences: "We realized that the participation of artists ended up confined to the limits of an ephemeral manifestation, a city festival . . . something useless and completely devoid of any aesthetic or content."[49]

Against the insufficiencies of *Campo Urbano*, for *Volterra '73* Crispolti invited what he called *operatori*, or cultural "workers" (avoiding the term "artist"), from within Volterra and the cities beyond. The participants then engaged in a collective discussion before executing their projects, so that they could assess the proper place and politics of their work. As Crispolti explained, "*Volterra '73* was not born from a table, from a unitary critical design. . . . It was born with the intention to offer a dialectical and problematic panorama of diverse actionable positions . . . as a collective experience in *progettazione*."[50] Reflecting a few decades later, in 1993, Crispolti put it in no uncertain terms: "The greatest scruple that besieged us was that the interventions were not configured in terms of colonization."[51]

In direct contrast to *Campo Urbano*'s quasi-colonial imposition of art, with its fleeting timeline and merely surface, symbolic engagement, Crispolti structured *Volterra '73* to foster both experimentation and social engagement, incorporating ongoing discussions and dialogue with the community from the start. The hope of all involved was to catalyze ongoing, lasting change in the area by working concretely to alter the infrastructure of urban space. This meant that participants in the show engaged the city's most iconic aspects: the psychiatric hospital, which was the largest in the region; the prison in Fortezza Medicea, a looming and macabre presence in the city; and the alabaster industry. For example, artist Ugo Nespolo worked with patients from the psychiatric hospital to make a sculpture with large beams of wood—a pyramid that supported large, flat figures decorated by the patients. Mauro Staccioli (a native of Volterra), constructed a hefty, abstract, metal sculpture that pointed toward the prison with a gesture that seemed both to acknowledge the prison (which most of the populace tried to ignore) and criticize it. Artists worked both within and against long-standing institutions in the town of Volterra, while also explicitly rejecting the constricting context of more central, urban exhibition structures and space.

This strategy of refusing one institution while engaging another, Martina Tanga has cogently shown, put *Volterra '73* in alignment with broader moves in Italian politics toward decentralizing power and dispersing its structures of governance.[52] Since the reconstruction of the Italian constitution in the postwar period, there had been promises of redistributing power to the regions of the country, but this was only implemented in 1970. Crispolti unequivocally asserted the connection between his socially engaged exhibitions and the broader interest in decentralization and (importantly) self-management (*gestione collettiva* or collective management).[53] In his call for decentralization and dispersal, Tanga argues, Crispolti connected contemporary trends in art toward dematerialization and site-specificity with the particularities of Italian regional politics and government structure.[54] But for many artists, the conversations among the far left about autonomy and organization would have been just as relevant to their expanded, participatory work—especially experiments with worker councils and factory self-governance, which were key strategies among the radical left.

Following Crispolti's framework, as well as the participatory ethos that pervaded both experimental art and political activity, Boriani and Devecchi's project, *Progettazione per l'alabastro* (Design/Plan for Alabaster), aimed to revitalize the centuries-old alabaster industry in the city of Volterra by bringing the expertise of these designer/researchers into dialogue with local artisans.[55] Organized by a team of Devecchi, Boriani, Corinna Morandi, and Lorenzo Forges-Davanzati, *Progettazione per l'alabastro* began with a public discussion between the designers and alabaster workers, union leaders, and city officials, with the intention of mapping out the multiple and interconnected challenges facing the industry at the time. The debate took place on February 24 at the Consiglio Comunale di Volterra and was broadcast to televisions placed around the historical center for public, and collective, viewing. (A transcript of the conversation was later published in the exhibition catalog.) As Boriani explained in his introduction to the initial debate, "Our task, as designers, is not to resolve the political problem directly, but to put the problems inherent to design in their political context. Therefore it seems to me that the first thing to do is define the actual situation, in order to work on it, also in the direction of opening new markets across new production, that designers are able to stimulate."[56] Boriani asserts the intricate relationship between research and transformation, knowledge and the capacity to act. The ensuing discussion touched on a wide range of issues, indicating how systematic and diffuse the problems facing the alabaster industry were. Alabaster had been Volterra's main export, from the Renaissance period all the way through the economic boom, until demands for cheaper production costs forced the industry to transition from traditional craft practices to industrial production.[57] Other economic pressures—the influx of tourism and the waning demand for finer alabaster products—meant that the nature of the objects changed as well, from widely exported sculpture and architectural decoration to kitschy consumer trinkets for local sale.[58] A diagram produced by Boriani, Devecchi, Morandi, and Forges-Davanzati for the catalog summarized these issues in full, laying out the issues in a grid so as to visualize their interconnection, from the association of alabaster with the cultural heritage of the city, to its handicraft origins and potential to shift to industrial modes, to the difficulty of attributing a "function" to alabaster

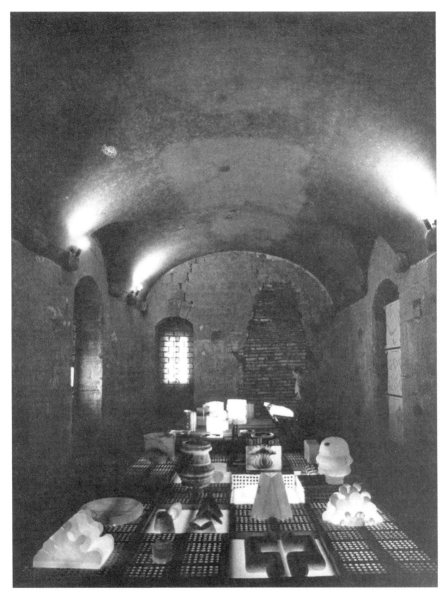

FIGURE 34 Davide Boriani, Gabriele Devecchi, Lorenzo Forges-Davanzati, and Corinna Morandi, exhibition of experimental prototypes made by the group, *Progettazione per l'alabastro,* 1973. Courtesy of Davide Boriani and Archivio Gabriele Devecchi.

objects (their decorative nature), to the general devaluation of alabaster as a material in the eyes of artists, designers, and art students at the time. The February discussion constituted preliminary research for the group, which would help them in creating designs for objects. These designs were intended to do two things: be better suited for industrialized production on a mass scale and appeal to contemporary tastes. For the most part, these models were for lights or small-scale sculptures, although the team did propose some utilitarian objects such as an ashtray and alabaster-encased "radio." The models were put on display for the public in August, alongside rooms showcasing the history of alabaster in Volterra and objects created for the current market (chess sets, lamps, and other decorative objects).

Despite these concrete proposals for objects destined for production, arguably the product that most comprehensively realized the goals of *Progettazione per l'alabastro* was the systematic analysis of the alabaster industry, which took a variety of forms: the broadcast public debates (another was held in October to assess the success or failure, and possible lasting effects, of the project); the printed transcripts of both discussions in the show's catalog; the gridded diagram of interlocking issues of alabaster made by Boriani, Devecchi, Morandi, and Davanzati, also printed in the catalog; and the metacritical discussion among the alabaster industry participants at large that promised to resonate and restructure the community conversation long after *Volterra* closed. *Progettazione per l'alabastro* was design research turned into a platform for rebuilding a collective. It enacted a model of how a collaborative, worker-organized reimagining of an industry might give way to a self-managed, sustainable form of production. Rather than turning its back on an outmoded craft, *Progettazione per l'alabastro* tried to envision a future of alabaster, taking into consideration these conflicting factors between local and international economic pressures, supply and demand, and the changing whims of taste among an unstable, ever-shifting public.

At the same time, Boriani, Devecchi, Morandi, and Davanzati incorporated an utterly absurd component to *Progettazione per l'alabastro,* which they deemed "Anti-Monuments": throughout the town center, the collaborators inserted plaster casts of body parts—legs hanging out a window, breasts, an isolated mouth and nose, a head, even a hand grasping a pistol coming out

of an old stone wall. It may seem, at first, impossible to reconcile these irreverent, quasi-surrealist staged encounters with the artists' sincere, productivist engagement with the alabaster industry in the town. Even as the casts invoke the familiar avant-garde gesture of defamiliarization, an aggressive interruption into the architecture intended to disrupt the audience's habitual interaction with the space, they also, in this context, speak to the limits of isolated experiments like this one. Somewhere between the socially engaged, earnest reboot of the alabaster industry and the incapacitated bodies strewn throughout the town walls, the many facets of *Progettazione per l'alabastro* figured forth the clash between *progettazione* as a strategy and the temporality of the exhibition—between, that is, the process of generating new plans and the irreverent gestures of art.

These two dimensions of *Progettazione per l'alabastro* stage the tensions between organization and autonomy, the latter understood in the negative, anti-institutional sense. Without being too reductive, then, we might consider how the theoretical terms of the debate between Tronti and Negri play out in this practical arena of one local economy and an experimental intervention

FIGURE 36 Davide Boriani, Gabriele Devecchi, Lorenzo Forges-Davanzati, and Corinna Morandi, "Anti-Monument," *Progettazione per l'alabastro*, 1973. Courtesy of Davide Boriani.

via art. The plaster cast body parts assert the impossibility of representation so central to Negri's thinking about collective action; this impossibility is experientially manifest in the absurdity of trying to identify with fragmented figures and dismembered body parts set within the city walls. They are funny, to be sure, but also unnerving—there is even a cast of a pistol, suggesting the violence of representation and a more insurrectionary stance. In contrast, the experiments in new forms of production, management, and control of the local alabaster economy resonate with Tronti's call for working "within and against" an organization in order to redirect it toward more empowering ends. The aim in all cases is to reimagine the basis of collective action and identity, and through a continual process; but these two positions are distinct in how they conceive that representation can assist with this goal. *Progettazione per l'alabastro* mocks the refusal of representation, programs, and solutions at the same time that it also enacts a clear intervention emphasizing process, collaboration, and a responsive, ongoing approach. By employing both strategies within a single (albeit expanded, multimedia) work, this collaborative *progettazione* dramatized the tensions of working within a system that is subject to so many competing imperatives, and the various degrees of agency and kinds of autonomy that are possible, given these constraints.

Collective Language as Common World: Massironi's Psychology of Graphic Images

While Boriani and Devecchi looked to a local economy of craft as a site for elaborating the possibilities for self-determination collection action, starting in the late 1960s Massironi devoted himself to researching the collective dimensions of visual signs, developing a comprehensive theory of graphic images. Like other artists affiliated with Arte Programmata, Massironi was influenced by theories of perception, especially those put forth in the fields of gestalt psychology and phenomenology. These theories ascribe a great deal of agency to the human perceptual apparatus when it comes to organizing experience into something coherent and meaningful; at the same time, they acknowledge that individuals cannot "make" whatever they want out of what is encountered. Whatever experience means, its significance is con-

stituted in and through the relationship between subject, object, and environment, in the negotiation of their physical and formal constraints. These theories of perception presume a material, observable, and scientifically explicable ground for subjective experience, and this was, and is, their appeal.

Massironi's interest in this dynamic understanding of perception and meaning was apparent in his kinetic art of the early 1960s, but he increasingly engaged these theories directly, before formulating his own. In 1967, in an exhibition catalog for a Gruppo N show in Łódź, Poland, Massironi explains his motivation for shifting from the practice of making art to an analysis of graphic language: "By replacing the idea of 'works of art' and instead simulating the aesthetic experience directly by means of the perceptive/imaginative faculties of the observer, visual research leads to the final deconsecration of art. From now on, art will be free from the need to be set against the background of a specific Philosophy, Aesthetics, and will instead be explained—just like any phenomenon—by means of science, namely, by the Psychology of Perception and Gestalt Psychology."[59] In his telling, Massironi stopped using art as a platform because he wanted to unravel the intricacies of perception rather than illustrate the insights of others. But Massironi proceeded to study perception not as a phenomenologist or psychologist but as a design theorist. While he drew on the writing of psychologists and their generalizations about the human brain, eye, and mind, Massironi's theoretical writing stemmed from a rigorous formal analysis of graphic design—not, for example, the study of people's perceptual apparatuses or behavior. By looking at the images rather than individuals, design offered Massironi privileged access to what he would later call "the common world." Graphics, for Massironi, were not merely abstractions, floating above or detached from existence, and thus an index of inevitable alienation. Rather, in his theorization, graphic design formed one of the most foundational, material conditions for collective life.

Massironi's treatise on the psychology of graphic images, *Vedere con il disegno: Aspetti tecnici, cognitivi, comunicativi* (To See With Design: Technical, Cognitive, and Communicative Aspects), only came out in 1982, but it synthesized over a decade of practice and teaching, as well as a few shorter publications.[60] The text explains the formal operations that make graphic

communication possible and effective. His research is propelled by a fascination with the capacity of graphic images, in contrast to language and writing, to convey meaningful information across cultures and epochs, and most of *Vedere con il disegno* is devoted to explaining how and why images function. He identifies three main ways the graphic sign conveys information: through its form, the characteristic of the line; the phenomenological position of the graphic within the plane of representation (i.e., perspective); and the dialectic of emphasis and exclusion, what the drawer/designer chooses to include, highlight, or leave out—that is, the translation from thing or idea to sign.[61] He then analyzes how these three aspects operate in a variety of graphic signs (illustrative, taxonomic, diagrammatic, imaginary, temporal, etc.). A central example examines how much you can degrade, alter, and abstract the depiction of an image of a face and still recognize it.[62] There is a long discussion of the importance of context, how an image conveys meaning, and the ways that images are shaped by what they are meant to do—how all designers are, effectively, always negotiating between signal and noise.[63]

The influence of information theory is telling and shifts Massironi's emphasis from the essential composition of people (and their perceptual processes) onto the material of design itself. Nevertheless, there is a recurring, and symptomatic, tension in the book between ahistorical foundations for communication and contextual, contingent ones. There are moments in the text where Massironi claims that the human perceptual apparatus is physiologically hardwired. He works hard to ground even the most elusive, abstract renderings—scientific charts, taxonomic diagrams, even "hypothetical" drawings of imaginary things—in some representational convention, such as perspective, orientation, and resemblance.[64] At the same time, Massironi acknowledges, "design is an emblematic case of the continued openness and sensibility to cultural variations."[65] He never describes this "hard wiring," instead focusing his analysis closely on the most basic graphic elements (line, contrast, figure/ground, for example). Human vision stands as alternately a priori and produced. Massironi continually acknowledges how the context constrains the shape of a given form. Designers have innumerable choices when it comes to how to construct an image, but they

are constricted by the demand to communicate something, as well as the assumptions that they make (usually unconsciously) about what their audience already knows.[66]

Massironi's psychology of graphic images is therefore an attempt to explicate a concrete ground for collective communication and experience, even as he acknowledges repeatedly that this ground is itself an effect of representational conventions and always in flux. In the 2002 English version, *The Psychology of Graphic Images,* this tension becomes even more explicit: "Multiple representations, however, should not be confused with multiple worlds."[67] "If one is concerned with communication as we are here," Massironi continues, "then it must be recognized that communication is not possible unless there is a substratum of common experience, and there is no common experience unless there is a common world that perceivers share. . . . To communicate means to have a world in common."[68] Becoming progressively more dialectical over time, Massironi maintains that the ground for this communicative process is firmly located within the material composition of design. Again and again, he describes this material composition as a field of possibilities and struggles between competing imperatives—clarity of message, openness of interpretation, ideas or experience, beauty or efficiency. In describing the differences between varying modes of representation, Massironi charts different methods for communicating, experiencing, understanding, and imagining the world; graphic representation, in other words, constitutes knowledge and not the other way around. He even cites Michel Foucault when analyzing taxonomic images (those that epitomize a species, or scientific type or category) and connects their relative abstraction to a particular epistemological realism that arose in seventeenth-century botany.[69] In a later section he examines what he calls "hypothetigraphy," or images of things that do not exist, to suggest that images may not always correlate to the world but that they do evidence important elements of how we think the world works.[70]

Massironi's book is admittedly dense, technical, with some alarming assertions and ahistorical generalizations, and its most interesting insights buried and difficult to discern. It seems a dramatic swerve for one of the most militant artists of Arte Programmata to have taken. Massironi

had a close friendship and intellectual affinity with Negri in the early 1960s, which continued in these later years. In a recent interview, Negri even claimed that Gruppo N's experiments with automated, collective production and perception were analogous to *operaismo*'s interrogation of the integral relationship between subjectivity and machines.[71] It is in light of this affinity that Massironi's later work should be understood. He, like Negri, remained devoted to the idea that subjectivity is produced by material structures, and this idea is continuous throughout their writing and work. And both Negri and Massironi emphasize immaterial platforms like language and communicational networks.

The affinities become even more evident if considered amid the complex debates about organization and the constitutive power of form. Seen within this theoretical trajectory, it becomes more evident how and why *Vedere con il disegno* uses graphic images to slow down, condense, and ultimately analyze what amounts to a societal struggle over meaning, the constitution of a common world. Language is a terrain of struggle through which collective identity and action are organized; it is a condition of possibility for collectivity, for better or worse. In taking this position, Massironi's theory of visual communication points forward to an important contribution of post-*operaismo* theory, which increasingly asserts language as essential to capitalism's most exploitative aspects *and* as a platform for struggle and new forms of collective organization and social change. This approach—one might even say, paradox—is central to Christian Marazzi's 1994 study, *Capital and Affects: The Politics of the Language Economy*, a seminal text for its positioning of language as central to contemporary capitalism and its exploitative, anti-democratic operations. Much of Marazzi's book is devoted to unpacking the "disciplinary structure" of language, and the way that, specifically in communicative capitalism, language allows for the appearance of autonomy (of means, which remain flexible and responsive to various identities and environments) while imposing a unilateral imposition (of ends: profit).[72] But Marazzi does not end up where we might anticipate he would, given his critique, condemning systems and language and advocating for singularities or autonomy and the like.[73] Rather, he concludes that "communicative technologies are not instruments of exile from the world,

nor reversible deviations from reality. Rather, they are mechanisms contributing to *the construction of the world* that we experience as a society, in our way of *being together.*"[74] Throughout the text, Marazzi foregrounds the same balance between multiplicity and unity that pervades not only Massironi's text but also, in varying ways, all of Arte Programmata's artwork and experimental designs. In many aspects, the formal problems that pervaded Arte Programmata from their inception—how to balance systems and spontaneity, how to generate infinite possibilities from a finite structure—are here manifest in the form of political problems: how to figure forth a political organization without domination, to coordinate multiple subjects without crushing what makes them singular.

The interrelated crises of labor, communication, collective identity, and organization underlay a range of Italian intellectual developments in this period, and the design practices of Arte Programmata were no exception; we see these same issues pervading Anceschi and Massironi's interrogation of visual communication and graphic design and Boriani and Devecchi's reimagining of labor, craft, and worker control. *Progettazione per l'alabastro* centered on labor and modes of production, while Massironi's writing emphasized the constitutive power of visual language, but in all cases they were trying to think through the operations that make collectivity possible. These experiments evidence the difficulties as much as the practicalities of this problem: tensions between individual and collective agency, for example, or an optimal process and the actuality of what needs to be produced; conflicts between novelty and convention, and among systems that are evident, but outmoded, and those in the process of being formed. All these projects also stage the very problem of *progettazione,* or planning, as a process at once necessary and fraught.

The demand for alternative forms of political and social organization intensified in Italy over the course of the 1970s, and 1973 was a critical turning point. Many on the far left continued to view the official Communist Party (PCI) with suspicion, while others, notably Tronti, held on to the hope that the party could be a useful partner in the project of social change. Tensions between these factions intensified in 1973, when the PCI attempted a "historic compromise" with the Christian Democrats (DC), which demanded a

swerve to the middle in an attempt to quell what they perceived as revolutionary forces rising on both the right and the left.[75] This effectively meant that the Italian Communist Party submitted itself to the DC's intensely conservative, pro-capitalist program, while gaining absolutely no power or official place in the government. This submission included supporting the DC's proposed austerity measures formed in response to the other major event roiling Italian politics in 1973: the international oil crisis. Set off by the nationalization of oil in OPEC countries (including Algeria, where the ground for this was being laid at the time of Anceschi's work with Sonatrach), the oil crisis raised the price of this essential resource across the globe, triggering economic instability for years. The DC used this (with the PCI's support) to justify cuts to social welfare and worker's rights that they had been wanting to enact all along, effectively but artificially pitting anti-colonial movements for national sovereignty against the livelihood of international workers.[76] These interconnected events of 1973 further tainted the legacy of any kind of "communism" and added to the imperative among those on the far left to reimagine a project for collectivity and community based on something other than these outmoded ideas and party forms.

As these already-existing institutions and ideas became even less viable, activists sought to innovate new ones. The year 1973 saw the founding of Autonomia, which launched a productive period of what Nanni Balestrini and Primo Moroni called *comunicazione autogestita, sovversiva* (self-managed, subversive communication).[77] This included the strategy of *controinformazione,* so important to combating the distortion of truth in the mainstream media. It also came to encompass an explosion of alternative newspapers and editorial initiatives (*Primo Maggio,* for example, and *A/traverso*) as well as an array of free radio stations. As Franco "Bifo" Berardi, member of A/traverso and its free radio station, Radio Alice, put it in retrospect, "New forms of organization—connected with Autonomy, but related to all aspects of collective life and cultural identity—were being established."[78] These concrete experiments with institutions and forms of community were a central part of what Autonomia was and how it worked. They also evince an essential aspect of what "autonomy" meant at this time. Autonomy was formed in and through organizational structures and new institutions. This is how,

and why, Autonomia was as much a cultural as a political movement and found such strong affinities with experimental design at the time.

Self-Design and New Signs: Mari's Experiments in the 1970s

The cultural and political shifts of 1973 constitute the background for Enzo Mari's most experimental designs of the 1970s and help to explain why they took the forms they did. Mari had a successful career as a designer and was better known in this field than any other. His work with the Danese company was extensive, generating some of his most iconic designs such as the Putrella multipurpose tray (1958) made from a single piece of bent industrial steel. From the start of his career, Mari was invested in thinking about design as a platform for both individual action and collective communication, and this is apparent in both his designs and his art. But the 1970s saw an intensification in the political framework for his work. He was active in the 1968 protests and aligned with the social movements of the 1970s, although he did not have a direct relationship to *operaismo* like the other artists discussed here (with the exception of Devecchi, the other three were directly engaged with this particular activist network).[79] Like so many others, then, Mari struggled to make work that was relevant and responsive in this period of politicization and polarization. He continually questioned how (and, at times, if) design might be an effective arena for thinking through and enacting social change.

This continual questioning was an important part of Mari's method of making design in this period. It was, in other words, a productive principle. But it also led to paradoxes across his work, as evident in his inclusion in the Museum of Modern Art's 1972 exhibition *Italy: The New Domestic Landscape*. Mari had more commercial objects included in the show than any other designer. At the same time, he refused to make anything for the show, submitting a statement asserting that designing objects of any kind no longer held any relevance.[80] The fact that Mari's work was spread across two of the most politically opposed parts of this exhibition might suggest a sense of impossibility among designers like Mari, who felt they now faced a choice between total submission to convention and absolute exodus from their field. But Mari's whole oeuvre is devoted to thinking through this dual

positionality, at once "within and against" design. Mari's dichotomous positioning in the New York exhibition is therefore more accurately understood as a reflection of the designer's willful defiance of the more readily legible, conventional strategies for enacting "radicality" in design. For Mari, like many others in Arte Programmata, there was no pure position outside of current systems; rather than paralyzing him, this insight absolved Mari of the simplistic choices that arise from an absolute opposition between complicity and critique.

Some of Mari's most innovative projects developed between 1974 and 1976 are centrally concerned with how to work both within and beyond a given system. They foreground the interrelation between autonomy and organization, epitomizing the idea of *progettazione* as a platform for generating new collectively shared systems of production and communication that not only allow for but advance the capacity for individual agency. As Mari wrote in 1974, "In my job as a designer, or rather as an intellectual who contradicts the actual state of things, I try within the network of commissions and projects to 'smuggle in' moments of research and ways of creating the stimulus to free oneself from ideological conditioning, standard norms, behavior and taste."[81] Three projects are exemplary of Mari's attempt to negotiate the problematic of planning and autonomy in design: one is a real prototype for a radically new mode of design; another is a graphic depiction of Marxist theory, reimagined in light of contemporary challenges; and the third dismantles an ossified revolutionary symbol (the hammer and sickle) to inspire counternarratives and open space for more capacious, flexible interpretations and identities. As we shall see, the practical limits and possibilities for individual autonomy within a network (of production, reception, information) were part of every design decision Mari made.

The project that most lucidly embodies Mari's political design practice in this period is *Proposta per un'autoprogettazione,* created in 1974 for an exhibition at the Galleria Milano. *Autoprogettazione,* literally "self-design" or "self-planning," is a book containing eighteen plans for constructing domestic furniture out of simple wood planks and nails. (It was reissued in 2002 with Mari's input.) Tables, various styles of chairs, a dresser, a wardrobe, a bed, and bookshelves, the designs in *Autoprogettazione* allow anyone to cheaply

furnish their domestic space, and to any scale necessary (the plans specified dimensions, but these were easily scaled up or down). For the 1974 launch of the project at the Galleria Milano, people were given two options: purchase the planks and nails on one's own and then follow the instructions, or procure all the materials necessary to make three pieces, for forty thousand lire, in a ready-made "pack" available from the Simon International Factory in Bologna. Mari stressed how he based the designs on things that "were not so much easy to acquire but that were already commonly owned," such as a hammer and nails, or basic concepts like beams and pilasters.[82] Most found the execution easy. One letter from a successful user (a young civil engineering student, noted only as P.C.) relays how he had cheaply constructed two

drawing tables, four chairs, two bookcases, and a table, and was now planning to make two wardrobes and a bed.[83]

The idea for "self-design" arose out of Mari's frustration with how "radical design" had been imagined and implemented before—namely works made for the mass market but formally manifesting subversive ideals. In 1972, still reeling from the protests of 1968, Mari had tried this more symbolic approach to political design with his "Day–Night" convertible sofa. This, he thought, was design "in the service of the people": low cost, simple construction, streamlined aesthetic.[84] But the sofa was, in these terms, a failure at the time. No one bought it, and its ethical revisioning of the aesthetics and economics of design did not register with its intended audience. The object was unable to transform the context into which it entered. It simply looked like bad, unmarketable design. In contrast to the sofa, Mari's self-design project was designed to be both an object and an alternative system of production, distribution, and use. The whole package of *Autoprogettazione* (book, style, gallery context) was therefore meant to not only *signify* but also *generate* alternatives.

The main purpose of the self-design project, then, was to make users entirely rethink all aspects of the design system. It was in many ways intended to carve out a space for users to experience an instance of unalienated labor, in the DIY, anti-hierarchical, author-as-producer ethos that has come to be associated with countercultural movements such as punk. *Autoprogettazione* invited individuals to enact the change they want to see, working autonomously from and entirely outside of systems of conventional design. But this was also the project's limitation. As Mari himself admitted, "self-design" could not work as a new model to be implemented on a larger scale, because it would be silly to ignore the capacity of industrial production to make objects far more swiftly and affordably than any DIY plan would allow.[85] Thus the "auto" in *Autoprogettazione* exists as both a promise and problem. In its form, mode of production, and circulation and use, the "self-design" project invited its audience to engage in and fantasize about autonomy and escape. But the project also asserted the limits of such strategies, insisting that users grapple with what is lost and what is gained when one works outside a system (in this case, of industrial production and mass distribution). The limits

of quality and scale were evident, and the contrast between this "self" design and the highly visible sheen of contemporary Italian design would have been readily apparent. As tactical, embodied thinking—in which 'viewers' become 'users' and make things—but also as a speculative "proposal," *Autoprogettazione* asked its audience to think beyond the present and imagine what a better, more functional but also equitable system of production might not only look like but also be organized and actually work. This is what Paolo Fossati called Mari's "double attitude": an attempt to reconcile that which "remains a metalanguage, a linguistic discourse on design, and the language of the single object," that is, to occupy a place between "a complex awareness of the problem of design . . . and the necessity to be clear and precise about how design actually does and can function in the world."[86]

There is a tension in Mari's *Autoprogettazione* project that echoes but also reverses the one found in the *progettazione per l'alabastro* from just a year earlier. The project for *Volterra '73* staged a conflict between the absurd gestures of individual artists and the systematic change possible when people work together, within and against a given economy and scale. Mari's "self-design" project also operated on two distinct registers, but here it was split between the object and the plan, or alternate program. At the level of the object, *Autoprogettazione* was pragmatic, a simple and cheap solution to a particular problem. At the level of the plan, however, it was fanciful and experimental, an open-ended, generative platform that launched users into the speculative realm of fantasy and imagined futures. It was far from a clear-cut proposition that Mari delivered to his audience, ready-made.

In the end, *Autoprogettazione* might encourage "self-design," but it also holds out the necessity of another, equally important arena for enacting social change: clear information and reliable networks of communication. Mari expressed frustration with the new social movements of the late 1960s and much of his later work sought to remedy the vagueness of leftist ideology and its inability to draw clear, strategic solutions.[87] Everyone might have agreed what they were *against,* but they were having a difficult time finding consensus on what they were *for.* Mari saw this as a problem of form—or perhaps more specifically, plat-forms: there was no shared language, even to articulate disagreement in a way that could make dialogue productive.

Two of Mari's other experimental designs—*The Atlas according to Lenin* (1974) and *44 Considerations* (1976)—probe this condition from different angles, and in so doing, epitomize the designer's approach to symbols and signs. Yet they do so from the same starting point of an "old" system that everyone thought they knew, even as it was continually being thrown into question: Communism.

Mari created *The Atlas according to Lenin* as an illustrated book in collaboration with the writer and poet Francesco Leonetti. Their objective was straightforward: to depict contemporary capitalist social relations in their totality, through five intricate diagrams intermingled with thirty-six pages of text. The diagrams worked like operational plans. "The Social Map," for example, showed the class structure of capitalism. Class consciousness is figured as the motor, a large orange rotating gear that shoots out relationships: the division of classes, professional specialization, "opium of the people," and repression all threaten to interfere; the bourgeoisie, represented in the bright swaths of green and purple, provides the raw materials and reaps the benefits. Institutions of power—the state apparatus, the police, and the church—appear as little abstracted icons that suggest how they at once condense, intensify, and abstract relations of power. "The Economic Map" delves further into the productive process and its obfuscation. Rendered in black and white, it portrays an assembly line of workers producing cars, which mutate into stacks of money. Surrounding the factory are depictions of culture—a painting of a butchered ox that invokes canonical works from Rembrandt to Velázquez to Francis Bacon and a set of classical, figurative sculptures on display. These Mari labeled as "the ideas that hide the real relations of production." There was also the "historical map," outlining key moments in the development of capitalism; and "geographic map," which telescopes out to a cosmic scale. As a whole, *The Atlas* was at least intended to operate like a didactic machine for the transmission of information through educational diagrams and explanatory text. Two years later, in *44 Considerations*, Mari took an entirely different tack. For this work, the artist disassembled a hammer and sickle, creating a set of forty-four biomorphic sculptures displayed on a grid of pedestals. (A first edition for the Galleria Plura in Milan was constructed in wood; for the Biennale the

FIGURE 38 Enzo Mari, "Economic Map," *Atlante secondo Lenin,* 1974. Courtesy of CASVA Gli Archivi del Progetto a Milano, Comune di Milano.

sculptures were made of marble.) Reminiscent of sculptures by Jean Arp or Henry Moore, none of the shapes retains any resemblance to the original. Next to the display Mari hung a diagram illustrating how the pieces fit together to create the Communist icon, so that the viewer's attention continually shuttles between the entirely abstract, formally innovative, but conventionally meaningless parts and the ideologically overdetermined whole. At the Galleria Plura installation, each piece was also associated with a line from a poem written by Leonetti and given a distinct price.

Taken together, *The Atlas* and *44 Considerations* attempt to salvage what they can of the Communist program while mining old symbols for new forms. They embody two kinds of graphic strategies and ways of reading:

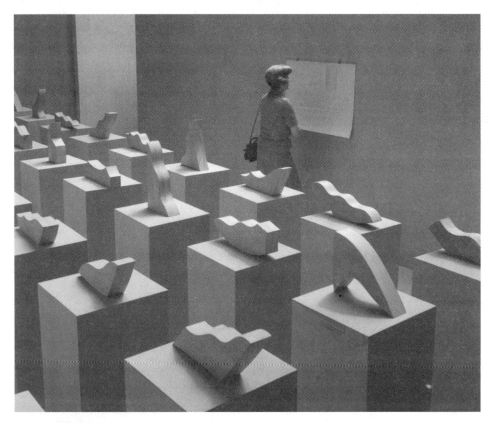

FIGURE 39 Enzo Mari, *44 Valutazioni* (44 Considerations), 1976. Courtesy of CASVA Gli Archivi del Progetto a Milano, Comune di Milano.

44 Considerations deploys formal experimentation to open what had been ideologically closed, while *The Atlas* aims to clarify a set of terms, narratives, and analytical devices in order to render them useful as a shared language for both action and debate. In both projects, Mari considered the actual context in which he was working: *44 Considerations* was set in a gallery, and played with the conventions of sculpture, especially the aspiration of abstract art to be a universal language; and it did so for an international audience. *The Atlas* used the format of a book, and the coupling of image

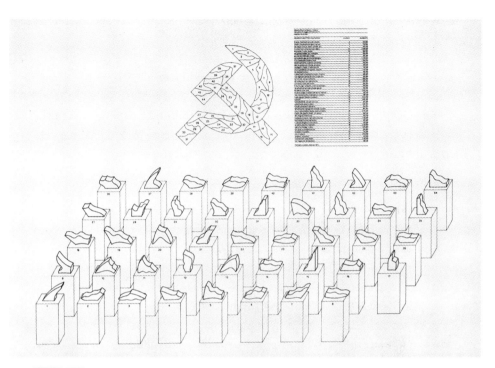

FIGURE 40 Enzo Mari, diagram for *44 Valutazioni,* 1976. Courtesy of CASVA Gli Archivi del Progetto a Milano, Comune di Milano.

and text, to question the self-sufficiency and legibility of both. While aiming for clarity, the intricacy and abstraction apparent in the images in *The Atlas* mean that they are often opaque and impenetrable rather than informational. This book was also intended for an Italian-speaking reader and likely a leftist already committed to thinking through the contemporary relevance of Marxist theory. Both projects are about the legacy of Communism, but they are also about the necessity of a shared language for any collective political program. Each interrogates the conditions of possibility for the formation and clear communication of intentions, aims, and ideas. Tensions between autonomy and organization therefore play out on an experiential register in both works. They each engender a mode of reading in which the

individual is constantly shuttling between conventional ideas and ideologies while also trying to dismantle them and break free.

These three examples of Mari's work in the 1970s, like the other *progettazioni* by Anceschi, Massironi, Boriani, and Devecchi, therefore evince a suspicion of plans at the same time that they invoke the power and scale of their vision. Drawing on ideas developed in their experimental art of the prior decade, these artists recognized that programs, with all their problems, are how we organize collective action—that if we are going to design anything beyond ourselves, we need a mechanism for doing so. Their designs attempted to engage and transform a given system, and many contain seeds of real alternatives. But they also insisted that their plans remain provisional, open-ended, participatory, and even at times absurd. We might then properly characterize Arte Programmata's *progettazioni* as having a *counter-institutional* ethos, gesturing toward a collaborative *counter-plan*— terms that capture the presence of both oppositional and constructive attitudes. They speak to the persistent appeal of *the program* in the work of Arte Programmata, and how and why their investment in relating freedom and structure took form in the intensified political arena of design in the 1970s.

With their desire to dispense with old plans without discounting plans altogether, Arte Programmata had much in common with other Italian leftists grappling with the delegitimization of Communism, especially those involved in Autonomia, for whom a counter-institutional strategy was also central. Artists, designers, activists, and intellectuals of this period confronted a political landscape in which the old plans were delegitimized but there was an immense amount of energy aimed at formulating alternatives that were concrete and compelling—small-scaled, in some cases, theoretically ambitious in others, but in all cases provided the movement something concrete to envision and take pragmatic steps to work *for*. Rather than succumb to the impasses that eventually came to paralyze political theory—autonomy versus organization—these small-scale experiments centered on their interrelation. In so doing, they sought to enact a collaborative method of action and decision-making that also advanced the conditions necessary to ensure autonomy and self-realization for all involved.

Counter-Institutions versus Counter-Design

Characterizing Arte Programmata's designs as "counter-institutional" invites comparison with a better-known political design movement at this time: Italian radical design, also known as counter-design. Exemplified by the practices of such collectives as Archizoom and Superstudio, and figures such as Ettore Sottsass Jr., Gaetano Pesce (who was briefly involved with Gruppo N), and Ugo La Pietra, "counter-design" was characterized by an ironic, insolent tone and alternatively pop, primitivist, and post-apocalyptic style. These qualities were most saliently on display at the 1972 exhibition *Italy: The New Domestic Landscape,* which included a large section devoted to this kind of critical work. The show brought Italian radical design to the attention of the English-speaking world (and continues to be a canonical touchstone of design history in this period).[88] As such, the exhibition crystalized the identity and political approach of these counter-design practitioners into a movement.[89] However, by organizing the show into sections that juxtaposed "design" and "counter-design" environments and "conformist" against "reformist" and "contestational" objects, *Italy: The New Domestic Landscape* reified the opposition between those that worked within and those who worked against design.[90]

The "Counter-Design as Postulation" section of *Italy: The New Domestic Landscape* shuttled between euphoric visions of better futures and demands to confront the catastrophic destruction that would be part of any path for getting there. Archizoom's environment, for example, consisted of an empty room with a single microphone-cum-speaker, which broadcast voices describing a dystopian future without objects alongside utopian visions for a less alienated existence (also without objects). The goal, they explained, was to challenge current ideology and not design anything, in the end. This meant emptying the room and eschewing any constructive vision. As they put it, they "refused to complete a *single* image . . . preferring instead that as many should be created as there are people listening to this tale. . . . Not a single utopia, then, but an infinity of utopias."[91] Similarly, Superstudio created a set of collages ("symbolic images") that tried to envision a new society but did so through negation rather than projection: a

city without objects, free from work, and lacking a rigid, oppressive urban plan. Their environment was empty save a series of life-support structures hooked up to air, water, food, and communication. Ugo La Pietra's *Domicile Cell: A Microstructure within the Information and Communications Systems* was neither a pragmatic proposal nor a critique; rather, it pointed to the irreconcilable tension between the two. Designed as a set of triangular "containers" each with a communications device (a telephone or television) that played recorded content, *Domicile Cell* was designed to illustrate how relationships (between individuals and society, domestic spaces and the wider world) are structured by media technologies. Consequently, the artist claimed, one is faced with an impossible choice: social engagement through insufficient, even oppressive filters of information networks, or total isolation. He designed *Domicile Cell* to show the inadequacy of both options: "The result is a 'crisis' between the user's desire to isolate himself from the context, and his aspiration for an unbalancing inclusion in the system."[92] One final example was particularly apocalyptic: Gaetano Pesce's *Project for an Underground City in the Age of Great Contaminations* laid out a devastating picture of life following total environmental collapse. Half tomb and half stage, his planometric drawings and models encase figures in thick walls meant to continually and ritualistically force inhabitants to confront the inevitability of their own death and complicity in ecological destruction.

From La Pietra's version of "deconditioning" rooms to Superstudio's proposal for a "life without objects" to Pesce's ritualized symbolic space, these "counter-designs" left viewers desiring nothing less than total revolution, but with no vision or plan or even suggestion of how to begin. In all cases, an idea of "the system"—that is, the environment as it actually exists—loomed large as a monolithically oppressive force and instability emerged as inherently subversive. As such, counter-design embodied what Filiberto Menna called in his catalog essay a "negative utopia," "not yet aimed at the building of ideal cities, but rather at an eradication of architecture and city planning, in order to liberate man."[93] Positioning the end of systems as a means for the liberation of individuals, Menna claimed that "if these designers really have to build something, they prefer to make structures and environments that

will enlist the active participation of the user, in the first person, in the shaping and enjoyment of his own surroundings."[94]

Whether spectacularly giving in to outmoded utopian programs, or visually elaborating the logic of capitalist consumerism and playing it out to its auto-destructive end, "counter-design" was resistant to concrete alternative plans and staunchly anti-programmatic. In the style of their designs as well as their political assertions, there is a clear emphasis on individual freedom defined in the negative as the freedom from structure or social constraints. This only intensified as the counter-designers faced perceived failures on multiple fronts. Politically, there was the "historic compromise" between the DC and the PCI in 1973, as well as fatigue with what many felt was unproductive in-fighting among the student movements. Artistically, there was a widespread sense that the 1972 MoMA show evacuated radical design of its radicality and reduced it to a mere style, as well as the general belief that any design was inevitably complicit with capitalism.[95] When everything seemed tainted by the present, only an "anti-practice" would suffice.

But the central figures of the Italian radical design movement struggled to constitute alternative foundations for collectivity and went on to experiment with alternative institutions, just like Arte Programmata. The critical difference was in *how* these collective platforms were imagined. "Counter-design" notably adopted a quasi-primitivist, back to the land approach to subjectivity and collectivity, in which idealized notions of craft and pre-industrial modes of production and community (as well nomadic, flexible living structures) provided a clear contrast to the contemporary environment and even utopian end goal to their critique.[96] The presumption, then, was to exit the urban environment and accelerate the destruction of contemporary capitalist industry, thereby *returning* individuals to something that used to exist. As Catherine Rossi has shown, "pastoral primitivism" permeated the work of Archizoom, Sottsass, Superstudio, and many others in radical design.[97] Projects like Superstudio's *Cultura materiale extraurbana* (Extra-Urban Material Culture) constituted an attempt at an "auto-anthropology" of a Tuscan peasant community.

The anti-programmatic, anti-technological primitivism of Italian radical "counter-design" is most evident in the practices of the group Global Tools, active from 1973 to 1975. Global Tools was a network of seminars, workshops, and zines that spanned the cities of Florence, Milan, and Naples and included members of both Archizoom and Superstudio, along with Ettore Sottsass Jr., Ugo La Pietra, and most of the other main figures of radical design. It was, primarily, an experiment in alternative education. Topics for seminars included techniques of ceramics, woodworking, nutrition, and "survival"—a course that claimed to introduce participants to "humble technology, primitive architecture, temporary shelters, use of water and fire, alternative urban behaviors." Global Tools was also a publication platform, which took the form of essays, instructions, and bulletins published in the journal *Casabella* during the group's active years. The aim of all of these was, a bulletin put it in 1974, "the free development of the creative individual."[98] They positioned themselves explicitly against the model of the Ulm Bauhaus and wanted to be "a school of formation, not information."[99]

The publications and seminars of Global Tools imagine they are enacting a process of *undoing* and *unschooling* as a means to uncouple creativity from the imperatives of industry and art—as well as, less explicitly, politics. Archizoom member and Global Tools founder Andrea Branzi put it this way: "Global Tools was not founded with the purpose of carrying out any particular ideological scheme or of elaborating any particular social and methodological model; in fact it moves within the limits of an operational field lacking any formal programming, a field in which the results are not compared with reference models but absorbed as acts of spontaneous communication."[100] Simon Sadler recently characterized this as a "tool globalism," and connected the group to those in the U.S. counterculture also focused on design, like Stewart Brand's *Whole Earth Catalog,* Ant Farm's experiments in nomadism, and Paolo Soleri's Arcosanti commune. For these groups, Sadler explains, "the aspiration to 'autonomy' on both sides of the Atlantic shared a suspicion of government, corporations, political parties, trade unions, and of all forms of hierarchical social and political organization from which to gain autonomy."[101]

Despite its members' insistence that Global Tools was anti-program, anti-project, and against plans of any kind, the group was operating with a set of assumptions about community, collectivity, and the foundations that make these social subjects possible. The distinction between "counter-design" and "counter-institutions" has to do with the temporality of the collective that they conceive: "counter-design" imagined an idyllic return to a lost past, and so their strategies—be they an accelerationist or primitivist slant—necessitated destruction. They imagined that this would unleash an otherwise suppressed, but nevertheless a priori ideal subjectivity and collectivity. Arte Programmata's designs, on the other hand, engaged with current systems, designing objects that creatively redirected them, and sought to construct new platforms that might allow a better future to collaboratively emerge. For them, collectivity existed firmly in the future and was the object of interrogation and construction, rather than an uninterrogated ground. The comparison between these two political design movements demonstrates that the opposition between "pro" and "anti" programmatic approaches, like in politics, only obscures the ways that programs are always present, even—and especially—when they are explicitly held up as something to avoid.

Two Critiques: Complicity and Failure

This chapter has sought to demonstrate how and why the program, as well as attendant notions of planning and *progettazione,* were foundational to how figures in both art and politics elaborated the ways that collectivity could operate and be radically rethought. Even as "programmed art" as a practice disintegrated, the theoretical and political concerns about freedom and structure continued in many of the participating artists' design practices. This had important resonances with *operaismo*'s interest in the relationship between spontaneous action and organization, as well as Autonomia's alternative institutions. Of course, not everyone used "the program" to think about the relationship between autonomy and organization, or freedom and structure, but in 1970s Italy these terms continually recur in the work and writing of artists and intellectuals alike.

Situating Arte Programmata's *progettazioni* within the discursive land-scape in which notions of autonomy were qualified and understood puts pressure on conventional ideas about the political agency of art. Namely, this contextualization makes apparent the ways in which Arte Progammata's works undo the language of complicity and efficacy. Charges of complic-ity have recurred throughout this chapter and presume that any engage-ment with plans, programs, and even the most socially conscious design will devolve into total subservience to the status quo. These are terms and practices so enmeshed in current systems of power that they will reproduce them, no matter the intentions of those who use them, or how. This per-spective propelled the anti-programmatic stance of Italian radical design, as outlined above. But charges of complicity force practitioners to either accept defeat, and give up working, or rely on fantastical spaces presumed to be wholly outside current systems. By contrast, Arte Programmata's designs were based on the presumption that one is always simultaneously within and beyond a given system, never wholly incorporated nor fully immune. In so doing, they were also able to eschew the essentializing notions of col-lectivity that became so rampant in radical design. Focusing on the plan, the technological platform, or mode of production allowed these designers to elaborate the *how* rather than the *what* of collectivity. By eschewing an all-or-nothing logic of complicity with systems, they could emphasize opera-tions rather than essences.

Charges of failure, by contrast, ignore how Arte Programmata's *pro-gettazioni* foreground the problem of individual agency, which is always dwarfed by the systems one seeks to confront. The works themselves the-matize this very problem; they are *about* the limits of individual autonomy. The specter of failure is already there in the works themselves, through the absurd elements that punctuate so many of them, and as statements of self-criticism issued by the designers. Mari issued one such claim to renounce design for the 1972 MoMA show. This same year, Boriani wrote a scathing critique of an exhibition of Mari's work titled "Svendita" (For Sale), claiming that designers "cannot harm the system any more than a pin can harm an elephant."[102] Design, this perspective would have it, is powerless in the face of overarching systems that require transformation. The artists themselves

seem well aware of this challenge facing all artists and designers; there is always a limit to what a single person (or small group of people) can do.

Arte Progammata's designs underscore the importance of institutions to the autonomy of individuals, but so too do they accentuate the ways that individuals exceed or elude institutions. Even their most pragmatic proposals work like their abstract art: as imperfect representations. The experiential, aesthetic dimensions of Arte Programmata's *progettazioni* continue to invite us to confront the relationship between technological platforms and collective action, freedom and organization, and even democracy and design, unsettling the imaginative impasses that continue to posit these terms as opposed.

CONCLUSION

We arrive, in many ways, where we began. It was in the late 1970s, in Italy as in so many other countries, that the social and political conditions that allow a historical analysis such as this one came to fruition and have continued to dominate ever since. These are conditions broadly associated with neoliberalism and involve a host of insidious reversals: participation becomes submission and self-management another form of servitude; freedom is just another kind of control, leisure is labor, and creativity—far from a line of flight *from* systematicity—is demanded of all of us, all the time. Byung-Chul Han summarizes the situation aptly: "Today's crisis of freedom stems from the fact that the operative technology of power does not negate or repress freedom so much as exploit it. Free choice *(Wahl)* is eliminated to make way for a free selection *(Auswahl)* from among the items on offer."[1] Han is one of many scholars to chart the instrumentalization of freedom in our neoliberal present;[2] he advances these analyses by examining how technologies of power like social media and digital capitalism hyperactively produce an individual's "feelings" of liberation—physical participation, psychological activation, affective fulfilment—while foreclosing the conditions that make collective self-determination possible.[3] The end is the beginning, then, because these are the circumstances and categorical confusions that brought to light the key concepts of this book—freedom, control, collectivity, computation—and made the complexity of their interrelation in urgent need of address.

While consciously shaped by the present, however, this book has also

held it at one remove, in order to draw out the historical pressures and conceptual paradoxes that prompted artists and intellectuals to imagine other possibilities for these terms and technologies whose significance seem so irrevocably entrenched today.[4] We have seen how the artists of Arte Programmata intensified their control over the small-scaled environment of their artworks, for example, but—in direct opposition to the technocratic domination described by Han—to pursue a collective sensibility that was being programmatically eliminated from other fields. By thematizing the disconnect between imagined alternatives and what has come to pass, this study has advanced, or at least sought to complicate, the ways that the political capacity of art and technology have come to be understood: by problematizing open-endedness and showing it to be less straightforward than we think; by asking after the opposition between freedom and control and how this polarity affects, and even arrests, our conceptions of collectivity and social life; and by returning to the issue of communication and asking whether, in an era where capital deterritorializes everything, dysfunction can or should remain such a laudable strategy of critique.

To this end, this book has situated Arte Programmata artists like Enzo Mari, Davide Boriani, Giovanni Anceschi, and Manfredo Massironi in the historical, discursive, and political contexts in which they worked and understood the meaning of their forms. It has teased out how and why these artists were concerned with freedom, not only as enacted by individual subjects but also how freedom exists (or fails) in the arenas in which subjects interact, the spaces that they share. As an art historian, I focused my attention on artistic instantiations of these issues, examining how artworks reflect ideas about subjectivity, an individual's agency and attention, and how phenomenological spaces and communicational networks convey a sense of collectivity in the artwork and potentially beyond. But I have also stressed how these questions of form and collectivity connected art and politics, as actors in both arenas engaged in parallel and intersecting attempts to rethink the nature of representation, organization, individual and collective identities, and the widening gulfs between. By way of conclusion, then, I want to trace what happens to this dialogue between art and politics, since it is during this period that the language of the historical avant-garde seeped into activ-

ism with an intensity like never before. Examining how social movements and political theorists drew on art, and recast its history, can help us assess what an art-historical perspective might contribute to this interdisciplinary inquiry into the form of politics and the politics of form.

It is often said that "1968" lasted a decade in Italy, in contrast to France and the United States. This *longue durée* is just as often called "a laboratory," due to the immense innovation and expansion of tactics of resistance that developed over the years.[5] The party form remained a bad object, and parliamentary politics a crucial foil for the revolutionary left. But in rejecting this conventional field of "the political"—becoming "post-political," as subsequent scholars have said—there was an explosive diversification of strategies across movements in Italy at this time. The break between Negri and Tronti traced in the last chapter was in large part about organization, but it also hinged on disagreements about *where* to focus one's energies in the struggle for transformation. As such, their debate reflects changes in actual tactics as they played out on the ground between 1968 and 1977. Although Tronti was one of the first to theorize "the social factory" as an expanded field of capitalist exploitation, in the 1970s he started emphasizing the autonomy of the official political arena. Negri, on the other hand, stressed how the political had collapsed into the social field, rendering traditional political organizations and concepts (the party, the state, the union, the working class) not only undesirable but effectively obsolete.[6] Negri's ideas better reflect the actual strategies of Autonomia, especially as they changed from its founding in 1973 to its culmination in the "Movement of '77," also known as Settantasette. Autonomists (albeit immensely diverse) increasingly centered their activity on sites of social reproduction—the household, the social center, the production and circulation of knowledge (alternative publications, zines, broadsides, offset pamphlets). In becoming "post-political," then, activists asserted "the autonomy of the social"—a notion that points to the more positive dimensions of refusal and launched an immense array of realized experiments in autonomy and self-valorization. But the framework of "the social" also conflates disparate (and overtly opposed) strands: proletarian youth organizations led by squatters and movements for *autoreduzione* (organized price-setting), feminist critiques of *operaismo* asserting the

importance of the family and unpaid housework as a sphere of exploitation and terrain of struggle, and attempts among university students to organize autonomous university and "self-teaching," to name a few.[7] Still, as Michael Hardt has explained, "the movements became a form of life. . . . Students, workers, groups of the unemployed, and other social and cultural forces experimented together in new democratic forms of social organization and political action in horizontal, nonhierarchical networks."[8] "Laboratory Italy" continues to be an inspiration due to this incredible broadening of the sites and subjectivities engaged in a struggle for self-determination.

It is through the emphasis on social reproduction in the late 1970s that art so explosively entered the political scene. What has come to be called "creative" or diffused Autonomia seized on the language of avant-garde negation and immediacy and claimed this legacy for their own.[9] Futurism, Dada, surrealism, and constructivism—all read through the lens of Situationist *dètournement* and writings of Gilles Deleuze and Félix Guattari—modeled a project premised on pleasure, creative expression, accessibility of art and culture, and liberation in everyday life. Comprising performance and street theater groups, free radio stations, and publishing collectives, creative Autonomia embraced absurdity and opposed organization; they hailed nonsense and strove for illegibility, attempting to not only reduce exploitation but mobilize desires to realize a more satisfying, liberated existence at the level of everyday life. Groups like the A/traverso collective, founded in 1976 and based in Bologna, developed notions like "Mao–Dadaism," which combined the avant-garde project of synthesizing art and life with what they saw as Mao's rejection of "hypostatic representation".[10] The collective published fourteen issues of an experimental magazine, the most prolific among more than seventy activist zines that flourished between 1975 and 1977.[11] As Nanni Balestrini and Primo Moroni explain, this dimension of Settantasette involved a synthesis of "the historical avant-garde, Maoism, but also hippie philosophy, orientalism of the sixties, happy and communitarian utopianism, connected with the pessimistic predictions of 'critical theory.'"[12] Actual tactics took a range of forms: from improvisational call-in radio broadcasts to the ludic protests of the Metropolitan Indians (whose primitivizing tendencies require more analysis than is allowed here); from the publication of

"fake" events (like a meeting between Argan and Pope Paul IV to denounce the historical compromise) to the printing of "perfectly falsified" train tickets that could actually be used.[13] These diffuse and experimental strategies emphasized the centrality of language in any liberatory politics—a poetics of transformation, transformation *via* poetics.[14] A/traverso's editorial collective summarized it best: "It was a new way of understanding the political organization. No longer the party, no longer large, politicized structures, but an organization born from below, from everyday life, from relations of love and friendship, from the refusal of waged labor and the pleasure of being together."[15]

For all their emphasis on techniques of mediation—language, radio, the printed word—there is a decidedly anti-representational ethos to this creative strand of Settantasette. A/traverso's 1976 publication *Alice è il diavolo: Sulla strada di Majakovskij; Testi per una practica di comunicazione sovversiva* (Alice Is the Devil: On the Street of Majakovsky; Texts for the Practice of Subversive Communication) became a kind of anti-mediation manifesto for this countercultural milieu: "To blow up the dictatorship of Meaning *[Significato]*," they wrote, "to introduce delirium into the order of communication, to make desire, anger, madness, impatience, and rejection speak."[16] Rejecting significance was a means to dismantle broader systems and codes, and linguistic interventions amounted to revolutionary redirections of the real.[17] Of all their tactics, the free radio network did the most to buttress the idea that experiments at the level of language could engender the collective actualization of alternative ways of life. Danilo Mariscalco has argued that the free radio movement central to creative Autonomia amounted to a working-class appropriation of technology. The speed and range at which communication could occur, as well as its participatory nature, meant that free radio could foster, in Mariscalco's words, "a common and immediate—temporally and politically—process of self-representation and self-organization, [and the] 'self-production' of imaginaries and possible realities."[18] No doubt this was how it felt to be on the ground in Bologna, making zines and improvising radio broadcasts, reading texts together about the incendiary power of desire. But this scale of the everyday obscures another essential condition. In Italy, radio was restricted to public

networks (Radio RAI), which could be censored by the state, until its liberalization in 1976.[19] This opened the airwaves to autonomous radio stations. This policy change was a condition of possibility for the freedom to create alternative networks, to circulate information of any sort (be it about a political event or an assertion of the impossibility of politics) without being censored. It was only due to this infrastructural support, then, that radio came to have its symbolic significance as a model for collectivity more fluid, more liberatory, and more desirable (and capable of accommodating desire) than the party or the state. In many activists' articulations, the immaterial network of the radio figured forth an ideal of a collective in continual becoming, based on processes of communication that never crystalized; many involved were actually opposed to *counterinformational* strategies, regarded as too conventional in its approach. But this negative freedom (from *significato* itself) was only made possible by a positive one (a change of policy at the level of the state). Only after the opening of radio in 1976 did the radio network itself (regardless of ownership or content, but especially because the content tended toward the absurd) flourish as a network in continual becoming but also immediately real, the antithesis to the party and traditional political sphere, insofar as it refused to condense, settle, or actually take shape.

The radio network emerged as the perfect model for a collectivity that does not dominate or eliminate the singularities within. However appealing (and familiar) this assertion of the radicality of creative praxis may be, such an anti-representational ethos arguably confuses *a critique of representation* with *a fantasy of perfect representation*—there is never a limit to the desire or will expressed. This fantasy refreshingly evades the problems (of inclusion and exclusion, or access and accountability) that arise with any collectivity, not just more codified forms like the party and the state. Art furthered this fantasy of escaping mediation, but only when one focuses attention on platforms (of production) instead of forms (of reception), the process of communicating rather than being understood, and when the broader political framework and context—the conditions for decoding, so to speak—were bracketed out or otherwise ignored. Indeed, these claims of realizing the historical avant-garde project of collapsing art and life seem to only work when one disregards participants' actual political engagements, allegiances,

and anxieties. The politics of the avant-garde practitioners, and the ways they resist synthesizing the disparate strands into any single "project," are nowhere discussed by the protagonists of creative Autonomia: the anarchism of Tristan Tzara and Hugo Ball (in comparison to the Spartacist sympathies of Raoul Hausmann); the tortured Trotskyism of André Breton and the attempt by many surrealists to formulate alternative communisms. Perhaps most appalling in the Italian context, although the agonism and absurdism is everywhere acknowledged, the fascism of so many futurists is never mentioned—despite the clear resonances among the liberatory claims of the free radio movement with F. T. Marinetti's "words in freedom" manifestos of 1914 (the content of which contained explicit descriptions of war).[20]

Rather than amplifying the central questions that propelled other dimensions of Autonomia and *operaismo*—what is autonomy, how might it be enacted, and what new forms of collectivity and organization might aid in its realization?—art (or more precisely, a particular idea of art) effaced them. This was not lost on contemporaries. Umberto Eco wrote a series of articles about the uses of language and art in these new social movements, and many single out A/traverso (and one of its most prominent members, Franco "Bifo" Berardi) for their "aesthetic vitalism" and for replacing representation for reality at the very moment they presume their collapse. For Eco, the revivification of the avant-garde in this new context only cast its unresolved contradictions into striking relief: "The ideology of desire can only be satisfied by the old utopia of an aesthetic society, where art and life are confused precisely because an achieved harmony has been guaranteed. But in a society that has not yet realized harmony a double question arises: how can I act so that my desire of today does not kill my desire of tomorrow, and how can my desire not suppress yours?"[21] Eco's critique rearticulates the very problems with which we began: What is the nature of freedom, its conditions and limits? How do these notions of freedom relate to, even foster, forms of collectivity, collective action, and social life? By drawing on an artistic legacy of experimental forms and unfiltered, exuberant expression, these activists sublated the tensions between individual and collective liberation; they ignored the gaps among the nodes in a network by valuing the network form as a solution unto itself. What becomes evident in any close

examination of creative Autonomia is that even claims for immediacy rely on metaphor, on the analogical power of particular forms.

Art history, then, is already internal to these political debates and movements about form and collective agency—be it "the political," "the social," or any number of terms one might invoke to name this force. What forms the social, and how might it be *re*formed? This question drove the immensely creative and productive period of activism in Italy between 1968 and 1977, just as, this study has sought to show, it was a central concern of artists and activists for several years before. By the late 1970s, many activists presumed representation itself to be a totalizing (even tyrannical) endeavor. They mined the history of art for models for experimenting with—and realizing—new and liberatory modes of collective life. In many cases, however, this turning to avant-garde forms left the very issue of *the form of the social* unresolved, even something one could presume to be a priori, rather than an open question to be actively engaged.

This book has traced an art-historical movement that aligns with another trajectory of thinking about the form of the social, one that emphasizes the constitutive possibilities of structures, systems, and representation, rather than imagining their disintegration or escape. Rather than presuming these platforms to be total, the interactive and participatory systems of Arte Programmata endorse a notion of representation as *imperfect*. Arte Programmata's artworks orchestrated encounters with systems; they demanded their audiences to constantly engage *and disengage* with representative forms and platforms, asserting that their promise (not their failure) lay in maintaining an incommensurability with the subject or self. This, then, engenders another way of imagining the politics of art, not in terms of collapse (and the harmony among people, and across spheres, that this presumes). Arte Programmata's interrogation of form and representation is constitutive of a particular kind of politics that works against this romanticization of immediacy, against the dissolution of aesthetics with politics, the social and political spheres. The program was never a perfect solution: tracing it as a concept that moved across time, space, and material instantiations has crystalized the limits of thinking of art as a model that can be easily transposed. Instead, the program allowed artists to pose the form of

the social as a problem, making art into a space to interrogate how context determines how these forms operate and tease out the distinction between individual and collective identities and capacities as they manifest in different spheres.

The idea that a given system, structure, or form need not entirely and perfectly incorporate, visualize, or otherwise include individuals has been percolating throughout the book. It was, after all, this blend of shape and indeterminacy that made "the program" such an appealing platform to think with starting in 1962. These same qualities are central to cybernetic theory (and its epistemology of uncertainty discussed in chapter 2). Nodes in a cybernetic system never obtain perfect knowledge, but nor does the system need to totally incorporate every aspect of its parts. This is not, of course, *inherently* liberatory—uncertainty can be mobilized to nefarious ends. But cybernetics offers a theory of representation that is neither straightforwardly *anti* nor absolute. It allowed artists, among others, to approach the problem of representation *as a problem,* without falling into the dichotomous framework of totalization or failure, which often substitutes condemnation for the descriptive and analytical work of critique. What is more, considering Arte Programmata in a broader history of Italian political thought, as in chapter 4, enabled us to recognize that, within the political sphere, distinct approaches to form and representation were responsible for many of the tensions that existed between creative and the more organized, or political, strands of Autonomia, tensions that still resonate within activist, and art-activist, milieus today.[22]

This period in Italy was in many ways a laboratory aimed at experimenting with new modes of collective life; it was, then, also a machine for generating new concepts of collectivity. These concepts, notably, drew heavily on the two arenas central to this book: art and technology. This allowed a clear confrontation with the limits and possibilities inherent to structures of mediation as easily as it fostered a fantasy of its escape—an oscillation that has only become more amplified in current iterations of post-Autonomist thought. Some of the most important contributions of this tradition are notions such as "the common" and "the multitude," which—especially in Hardt and Negri's influential theorizations—invoke the language of networks

and computerized communicational channels.[23] But they have largely emphasized process and immediacy, thereby evading these knotty issues of mediation and form.[24] These texts echo an exuberant embrace of recent re-theorizations of community, and its impossibility, among art historians and contemporary artists. This is especially evident in the work around relational aesthetics and social practice, in which the medium is understood to be social relations themselves and the project of "collapsing art and life" is presumed to be achieved simply by bringing people together, without (presumably) any mandate or mediating form.[25] In contrast to this fantasy of immediacy, and the conception of political action (or post-political activity) that it figures forth, this study has sought to show that there is no way to conceive of collectivity, of "life" or "the social," without form. It has traced a path through another art history, then, a different avant-garde trajectory of affecting, and conceptualizing, life. This notion of the avant-garde project, and the politicization of art that continues it into the present, presumes that the connecting tissue of art and life can be found in these forms, analogies, models, and metaphors. This is not to say that there is a smooth transition from one arena to the next—that one can seamlessly transport an artistic program, for example, into the political sphere. To the contrary, these metaphors stage a set of confrontations with the limits and exclusions that arise with any form. Tracing Arte Programmata's use of "the program" has brought about a critical engagement with categories that seem to some to be tainted beyond repair: technology, communication, organization, and to a lesser degree "the political" and the state. That collectivity, freedom, subjectivity, and social life cannot be thought without these structures—although not reducible to them—is a central lesson of this book. This dynamic network is hidden in the language of freedom—indeed, hidden *by* this language of freedom, when defined in opposition to programs and used to perpetuate the fantasy that creative expression can look the same in art and life. To unsettle the obfuscating operations of freedom requires more than understanding programming as one of its conditions, although this is a large part of what needs to be done. Programs are the determining conditions of our everyday, terms of individual expression, the nature of meaning, structure

of communication, and the terrain on which social and political life is enacted and understood. Recognizing this also means parsing liberation from freedom and reckoning with what kinds of durable structures can best support a liberatory project, and how. It involves seeing in the program everything we wish freedom could be.

ACKNOWLEDGMENTS

If this book dwells on the importance of collectivity for sustaining art, ideas, and life itself, it is because I have been fortunate to have so many brilliant friends, colleagues, mentors, and generous acquaintances that made writing and thinking not only possible but a delight. The central ideas of this project first emerged in the intersection of two overlapping communities that I was a part of in the early aughts: an activist-art milieu in New York City, which had a close but complicated relationship to participatory art and relational aesthetics as it was reaching its critical height; and an intellectual network of friends sharing in a flurry of excitement—and multiple reading groups—centered on Italian Autonomist Marxism, galvanized by, among other things, Michael Hardt and Antonio Negri's publication of *Empire* (2000) and its sequel *Multitude* (2004). Encountering escalating calls for "open-endedness" among artists at the same time I was devouring essays on social reproduction, the commons, and constitutive power was formative, to say the least. It took many years and a few disciplinary swerves to find a project that could so perfectly synthesize, historically ground, and sustain an inquiry into questions about agency, freedom, and collectivity that this moment first incited (inchoately and chaotically at the time). Romy Golan introduced me to Arte Programmata and the fact that Eco's writing on the open work converged with this weird kinetic abstraction that defied everything I ever associated with political art. She advised the dissertation that became this book, offering countless insights and off-the-cuff suggestions that proved to be essential; most of all, Romy modeled how the close

reading of artworks can complicate what we think we know about history. Claire Bishop continues to inspire and inform what I think art history is and should be, and it's impossible to overstate the importance of her mentorship, scholarship, and friendship for this project, and far beyond. Thanks also to David Joselit and Fred Turner for their careful reading of my dissertation and generative feedback that propelled its transformation into the book that it became. I was also privileged to learn from inspiring scholars in both the art history and sociology departments during my time at the CUNY Graduate Center: thanks especially to Geoffrey Batchen for his encouragement and challenges to my most ingrained assumptions, and to the late Stanley Aronowitz for teaching me contemporary social theory and the history of ideas—especially those pertaining to the relationship between systems and agency, subjects and structure, which are foundational to my thinking (and teaching) about almost everything to this day.

This project also benefited at a formative moment from my participation in the Whitney Independent Study Program. I would like to thank all the participants and seminar leaders at the ISP, especially Alexander Alberro, Benjamin Buchloh, Tom McDonough, and Ron Clark, each of whom offered advice, support, and incisive questioning that has stayed with me and shaped this project for the better. This book came into its own at Brown University, where colleagues generously offered insights, advice, and specific feedback on its arguments and ideas. Thanks to Sheila Bonde, Evie Lincoln, Jeff Muller, Dietrich Neumann, Doug Nickel, Itohan Osayimwese, Gretel Rodríguez, and Holly Shaffer. I would like to give special thanks to Jeff Moser, who read the whole manuscript in the final weeks before submission and offered essential edits and astute comments. Thanks also to Massimo Riva and Suzanne Stewart-Steinberg in the Italian studies department for stimulating conversation and the opportunity to workshop chapter 2; Allison Levy for publishing advice; and Foad Torshizi at RISD for his feedback on my book's Conclusion.

I would like to acknowledge and thank the many institutions that granted me access to their archives and provided image permissions, and the associated individuals who generously helped me along the way: the Archivio Storico Olivetti in Ivrea, Italy; the Archivio Storico delle Arti Con-

temporanee at the Biennale di Venezia in Venice, Italy; the Centro Studi e Archivio della Comunicazione in Parma, Italy; the Biblioteca del Progetto at the Triennale in Milan, Italy; the Muzej suvremene umjetnosti Archives in Zagreb, Croatia; the Archives of the Museum of Modern Art, New York; and the Institute of Contemporary Art and Tate Archives, both in London. Thanks also to Karen Bouchard at the Brown University Library for her help tracking down particularly rare books. I would also like to thank the Archivio Devecchi, Archivio Ugo Mulas, Foundazione Pistoletto, Archivio Gianni Colombo, and La Galleria Nazionale d'Arte Moderna e Contemporanea in Rome, CASVA Gli Archivi del Progetto in Milano (which holds Enzo Mari's papers), and Michele Massironi for their generosity and assistance with illustrations. Thank you also to Giovanni Anceschi and Davide Boriani for graciously sharing their writings, memories, and images with me.

The development and completion of this book at the dissertation stage benefited from funding through the American Council for Learned Societies for the Dissertation Completion Grant and CUNY's Center for the Humanities, through both a three-year Humanities Fellowship and a Mellon Dissertation Fellowship in the Humanities. The latter was part of a yearlong, interdisciplinary seminar on "Images and Information," and I would like to thank all the participants, especially the organizers Valerie Tevere and Charity Scribner, for their feedback during this enriching year. Thanks also to Aoibheann Sweeney and Katherine Carl at the Center for Humanities. I would like to thank the participants in the three interdisciplinary seminars that I co-organized with Claire Bishop, particularly those involved in the 2012–13 "OSXXI: Art History and the Digital Turn," for such engaged dialogue, especially Kenneth Goldsmith, David Grubbs, and Tan Lin. The book received a grant from the Millard Meiss Publication Fund administered by the College Art Association, for which I am grateful. A Humanities Research Fund at Brown University provided funds to have Francesca Zambon help me with the time-consuming work of securing illustrations and permissions, and I thank her for such detailed work.

I am incredibly grateful for friends and colleagues who at various times and in myriad ways fostered my thinking and writing. The camaraderie I found among the community of graduate students at the CUNY

Graduate Center sustained me and this project from its emergent stage. Many read chapters (multiple times) and all continue to inspire me with their work: Saisha Grayson, Andrew Cappetta, Nikolas Drosos, Media Farzin, Arnaud Gerspacher, Rachel Wetzler, Janna Schoenberger, Beth Saunders, Nara Hohensee, Michelle Fisher, Lauren Rosati, Daniel Quiles, Martha Schwendener, and Kerry Greaves. I'm grateful also to friends in the sociology department, especially Jamie McCallum, Jesse Goldstein, and Alyson Spurgas. Thanks to so many other friends and colleagues: Nadja Millner-Larsen is an important interlocutor for my thinking about anti-representation, and I thank her for the helpful feedback on my Conclusion. Jacopo Galimberti has been generous with his scholarship and conversation, and I thank him for offering his comments on chapter 4. Thanks to Gigi Roggero for sending me his books on *operaismo* at a crucial moment, and to him and Anna Curcio for showing me the importance of autonomous institutions (and amazing food) for sustaining militant research in Italy. Thanks also to Malav Kanuga and Kevin Van Meter for generative discussions about Autonomia and other Marxisms. I am grateful to Larry Busbea for his generous and helpful conversations. I would also like to express gratitude to two pairs of organizers, Ruth Erickson and Catherine Spencer, and Cary Levine and Philip Glahn, who included me in their College Art Association conference panels, where I presented portions of chapters 3 and 4 (respectively). For thoughtful edits on part of chapter 1 that appeared in *Grey Room*, I thank Eric de Bruyn and the other editors, as well as Benjamin Young.

For always enriching conversation about art and politics, among other things, thanks to Josh MacPhee, Benjamin Tiven, Denisse Andrade, Colby Chamberlain, Tina Rivers Ryan, Huong Ngo, Joe Diebes, Trista Mallory, Park McArthur, Claire Grace, Leslie Wilson, Brian Sholis, Matthew Porter, Gavin Grindon, Rebekah Rutkoff, Paige Sarlin, Erika Biddle, Marco Deseriis, Miriam Tola, Adrian Duran, Judy Ditner, Joanna Fiduccia, Emily Coates, Christine Smallwood, Gabe Boylan, Sonali Thakkar, and Zach Samalin. I would also like to thank, and remember, my dear friend Dara Greenwald, whose perceptive analysis of art and activism continue to keep me centered on the things that matter most. Stevphen Shukaitis and Jack Bratich organized a class on Autonomist Marxism at Bluestockings bookstore in New

York in 2005, which planted seeds of ideas and provided my first encounters with foundational texts that I found myself returning to more than a decade later. Jack's friendship and professional advice continue to be indispensable and were crucial to the completion of this book. To my family, deepest thanks to my mom, Joan; dad, Bruce; and brother, Adam, for their unconditional enthusiasm and support.

At the University of Minnesota Press, Pieter Martin gave affirmation and clear direction to jump-start the realization of this project as a book and see it through to completion. Thanks to Anne Carter for her help with the preparation and submission, and to Eric Lundgren for the assistance with grants. I am infinitely grateful to Josh Rutner for the amazing index and essential edits at the final stage of the book. Janet Kraynak wrote deeply thoughtful and incisive reviews of this book at two stages, and her comments were essential in enabling me to see the path from draft to done. Thanks also to a second anonymous reviewer for valuable and perceptive feedback, which was also crucial for improving the book and advancing and concretizing its arguments.

Finally, thanks most of all to Jonah Westerman, for more than a decade of brilliant, clarifying insights on this book, as well as everything else, and to our daughter Eva, for all she does. I dedicate this book to them.

Introduction

1. When referring to the 1962 exhibition, specifically, I use the italicized *Arte programmata*. When discussing the artists associated with programmed art as a genre, I will use Arte Programmata.

2. Historians and curators tend to locate the dissolution of Arte Programmata around 1968 and exclude the artists' work in design. See for example Marco Meneguzzo, "From Kinetic to Programmed: An Italian Tale," in *Arte programmata e cinetica in Italia, 1958–1968* (Parma: La Galleria, 2000), 259–60. Meneguzzo has curated a number of exhibitions of Arte Programmata and none includes their environments or design. See Meneguzzo, *Arte programmata e cinetica in Italia, 1958–1968*; Volker Feierabend and Marco Meneguzzo, *Luce, movimento & programmazione: Kinetische Kunst aus Italien, 1958–1968* (Milan: Silvana Editoriale Spa, 2001); and Marco Meneguzzo, Enrico Morteo, and Alberto Saibene, eds., *Programmare l'arte: Olivetti e le neoavanguardie cinetiche* (Monza: Johan and Levi, 2012). Objects are also the only works included in Lea Vergine, *L'Ultima avanguardia: Arte programmata e cinetica, 1953–1963* (Milan: Gabriele Mazotta editore, 1983). *Gli ambienti del Gruppo T: Le origini dell'arte interattiva* (The Environments of Gruppo T: The Origins of Interactive Art, held at La Galleria Nazionale d'Arte Moderna e Contemporanea in Rome in 2006) featured a stunning re-creation of a selection of their environments, isolated from the objects and design work by the artists in the group. See Mariastella Margozzi, Lucilla Meloni, and Federico Lardera, eds., *Gli ambienti del Gruppo T: Le origini dell'arte interattiva* (Rome: La Galleria Nazionale d'Arte Moderna e Contemporanea di Roma, 2006).

3. In a 2006 interview, Boriani explained, "In '68, seeing the impossibility of working in the art system, I chose design and school as channels through which to apply, verify, and develop research in wider environments." Davide Boriani, "Intervista a Davide Boriani," in Margozzi, Meloni, and Lardera, *Gli ambienti del Gruppo T*, 25.

4. Interestingly, one of the only Italian films of this period to feature computers

is undecidable in its take (utopian or dystopian) on technological rationalization. *The 10th Victim* (1965) by director Elio Petri (based on a Robert Sheckley short story) centers a computer-orchestrated killing game called "The Big Hunt," which promises to help humanity avoid mass, international war by allowing individuals to express their violent urges in a contained, regulated, and—significantly—voluntary way. In contrast to films in which computers are deadening, life-sucking entities, and the world in which they operate an unequivocal nightmare, in *The 10th Victim* computers orchestrate a markedly sexualized situation in which the two main protagonists (Marcelo Mastroianni and Ursula Andress) are fully in control—idealized (albeit clichéd) agents of their own desires and destinies. However absurd the conceit, the allegory suggests that it is the evil inherent to humanity that needs to be managed by computers, not the other way around. (Capitalism, consumerism, and celebrity culture, on the other hand, are satirized and criticized as insidious, corrupting forces; that these are not seen as inextricably intertwined with computing makes this film unique for the time.)

5. Jacques Ellul, *The Technological Society,* trans. John Wilkinson (New York: Knopf, 1964), 418. The original French publication, *La technique, ou, L'enjeu du siècle* (1954), was translated into Italian in 1969. Jacques Ellul, *La tecnica: Rischio del secolo* (Milan: Giuffrè, 1969).

6. Lewis Mumford, *The Myth of the Machine: The Pentagon of Power* (London: Secker and Warburg, 1971), 287.

7. Marcuse and Touraine both focused a great deal of their book on deconstructing false freedom, or "dependent participation." Janet Kraynak has noted the importance of this idea in the work of Bruce Nauman, especially his immersive installations. Kraynak argues that Nauman thematizes the inextricability of programming and control as a means for making visible and criticizing this new form of domination. See Janet Kraynak, *Nauman Reiterated* (Minneapolis: University of Minnesota Press, 2014). Kraynak's book also advances the idea that only "breaking down" circuits can combat such a domineering technological interface of power and control. As Kraynak concludes, "In Nauman's installations the subject ultimately is the one who must navigate a minefield of participation and control, discovering those small opportunities where conformity breaks down and possibility, even if fleeting and limited, accrues" (229).

8. Ellul, *Technological Society,* xxxii–xxxiii.

9. Alain Touraine, *The Post-Industrial Society: Tomorrow's Social History: Classes, Conflicts, and Culture in the Programmed Society,* trans. Leonard F. X. Mayhew (New York: Random House, 1971), 233. Earlier Touraine writes, "What dominates our type of society is not the internal contradictions of the various social systems but the contradictions between the needs of these social systems and the needs of individuals" (61).

10. Marshall McLuhan, *Understanding Media: The Extensions of Man* (New York: McGraw-Hill, 1964), 356.

11. Fred Turner notes that McLuhan's idea of the media was as much tribal as cybernetic. "The twin interests in cybernetic approaches to communication media and tribal forms of social organization that McLuhan developed in the early 1950s became key elements of his media theories in the early 1960s and important influences on the art worlds of that period." Fred Turner, *From Counterculture to Cyberculture: Stewart Brand, the Whole Earth Network, and the Rise of Digital Utopianism* (Chicago: University of Chicago Press, 2006), 53.

12. McLuhan, *Understanding Media*, 5–6.

13. "Panic about automation as a threat of uniformity on a world scale is the projection into the future of mechanical standardization and specialism, which are now past." McLuhan, 359.

14. Gene Youngblood, *Expanded Cinema* (London: Studio Vista, 1970), 419.

15. "The art and technology of expanded cinema will provide a framework within which contemporary man, who does not trust his own senses, may learn to study his values empirically and thus arrive at a better understanding of himself." Youngblood, 116.

16. Gloria Sutton, *The Experience Machine: Stan VanDerBeek's "Movie-Drome" and Expanded Cinema* (Cambridge, Mass.: MIT Press, 2015).

17. Turner, *From Counterculture to Cyberculture*, 38. Another book by Turner looks at an early cultural moment, the 1930s, when proto-cybernetic ideas were initially embraced wholeheartedly by artists and designers as a way to produce empowered subjects capable of participating in (and propagating) an improved democracy. Fred Turner, *The Democratic Surround: Multimedia and American Liberalism from World War II to the Psychedelic Sixties* (Chicago: University of Chicago Press, 2013).

18. Turner, *From Counterculture to Cyberculture*, 79.

19. Nicholas Negroponte, *Being Digital* (New York: Knopf, 1995), 229.

20. Of particular contrast is the difference between Norbert Wiener (who stressed equilibrium) and Stafford Beer (whose term homeostasis was more flexible). This difference is discussed in detail by Andrew Pickering and Eden Medina in their studies of cybernetics in the UK and Chile, respectively. See Andrew Pickering, *Cybernetic Brain: Sketches of Another Future* (Chicago: University of Chicago Press, 2014); and Eden Medina, *Cybernetic Revolutionaries: Technology and Politics in Allende's Chile* (Cambridge, Mass.: MIT Press, 2014).

21. Since World War II, society has been rapidly transitioning, prompting "a generalized crisis in relation to all environments of enclosure. . . . The disciplinary man was a discontinuous producer of energy, but the man of control is undulatory, in orbit, in a continuous network." Gilles Deleuze, "Postscripts on the Societies of Control," *October* 59 (Winter 1992): 3–4, 5–6.

22. "The societies of control operate with machines of a third type, computers, whose passive danger is jamming and whose active one is piracy and the introduction of viruses." Deleuze, 6.

23. Manuel Castells, *The Rise of the Network Society* (Malden, Mass.: Blackwell, 1996), 3.

24. Quoted in Alexander Galloway, *Protocol: How Control Exists after Decentralization* (Cambridge, Mass.: MIT Press, 2004), 17. From Gilles Deleuze, "Control and Becoming," in *Negotiations,* trans. Martin Joughin (New York: Columbia University Press, 1990), 175.

25. David Joselit, *Feedback: Television against Democracy* (Cambridge, Mass.: MIT Press, 2007), 48. Like Deleuze, Joselit recognizes the multifaceted dimensions of these operations: "When viruses enter an ecological system, like a body, they block existing channels and open new ones" (50). However, throughout Joselit and Deleuze—and even more so in the artists and art historians influenced by their ideas—the priority is on the negative work of dismantling rather than the constructive act of creation. There is nothing inherently wrong with this strategy, especially if it is directed toward particular facets of control societies, such as surveillance. Contemporary artists who deploy this inoperability to undermine surveillance make some of the most compelling art today. Two examples are Zach Blas, whose *Face Cages* (2013–16) are masks capable of evading facial recognition technology, and Hito Steyerl's *How Not to Be Seen: A Fucking Didactic Educational .MOV File* (2013), a tongue-in-cheek video instructing viewers on how to become invisible in various contexts (by shrinking to a size smaller than a pixel, for example, or moving to a gated community). Both Blas and Steyerl posit invisibility as a tactic of resistance (one often available only to a privileged few) in a society where surveillance, mapping, and data mining are so pervasive. Recently, art historians are similarly positing noncommunication and perpetuating noise as ways to resist domination and cultural hegemony, which seeks to capture, incorporate, and render productive (i.e., profitable) individual creativity and artistic expression.

26. Tiziana Terranova, *Network Culture: Politics for the Information Age* (London: Pluto Press, 2004), 100; and Galloway, *Protocol.* As Galloway puts it, "The central political question that *Protocol* asks is where the power has gone. If we are indeed living in a post-industrial, postmodern, postdemocratic society, how does one account for political agency in situations in which agency appears to be either caught in networks of power or distributed across multiple agencies?" (xix).

27. Wendy Hui Kyong Chun, *Control and Freedom: Power and Paranoia in the Age of Fiber Optics* (Cambridge, Mass.: MIT Press, 2006), 250. Chun's book traces how this collapse of terms ("control-freedom") stems from the replacement of political solutions with technological ones—from the perceived navigability of cyberspace that replaces real control over access and design to the ways that freedom becomes con-

flated with both disembodiment and user empowerment all in the name of a highly individualistic, neoliberal ideal of agency. She shows how in one instance freedom is conflated with security—in panics about cyber-porn—while in another it becomes a post-racial fantasy that leaves the actual structures of racism perfectly intact. As she puts it, "Thus far, I have outlined the ways in which control-freedom thrives on a paranoid knowledge that focuses on technological rather than political solutions and that relies on racial profiling. In this paranoid mind-set, freedom as autonomy—freedom from constraint, the sexual freedom to expose and reinvent ourselves, etc.—plays a key role in our simultaneous resignation to the reality of unfreedom and our delusion of freedom as an intimate discourse grounding our independence and sexual freedom. . . . Freedom, however, cannot be reduced to control. Freedom exceeds, rather than complements, control. The ideological conflation of freedom with safety—the idea that we are only free when safe—defers freedom, and makes it an innocuous property of subjectivity. But freedom comes with no guarantees; it breaks bonds, enabling good *and* evil" (290–91). As this incredible passage demonstrates, Chun does not dispense with freedom (or technology as a means for advancing it), but she does emphasize relationality, collectivity, vulnerability, and the porosity of ourselves in understanding a freedom beyond control—which is something that the present study also aims to do.

28. DC control of the Italian Parliament began in 1948 and only ended in 1994, after a widespread investigation into political corruption (called *mani pulite*, or clean hands), which implicated most of the party's leaders and resulted in many arrests and resignations—a scandal known in Italy as Tangentopoli, named after *tangente*, or bribes. This long span of power should not be confused with a unity of purpose or ideology.

29. Fanfani first argued that the DC should open to the left at the party's conference in July 1957. As Paul Ginsborg writes in *A History of Contemporary Italy: Society and Politics, 1943–1988* (New York: Palgrave Macmillan, 2003), "For Fanfani, a new DC–PSI axis, controlled by himself, would be a firm basis for social planning, for moderate reform and for further public intervention in the economy" (255).

30. Ginsborg, 165.

31. For more on the period of postwar reform and the DC, see chapter 5 and 8, on "Christian Democracy in State and Society" and "The Centre-Left," respectively, in Ginsborg, 141–85, 254–97.

32. For an account of Adriano Olivetti's relationship to American ideals of planning, see Paolo Scrivano, *Building Transatlantic Italy: Architectural Dialogues with Postwar America* (Burlington, Vt.: Ashgate, 2013). Citing a 1955 seminar that brought Italian and American architects and planners to discuss planning and housing, titled "Italo-American City and Regional Planning and Housing Seminar," Scrivano explains that "one of the terms recurrently used during the seminar was 'community':

'Planning'—one could read in a passage from the memorandum—'will emphasize not static schemes of physical arrangement but schemes of development to guide the *creative evolution* of communities.' . . . In fact, it is difficult to understand which common notion of 'community' Americans and Italian participants had in mind, particularly in the mid-1950s when issues about the 'communitarian' roots of US regionalism had almost completely disappeared from the planning debate" (138).

33. One American journalist deemed Olivetti's computer a revelation: "We would see a computer in every office even before there are two cars in every garage. . . . Fundamental business applications like amortization, mortgage, and payroll are also easily computed on Programma 101." "A Desk Top Computer," *New York Journal American*, October 25, 1965. For more on Programma 101's unveiling see Annmarie Brennan, "Olivetti: A Working Model of Utopia" (PhD diss., Princeton University, 2011), 192–94.

34. There is a rich and critical art-historical literature on these collaborations. See Pamela M. Lee, *Chronophobia: On Time in the Art of the 1960s* (Cambridge, Mass.: MIT Press, 2006) for more on Chamberlain at RAND. For a close examination of E.A.T.'s Osaka Pavilion and the ways the labyrinthine structure formally prefigures technocracy, in which visitors are free to move within an environment carefully designed and controlled by a privileged, technologically literate elite, see Fred Turner, "The Corporation and the Counterculture: Revisiting the Pepsi Pavilion and the Politics of Cold War Multimedia," *The Velvet Light Trap* 73 (Spring 2014): 66–78. For a survey of these and many of the most canonical examples, see John Beck and Ryan Bishop, *Technocrats of the Imagination: Art, Technology, and the Military-Industrial Avant-garde* (Durham, N.C.: Duke University Press, 2020).

35. See Pamela M. Lee, *Think Tank Aesthetics: Midcentury Modernism, the Cold War, and the Neoliberal Present* (Cambridge, Mass.: MIT Press, 2020).

36. Romano Alquati, "Composizione organica del capitale e forza-lavoro alla Olivetti" (1962), in *Sulla FIAT e altri scritti* (Milan: Feltrinelli, 1975), 85–163. Originally published in *Quaderni rossi 2* (June 1962).

37. As Sidney Tarrow explains in *Democracy and Disorder: Protest and Politics in Italy 1965–1975* (Oxford: Clarendon Press, 1989), his study of the wave of protests that swept Italy in the second half of the 1960s, "The period from the late 1940s to about 1962 was one of unprecedented prosperity and unrestrained entrepreneurship. But this prosperity was also based on high rates of domestic labour exploitation made possible by reservoirs of cheap labour and by the weakness of and divisions between the trade unions" (44).

38. Steve Wright, *Storming Heaven: Class Composition and Struggle in Italian Autonomist Marxism* (London: Pluto Press, 2002), 44–45. As I will discuss in chapter 4, a critique of state planning was central in the writing of two major theorists at the time, Mario Tronti and Antonio Negri.

39. Mario Tronti, "Il piano del capitale," *Quaderni Rossi* 3 (1962): 45–71.

40. Indeed, it was a stated strategy of the Italian Communist Party (Partito Comunista Italiano, or PCI) in the late 1940s to barter worker cooperation with reconstruction for advancements in their autonomy and control. This was calamitous, however, since the PCI was expelled from government in 1948 and therefore could not deliver on the promises it had made to workers, essentially assuring their compliance but winning them nothing in return.

41. Pier Vittorio Aureli, *The Project of Autonomy: Politics and Architecture within and against Capitalism* (Princeton, N.J.: Princeton Architectural Press, 2008), 18.

42. See for example the chapter on "cybernetic socialism" in Armin Mendosch, *New Tendencies: Art at the Threshold of the Information Revolution (1961–1978)* (Cambridge, Mass.: MIT Press, 2016). Klara Kemp-Welch's study of artists in the Eastern Bloc and their commitment to a global, international community has done much to excavate lesser-known examples, but she does focus most heavily on those who stress individualism against the mandated collectivism of the governments, especially those whose work most resembles Fluxus performance or conceptual art; none of the New Tendencies artists are discussed. See Klara Kemp-Welch, *Networking the Bloc: Experimental Art in Eastern Europe 1965–1981* (Cambridge, Mass.: MIT Press, 2019). For a different reading, which emphasizes the individualism of Moscow conceptual art practices, see Claire Bishop, "Zones of Indistinguishability: Collective Actions Group and Participatory Art," *e-flux* 29 (November 2011), https://www.e-flux.com/journal/29/68116/zones-of-indistinguishability-collective-actions-group-and-participatory-art/. For a study of actual cybernetic socialism, not the kind prefigured in artworks, see Medina, *Cybernetic Revolutionaries*.

43. Eve Meltzer, *Systems We Have Loved: Conceptual Art, Affect, and the Antihumanist Turn* (Chicago: University of Chicago Press, 2013).

44. In some ways, every postwar, post-medium practice of this period could be understood as an attempt to do exactly this: create a space where philosophical or political problems become conscious, especially as they pertain to notions of the subject. See Hal Foster, "The Crux of Minimalism" in *The Return of the Real: The Avant-Garde at the End of the Century* (Cambridge, Mass.: MIT Press, 2001), 35–70; and Claire Bishop, *Installation Art: A Critical History* (London: Tate, 2011).

45. Bruno Latour, *Reassembling the Social: An Introduction to Actor-Network-Theory* (Oxford: Oxford University Press, 2008).

46. In "Liberalism in the Cold War: Norberto Bobbio and the Dialogue with the PCI," *Journal of Modern Italian Studies,* 8, no. 4 (2003), Nadia Urbinati explains how socialism was meant to be understood in the journal's special issues: "Its ideal perspective was *continentalist* or Europeanist. It was a 'third way,' different from both a neoliberal and a Marxist conception of civil society and the state, two mirror images that shared a similar theoretical approach—the priority of the pre-political and the

interpretation of politics and the state as instrumental to the preservation of the social" (588).

47. The key essays are Norberto Bobbio, "Democrazia e dittatura," in *Politica e cultura* (Turin: Einaudi, 2005), 167–77; and Galvano Della Volpe, "The Problem of Egalitarian Liberty in the Development of Modern Democracy; or the Living Rousseau," in *Rousseau and Marx and Other Writings,* trans. John Fraser (Atlantic Highlands, N.J.: Humanities Press, 1979), 49–70.

48. For an in-depth discussion of the Bobbio / Della Volpe debate, see Richard Bellamy, *Modern Italian Social Theory* (Cambridge: Polity Press, 1987), 141–56.

49. Della Volpe, "Problem of Egalitarian Liberty," 63.

50. Gigi Roggero, *L'operaismo politico italiano: Genealogia, storia, metodo* (Rome: DeriveApprodi, 2019), 18. Bobbio organized the conference in 1971 where Tronti first presented his idea of the "autonomy of the political."

51. Perry Anderson's article on Bobbio shows how his notion of liberalism is distinct from others, and especially the market fundamentalism of neoliberalism. Anderson also stresses the uniqueness of liberalism in Italy. See Perry Anderson, "The Affinities of Norberto Bobbio," *New Left Review* 170 (July–August 1988): 3–36.

52. Marco Baravalle, "Alteristituzioni e arte: Tra governamentalità e autonomia," *Operaviva,* August 3, 2018, https://operavivamagazine.org/alteristituzioni-e-arte/.

53. Another important figure in this distinction between freedoms is Isaiah Berlin, who wrote on the difference between positive and negative liberty in 1958. Berlin, however, is not committed to the Marxist tradition, whereas Fromm is, and so seems a better figure to elaborate this idea for our purposes here. I want to also mention that it was in reading Fromm that I was introduced to this distinction, and his work has shaped my own understanding of Arte Programmata. My aim is also to wrest the history of ideas about freedom from the history of liberalism (especially in its later, neoliberal trajectory), yet another reason to ground my understanding of freedom in a Marxist tradition rather than the liberal one of Berlin. See Isaiah Berlin, "Two Concepts of Liberty," *Four Essays on Liberty* (Oxford: Oxford University Press, 1969), 118–72.

54. Erich Fromm, *Escape from Freedom* (New York: Avon Books, 1965), 27.

55. Of interest in the larger context is that Fromm cites information overload as one of the barriers to freedom, since it stultifies critical and engaged thinking and perpetuates conformity: "The pathetic superstition prevails that by knowing more and more facts one arrives at knowledge of reality. Hundreds of scattered and unrelated facts are dumped into the heads of students; their time and energy are taken up by learning more and more facts so that there is little left for thinking. To be sure, thinking without a knowledge of facts remains empty and fictitious; but 'information' alone can be just as much of an obstacle to thinking as the lack of it" (273).

56. Fromm, 299. For Fromm, the replacement should be democratic socialism.

57. Fromm, 301.

58. Both Anderson and Bellamy address this failure.

59. Juliane Rebentisch, *The Art of Freedom* (London: Polity Press, 2016), 2.

1. Collectivizing Authorship

1. Bruno Munari, "Arte Programmata," in *Arte Programmata Kinetic Art,* exh. cat. (1964), n.p., in Archivio Storico Olivetti Biblioteca (hereafter cited as ASOB), Solo F. Arte fascicolo (6) 1, emphasis added. *Arte programmata* traveled to the Smithsonian Museum in 1964 and an English-language catalog was printed for the occasion, which included this expanded statement by Munari defining "programmed art."

2. Umberto Eco in *Arte programmata,* exh. cat., ed. Bruno Munari et al. (Milan: Olivetti, 1962), n.p., in ASOB, Ivrea, Solo F. Arte fascicolo (6) 1. English in the original catalog.

3. Eco.

4. Umberto Eco, *Opera aperta: Forma e indeterminazione nelle poetiche contemporanee* (Milan: Bompiani, 1962); published in English as Umberto Eco, *The Open Work,* trans. Anna Cancogni (Cambridge, Mass.: Harvard University Press, 1989).

5. Recent literature on Italian art, some including analyses of artists included in *Arte programmata,* focuses exclusively on the notion of artistic labor. Labor is how both artists of this period and, more recently, art historians articulate the political intentions *and* effects of art. I contend that labor is absolutely a primary way that artists implement their intentions but that it cannot be confused with the effects or meanings of the work. In trying to distinguish between the intentions of the artists and the meanings of the works (both historically and today), I therefore stress this distinction between labor and reception. What and how a work communicates lies in its form and the context in which it is received. For examples of the labor focus I am describing, see Jaleh Mansoor, *Marshall Plan Modernism: Italian Postwar Abstraction and the Beginnings of Autonomia* (Durham, N.C.: Duke University Press, 2016); and Jacopo Galimberti, *Individuals against Individualism: Art Collectives in Western Europe (1956–1969)* (Liverpool: Liverpool University Press, 2017).

6. Forma 1, "Manifesto of the Forma Group" (1947), in *The Italian Metamorphosis,* ed. Germano Celant (New York: Guggenheim Museum, 1994), 712. Originally published in *Forma 1: Mensile di arti figurative* (Rome, April 1947).

7. As works such as *Ciclo della protesta n. 3* (Cycle of Protest No. 3, 1956) attest, Vedova considered his gestural abstraction to be illustrative of a commonly held struggle against alienation, oppression, and tyranny. *Ciclo della protesta* was painted after the artist, during a visit to Brazil, witnessed the exploitation taking place on coffee plantations.

8. For a detailed account of this bifurcation, as well as the intricacies of the political commitment of Vedova, see Adrian R. Duran, *Painting, Politics, and the New Front of Cold War Italy* (Burlington, Vt.: Ashgate, 2014).

9. Guttuso quoted in Duran, 111.

10. For more on the importance of 1956 for communism in Italy, see Paul Ginsborg, *A History of Contemporary Italy: Society and Politics, 1943–1988* (New York: Palgrave Macmillan, 2003), 204–9.

11. For a study of these debates in poetry, see John Picchione, *The New Avant-Garde in Italy: Theoretical Debate and Poetic Practices* (Toronto: University of Toronto Press, 2004).

12. For more on this development, see Marcia E. Vetrocq, "National Style and the Agenda for Abstract Painting in Post-War Italy," *Art History* 12, no. 4 (December 1989): 448–71. On *arte informale* in general, see Enrico Crispolti, *Ricerche dopo l'informale* (Rome: Officina, 1968); and Renato Barilli and Franco Solmi, *L'Informale in Italia* (Milan: Mazzotta, 1983).

13. Alberto Burri, "Words Are No Help," in *The New Decade: 22 European Painters and Sculptors,* ed. Andrew Carduff Ritchie (New York: Museum of Modern Art, 1955), 82.

14. Giulio Carlo Argan, *Salvezza e caduta nell'arte moderna* (Milan: Il Saggiatore, 1964), 56.

15. Enrico Baj et al., "Against Style" (1957), in *The Italian Metamorphosis, 1943–1968,* ed. Germano Celant (New York: Guggenheim Museum, 1994), 719.

16. Munari's engagement with the futurists and their rhetoric of war, violence, and aesthetic experimentation is not as straightforward as the artist later wanted to make it. His useless machines might appear to subvert the futurists' glorification of technology, but Munari fit very well into the artistic scene of late futurism. He always emphasized play and absurdity, but this did not preclude him from working well within the *aeropittura* milieu. For a nuanced analysis of Munari's 1930s work and its relation to futurism and war, see Jeffrey Schnapp, "Bruno Munari's Bombs," in *Magazines, Modernity, and War,* ed. Jordana Mendelson (Madrid: Museo Nacional Centro de Arte Reina Sofia, 2008), 143–64.

17. MAC was the Italian manifestation of a widespread, international movement of concrete art, first articulated by Theo van Doesburg in 1930. Munari and the other artists and theorists of MAC positioned themselves within this broader movement and continued to advance its legacy. To see how MAC relates to this broader context, see Max Bill and Ettore Sottsass, *Arte astratta e concreta* (Milan: Palazzo Exreale, 1947); and G. C. Argan, P. Bucarelli, and J. Jarema, eds., *Arte astratta e concreta in Italia* (Rome: La Galleria Nazionale d'Arte Moderna e Contemporanea, 1951).

18. Luciano Caramel, *MAC: Movimento arte concreta, 1948–1958* (Florence: Maschietto e Musolino, 1996).

19. Caramel, 23.

20. Paolo Fossati, *Il Movimento Arte Concreta (1948–1958)* (Turin: Einaudi, 1980), 96.

21. This description of the desk tidy was featured in Nathan H. Shapira and Renzo Zorzi, *Design Process: Olivetti, 1908–1978* (New York: Museum of Modern Art, 1978), 192.

22. Enzo Mari, *25 modi per piantare un chiodo: Sessant'anni di idee e progetti per difendere un sogno* (Milan: Mondadori, 2011), 43. Mari goes on to explain that he was never interested in upholding the category of art, whereas Munari was.

23. A similar distinction can be made in their ideas about design: whereas Munari wanted design to empower individual users, Mari wanted his design to make plain the user's lack of autonomy and reliance on systems and structures. We might say, then, that for Munari collectivity was a form, while for Mari it was a process. This is why Munari drops out of this study after chapter 1: he doesn't follow the more politically potent thinking about programming.

24. Mari, *25 modi per piantare un chiodo*, 25.

25. Mari, 27. Mari seems nostalgic for a world in which signs are stable. The creators and viewers of Renaissance paintings would have all shared the same church dogma, which made such clear communication possible.

26. Mari, 30.

27. Mari, 42.

28. This biographical background of the members of Gruppo T is described in Umberto Palamara, "Arte Programmata: Il Gruppo T" (PhD diss., Università Degli Studi di Torino, 2003), 68–72.

29. Gruppo T, "Miriorama I declaration" (1959), in *Gruppo T: Anceschi, Boriani, Colombo, De Vecchi, Varisco: Miriorama, Le Opere, I Documenti*, ed. Luca Cerizza (Bologna: P420 Arte Contemporanea, 2010), 27.

30. Italo Mussa, ed., *Il Gruppo Enne: La situazione dei gruppi in Europa negli anni 60* (Rome: Bulzoni, 1977), 119.

31. For more on Manzoni and his relationship to Gruppo N, see Jacopo Galimberti, "The Intellectual and the Fool: Piero Manzoni between the Milanese Art Scene and the Land of Cockaigne," *Oxford Art Journal* 35, no. 1 (March 2012): 75–94.

32. Alberto Biasi, "Lettera a Piero Manzoni," in *Il Gruppo Enne*, ed. Mussa, 298.

33. Statement by Gruppo N, in *Il Gruppo Enne*, ed. Mussa, 305.

34. Quoted in Margit Rosen et al., eds., *A Little-Known Story about a Movement, a Magazine, and the Computer's Arrival in Art: New Tendencies and Bit International, 1961–1973* (Karlsruhe: ZKM, 2011), 122–23.

35. Bruno Munari, *Design as Art* (1966), trans. Patrick Creagh (New York: Penguin, 1971), 174. This statement resonates remarkably with much of Mari's writing on the problem of communication and how art may address it by pursing both novel forms and clarity of concepts.

36. Italo Calvino, "Cybernetics and Ghosts" (1967), in *The Uses of Literature: Essays*, trans. Patrick Creagh (San Diego: Harcourt Brace Jovanovich, 1986), 15.

37. "Anche in Italia il futuro è già cominciato," *Epoca,* October 15, 1959.

38. "Anche in Italia," 9.

39. Olivetti published on his social ideals in several books over the course of the 1950s. See Adriano Olivetti, *Society, State, Community* (Milan: Edizioni di Comunità, 1954); and Adriano Olivetti, *Community Ideals* (Ivrea: Movimento Comunità, 1956).

40. Romano Alquati, "Composizione organica del capitale e forza-lavoro alla Olivetti" (1962), in *Sulla FIAT e altri scritti* (Milan: Feltrinelli, 1975), 81–163. Originally published in *Quaderni rossi,* no. 2 (June 1962).

41. See especially the section "La cooperazione come 'ruffianesimo,'" 152. For a detailed analysis of Alquati, Olivetti, and cybernetics, as well as their implications for contemporary labor dynamics, see Matteo Pasquinelli, "To Anticipate and Accelerate: Italian Operaismo and Reading Marx's Notion of the Organic Composition of Capital," *Rethinking Marxism* 26, no. 2 (2014): 178–92.

42. Carlo Tagliavini, "L'automazione nelle ricerche fonetiche," in *Almanacco letterario Bompiani 1962,* ed. Sergio Morando (Milan: Bompiani, 1962), 120–22.

43. Stanislao Valsesia, "Verso la 'biblioteca elettronica': L'information retrieval,'" in *Almanacco letterario Bompiani 1962,* ed. Morando, 117–20.

44. "Breve crestomazia dei più celebri automi e automatarii," in *Almanacco letterario Bompiani 1962,* ed. Morando, 159–74.

45. A poet, writer, and activist, Balestrini was a member of Gruppo 63 and active in the debates about the politics of form. For primary documents from these debates, see Nanni Balestrini et al., *Gruppo 63* (Milan: Bompiani, 2013). For a translation, as well as the code used to produce *Tape Mark 1,* see Hannah B. Higgins and Douglas Kahn, eds., *Mainframe Experimentalism: Early Computing and the Foundations of the Digital Arts* (Berkeley: University of California Press, 2012), 266–74.

46. Umberto Eco, "La forme del disordine," in *Almanacco Bompiani 1962,* ed. Morando, 175–88.

47. Umbro Apollonio, "Ipotesi su nuove modalità creative," *Quadrum* 14 (1963), quoted in Enrico Crispolti, "Neoconcretismo, arte programmata, lavoro di gruppo," *Il verri* 12 (1963): 42.

48. Gruppo N to Munari, January 19, 1962, in Archivio Alberto Biasi, Padua, reprinted in Marco Meneguzzo, Enrico Morteo, and Alberto Saibene, eds., *Programmare l'arte: Olivetti e le neoavanguardie cinetiche* (Monza: Johan and Levi, 2012), 15.

49. "Intervista a Davide Boriani," in *Gli ambienti del Gruppo T: Le origini dell'arte interattiva,* ed. Mariastella Margozzi, Lucilla Meloni, and Federico Lardera (Rome: La Galleria Nazionale d'Arte Moderna e Contemporanea di Roma, 2006), 23.

50. Eco, *Open Work,* 9.

51. Eco, 19.

52. *Opera aperta* predates and clearly prefigures Eco's writing on semiotics. See, for

the earliest example, Umberto Eco, *La struttura assente: Introduzione alla ricerca semiologica* (Milan: Bompiani, 1968).

53. The article was then published as a book with an introduction by Warren Weaver: Claude Shannon, *The Mathematical Theory of Communication* (1948; repr., Chicago: University of Chicago Press, 1998).

54. Eco cites Shannon's definition of information in his essay "Openness, Information, Communication," in *The Open Work,* 46.

55. Abraham Moles, *Information Theory and Esthetic Perception,* trans. Joel E. Cohen (Chicago: University of Illinois Press, 1966), 196.

56. Eco, "The Open Work in the Visual Arts," in *The Open Work,* 100.

57. Eco, "Openness, Information, Communication," 60.

58. Umberto Eco, "Del modo di formare come impegno sulla realtà," *Il Menabò* 5 (1962): 198–237. This essay was included in the second edition (1967) and in all subsequent editions of *Opera aperta*.

59. The entire issue of *Il Menabò* was conceived as a defense of experimentalism, as Eco recounts in his introduction to *Opera aperta*. Eco, *Opera aperta,* vi–vii.

60. Eco, vi–vii.

61. Eco, "Form as Social Commitment," in *The Open Work,* 149. Calvino makes a similar defense of avant-garde art in "La sfida al labirinto," arguing that literature's greatest promise is in its ability to educate. Italo Calvino, "La sfida al labirinto," *Il Menabò* 5 (1992): 85–99.

62. Eco, "Form as Social Commitment," 157.

63. Eco, "Open Work in the Visual Arts," 85, 87.

64. Eco, 103.

65. Eco, 91.

66. Eco, 104.

67. Eco, 100.

68. Calvino, "La sfida al labirinto," 94.

69. Crispolti, "Neoconcretismo, arte programmata, lavoro di gruppo," 57.

2. Programming the Spectator

1. Manfredo Massironi, "Ricerche visuali" (1973), in *Il Gruppo Enne: La situazione dei gruppi in Europa negli anni 60,* ed. Italo Mussa (Rome: Bulzoni, 1977), 320.

2. "Op Art: Pictures That Attack the Eye," *Time,* October 23, 1964. This was the first use of the term op, according to Cyril Barrett's comprehensive study of the genre. Cyril Barrett, *Op Art* (New York: Viking Press, 1970), 5.

3. William Seitz, *The Responsive Eye* (New York: Museum of Modern Art, 1965), 9.

4. Seitz, 43.

5. Seitz, 43.

6. Lawrence Alloway, "Notes on Op Art" (1966), in *The New Art: A Critical Anthology*, ed. Gregory Battcock (New York: Dutton, 1966), 84. Alloway's essay was both a review of the show and an assessment of its critical reception.

7. Thomas B. Hess, "You Can Hang It in the Hall," *ARTnews* 64 (October 1965): 41–43, 49–50. Hess did not make this comment to suggest that the works were *using* advertising for critique, but rather were, like ads themselves, simply promoting a style and with it, consumerist behavior.

8. William Seitz, "The New Perceptual Art," *Vogue*, February 15, 1965.

9. Barbara Rose, "Beyond Vertigo: Optical Art at the Modern," *Art Forum* 3 (July 1965): 30. Rose continued, "You know absolutely that you have gotten the message once nausea or vertigo set in. . . . [op] goes Pop art one better by being considerably more mindless."

10. Rosalind Krauss, "Afterthoughts on 'Op,'" *Art International* 9, no. 5 (June 1965): 75–76; Lucy R. Lippard, "Perverse Perspectives," *Art International* 9, no. 3 (March 1967): 28–33, 44. Krauss contrasted Op with works by Barnett Newman and Larry Poons (the only artist in *The Responsive Eye* that according to Krauss used perceptual play to avoid trickery and to manifest more clearly the flattened space of the canvas); Lippard compared Op to sculptors Donald Judd and Mark di Suvero, who for her explored ambiguities of perception without resorting to trickery. She also discussed artists who used the illusion of depth to reflect on such literalism more critically, such as Larry Bell, who practices what Lippard calls "anti-illusionist illusionism" (30).

11. "Special to Chicago Newspapers," press release no. 19, March 3, 1965, Museum of Modern Art, New York.

12. Gordon Hyatt, writer and producer, *The Responsive Eye*, television program (New York: CBS Inc., 1965).

13. Brian De Palma, dir., *The Responsive Eye*, film (New York: MoMA, 1966). The film was composed of footage taken at the 1965 opening of the exhibition but released in 1966.

14. Massironi, "Ricerche visuali," 320.

15. In a discussion from 1965, Mari lamented how "a large part of this material, I believe as large as 80%, is not in fact research but is only the imitation of research and the commercialization *[mercificazione]* of research." Enzo Mari, untitled, in *Nove tendencija 3* (international version) (Zagreb: Galerija Suvremene Umjetnosti, 1965), 169. Speaking of the group New Tendencies, with which Arte Programmata were involved, the historian Margit Rosen has noted that "1965 was also the year of a severe internal crisis and the [New Tendencies] movement ground to a halt. Serious doubt prevailed about whether the possibility of establishing art as research under the present social conditions was viable." Margit Rosen, "Editorial," in *A Little-Known Story about a Movement, a Magazine, and the Computer's Arrival in Art: New Tendencies and Bit International, 1961–1973*, ed. Margit Rosen et al. (Karlsruhe: ZKM, 2011), 11.

16. Seitz, *Responsive Eye*, 41–42.

17. For an in-depth study of British cybernetics and its distinct ideas about control (discussed later in this chapter), see Andrew Pickering, *The Cybernetic Brain: Sketches of Another Future* (Chicago: University of Chicago Press, 2010).

18. The undecidability between *subjection* and *subjectivization* is foundational to control as Gilles Deleuze theorized it in 1991. This is something that Jason Read has productively thought through in an article written on the occasion of the thirtieth anniversary of Deleuze's publication on control. Jason Read, "Postscript as Preface: Theorizing Control after Deleuze," *Coils of the Serpent* 6 (2020): 15–25.

19. Paul Ginsborg, *A History of Contemporary Italy: Society and Politics, 1943–1988* (New York: Palgrave Macmillan, 2003), 238.

20. See Stephen Gundle, "L'Americanizzazione del quotidiano: Televisione e consumismo nell'Italia degli anni cinquanta," *Quaderni storici* 62 (August 1986): 561–94.

21. Quoted in Ginsborg, *History of Contemporary Italy*, 241. As Ginsborg explained, situating Pasolini in context, "By linking rising living standards with accentuated individualism, [the economic miracle] seemed to fulfill the American dream. It had introduced a new model of social integration to Italy" (248).

22. Quoted in Ginsborg, 247–48.

23. For more on this outcry on the part of artists, intellectuals, and the PCI, see Stephen Gundle, *Between Hollywood and Moscow: The Italian Communists and the Challenge of Mass Culture, 1943–1991* (Durham, N.C.: Duke University Press, 2000), especially chapter 3, "What's Good for Fiat Is Good for Italy: Television, Consumerism, and Party Identity," 75–105.

24. Cesare Mannucci, *Lo spettatore senza libertà: Radio-televisione e comunicazione di massa* (Bari: Editori Laterza, 1962).

25. Mannucci, 16. For Mannucci, the telecommunications industry in Italy was "rotten at its roots" because it lacked the "three basic needs of every democratic regime of radio and television: the independence, accountability, and last but not least, freedom of culture" (316).

26. Walter Lippmann, *L'Opinione pubblica,* trans. Cesare Mannucci (Roma: Donzelli Editore, 1995). For a history of the reception of Lippmann's book in Italy, see Nicola Tranfaglia's preface to this edition.

27. "Manifesto of the Spatialist Movement for Television," in *Italian Metamorphosis, 1943–1968,* ed. Germano Celant (New York: Guggenheim Museum, 1994), 717.

28. For a close study of this television work, as well as its relationship to Fontana's oeuvre, see Anthony White, "TV and Not TV: Lucio Fontana's *Luminous Images in Movement*," *Grey Room* 34 (Winter 2009): 6–27; and Jaleh Mansoor, "Fontana's Atomic Age Abstraction: The Spatial Concepts and the Television Manifesto," in "Postwar Italian Art," ed. Claire Gilman, special issue, *October* 124 (Spring 2008): 137–56. For

more on Fontana and the history of television art, see Christine Mehring, "Television Art's Abstract Starts: Europe circa 1944–1969," *October* 125 (Summer 2008): 29–64.

29. Fontana first defined his "spatial art" in the "White Manifesto": "The new art requires that all of man's energies be used productively in creation and interpretation. Existence is shown in an integrated manner, with all its vitality." Lucio Fontana, "The White Manifesto" (1946), in *Art in Theory, 1900–2000: An Anthology of Changing Ideas,* ed. Charles Harrison and Paul Wood (Malden, Mass.: Blackwell Pub, 2003), 647.

30. The manifesto was supposed to launch an actual transmission of Fontana's artworks, a plan that entirely overestimated RAI's capabilities; Fontana's televisual art was therefore never realized. Anthony White explains, "In 1952, a year when Italian television was still in its infancy, RAI conducted a brief series of transmissions between April 12 and April 27 to coincide with the Milan Trade Fair. After this period, all broadcasts were suspended until September 1952. The broadcast could therefore not have taken place in May as the manifesto suggests." White, "TV and Not TV," 8.

31. Gillo Dorfles, *Simbolo, comunicazione, consumo* (Turin: G. Einaudi, 1962), 16. Dorfles cited the information theory of Max Bense to support this integrative function of communication.

32. Dorfles, 26.

33. Umberto Eco, *Apocalittici e integrati* (Milan: Bompiani, 1965), 4.

34. For examples of this, see the essays in *Apocalittici e integrati.*

35. The cultural historians Stephen Gundle and David Forgacs have argued in *Mass Culture and Italian Society from Fascism to the Cold War* that while it was commonplace for Italian intellectuals and historians in the 1960s to lament the didacticism of mass media, to worry (as Pasolini and Mannucci did) that it was dictating meaning and controlling spectators was oversimplistic. The reality, they contend, was far more complex. Media like television and radio might have propagated consumeristic values, but they also exposed the Italian public to the same cultural content, unifying the country in the process. As Forgacs and Gundle put it, "Mass culture functioned 'disintegratively' as well as 'integratively.'" David Forgacs and Stephen Gundle, *Mass Culture and Italian Society from Fascism to the Cold War* (Bloomington: Indiana University Press, 2007), 2.

36. Giulio Carlo Argan, *Walter Gropius e la Bauhaus* (Turin: G. Einaudi, 1951).

37. Giulio Carlo Argan, "La ricerca gestaltica," *Il Messaggero,* August 24, 1963, reprinted in *Il Gruppo Enne,* ed. Mussa, 352.

38. Argan had been one of the first scholars in Italy to take an interest in gestalt psychology, translating Herbert Read's *Education through Art* into Italian in 1954. Herbert Read, *Educare con l'arte,* trans. Giulio Carlo Argan, (Milan: Edizioni di Comunià, 1954).

39. Argan, "La ricerca gestaltica," 352.

40. Enzo Mari, Gruppo T, and Gruppo N, "Arte e libertà: Impegno ideologico nelle

correnti artistiche contemporanee," *Il Verri* 12 (1963): 134. This statement was presented at the Verucchio conference and subsequently published in this issue of *Il Verri*.

41. The "most progressive" of the artists, Meštrović claimed, "wanted to include in the problematic of their work and research . . . the practical demands that emerge from laws of production and insights into new social structures and new notions of social life." Matko Meštrović, "Untitled" (1963), in *A Little-Known Story,* ed. Rosen et al., 116.

42. François Molnar and François Morellet, "For a Progressive Abstract Art" (1963), in *A Little-Known Story,* ed. Rosen et al., 136. Originally published in Croatian in Galerija suvremene umjetnosti, *Nove tendencije 2* (Zagreb: Galerija suvremene umjetnosti, 1963), n.p.

43. Gruppo N, "Artist Commentaries," (1963), in *A Little-Known Story,* ed. Rosen et al., 122. Originally published in Croatian in *Nove tendenije 2,* n.p.

44. "Bulletin no. 1" (1963), in *A Little-Known Story,* ed. Rosen et al., 145. Original published in French as *Bulletin no. 1: Nouvelle Tendance—recherche continuelle; evolution de sa composition.*

45. "Bulletin no. 1."

46. "When we began to work, our products were intended to be artistic and our efforts individual. . . . Our making became collective in order to find the terms of an organization that searched to overcome our distrust of the base, distrust born from the consciousness of the difficulty of relations and intentions. Distrust in cultural organizations, in the market, in critics who continue to theorize abstractly." Manfredo Massironi, "Impegno ideologico nelle correnti artistiche contemporanee," in *Il Gruppo Enne,* ed. Mussa, 305.

47. Manfredo Massironi, "Untitled," *Marcatré* 4/5 (March/April 1964): 12, quoted in Jacopo Galimberti, "The N Group and the *Operaisti*: Art and Class Struggle in the Italian Economic Boom," *Grey Room* 49 (Fall 2012): 94.

48. Anty Pansera, *Storia e cronaca della Triennale* (Milan: Longanesi, 1978), 94–96.

49. Ignazio Delogue, "Che cos'è il tempo libero? Un libro di Gianni Toti pubblicato dagli Editori Riuniti," *L'Unità,* March 7, 1962. In the context of this study of artists using computer technology, it seems appropriate that Toti went on in the 1980s to become an electronic poet and musician.

50. Stephen Gundle notes that while in the 1950s the idea of *tempo libero* "was rejected out of hand by many labor movement spokesmen as neocapitalist mystification . . . by the early 1960s it was widely recognized that, as a result of economic and social change, there had been a massive increase in expenditure on culture and recreation. Cinema, television, theater, and sports events, as well as the jukebox and other entertainments, had greatly altered how vast numbers of people, not only urban dwellers, organized their social life." Gundle, *Between Hollywood and Moscow,* 102.

51. As architectural historian Beatriz Colomina put it, "From the parking lots of

factories . . . to the aerial views of suburban houses with a blue swimming pool in each yard, to the close-ups of shopping carts and shelves full of goodies in supermarkets and housewives cooking dinner in kitchens equipped with every imaginable appliance, the message of the film was clear: we are the same but, on the material level, we have more." Beatriz Colomina, "Enclosed by Images: The Eameses' Multimedia Architecture," *Grey Room* 2 (Winter 2001): 13.

52. Pansera, *Storia e cronaca della Triennale*, 96. Pansera noted that in place of the celebrity signature was placed the anonymous objects of mass consumption. However, it seems that no matter how anonymous the designers, the curators, by organizing the exhibition around this theme and argument, amplified the sense that the show was authored.

53. *Tredicesima triennale di Milano: Tempo libero; Esposizione internazionale delle arti decorative e industriali modern e dell'architettura moderna, Palazzo dell'Arte al Parco Milano, 12 Guigno 27 Settembre 1964* (Milan: n.p., 1964), 15. Bilingual publication; all texts quoted are the original English.

54. *Tredicesima triennale di Milano*, 16.

55. *Tredicesima triennale di Milano*, 14.

56. *Tredicesima triennale di Milano*, 16.

57. John Ashbery, "Want a Loudspeaker for Water Music?," *New York Herald Tribune*, August 25, 1964.

58. Paolo Portoghesi, "L'anticatalogo della XIII Triennale di Milano," *L'Architettura*, November 1964, 439.

59. This became clearer to the curators in retrospect. As Gregotti recounted in 2004, "What seems to me still interesting is that it was a bit of an anticipation of the total environment, in which everybody contributed to construct a type of spatial atmosphere, in which the arts could be the protagonist of dialogue; poetry, cinema, music, a conglomerate of arts which has since been transformed into the multimediality which everyone talks about today. This was the fruit of a long discussion. There was a very strong leitmotiv in this formulation, marked by a critical attitude towards society." Gregotti, interview in *Design in Triennale, 1947–68: Percorsi fra Milano e Brianza*, ed. Alberto Brassi, Raimonda Riccini, and Ceclia Colombo (Milan: Silvana Editoriale, 2004), 168.

60. *Tredicesima triennale di Milano*, 31. This English translation offered in the exhibition catalog is unclear and imprecise. The Italian text reads, "Televisione, cinema, spettacolo sportivo, musica leggera, strip-tease, pubblicità, manifestazioni culturali, folklore. Attraverso le forme dello spettacolo, i miti della mediocrità piccolo borghese, dell'arrivismo, della violenza, condizionano migliaia di ore di tempo libero" (28). The takeaway: through these thousands of hours of banal entertainment, the dominant ideology of bourgeois capitalism reproduces itself and prevails. These "performances" *(spettacolo)* are defamiliarized in the performance presented here.

61. Enzo Mari, *Funzione della Ricerca Estetica / The Function of Aesthetic Research* (Milan: Edizioni di Comunità, 1970), 109. English in original publication.

62. Giovanni Anceschi, "Tentativo di Definizione (1964): Intervento di Giovanni Anceschi al congresso artisti e critici d'arte, San Marino," in "L'Arte Programmata," special edition, *Il Verri* 22 (1964): 122.

63. Anceschi, 122, emphasis mine.

64. "Bulletin no. 1," 147.

65. Karl Gerstner, "What Is the Nouvelle Tendance?" (1964), quoted in Frank Popper, *Art, Action, and Participation* (London: Studio Vista, 1975), 15, Gerstner's emphasis. Originally published as "Qu'est ce la Nouvelle Tendance?," in Union Centrale de Arts Décoratifs and Musée des Art Décoratifs, *Propositions visuelles du mouvement international Nouvelle Tendance* (Paris: n.p., 1964), n.p.

66. As Frank Popper explained, "It must . . . be emphasized that when artists attempt to provoke a 'total' participation in the spectator, participation in all senses and of the conscious mind as well, they are not bound by the limitations created by rules and traditions in the general sense. . . . We therefore approach at this point the notion of the autonomous behavior of the spectator, as advocated already by the GRAV and in particular Joël Stein and François Morellet. In this case, the desired objective is the complete abandonment of all control by the artist after the choice of the basic elements: a few props (artistic 'utensils'), a particular location for the 'action' and perhaps the time of the action and its limit of duration. Only one step has to be taken from this point to what is now termed simply an 'action,' in which the autonomous behavior of the spectator is transformed into the beginnings of creativity—creative action in a determine context." Popper, *Art, Action, and Participation*, 183.

67. Lily Woodruff, *Disordering the Establishment: Participatory Art, and Institutional Critique in France, 1958–1981* (Durham, N.C.: Duke University Press, 2020), 63. Woodruff's analysis of what she calls GRAV's "technocratic aesthetics" hinges on their simultaneous identification with and undermining of rationality.

68. GRAV reproduced in *GRAV: Stratégies de participation, 1960/1968*, ed. Yves Aupetitallot (Grenoble: Magasin, Centre National des Arts Plastiques, 1998), 126.

69. "The Avant-Garde of Presence" (1963), trans. John Shepley, in *Guy Debord and the Situationist International*, ed. Tom McDonough (Cambridge, Mass.: MIT Press, 2002), 141–42. For a discussion of Debord's critique of GRAV, see Larry Busbea, "Kineticism–Spectacle–Environment," *October* 144 (Spring 2013): 92–114; and Claire Bishop, *Artificial Hells: Participatory Art and the Politics of Spectatorship* (New York: Verso, 2012), 87–93. Bishop, too, notes this paradox in GRAV: "The conflicting messages of this manifesto *[Assez des mystifications]* are undeniable: the very idea of 'making' someone participate undermines the claim to defeating apathy, and almost incapacitates the viewer from the beginning; all he or she can do is fulfill the artists' requirements to complete the work appropriately" (89).

70. That metaphors of programming were restricted to the realm of artistic production is clear in Karl Gerstner's book *Designing Programmes* (1964) and GRAV member François Morellet's essay "The Case for Programmed Experimental Painting" (1962). See Karl Gerstner, *Designing Programmes* (New York: Hastings House, 1964) and Karl Gerstner, *Groupe de Recherche d'Art Visuel* (Paris: Galerie Denise René, 1962).

71. This work was included in the 2006 exhibition *Gli ambienti del Gruppo T* at La Galleria Nazionale d'Arte Moderna e Contemporanea in Rome, and the catalog included a DVD video of all the environments. I am basing my description on this video, the photographs from 2006 and 1964, as well as the diagrams of the work provided by Boriani.

72. In addition to being included in the 2006 exhibition *Gli ambienti del Gruppo T,* it was also on view as part of the permanent collection at La Galleria Nazionale d'Arte Moderna e Contemporanea in Rome, where I saw it.

73. Arte Programmata's *ambienti* have been discussed as part of the history of interactive art. See Chris Salter, *Entangled: Technology and the Transformation of Performance* (Cambridge, Mass.: MIT Press, 2010), 308–9; and Mariastella Margozzi, Lucilla Meloni, and Federico Lardera, eds., *Gli ambienti del Gruppo T: Le origini dell'arte interattiva* (Rome: La Galleria Nazionale d'Arte Moderna e Contemporanea di Roma, 2006). Both texts define interactive art as works that literally stimulate actual movement in the audience.

74. My discussion of interactivity here diverges from histories of this artistic strategy that primarily focus on the novelty of a given medium rather than the theory of subjectivity it espouses. See, for example, Peter Weibel, "It Is Forbidden Not to Touch: Some Remarks on the (Forgotten Parts of the) History of Interactivity and Virtuality," in *MediaArtHistories,* ed. Oliver Grau (Cambridge, Mass.: MIT Press 2010), 39. Weibel makes no distinction between discrete objects such as op art and early Arte Programmata and the more sensorially assaulting and immersive *ambienti.* Frank Popper, on the other hand, distinguishes between these two types of interactive works. But again, the division derives from the type of media being used; Popper divides works that use light, technology, and new media from works that explore interactivity, immersion, and virtuality through nontechnical means. See Frank Popper, *From Technological to Virtual Art* (Cambridge, Mass.: MIT Press, 2007), 27.

75. Mestrovic's contribution as summarized in Matko Meštrović and Radoslav Putar, "Working Meeting of the Participants of *NT3,*" (1963), in *A Little-Known Story,* ed. Rosen et al., 231. Originally published in *Nova tendencija 3,* ed. Meštrović, 161–65.

76. Manfredo Massironi, "Appunti critici apporti teorici all'interno della nuova tendenza dal 1959 al 1964," in *Nove tendencija 3,* ed. Meštrović, 36.

77. Enzo Mari, "Divulgation des exemplaires de recherches," in *Nove tendencija 3,* ed. Meštrović, 6–7.

78. Cybernetics is indebted to a series of conferences that took place between 1946 and 1953 that brought together thinkers from a variety of disciplines. Called

"The Macy Conferences on Cybernetics," these meetings were funded by the Macy Foundation, directed by Frank Fremont-Smith, and were intended to foster cross-disciplinary dialogue. Participants included the anthropologists Gregory Bateson and Margaret Mead, the cyberneticians William Ross Ashby and William Grey Walter, and the neuroscientist Warren McCulloch. Cybernetics was developed in the spirit of these meetings; it is a fundamentally interdisciplinary field that merged biology with physics, blended psychology with sociology, and integrated mathematics with engineering. One of the best intellectual histories of the Macy's conferences and its interdisciplinary environment is Steve Heims, *The Cybernetics Group* (Cambridge, Mass.: MIT Press, 1991).

79. Norbert Wiener, *The Human Use of Human Beings: Cybernetics and Society* (New York: Doubleday, 1954), 23.

80. Wiener, 122.

81. For a discussion of the influence of cybernetics on the other artists in *New Tendency 3* and the New Tendency movement more generally, especially those coming from Yugoslavia, see Armin Medosch, *New Tendencies: Art at the Threshold of the Information Revolution (1961–1978)* (Cambridge, Mass.: MIT Press, 2016), especially the chapter on "Dreamworlds of Cybernetic Socialism (1963–1965)." Medosch notes the use of cybernetics as a social metaphor for many of the artists and does discuss the Italians; but his analysis foregrounds the "ludic," playful, and ultimately open-ended interactivity of these works rather than the dynamics of control and collectivity I am focusing on here.

82. Umberto Eco, "Apertura, informazione, comunicazione," in *Opera aperta: Forma e indeterminazione nelle poetiche contemporanee* (Milan: Bompiani, 2009), 95–151.

83. Max Bense, *Aesthetische Information Aesthetica II* (Krefeld: Agis-Verlag, 1956); Abraham Moles, *Théorie de l'information et perception esthétique* (Paris: Flammarion, 1958).

84. Bense taught at Ulm starting in 1953, the same year the school was founded. In 1954 he founded the Information Department, developing a curriculum based on what would become his book on aesthetics, designing two modules, one on theory *(informationslehre)* and one devoted to practice *(informationpraxis)*. He designed the Information Department to work in close conjunction with the Department of Visual Communication. Although he left the school in 1958, his ideas structured the two departments for years to come. Bense outlined his modules for the Information Department curriculum in an essay in 1956, "Texte und Zeichen als Information: Ein experimenteller Lehrplan für Information an der Hochschule für Gestaltung Ulm" (Texts and Signs as Information: An Experimental Curriculum for the Ulm School of Design) in the journal *Texte und Zeichen*. This essay is reprinted in Max Bense and Barbara Büscher, *Ästhetik als Programm: Max Bense, Daten und Streuungen* (Berlin: Vice Versa, 2004). Anceschi translated Bense's books on aesthetics into Italian and published them in a single volume in 1974; see *Estetica* (Milan: Bompiani, 1974).

85. Moles, "Cybernetics and the Work of Art," (1965), in *A Little-Known Story,* ed. Rosen et al., 217–25. Originally published in French in *Nove tendencija 3,* ed. Meštrović, 91–102. There is no change in Moles's idea of the purpose of art from his 1958 book on information theory and aesthetics (discussed in chapter 1) and this 1965 essay: artists introduce (entirely formal) complexity into the world. Therefore, although Moles acknowledged that "the artist" is now a human–machine assemblage, and creativity is a characteristic inherent to both sides, Moles used cybernetics to reinscribe the authorial role Arte Programmata had been trying to diminish. Similarly, *New Tendency 3* included work by a new Italian collective, Gruppo di ricerca cibernetica. In their statement for the catalog, the group claimed that their work—a series of fourteen diagrams exploring the relationship between figure and ground in various depictions of a triangle—"reveals the potential of giving artists in particular a more profound awareness of their working methods." Gruppo di Ricerca Cibernetica, "Untitled Artist Statement" (1965), in *A Little-Known Story,* ed. Rosen et al., 216. Originally published in *Nove tendencija 3,* ed. Meštrović, 107.

86. While *Ambiente sperimentale* was restaged, the only remains of Devecchi's and Colombo's works are diagrams drawn by the artists. I discuss *Ambiente sperimentale,* especially the survey, further in chapter 3. As for the titles: the Italian word *strutturazione* is difficult to translate; its means organization or "structuring," although the latter is awkward in English. I translate it as "structure," although this loses the dynamism in the Italian original.

87. In addition to seeing *Spazio elastico* in the New Museum show in 2012, I also viewed *Topoesthesia* at the Museo del Novecento in Milan, where it was reconstructed in 2012 and is on view as part of the permanent collection. The third room in *Topoesthesia* is identical to *Spazio elastico:* the visitor walks down a path demarcated by a grid of elastic cords that slowly move. The preceding corridors in *Topoesthesia* use flashing lights and uneven flooring and are much more sensorially assaulting.

88. Gabriele Devecchi, in *Nove tendencija 3,* ed. Meštrović, 117.

89. As N. Katherine Hayles has shown in *How We Became Posthuman,* cybernetics was an exercise in such boundary dissolution, not only the dissolution of disciplinary borders but also the blurring of the edges between self and environment: "The idea of the feedback loop implies that the boundaries of the autonomous subject are up for grabs, since feedback loops can flow not only within the subject but also between the subject and the environment. From Norbert Wiener on, the flow of information through feedback loops has been associated with the deconstruction of the liberal humanist subject." N. Katherine Hayles, *How We Became Posthuman: Virtual Bodies in Cybernetics, Literature, and Informatics* (Chicago: University of Chicago Press, 1999), 2.

90. Enzo Mari, untitled artist statement, in *Ambiente/Environment: Trigon 67,* ed. Wilfried Skreiner and Horst Gerhard Haberl (Graz: Neue Galerie am Landesmuseum Joanneum, 1967), n.p., emphasis mine.

91. Mussa, "Ambienti," in *Il Gruppo Enne*, ed. Mussa, 125.

92. Mussa, 125.

93. Pickering continues: "Cybernetics staged an ontology in which the fundamental entities were dynamic systems evolving and becoming in unpredictable ways." Andrew Pickering, *The Cybernetic Brain: Sketches of Another Future* (Chicago: University of Chicago Press, 2010), 31–32. Pickering is careful to explain that this conception of cybernetics was unique to a discrete group of British intellectuals (cyberneticians like Stafford Beer and artist/engineers like Gordon Pask, notably), and that it stands in contrast to the field as it developed in the United States. This is an important reminder that cybernetics is not some sort of stable, interpretive key to these artworks. Cybernetics is a sprawling field that encompasses multiple positions and cannot be reduced to a single precept or theme. Artists like Arte Programmata took considerable liberties with cybernetics and exploited the instability of its terms, pushing the tensions and paradoxes in productive ways that are unique to these artists' work.

94. Pickering, 23.

95. This is something that Wendy Chun suggests in both of her books about programming and control. In *Control and Freedom: Power and Paranoia in the Age of Fiber Optics* (2006) she concludes with a definition of freedom drawn from Jean-Luc Nancy, as experience, "not the lack of relation but the very possibility of relation" (292). Similarly, in *Programmed Visions: Software and Memory* (2011) she advocates a "freedom [that] does not offer a feeling of mastery; it neither relies on maps nor sovereign subjects not strategies, but rather depends on a neighborhood of relations and on unfolding actions" (178). Wendy Hui Kyong Chun, *Control and Freedom: Power and Paranoia in the Age of Fiber Optics (Cambridge, Mass., MIT Press, 2006);* Wendy Hui Kyong Chun, *Programmed Visions: Software and Memory (Cambridge, Mass., MIT Press, 2011).*

96. Germano Celant, "L'IM-Spazio," in *Lo spazio dell'immagine*, ed. Umbro Apollonio et al. (Venice: Alfieri, 1967), 21. Bilingual publication; all texts quoted are the original English.

97. See Umbro Apollonio, "Plastic–Visual Objects and Their Predestination," in *Lo Spazio dell'Immagine,* ed. Apollonio et al., 6–11; and Gillo Dorfles, untitled, in *Lo spazio dell'immagine,* ed. Apollonio et al., 25–28.

98. Gruppo MID was a Milan-based collective formed in 1964 by the artists Antonio Barrese, Alfonso Grassi, Gianfranco Laminarca, and Alberto Marangoni. They were active until 1972, when Barresse left the group. From 1972 to 1992, the other three collaborated under the name MID Design.

99. This division was for the most part accepted by the other writers in the catalog. Apollonio's essay deals with New Tendencies artists only, and he distances them from figuration when he writes, "Their objects are not adulterated by occult meanings, by enigmatic phantasmagorias or by uncertainties of interpretation. If the artist lives in a world that is still ambiguous and dissociated, they seem to say, he must not

be satisfied with an intervention that is simply ironic mockery or analogous duplicity or the setting up ersatz images of real panoramas." Dorfles also sees the programmed artists as "making an alliance with architecture and mass media," distinct from a "figurative trend" he associates with Pop and Arte Povera. Apollonio, "Plastic–Visual Objects and Their Predestination"; Dorfles, untitled, 28.

100. Celant, "L'IM-Spazio," 22.

101. Celant, 23.

102. Gillo Dorfles, "Lo Spazio Dell'Immagine at Foligno," *Studio International* 11 (October 1967): 47.

103. Fagiolo dell'Arco, "Italia, Estate 1967," *Studio International* 11 (October 1967): 45.

104. Davide Boriani, untitled artist statement, in Apollonio, et al., *Lo spazio dell'immagine*, 77.

105. Claire Gilman describes Pistoletto's mirror paintings thusly: "His work retained an investment in the persistence of authentic human experience. It is this belief in a world inhabited by free subjects that the mirror panel invokes, its reflective function ensuring a relationship between viewer and viewed that is less spectacular in the Debordian sense than it is theatrical." Claire Gilman, "Pistoletto's Staged Subjects," in "Postwar Italian Art," ed. Claire Gilman, special issue, *October* 124 (Spring 2008): 64. See also Romy Golan, "Flashbacks and Eclipses in Italian Art in the 1960s," *Grey Room* 49 (Fall 2012): 102–27.

106. Michelangelo Pistoletto, untitled artist statement, in *Lo spazio dell'immagine*, ed. Apollonio et al., 96.

107. Germano Celant, *Arte Povera / Art Povera*, trans. Paul Blanchard (Milan: Electa Editrice, 1985), 35.

108. Celant, 35, emphasis mine.

109. Celant, 37.

110. Celant explained that "a poor art [is] concerned with contingency . . . an anthropological outlook, 'real' man (Marx)." The difference between "rich" and "poor" art, which Celant connects to the media employed by the artists (technology versus matter), is essentially one of mediation versus immediacy: "On one hand, then, is a rich attitude linked by osmosis to the system's sophisticated tools and wealth of information, an attitude that imitates and mediates reality, that determines the dichotomy between art and life, public behavior and private life. But contrary to this is a 'poor' inquiry that aims at achieving an identity between man and action, between man and behavior, and thus eliminates the two levels of existence. The latter prefers essential information. It does not dialogue with the system of society or with that of culture. It aspires to appear sudden and unpredictable with respect to conventional expectations." Celant, 35.

3. The Politics of Information

1. Jack Burnham, "Notes on Art and Information Processing," in *Software: Information Technology: Its New Meaning for Art,* ed. Jack Burnham (New York: Jewish Museum, 1970), 11.

2. Abraham Moles, *Information Theory and Esthetic Perception,* trans. Joel E. Cohen (Chicago: University of Illinois Press, 1968), 19.

3. Nees's beginnings are recounted by Frieder Nake in "The Semiotic Engine: Notes on the History of Algorithmic Images in Europe," *Art Journal,* Spring 2009, 80.

4. Georg Nees, "Programming Stochastic Computer Graphics" (1965), in *Cybernetic Serendipity: The Computer and the Arts,* ed. Jasia Reichardt (London: Studio International, 1968), 79.

5. Max Bense, "The Projects of Generative Aesthetics" (1965), in *Cybernetics, Art, and Ideas,* ed. Jasia Reichardt (London: Studio Vista, 1971), 57–60.

6. Jack Burnham, *Beyond Modern Sculpture: The Effects of Science and Technology on the Sculpture of This Century* (New York: George Braziller, 1975), 344.

7. Bense, quoted in Claus Pias, "'Hollerith "Feathered Crystal"': Art, Science, and Computing in the Era of Cybernetics," translated by Peter Krapp, *Grey Room* 29 (Winter 2008): 120.

8. Paul Betts has made a similar argument about Bense and Moles together. See Paul Betts, "Science, Semiotics and Society: The Ulm Hochschule für Gestaltung in Retrospect," *Design Issues* 14, no. 2 (Summer 1998): 67–82.

9. Nake, "Semiotic Engine," 83.

10. A. Michael Noll, "The Beginnings of Computer Art in the United States: A Memoir," *Leonardo* 27, no. 1 (1994): 39.

11. A. Michael Noll, "Computers and the Visual Arts," in "Design and the Computer," special issue, ed. Peter Seitz, *Design Quarterly* 66/67 (1966): 70. The results of Noll's Mondrian test were published in 1966. See A. Michael Noll, "Human or Machine: A Subjective Comparison of Piet Mondrian's 'Composition with Lines' and a Computer-Generated Picture," *Psychological Record* 16, no. 1 (January 1966): 1–10.

12. Noll, "Computers and the Visual Arts," 70. Noll explained that Bell even decided to cancel the show, but the decision came too late. Instead, the company insisted that the gallery and artists limit publicity, so as to avoid any potentially negative associations of the company with the event.

13. Grant D. Taylor, *When the Machine Made Art: The Troubled History of Computer Art* (New York: Bloomsbury, 2014), 31–33. Taylor writes that *Time* magazine lamented the works' resemblance to IBM punch cards, the *New York Times* called the show "bleak," and the *New York Herald Tribune* deemed the works "cold and soulless."

14. Taylor, 39.

15. A. Michael Noll, "The Digital Computer as a Creative Medium," *Bit International* 2 (1968): 61–62. This essay was first published in *IEEE Spectrum* 4, no. 10 (1967): 89–95.

16. Georg Nees, "Computer Graphics and Visual Complexity" (1968), in *A Little-Known Story about a Movement, a Magazine, and the Computer's Arrival in Art: New Tendencies and Bit International, 1961–1973*, ed. Margit Rosen et al. (Karlsruhe: ZKM, 2011), 320. Originally published as "Computergraphik und visuelle Komplexizität," *Bit International 2: Computers and Visual Research*, 1968, 31–43.

17. Herbert W. Franke, *Computer Graphics–Computer Art* (London: Phaidon, 1971), 162.

18. Jasia Reichardt, "Introduction," in *Cybernetic Serendipity*, ed. Reichardt, 5.

19. Jasia Reichardt, "In the Beginning . . . ," in *White Heat Cold Logic: British Computer Art, 1960–1980*, ed. Paul Brown et al. (Cambridge, Mass.: MIT Press, 2008), 77.

20. Press release for the exhibition *Cybernetic Serendipity*, Administrative Records of the Institute of Contemporary Arts, London, Visual Arts Department Files, Box 955/7/8/2, Tate Archive, London (hereafter cited as Administrative Records of the ICA).

21. Press release for the exhibition *Cybernetic Serendipity*.

22. Program of events for the exhibition *Cybernetic Serendipity*.

23. For another reading of Pask's interactivity, see María Fernández, "'Aesthetically Potent Environments,' or How Gordon Pask Detourned Instrumental Cybernetics," in *White Heat Cold Logic*, ed. Brown et al., 53–71. For a discussion of the seemingly random use of gender to aid the discussion of machine–human relationships in the writing of Alan Turing, see the introduction to N. Katherine Hayles, *How We Became Posthuman: Virtual Bodies in Cybernetics, Literature, and Informatics* (Chicago: University of Chicago Press, 1999).

24. In a conversation with Bryan Robertson, John Weightman, and Harold Hobsen on the BBC's *Wilfrid Thomas Programme*, Eric Rhode remarked, "Many people are frightened by the technological age, by machines, and they will be reassured, to some extent, by this exhibition, where the machines are very benign." *Wilfrid Thomas Programme*, BBC, typescript, Administrative Records of the ICA, Box 955/7/8/4.

25. *Wilfrid Thomas Programme*, BBC, typescript.

26. "Aesthetic Gadgetry," *New Society*, August 8, 1968, quoted in Rainer Usselmann, "The Dilemma of Media Art: Cybernetic Serendipity at the ICA London," *Leonardo* 36, no. 5 (2003): 392.

27. For a compelling argument of the political implications of the show's blurring between humans and machines and prescient post-humanism, see María Fernández, "Detached from History: Jasia Reichardt and 'Cybernetic Serendipity,'" *Art Journal* 67, no. 3 (Fall 2008): 6–23.

28. Moles explained that "the role of the New Tendency consists first in develop-

ment in the direction of what one can call *the most modern.* But it is at the same time an integrating activity. . . . Lastly, it is part of a sociocultural evolution by its preoccupation, prevalent within the New Tendency, with a social problem; namely, the *relationship between art and society."* Abraham Moles, "Introduction to the Colloquy," in *A Little-Known Story,* ed. Rosen et al., 263.

29. Moles was even more clear on this point in a later publication from 1968, "Experimental Aesthetics in the New Consumer Society": "The position of art in the contemporary world then becomes akin to that of science and a crisis arises before our very eye in the communication of art to the public. . . . Henceforth, the scientist and the artist play the same role in contemporary society of providing, either in bulk or in small packages, the quantity of essential originality, the requisite dose of subversion and, hence, of self-questioning, for society to progress." Abraham Moles, "Experimental Aesthetics in the New Consumer Society," in *A Little-Known Story,* ed. Rosen et al., 303.

30. Margit Rosen, "'They Have All Dreamt of the Machines—and Now the Machines Have Arrived,'" in *Mainframe Experimentalism: Early Computing and the Foundations of the Digital Arts,* ed. Hannah B. Higgins and Douglas Kahn (Berkeley: University of California Press, 2012), 108. Armin Mendosch also delves into this rupture between "software" artists and the early work of programed art. See Armin Mendosch, *New Tendencies: Art at the Threshold of the Information Revolution (1961–1978)* (Cambridge, Mass.: MIT Press, 2016), especially chapter 4.

31. Alberto Biasi, "Situation 1967," in *A Little-Known Story,* ed. Rosen et al., 269. Biasi's lecture was delivered at the International Colloquy on Computers and Visual Research in Zagreb on August 3–4, 1968. The proceedings, including Biasi's lecture, were published in their entirety in *Bit International* that year.

32. A number of recent books have criticized and historicized this same move in the United States. See Pamela M. Lee, *Think Tank Aesthetics: Midcentury Modernism, the Cold War, and the Neoliberal Present* (Cambridge, Mass.: MIT Press, 2020); and John Beck and Ryan Bishop, *Technocrats of the Imagination: Art, Technology, and the Military–Industrial Avant-Garde* (Chapel Hill, N.C.: Duke University Press, 2020).

33. Biasi, "Situation 1967," 269.

34. Frieder Nake, "Reply to Alberto Biasi," in *A Little-Known Story,* ed. Rosen et al., 270–71.

35. This is a model, it should be noted, that Arte Programmata had already learned to be wholly ineffective in 1965 with the *Responsive Eye* exhibition.

36. Nake identified as a "committed socialist." Nake, "Reply to Alberto Biasi," 271.

37. Nake made the same distinction in an article from 2009, writing that "the range between fun event and visual research demonstrates what early computer art meant in Europe: an oscillation between playful leisure and entertainment on the one hand, and serious analysis and research on the other." Nake, "Semiotic Engine,"

87. In 1970, Nake announced that he was going to stop making art to focus on visual research because it was so implicated in the capitalist art market, showing that he, unlike others at the time, did not see science and technology as also irrevocably intertwined with capitalism. Despite this announcement, Nake continued to make almost the exact same kind of work, as noted below.

38. Enzo Mari, "Nouvelle tendance: Éthique ou poétique," in *Tendencije 4 / New Tendencies 4* (Zagreb: Galerija Suvremene Umjetnosti, 1970), n.p.

39. Mari, n.p.

40. Warren Weaver, "Recent Contributions to the Mathematical Theory of Communication" (1949), in *The Mathematical Theory of Communication,* ed. Claude Shannon and Warren Weaver (1948; repr., Chicago: University of Chicago Press, 1998), 9.

41. Moles, *Information Theory and Esthetic Perception,* 162.

42. Gruppo T, untitled artist statement, in *Nove tendencija 3* (Zagreb: Galerija Suvremene Umjetnosti, 1965), 116. English translation in *A Little-Known Story,* ed. Rosen et al., 214.

43. Mari, "Nouvelle tendance," n.p.

44. Enzo Mari, *Funzione della ricerca estetica* (Milan: Edizioni di Comunità, 1970), 104–5. English in the original publication.

45. Enzo Mari, untitled artist's statement, in *Ambiente/Environment: Trigon 67,* ed. Wilfried Skreiner and Horst Gerhard Haberl (Graz: Neue Galerie am Landesmuseum Joanneum, 1967), n.p.

46. Francesco Leonetti, "Allegorical, Abstract, and Conceptual: Notes Written in 1988, Concerning Enzo Mari," in *Enzo Mari: Modelli del Reale / Models of the Real,* ed. Francesco Leonetti, Filiberto Menna, and Renato Pedio (Milan: Mazzotta, 1988), 116. Leonetti was a friend of Mari's who wrote for *Il Menabò* in the 1960s. He was also a founding editor, along with Carlo Oliva, Roberto di Marco, and Gianni Scalia, of *Che Fare?* a radical journal that was published in ten issues between 1967 and 1972. Mari and Leonetti will collaborate on the book *Atlante secondo Lenin* discussed in chapter 4.

47. As Mari put it, "The comprehensibility of what we register visually varies with the level of codification of the language used by or available to the designer, or secondarily, to the extent to which the person to whom it is directed knows this language." Mari quoted in Frank Popper, *Art—Action Participation* (New York: New York University Press, 1975), 19. Prior to this citation, Popper explains, "Mari tends to put the accent on 'visual communication' as a form of eliminating the superfluous." He therefore recognized, in 1975, that Mari was first and foremost interested in clarity.

48. The conference was called *Vision 67* and held at the Loeb Student Center at New York University from October 19 to 21. It centered on the theme "Survival and Growth." Speakers included Max Bense, Gillo Dorfles, R. Buckminster Fuller, Vittorio Gregotti, and Gordon Pask, among others. Eco's paper was first published

in the collection *Il costume di casa* in 1973. Umberto Eco, *Il costume di casa: Evidenze e misteri dell'ideologia italiana* (Milan: Bompiani, 1973).

49. Umberto Eco, "Towards a Semiological Guerilla Warfare" (1967), in *Faith in Fakes: Essays,* trans. William Weaver (London: Secker and Warburg, 1986), 138.

50. Eco, 142.

51. Kynaston McShine to Joseph Beuys, March 14, 1970, Museum of Modern Art Exhibition Records, 1970–79, *Information* Correspondence A-Bl, Folder 934.2, Museum of Modern Art Archives, New York (hereafter cited as MoMA Archives).

52. Kynaston McShine, "Acknowledgements," in *Information* (New York: Museum of Modern Art, 1970), n.p.

53. Kynaston McShine, introduction to *Information,* 139–41.

54. Marshall McLuhan, *Understanding Media: The Extensions of Man* (New York: McGraw-Hill, 1964), 8–9. McLuhan's primary example of a medium being the message is electric light, which he calls "pure information." *Marshall McLuhan DEW-Line Newsletter* 1, no. 9 (March 1969), Kynaston McShine *Information* exhibition research, 1969–70, I. 11.b, MoMA Archives. This pamphlet was one among many *DEW-Line* newsletters in McShine's preparatory materials.

55. McLuhan suggests this in the next clause of the *DEW-Line* essay: thinking about information as the environment "suggests how people may learn to create total environments for serving human aspirations, while avoiding some potentially harmful consequences." And in another of McLuhan's pamphlet's in McShine's materials, McLuhan writes, "Since Sputnik (1957), the planet has become an art form, i.e., the content of the man-made environment." *McLuhan DEW-Line Newsletter* 3, no. 2 (September–October 1970), Kynaston McShine *Information* exhibition research, 1969–70, 1.11a (3), MoMA Archives.

56. McShine, introduction to *Information,* 138.

57. Nicholas Negroponte, *The Architecture Machine* (Cambridge, Mass.: MIT Press, 1970), 7.

58. Jack Burnham, "Notes on Art and Information Processing," 14.

59. Jack Burnham, "System Esthetics," *Artforum,* September 1968, 31, Burnham's emphasis. Expanding this idea in *Beyond Modern Sculpture,* Burnham argued that a "systems consciousness" had taken hold of contemporary art, "a concern for organizing quantities of energy and information . . . a refocusing of aesthetic awareness—based on future scientific-technological evolution—on matter–energy–information exchanges and away from the invention of solid artifacts. These new systems prompt us *not* to look at the 'skin' of objects, but at those meaningful relationships within and beyond their visible boundaries" (369–70).

60. Burnham, "System Esthetics," 32.

61. Burnham, "Notes on Art and Information Processing," 12. The artist Les Levine suggested the term, on which he elaborated in his text for the show's catalog:

"Software is the programming material which any system uses, i.e. in a computer it would be the flow charts or subroutines for the computer program. In effect software in 'real' terms is the mental intelligence required for any experience. It can also be described as the knowledge required for the performance of any task or transmission of communication. They say: 'It's going to be raining tomorrow' is software." Les Levine, "Systems Burn-Off X Residual Software, 1969," in *Software*, ed. Burnham, 60–61. For a critical analysis of this fantasy of software as a thing separate from hardware, see Wendy Hui Kyong Chun, *Programmed Visions: Software and Memory* (Cambridge, Mass.: MIT Press, 2013), 19–58.

62. Theodor H. Nelson, "The Crafting of Media," in *Software*, ed. Burnham, 17. In 1974, Nelson wrote a book called *Computer Lib: You Can and Must Understand Computers Now,* inspired by Stuart Brand's *Whole Earth Catalog.*

63. For more on the relationship between Burnham and Haacke, see Marga Bijvoet, *Art as Inquiry: Toward New Collaborations between Art, Science, and Technology* (New York: Peter Lang, 1997), especially chapter 4, "Hans Haacke and Jack Burnham: Exchange of Ideas."

64. In "Systems Esthetics" Burnham quoted Haacke as saying "a system is not imagined, it is real" (35). The quote was taken from the exhibition catalog for the artist's 1968 solo show at Howard Wise Gallery.

65. Quoted in *Six Years: The Dematerialization of the Art Object, 1966–1972,* ed. Lucy R. Lippard (1973; repr., Berkeley: University of California Press, 1997), xiii.

66. Hans Haacke, "Lessons Learned," "Landmarks Exhibition," special issue, *Tate Papers* 12 (Autumn 2009): http://www.tate.org.uk/research/publications/tate-papers /12/lessons-learned.

67. Fredric Jameson, "Hans Haacke and the Cultural Logic of Postmodernism," in *Hans Haacke: Unfinished Business,* ed. Brian Wallis (Cambridge, Mass.: MIT Press, 1986), 45.

68. As Jameson noted, Haacke's work can be seen in light of the publication of Louis Althusser's essay "Ideological State Apparatuses": "It is convenient to mark the moment of the maturity of institutional analysis with the publication of Althusser's programmatic essay . . . in 1970" (47).

69. It is worth noting that Benthall was coauthor with Gustav Metzger and Gordon Hyde of the Zagreb Manifesto, presented at the 1969 *New Tendencies 4* symposium "Computer and Visual Research," in which the authors argued for the continued relevance of researching the relationship between computers and art in a way that prefigures Bentham's 1972 text. Jonathan Benthall, Gordon Hyde, and Gustav Metzger, "Zagreb Manifesto," *Bit International,* no 7 (1971): 4.

70. Franke, *Computer Art–Computer Graphics,* 132. This narrow focus on the creative capacity of computers dominated later histories of computer art as well. Frank Dietrich wrote in 1986 that "computer art represents a historical breakthrough in

computer applications. For the first time computers became involved in an activity that had been the exclusive domain of humans: the act of creation." Frank Dietrich, "Visual Intelligence: The First Decade of Computer Art (1965–1975)," *Leonardo* 19, no. 2 (1986): 159.

71. Metzger's presentation at the 1969 "Computers and Visual Research" symposium in Zagreb, 1969, later published as "Untitled Paper on Theme Number Three," *Bit International* 7 (1971): 28. Metzger cited as evidence the fact that in 1963 the U.S. Ballistic Missile Research Group won the first prize in computer art in a contest called "Computers and Automation." For more on Metzger's computer art, see Simon Ford, "Technological Kindergarten: Gustav Metzger and Early Computer Art," in *Proud to Be Flesh: A Mute Magazine Anthology of Cultural Politics after the Net,* ed. Josephine Berry Slater and Pauline van Mourik Broekman (London: Mute Publishing, 2009), 114–20.

72. For more on the computer art exhibition, see Francesca Franco, "The First Computer Art Show at the 1970 Venice Biennale: An Experiment or Product of the Bourgeois Culture?," in *Relive: Media Art Histories,* ed. Sean Cubitt and Paul Thomas (Cambridge, Mass.: MIT Press, 2013), 119–34. For more on the experimental research component, see Vittoria Martini, "1970: A Biennale in Search of Itself," *Exhibitionist* 11 (July 2015): 49–60.

73. Jonathan Benthall, *Science and Technology in Art Today* (London: Thames and Hudson, 1972), 60. In fact, Benthall all but dismissed Nake and criticized the artist for leaving computer art for an equally rarified realm: Nake's "attempt to isolate 'aesthetics' as a self-contained subject," Benthall argued, "seems to be mistaken."

74. Benthall, 20.

75. Benthall, 47.

76. Benthall, 127.

77. Burnham argued that the legacy of computer art lay in these non-technological practices in what is often misread as a redaction of his previous position, "Art and Technology: The Panacea That Failed." In fact, while the essay admitted that fusing art and technology via "tech art" was always a failure (a position that Burnham held in the 1970s as well), Burnham claimed the success of their underlying ideas about systems: "The cybernetic art of the 1960s and 1970s is considered today little more than a trivial fiasco. Nevertheless, avant garde art during the past ten years has, in part, rejected inert objects for the 'living' presence of artists, and by that I am referring to Conceptual Art, Performance Art, and Video Art. In the case of such artists as Chris Burden, Joseph Beuys, Christian Boltanski, James Lee Byars, and Ben Vautier, art and life activities have become deliberately fused, so that the artist's output is, in the largest sense, *life-style.*" Jack Burnham, "Art and Technology: The Panacea That Failed," in *The Myths of Information: Technology and Postindustrial Culture,* ed. Kathleen Woodward (London: Routledge and Kegan Paul, 1980), 213.

78. According to Robert Lumley, the first street protest that turned violent in

Milan was a demonstration against the RAI television and radio reporting of the widespread strikes taking place across Italy. Therefore, distrust of the media was a pressing concern by 1969. Robert Lumley, *States of Emergency: The Cultures of Revolt in Italy from 1968 to 1978* (London: Verso, 1990), 234.

79. It is important to recognize, however, that the independent leftist media doubted the anarchist attribution from the start.

80. As Lumley explains, *La strage di stato* "established the importance of the development of alternative sources of information . . . [and] it set in motion grassroots investigations in factories, schools, and neighborhoods into local Fascists." Lumley, *States of Emergency*, 123.

81. Massimo Veneziani, *Controinformazione: Stampa alternativa e giornalismo d'inchiesta dagli anni Sessanta a oggi* (Rome: Castelvecchi, 2006).

82. Invented by the ophthalmologist Adelbert Ames Jr. in 1934, an Ames room is a space designed to produce the optical illusion that two people roughly the same height are radically different sizes. The room is shaped like a trapezoid, with severely sloping walls and inclined floors, but appears to viewers, when seen through a pinhole, to be perfectly square. As a result of this illusion, two people standing at each corner will look vastly different sizes, and a person walking from corner to corner will appear to grow or shrink.

4. Autonomy and Organization

1. For an analysis of why the theme of the 1968 Triennale (*Il grande numero*, or The Greater Number) antagonized, rather than amplified, the new social movements growing in Italy, see Federica Vannucchi, "The Contested Subject: The *Greater Number* at the 1968 XIV Triennale of Milano," in *Exhibiting Architecture: A Paradox?*, ed. Eeva-Liisa Pelkonen, Carson Chan, and David Andrew Tasman (New Haven, Conn.: Yale School of Architecture, 2015), 109–18.

2. As Boriani put it in retrospect, the protest was "against the reduction of culture to a commodity, against the alienation of intellectual labor, against the compromises in which instances of research are thwarted." "Testimonianza di Davide Boriani," in Paola Nicolin, *Castelli di carte: La XIV Triennale di Milano, 1968* (Macerata: Quodlibet, 2011), 259.

3. In her study, Paola Nicolin considers the occupation to be a strategy of negation, meant to attack the exhibition and the values it represented by asserting the impossibility, at present, of anything but a destructive act. She writes in a related article, "By recognizing the construction of a space of knowledge as a space of power, it is possible to see the '68 protest itself as a declaration of the impossibility of sustaining a linear and univocal vision of consensual reality (itself almost always coerced)." Paola Nicolin, "Beyond the Failure: Notes on the XIVth Triennale," *Log* 13/14 (2008): 95. For more on the relationship between the Biennale and Triennale, see Paola Nicolin,

"T68/B68," in *The Italian Avant-Garde: 1968–1976,* ed. Alex Coles and Catherine Rossi (New York: Sternberg Press, 2013), 79–95.

4. It is worth noting that the theme and works in the 1968 Triennale were in line with Arte Programmata's practice. The introductory section (on "the greater number") was organized into three parts: errors, information, and *prospettive*—a word that means both perspective and prospects, hope, probabilities, and so has a decided orientation toward the future. Gruppo MID designed an initial room that, as Anty Pansera recounts, included "fifty-three metres of screen, along the walls, supporting programmed projections of visual sequences designed to illustrate the theme of the desalinisation of seawater and various environmental problems." Anty Pansera, "Chant and Counterchant: Programmed Art and Industrial Design, from the Work to the Everyday Object, From Multiples to Serials," in *Arte programmata e cinetica in Italia, 1958–1968,* ed. Marco Meneguzzo (Parma: La Galleria, 2000), 267.

5. This statement was signed by Enzo Mari, with the collaboration of Enrico Castellani, Manfredo Massironi, Roberto Pieraccini, Mario Spinella, Paolo Valesio, and Lea Vergine. Enzo Mari Papers, Centro Studi e Archivio della Comunicazione, Università degli Studi di Parma, Italy (hereafter cited as Enzo Mari Papers). The statement was published in the newspaper *Arte Oggi;* see "Proposta politica dei progettatori," n.d., from the folder on the 1968 Venice Biennale held at the Archivio Storico delle Arti Contemporanee, La Biennale di Venezia, Venice, Italy.

6. "Un rifiuto possibile," July 3, 1968, signed by Enzo Mari, Enrico Castellani, Manfredo Massironi, Davide Boriani, and Alberto Biasi, Enzo Mari Papers. When the statement was published in *Arte Oggi,* only Mari and Castellani's names were printed as signatories. However, when it appeared in the 1969 *Bompiani Almanac* (published in November 1968), Massironi's and Boriani's names were added. "Un rifiuto possibile," in *Almanacco letterario Bompiani 1969* (Milan: Bompiani, 1968), 163.

7. "Proposta politica dei progettatori," n.p.

8. "Proposta politica dei progettatori," n.p.

9. Giulo Carlo Argan asserted the affinity of programmed art and design in 1970: "Historically, visual–kinetic research is connected to the theory of industrial design: also because it uses materials that come from modern industry and aims at mediating their aesthetic perception . . . (and) tends to equip the user for a lucid, critical perception of reality." Translated and quoted in Anty Pansera, "Chant and Counterchant," 267. Originally published in G. C. Argan, *L'arte moderna, 1770/1790* (Florence: Sansoni, 1970). Argan's assessment of the similarities therefore hinge on the media, whereas I am arguing that they rely on notions of use and societal interventions. Pansera also makes an argument for this relationship by discussing the relationship between Gianni Colombo and his brother, Joe Colombo, who is a very well-known designer. There is one case in which Gianni and Joe designed something in collaboration: in 1962, they constructed the Acrilica lamp for Oluce, which won the gold medal at the

1964 Milan Triennale. Pansera uses this to argue that Joe is another example of a designer that draws heavily on the legacy of programmed art, writing that it was "an exemplary image of the 'technological,' rigorous climate of Programmed Art, but also of the 'taste' that then counted as modern and trendy." "Chant and Counterchant," 272. Joe Colombo's work is closer to Mari, in that he designs configurable systems. His "programmable system for living" was included in the 1968 Triennale, and his "total furnishing unit" appeared prominently in *Italy: The New Domestic Landscape* at MoMA in 1972.

10. Paul Ginsborg notes that one of the first worker uprisings in 1968 took place outside the traditional centers and without unions, at the Marzotto textile factory at Valdagno. Paul Ginsborg, *A History of Contemporary Italy: Society and Politics, 1943–1988* (New York: Palgrave Macmillan, 2003), 311. Ginsborg goes on to discuss the complex role of the unions in the next three years, a history that is beyond the scope of this study, concerned as it is with the extra-institutional left and *operaismo*. See Ginsborg, 311–22.

11. Steve Wright discusses the craftspeople at Porto Marghera, specifically, in *Storming Heaven* (London: Pluto Press, 2002), 110–11.

12. Nanni Balestrini and Primo Moroni, *L'orda d'oro, 1968–1977: La grande ondata rivoluzionaria e creative, politica ed esistenziale* (Milan: Feltrinelli, 2011), 233.

13. As Gigi Roggero explains, "The students' movements of 1968 and the workers' 'hot autumn' of 1969, the autonomous committees in the universities and in the factories, were unified in a common process, in Turin as well as Porto Marghera, in Milan, in Bologna, or in Rome. That is to say, in a common process of a new class composition." Gigi Roggero, "Organized Spontaneity: Class Struggle, Workers' Autonomy, and Soviets in Italy," *WorkingUSA: The Journal of Labor and Society* 13 (June 2010): 206. By class composition, Roggero is invoking a central analytical term of the time, a sense that class is a dynamic operation—one formed in and through struggle—rather than a static identity or fixed position.

14. The meeting itself resulted in the formation of a group, the Assemblea operai–studenti (Workers and Student Assembly) that called for a rent strike. Roggero, "Organized Spontaneity," 206.

15. Romano Alquati, "Struggle at FIAT (1964)," trans. Evan Calder Williams, *Viewpoint Magazine,* September 26, 2013, https://www.viewpointmag.com/2013/09/26/struggle-at-fiat-1964/.

16. Romano Alquati, "Composizione organica del capitale e forza-lavoro alla Olivetti" (1962), in *Sulla FIAT e altri scritti* (Milan: Feltrinelli, 1975), 85–163. Originally published in *Quaderni rossi* 2 (June 1962).

17. Mario Tronti, "Lenin in England," in *Workers and Capital,* trans. David Broder (New York: Verso, 2020), 67.

18. Tronti, 65.

19. Wright, *Storming Heaven*, 49. Gigi Roggero provides a similar, useful definition: "Class composition is the relationship between the capitalist articulation of labor power, in its combination with machines, and the formation of class as a collective subject." Gigi Roggero, *L'operaismo politico italiano: Genealogia, storia, metodo* (Rome: DeriveApprodi, 2019), 34.

20. Gigi Roggero, *Elogio della militanza: Note su soggettività e composizione di classe* (Rome: DeriveApprodi, 2016), 34.

21. Tronti, "Marx, Labor Power, Working Class," in *Workers and Capital*, 173.

22. Roggero, *Elogio della militanza*, 102.

23. Tronti, "The Plan of Capital," in *Workers and Capital*, 63.

24. Wright, *Storming Heaven*, 119–30. See also Ginsborg, *History of Contemporary Italy*, 312. Ginsborg's list also includes "the Maoists of Servire Il Popolo ('Serve the People'), with their attention to peasant politics . . . the Movimento Studentesco ('Student Movement'), with its stronghold at the state university in Milan . . . [and] last but not least Il Manifesto, a small breakaway group from the left of the Communist Party" (312).

25. Anonymous writer quoted and translated in Wright, *Storming Heaven*, 129. For a detailed history of this whole movement see Wright, 125–30.

26. Toni Negri, "Keynes and the Capitalist Theory of the State Post-1929," in *Revolution Retrieved: Writings on Marx, Keynes, Capitalist Crisis, and New Social Subjects (1967–83)* (London: Red Notes, 1988), 18. He continues: "In other words, the path to stability now seemed to depend on the recognition of this new precarious basis of state power: the dynamic of state planning implied acceptance of a sort of 'permanent revolution' as its object—a paradoxical *Aufhebung* of the slogan on the part of capital." In this essay, Negri in essence argues for capital's "shock doctrine," and claims that most working-class parties and strategies (aimed at regulation and mitigation of capitalism's worst effects) are Keynesian. He calls, in contrast, for a revolutionary strategy beyond capitalism, one that refuses to drive capital's plan and capitalist development.

27. "There is a truth that must be recognized. That is, that the entire cycle of modern architecture and of the new systems of communication came into being, developed, and entered into crisis as an enormous attempt—the last to be made by the great bourgeois artistic culture—to resolve, on the always more outdated level of ideology, the imbalances, contradictions, and retardations characteristic of the capitalist reorganization of the world market and product development. Order and disorder, understood in this way, no longer oppose each other. Seen in the light of their real historical significance there is no contradiction between Constructivism and the 'art of protest'; between the rationalization of building production and the subjectivism of abstract expressionism or the irony of pop art; between capitalist plan and urban chaos; between the ideology of planning and the 'poetry of the object.'" Manfredo

Tafuri, *Architecture and Utopia: Design and Capitalist Development,* trans. Barbara Luigia La Penta (Cambridge, Mass.: MIT Press, 1976), 178–79. Original published in Manfredo Tafuri, "Per una critica dell'ideologia architettonica," *Contropiano,* 1969, 77. Negri's essay was a touchstone for Tafuri, as was Cacciari and the legacy of the German Frankfurt school.

28. Pier Vittorio Aureli, *The Project of Autonomy: Politics and Architecture within and against Capitalism* (New York: Buell Center, 2013), 49.

29. For a longer history of the cultural analyses presented in *Contropiano,* especially ideas about art as ideological critique, see Mario Valente, *Ideologia e potere: Da "Il Politecnico" a "Contropiano," 1945/1972* (Turin: ERI, 1978).

30. Mario Tronti "Estremismo e riformismo," *Contropiano* 1 (1968): 41–42. This includes Tronti's controversial negative characterization of the working class.

31. Negri's essay on Marx and the cycle of crisis was his last contribution to *Contropiano.*

32. Tronti, quoted in Roggero, *Elogio della militanza,* 117.

33. Thus, as Roggero summarizes in *Elogio della militanza,* "For Negri one needs to simply accelerate the development of a new technical composition to transform the political composition, for Tronti one needs only to hold back the old forces of political composition to fight the technical composition" (123).

34. As Alberto Toscano explains, for Negri "practices of autonomy [are] aimed at [the] destabilizing and de-structuring of the political conditions for the perpetuation of capitalism." Alberto Toscano, "Chronicles of Insurrection: Tronti, Negri, and the Subject of Antagonism," *Cosmos and History: The Journal of Natural and Social Philosophy* 5, no. 1 (2009): 6.

35. As Lucia Rubinelli explains, constituent power is "self-founding, unlimited in both time and space and expression pure *strength,* as opposed to institutionalised *power.*" Lucia Rubinelli, *Constituent Power: A History* (Cambridge: Cambridge University Press, 2020), 10. See also Antonio Negri's 1977 essay "Towards a Critique of the Material Constitution" in *Books for Burning: Between Civil War and Democracy in 1970s Italy* (New York: Verso, 2005).

36. This seems to be changing, as evident in the recent translations of Tronti's writing. See Tronti, *Workers and Capital*; and Mario Tronti, *The Weapon of Organization: Mario Tronti's Political Revolution in Marxism,* ed. and trans. Andrew Anastasi (Brooklyn, N.Y.: Common Notions, 2020).

37. The pipeline was proposed in 1969, researched for the next two years, but only began construction in 1978. It led to Italy becoming one of the largest consumers of Algerian national gas. For a brief history of Sonatrach's nationalization of Algerian oil, see "History of Hydrocarbons in Algeria," Sonatrach, accessed October 22, 2015, http://www.sonatrach.com/en/elements-histoire.html.

38. Jacopo Galimberti, "Le pétrole et les colonels: Artistes italiens entre tiers-

mondisme, panarabisme et socialisme (1966–1974)," in *L'espace des images: Art et culture visuelle en Italie, 1960–1975,* ed. Valérie Da Costa and Stefano Chiodi (Paris: Éditions Manuella, 2022). Page numbers not available, as publication is forthcoming. Thanks to Jacopo Galimberti for providing me with a copy of this essay, which is one of the only sources of information about this important time in Anceschi's career.

39. Giovanni Anceschi, "La grafica di Potere Operaio," 2018, https://www.deriveapprodi.com/2018/09/la-grafica-di-potere-operaio/.

40. Galimberti, "Le pétrole et les colonels," n.p. Galimberti also notes the way the artists drew on local decorative traditions, for example in their designs for the Sonatrach stamps.

41. For more analysis of the oil crisis and class struggle see Midnight Notes, *Midnight Oil: Work, Energy, War, 1973–1992* (New York: Autonomedia, 1992).

42. Galimberti, "Le pétrole et les colonels," n.p.

43. The term "basic design" comes from the Bauhaus, but for Anceschi the reference was to the Ulm School of the 1950s and 1960s rather than the Weimar and Dessau schools of the 1920s. Anceschi went on to teach the class "Design and Visual Communication" from 1971 to 1976 at the University of Venice. For a history of the development of Italian design education, see Elena Dellapiana and Daniela N. Prina, "Craft, Industry, and Art: ISIA (1922–1943) and the Roots of Italian Design Education," in *Made in Italy: Rethinking a Century of Italian Design,* ed. Grace Lees-Maffei and Kjetil Fallan (New York: Bloomsbury, 2014), 109–25. As Dellapiana and Prina explain, official schooling programs in industrial design education developed particularly late, compared to Germany and the United States, but industrial design education coincided with manufacturing industries in Italy, both of which developed in the mid to late nineteenth century. Three important developments occurred in the mid-1950s to condense and formalize design education in Italy: the Centro Studi Arte-Industria was founded in 1954, a private institution located in Novara; the first industrial design course took place at the Faculty of Architecture in Florence in 1955; and finally, the Corso Superiore di Disegno Industriale opened in Venice in 1960 (123).

44. Anceschi describes his designs in Anceschi, "La grafica di Potere Operaio."

45. Anceschi's design therefore also contrasted notably with activist zines such as *A/traverso,* which employed a disjointed, montage style and used many fonts and often cut-out, appropriated images and letters.

46. Boriani has explained: "Starting in 1971 teaching at Brera, I organized my course as a laboratory for the design and implementation of interventions inserted in the architecture and in the territory." "Art, Design, Research, Political Commitment," interview by Elizabeth Longari, typescript, Davide Boriani Archives, Curitiba, Brazil, unpublished text courtesy of the artist.

47. Devecchi reflected on this moment years later, explaining that "my problem was to broaden its range of users, making it available in large numbers and at low

cost." Gabriele Devecchi, interview by Matteo Devecchi, in *La lingua degli specchi: L'atelier De Vecchi; 50 anni di storia nell'argento,* ed. Tersilla Faravelli Giacobone (Milan: Electa, 1997), 65–66.

48. Devecchi, interview in *La lingua degli specchi,* ed. Giacobone, 139.

49. Davide Boriani, in *Campo Urbano: Interventi estetici nella dimensione collettiva urbana,* ed. Luciano Caramel, Bruno Munari, and Ugo Mulas (Como: Editrice Cesare Nani, 1969), 118.

50. Enrico Crispolti, introduction to *Volterra '73: Sculture, ambientazioni, visualizzazioni, progettazione per l'alabastro, Volterra, 15 Luglio–15 Settembre 1973* (Florence: Centro Di, 1974), n.p.

51. Enrico Crispolti, "Estate '73 miracolo a Volterra," *Unità,* August 30, 1993, 14.

52. Martina Tanga, "Extramural Exhibitions: *Volterra '73* and *Ambiente come Sociale,*" *Arte Ambientale, Urban Space, and Participatory Art* (New York: Routledge, 2019), 25–26.

53. Tanga, 38.

54. Tanga, 25–26.

55. Because of the importance of alabaster to the city's history and economy, many participating artists chose to engage with it, although none with the same duration and scope as *Progettazione.* For example, Alik Cavaliere set up a stand in the main square selling alabaster memorabilia to tourists in his *Bancarella dall'alabastro* (Alabaster Stand), indicating how this ancient craft had to resort to cheap commodity production in order to survive.

56. Debate between operators of alabaster and designers, led by Manuel Crescentini, Consiglio Comunale di Volterra, February 24, 1973, transcript, in *Volterra '73,* n.p. Later Boriani added to the conversation: "Hence our intervention is experimental at the beginning, rather than the type immediately applicable to commercial uses. All this for a free choice. On our part we put the commitment in design/planning [*progettazione*] and we call on you to make an analogous commitment for the expert advice and the realization of the models."

57. Tanga, "Extramural Exhibitions," 161.

58. As Boriani put it, "One of the problems of alabaster seems to us constituted at the qualitative base level of current production, and it is this level we want to address and improve—the method of production and design, the aesthetic quality and the value of the products on the market." Debate between operators of alabaster and designers, transcript, n.p.

59. Quoted in Ugo Savardi, "Remembering Manfredo Massironi," *Gestalt Theory* 34, no. 1 (2012): 12. For more on the history of this relationship between design pedagogy, theories of perception and psychology, and visual epistemologies, see Zeynep Çelik Alexander, *Kinaesthetic Knowing: Aesthetics, Epistemology, Modern Design* (Chicago: University of Chicago Press, 2017).

60. Prior publications include Manfredo Massironi and Paolo Bonaiuto, "Ricerche sull'espressività: Qualità funzionali, intenzionali e realizione di causalità in assenza di 'movimento reale,'" *Rassegna di psicologia general e clinica* 8 (1966): 3–42; and Manfredo Massironi, "Efficacia e limiti delle tecniche di rappresentazione dello spazio visuale," report, Laboratorio di Psicologia, Universita degli Studi, Bologna, 1973. The text also came out of his teaching of graphic design and perceptual psychology, which began in 1967. This book was expanded and translated into English in 2002 as Manfredo Massironi, *The Psychology of Graphic Images: Seeing, Drawing, Communicating,* trans. N. Bruni (Mahwah, N.J.: Lawrence Erlbaum Associates, 2002).

61. Manfredo Massironi, *Vedere con il disegno: Aspetti tecnici, cognitivi, comunicativi* (Padua: Franco Muzzio, 1982), 10.

62. Massironi, *Psychology of Graphic Images,* 45.

63. The English text does cite information theory and deals with the meaning of information from a scientific perspective, explicitly, although the idea of choice and whittling down a form to its most essential parts is already there in *Vedere con il disegno.*

64. Massironi cited the psychologist James Gibson and art historian Ernst Gombrich, among others, to support these various claims. Gibson and Gombrich were engaged in a prolonged conversation about these questions of the perception and interpretation of form that began in the 1950s and continued through the 1970s.

65. Massironi, *Vedere con il disegno,* 115. Earlier in the text, he discusses how objects are "inexhaustible fonts of possible representations" (63).

66. Massironi, 54.

67. Massironi, *Psychology of Graphic Images,* 66.

68. Massironi, 67. This tension between the historical contingency of interpretation and universal principles of perception is, in many ways, constitutive of fields devoted to theorizing form, from design to art-historical formal analysis. See Alexander, *Kinaesthetic Knowing*; and Johanna Drucker, *Graphesis: Visual Forms of Knowledge Production* (Cambridge, Mass.: Harvard University Press, 2014).

69. Massironi, 123–25.

70. Massironi, 171.

71. Jacopo Galimberti, "The Urges of Rebellion and Resistance: An Interview with Antonio Negri," *Immediations* 2, no. 3 (2010): 102.

72. Christian Marazzi, *Capital and Affects: The Politics of the Language Economy,* trans. Guiseppina Mecchia (New York: Semiotext(e), 2011), 39.

73. Marazzi explains: "Some have described our current situation as a 'crisis of meaning'—an incapacity to elaborate and propose to all members of society a system of references (ideas, norms, values, ideals) that makes it possible to give to one's existence a stable and coherent meaning, to develop an identity, to communicate with others, to participate in the construction—real or imaginary—of a liveable world.

This state of affairs is not a consequence of society being characterized by a radical absence of meaning. The opposite is true: we live in a genuine 'fair of meanings' where each of us can 'freely' appropriate the images, symbols, and myths that s/he prefers. What we lack is a 'symbolic order' capable of structuring and unifying the scattered fragments of our lives" (72). He continues: "Everything is returning—but in a perverted, reactionary, conservative way . . . At the very time when the 'absence of meaning' brings within our reach an era in which human beings finally seem able to speak to one another, by virtue of free access to communication, we are witnessing the return of the idea of 'race' and of every myth of origin and belonging. The potential liberty of the 'transparent society' turns into its opposite: a racist intolerance that defends the borders of its homeland" (73).

74. Marazzi, 136.

75. Ginsborg, *History of Contemporary Italy*, 354–58. See also Franco "Bifo" Berardi, "Anatomy of Autonomy," in *Autonomia: Post-Political Politics,* ed. Sylvère Lotringer and Christian Marazzi (New York, Semiotext(e), 2007), 148–71.

76. Midnight Notes, *Midnight Oil,* 6–7.

77. Balestrini and Moroni, *L'orda d'oro,* 582. For more on this creative activity see Roggero, *L'operaismo politico italiano,* 67–73.

78. Franco "Bifo" Berardi, "Anatomy of Autonomy," in *Autonomia,* ed. Lotringer and Marazzi, 156.

79. This is especially evident in Mari's ideas about work and labor. Recalling the occupation of the Milan Triennale, Mari reflected, "When in the assemblies I tried to speak of intense work as transformation. . . . Work, for these youths, is only synonymous with alienation, and therefore to be rejected entirely." Enzo Mari, "Sessantotto, Settantasette, e Quarantaquattro valutazioni," in *25 modi per piantare un chiodo: Sessant'anni di idee e progetti per difendere un sogno* (Milan: Mondadori, 2011), 96.

80. Emilio Ambasz, ed., *Italy: The New Domestic Landscape* (New York: MoMA, 1972), 262–65.

81. Enzo Mari, "Introduction to *Avanguardie e culture populari* (1975)," in *Autoprogettazione?,* 2nd ed. (Mantua: Corraini Edizioni, 2002), 33.

82. Mari, *Autoprogettazione?,* 49.

83. Bari to P.C., January 1, 1975, in Mari, 39.

84. Mari described the Day–Night sofa and its connection to 1968 politics in Enzo Mari, "Imprese di design e autoprogettazione," in *25 modi per piantare un chiodo,* 82.

85. "Obviously the models proposed were totally uneconomical from this point of view: any table, to give an example, correctly made by machine, requires no more than 30 percent of the material used in our models, with results that are far more stable and long lasting." Mari, *Autoprogettazione?,* 51.

86. Paolo Fossati, *Il design in Italia* (Turin: Giulio Einaudi Editore, 1972), 143, 146.

87. This was noted explicitly in Arturo Carlo Quintavalle, *Enzo Mari* (Parma: CSAC dell'Università di Parma, 1983), 301.

88. See for example Felicity D. Scott, *Architecture or Techno-Utopia: Politics after Modernism* (Cambridge, Mass.: MIT Press, 2007); and Mark Wasiuta and Craig Buckley, eds., *Environments and Counter-Environments: Experimental Media in Italy; The New Domestic Landscape, MoMA, 1972* (Barcelona: Acatar, 2011).

89. From 1966 to 1973, these groups continued to make objects, but it is their environments—especially those on view at the 1972 MoMA show—that most saliently capture the approach of counter-design.

90. Reviewers were quick to note this split between critical and assimilationist design. Dorfles, in a short review for *Corriere della Sera,* remarked on "the notable discrepancy between those who still defend the hyper-technological imposition of our society and those that are attuned to the dangers of consumerism," while Eco's review in the same newspaper concluded that "the exhibition puts on the table all the problems of design, today, without reserve, in a continual oscillation between triumphalism and masochism." Umberto Eco, "Dal cucchiaio alla città," *Corriere della Sera,* January 30, 1972; and Gillo Dorfles, "L'Ambiente per l'uomo," *Corriere della Sera,* January 30, 1972, both in press files, 1004/156, *Italy: The New Domestic Landscape,* Archives of the Museum of Modern Art, New York.

91. Archizoom, untitled artists' statement, (1972) in *Italy,* ed. Ambasz, 234. They continued, "The self-production and self-consumption of culture imply the ability to free oneself from all those repressive systems that 'official culture' has woven around us, by attributing an infinite variety of 'values' and 'meanings' to the reality around us and thus, in fact, taking away our freedom to modify that very environment at will. Our task, then, is to reduce to zero the moral weight of things, methodically questioning all the patterns of religious, aesthetic, cultural, and even environmental behavior" (234–35).

92. Ugo La Pietra, "The Domicile Cell: A Microstructure within the Information and Communications System," in *Italy,* ed. Ambasz, 226.

93. Filiberto Menna, "Design for New Behaviors," in *Italy,* ed. Ambasz, 411.

94. Menna, 413.

95. Paolo Fossati presents a trenchant critique of the MoMA show in a long footnote for the introduction to *Il design in Italia,* 72–73.

96. In addition to Catherine Rossi's essay cited below, see Catherine Rossi, "From East to West and Back Again: Utopianism in Italian Radical Design," in *Hippie Modernism: The Struggle for Utopia,* ed. Andrew Blauvelt (Minneapolis: Walker Art Center, 2016), 58–67.

97. Catherine Rossi, "Crafting a Design Counterculture: The Pastoral and the Primitive in Italian Radical Design, 1972–1976," in *Made in Italy,* ed. Lees-Maffei and

Fallan, 154. This is also rampant in the countercultural design movements in the United States, as my discussion of Gene Youngblood's marrying of cybernetics and "paleolithics" in the Introduction makes plain.

98. Global Tools Bulletin No. 1, Document-o No. 1, *The-La-Co-n-stitu-z-t-ion-e,* as reproduced in Valerio Borgonuovo and Silvia Franceschini, eds., *Global Tools: When Education Coincides with Life, 1973–1975* (Rome: Nero, 2018), 18. Originally published by Edizioni L'uomo e l'arte (Milan) in June 1974.

99. Andrea Branzi quoted in Borgonuovo and Franceschini's introduction, "When Education Coincides with Life," *Global Tools,* ed. Borgonuovo and Franceschini, 16.

100. Branzi quoted in Simon Sadler, "The Hammer and the Garrote: A Parable of 'Tool Globalism,'" *Global Tools,* ed. Borgonuovo and Franceschini, 79. When Global Tools is associated with contemporary Italian politics, it is done in the context of *operaismo's* critique of work, but in a way that entirely ignores the debates about organization and autonomy and, worse, entrenches the opposition between these terms. This argument is evident in Maurizio Lazzarato's essay in this volume (153–66). Lazzarato suggests that Global Tools' focus on the nonproductive part of creativity—their emphasis on the processes of making and the pedagogical contexts that allow for unbridled experimentation—has aligned the group with *operaismo's* idea of the refusal to work.

101. Sadler, "The Hammer and the Garrote: A Parable of 'Tool Globalism," in *Global Tools,* ed. Borgonuovo and Franceschini, 85. He goes on to note that "Global Tools' autonomy recalled a left libertarianism of fraternity; [while] *Catalog* autonomy gestured toward a conservative libertarianism of personal spiritual and economic freedom." Sadler gestures towards how Global Tools invokes a "'global commons' imagined as an 'open work' rather than owned resource."

102. Davide Boriani, "Gli artisti e l'impegno rivoluzionario: A proposito della svendita di opera di Enzo Mari," *NAC: Notiziario Arte Contemporanea,* March 1972, 7.

Conclusion

1. Byung-Chul Han, *Psychopolitics: Neoliberalism and the New Technologies of Power,* trans. Erik Butler (New York: Verso, 2017), 15.

2. See, for example, David Harvey, *A Brief History of Neoliberalism* (New York: Oxford University Press, 2007); and Wendy Brown, *Undoing the Demos: Neoliberalism's Stealth Revolution* (New York: Zone Books, 2015). The literature on neoliberalism and freedom also includes many studies of culture and art mentioned throughout the book: Alexander Galloway's *Protocol: How Control Exists after Decentralization* (2004), Wendy Chun's *Control and Freedom: Power and Paranoia in the Age of Fiber Optics* (2006) and *Programmed Visions: Software and Memory* (2013), and most recently Pamela Lee's *Think-Tank Aesthetics: Midcentury Modernism, the Cold War, and the Neoliberal Present* (2020).

3. Han continues: *"The neoliberal regime utterly claims the technology of the self for its own purposes" (Psychopolitics,* 28); italics in original.

4. However tempting such a narrative of naivete and failure may be, the cynical position of knowing better and assuming the worst is in part an effect (even, arguably, an avoidance) of the analytical impasses at which we find ourselves today. This book not only refuses but also historicizes the split between celebration and condemnation—what Eco already in 1964 recognized as "apocalyptic" and "integrated" positions from which to assess new artistic and technological media and their varied effects. See Peter Sloterdijk, *Critique of Cynical Reason,* trans. Michael Eldred (Minneapolis: University of Minnesota Press, 1988); and Slavoj Žižek, *The Sublime Object of Ideology* (New York: Verso, 2009). For a discussion of cynicism in 1980s Italy, see Massimo De Carolis, "Toward a Phenomenology of Opportunism," in *Radical Thought in Italy: A Potential Politics,* ed. Michael Hardt (Minneapolis: University of Minnesota Press, 1996), 37–51. De Carolis connects cynicism to the technocratic condition described by Han: "Forms of behavior such as opportunism and cynicism derive from this infinite process in which the world becomes no more than a supermarket of opportunities empty of all inherent value, yet marked by the fear that any false move may set in motion a vortex of impotence" (40–41).

5. Michael Hardt, "Introduction: Laboratory Italy," in *Radical Thought in Italy,* ed. Hardt, 1–10.

6. See, for example, Negri's theorization of "the social worker" or *operaio sociale,* in *Dall'operaio massa all'operaio sociale: Intervista sull'operaismo* (Milan: Multhipla Editori, 1979), 10–11.

7. For a clear disambiguation of the strands of Autonomia, see Patrick Cunninghame, "Mapping the Terrain of Struggle: Autonomous Movements in 1970s Italy," *Viewpoint Magazine,* November 1, 2015. See also Cunninghame's interview with Sergio Bologna, "For an Analysis of Autonomia: An Interview with Sergio Bologna," *Left History* 7, no. 2 (September 2000): 89–102. George Katsiaficas emphasizes the connections between these various sectors of social movements at the time, centering feminism but glossing over the antagonisms among feminists and those in both organized and creative Autonomia. See George Katsiaficas, *The Subversion of Politics: European Autonomous Social Movements and the Decolonization of Everyday Life* (Chico, Calif.: AK Press, 2006).

8. Hardt, "Introduction," 3.

9. Patrick Cunninghame, "'A Laughter That Will Bury You All': Irony as Protest and Language as Struggle in Italian 1977 Movement," *International Review of Social History* 52 (2007): 153–68.

10. Nanni Balestrini and Primo Moroni, *L'orda d'oro, 1968–1977: La grande ondata rivoluzionaria e creativa, politica ed esistenziale* (Milan: Feltrinelli, 2011), 604.

11. Danilo Mariscalco, "Dai laboratori alle masse: Le Pratiche culturali del

movimento del '77 come forme dell'intellettualità diffusa" (PhD diss., Università degli studi di Palermo, 2009). For a list of the publications and their issues and dates, see pp. 63–66.

12. Balestrini and Moroni, *L'orda d'oro*, 627–28. In "'A Laughter That Will Bury You All'" Cunninghame characterized this more as a decomposition: "Whereas 1968 saw an explosion of antagonistic movements, behaviors, and mentalities that spread through Italian, and indeed global society, synchronizing with a profound process of social, economic, and cultural crisis and change, 1977, as the culmination of that process, represented its imposition and dispersion throughout society in an individualized rather than collective form" (157).

13. These tactics are described in Balestrini and Moroni, *L'orda d'oro*, 590–91. An *A/traverso* bulletin from February 1977 was called "False Information Can Produce True Events," an unsettling sentiment in these days of fake news; and as explained above, strategies did include publishing false events, but it is closer to what Carrie Lambert-Beaty has called "parafiction" in their utopianism. See Carrie Lambert-Beaty, "Make-Believe: Parafiction and Plausibility," *October* 129 (Summer 2009): 51–84.

14. "Creative language is the privileged terrain of action." Collettivo A/traverso, *Alice è il diavolo: Storia di una radio sovversiva* (Milan: Shake Edizioni, 2007), 11. In his 1978 book *Avanguardia di massa* (Milan: Postmedia Books, 2018), Maurizio Calvesi claimed that these strategies of creative and subversive communication realized the ambitions of the historical avant-garde, not only subverting the means of communication but making a more experimental mode of being, communicating, and imagining more widely available to all.

15. They continue: "This form of linguistic practice is the only form adequate for a comprehensive practice that blows up the dictatorship of the Political and introduces into behavior the actions of appropriation, refusal of work, liberation, and collectivization." Collettivo A/traverso, *Alice è il diavolo*, 10–11. The passage comes partially as an explanation of the title's first issue ("Piccolo gruppo in moltiplicazione," which means "Small Group in Multiplication" as in infinitely expanding). For more on these strategies of "creative" Autonomia and A/traverso in particular, see Danilo Mariscalco, "The Italian Movement of 1977 and the Cultural Praxis of the Youthful Proletariat," in *The Politics of Authenticity: Countercultures and Radical Movements across the Iron Curtain, 1968–1989,* ed. Joachim C. Häberlen, Mark Keck-Szajbel, and Kate Mahoney (New York: Berghahn Books, 2020), 174–90; and Danilo Mariscalco, "Autonomia e abolizione dell'arte: Emergenze maodadaiste nel movimento del Settantasette," *Palinsesti* 4 (2014): 21–34. For a closer look at the Maoism in Mao–Dadaism, see Jacopo Galimberti, "Maoism, Dadaism, and Mao–Dadaism in 1960s and 1970s Italy," in *Art, Global Maoism, and the Chinese Cultural Revolution,* ed. Jacopo Galimberti, Noemi de Haro García and Victoria H. F. Scott (Manchester: Manchester University Press, 2020), 213–32.

16. Collettivo A/traverso, *Alice è il diavolo,* 114. Also quoted in Balestrini and Moroni, *L'orda d'oro,* 605.

17. "Il linguaggio si ribella" one part of the publication asserted: "Language rebels." Collettivo A/traverso, *Alice è il diavolo, 93.*

18. Mariscalco, "Dai laboratori alle masse," 98.

19. In some cases, this restriction of radio to the RAI network fostered some degree of freedom, as recounted by Eco in his discussion of Luciano Berio's studio and radio program in the 1950s.

20. An important example of this separation of futurism and fascism is Renato Poggioli's *Teoria dell'arte d'avanguardia* (Theory of the Avant-Garde), published in Italy in 1962. Poggioli discusses the "agonism" of the avant-garde and the politics of form, never mentioning fascism.

21. Umberto Eco, "Sono seduto a un caffè e piango," in *Sette anni di desiderio* (Milan: Bompiani, 2018), 97. Originally published in *L'Espresso,* May 1, 1977.

22. These rifts align with what sociologists Luc Boltanski and Eve Chiapello have identified as two vying traditions, the artistic versus social critiques of capitalism. These critiques, and the way they have historically worked at cross-purposes, are premised on the opposition between individual liberty and systematic (i.e., social) determination. The artistic critique values the former: as Boltanski and Chiapello explain in *The New Spirit of Capitalism* (New York: Verso, 2005), it "stresses the objective impulse of capitalism and bourgeois society to regiment and dominate human beings . . . [and] counterposes the freedom of artists . . . free of all attachments." The social critique, on the other hand, abhors the individualism inherent to both capitalism and the artistic critique, and instead focuses on redistributing wealth, and thus "is often accompanied by a nostalgia for traditional or orderly societies, particularly their communitarian aspects" (35–37). For the artistic critique, individual autonomy from structures and limits is the ultimate goal. It is an essentially antiprogrammatic position. The social critique locates and tries to incite those aspects of individuals that are social and systematic, such as class identity and exploitation. The goal is to imagine and implement new programs. With the artistic critique, individual freedom is won at the expense of shared social meaning, which is in turn viewed as always dominating, ideological, or oppressive; but in the social critique, individual desires, freedom, and spontaneity are all subsumed under the needs of the collective, which itself tends to be posited as a priori or presumed.

23. "The multitude . . . might be conceived as a network: an open and expansive network in which all differences can be expressed freely and equally, a network that provides the means of encounter so that we can live and work in common." Antonio Negri and Michael Hardt, *Multitude: War and Democracy in the Age of Empire* (New York: Penguin, 2004), xiii–xiv. The centrality of conversation to "the common" is driven home by Cesare Casarino: "For the common is that which is always at stake

in any conversation: there where a conversation takes place, there the common expresses itself; there where we are in common, there and only there is a conversation possible." Cesare Casarino, "Surplus Common: A Preface," in *In Praise of the Common: A Conversation on Philosophy and Politics,* by Casarino and Negri (Minneapolis: University of Minnesota Press, 2008), 1–3.

24. For a cogent critique of this anti-mediation bias in Hardt and Negri's coauthored books, see Reinhold Martin, "Public and Common(s)," *Places Journal,* January 2013, https://doi.org/10.22269/130124. He writes, "What is less clear, however, is the medium by which *communication* becomes *common.* Unlike many theorists of the communicative public sphere, Hardt and Negri have relatively little to say about the specific forms of mediation by which collective subjectivities are formed. By this I mean not only technological mediation—as in the properties of those communications systems by which a multitude comes into a heterogeneous being-in-common—but also other mediating instruments, like social structures (the family, the nation) or institutions (schools, hospitals, housing, workplaces, prisons, communications networks). If the segmented realm of public and private is to be replaced by the networked realm of the common, what will replace these mediators?" David Harvey makes a similar critique in "Commonwealth: An Exchange," *Artforum* 43, no. 3 (November 2009): 210–15.

25. In *Relational Aesthetics* (Dijon: Les Presses du Réel, 2002), Nicolas Bourriaud famously called the medium of relational aesthetics "the whole of human relations and their social context" (14).

INDEX

abandonment: of abstraction, 40; of art (as category), 51; of art (as practice), 4, 160, 171, 207, 275n37, 279n73; of computers (as art), 130–31, 133, 160; of control, 267n66; of object-designing (Mari), 213; as valued, 51

abstraction, 28; abandonment of, 40; and authenticity, 41; vs. concrete art, 44; and communism, 40, 66; via deconstruction, 218–22; and modes of viewing, 75; and nature, 44 and politics, 5, 18, 40–42; vs. realism, 39–42, 45; and referentiality, 42–44; and representation, 208–9. See also *arte informale*; politics

absurdity/irreverence, 14, 222, 258n16; and the "Anti-Monuments" of *Progettazione per l'alabastro,* 202–6, 217; and Autonomia, 234; and the historical avant-garde, 30, 237; Manzoni's, 50–51; Mari's, 158. See also alabaster; avantgarde, historical; body, the; Manzoni, Piero; Mari, Enzo

Acconci, Vito, 161, 164; *Service Area* (1970), 161. See also *Information* (1970 MoMA exhibition); *Software* (1970 Jewish Museum exhibition)

action, 267n66; for action's sake, 189; and identity, 124; and knowing, 180, 182, 200; and language, 210, 292n14; and mediation, 118; and not-knowing, 114–17; spontaneous, 189–90. See also *ambienti*; viewer, the

adaptability, 7, 114; and feedback, 106; and temporality, 109. See also cybernetics; feedback; mutability

Adorno, Theodor, 83. See also mass media

advertisements: as corrupting, 79–80; op/pop art as, 74. See also capitalism; *Carosello*; television

aesthetic information, 65–66, 131–36, 151–52. See also Bense, Max; information theory; Moles, Abraham

affordability: and design (for Devecchi), 197, 285n47; of industrial production vs. DIY, 216, 288n85; of the Programma 101, 17; of self-design, 216–17. See also computers; Devecchi, Gabriele; Mari, Enzo

agency, 26, 39; of art, 124; of chance, 2–4, 100; and computers, 57, 139; vs. control, 2–4; dispersal of, 106; limits of, 160; and mass media, 123; of the reader, 194; and structure, 20, 111, 160, 195; and technology, 181; of the viewer, 11–12, 15, 38–39, 52–53, 85, 92–94, 105, 114–20, 267n66; of the working class, 88, 185. *See also* autonomy; choice; freedom; *operaismo* (workerism); subjectivity

"end" of, 4–5, 29, 129, 182, 249n2; and the open work, 33–71; and politics, 4–5, 21, 29–31, 52, 87–89, 129–75; and *progettazione*, 191–206; and representation, 30; and unpredictability, 114–17. *See also* politics; *progettazione* (design/planning)

Arte programmata (1962 exhibition), 1–3, 16–17, 19, 27–28, 33–39, 42, 44, 49, 51, 53, 55, 57–63, 68–71, 75, 86, 110. *See also* Olivetti (company)

art for art's sake, 26, 171. *See also* action: for action's sake; computer art; experimentation for experimentation's sake; spontaneity: for its own sake

Art Workers' Coalition: *And Babies* (1969), 161, 163. See also *Information* (1970 MoMA exhibition); Wallace, Mike

Ashbery, John: on the 1964 Milan Triennale, 94. *See also* Milan Triennale

Asor Rosa, Alberto: and *Contropiano*, 188; and *Quaderni rossi*, 184. See also *Contropiano* (journal); *Quaderni rossi* (journal)

A/traverso, 234–35, 237; "aesthetic vitalism," 237; *A/traverso* (newsletter), 212, 285n45; "Mao–Dadaism," 234. *See also* Autonomia

Aureli, Pier Vittorio: on capitalist development, 188; on 1960s neocapitalism, 19–20. *See also* architecture; capitalism; *Contropiano* (journal); *operaismo* (workerism)

authorship: amplification of, 175; and chance, 2–4, 73, 100; collective/dispersed, 27, 33–73, 149; and computer art, 147–48; and generative aesthetics, 135; and political agenda, 40–41; politics of, 39–52. See also *impegno*

automation: and art, 56, 70, 76, 100; and exploitation, 147, 183; and Gruppo N, 210; and temporality, 251n13; virtues of, 2. *See also* autonomy; computers; exploitation

Autonomia, 181–82, 212–13, 222, 227, 233–39; as against planning, 19; creative, 234–39, 292n15; "Movement of '77" (*Settantasette*), 233–35; and refusal, 30, 181, 292n15; and social reproduction, 233–34. *See also* A/traverso; *operaismo* (workerism); refusal

autonomy: and capitalism, 284n34; vs. computers, 7; and design, 214; dismantling of, 45, 104–5, 110–11, 118–20, 150; of Global Tools, 290n101; within a network, 214–22; and organization, 189–91, 199, 203, 221–22, 226; of the political, 190; and radio, 236; regional, 196; of the social, 233; unsettling of, 92–94; of the viewer, 267n66; of the working class, 185–86, 189–90. *See also* agency; Autonomia

Autunno caldo (Hot Autumn), 129, 172–73, 183, 282n13. *See also* politics; protests; strikes

Avanguardia operaia, 182, 187. *See also* politics

avant-garde, historical, 30, 234–40, 292n14; and immediacy, 234; irreverence of, 30, 237. *See also* absurdity/irreverence; Dada; futurism; surrealism

Baj, Enrico: on emotive gestural painting as capitalist, 42; and the 1964 Milan Triennale, 89. *See also* Milan Triennale: 1964

Baldessari, John, 164. See also *Information* (1970 MoMA exhibition); *Software* (1970 Jewish Museum exhibition)

Balestrini, Nanni, 260n45; and Anceschi, 193; and the 1964 Milan Triennale, 89–90; on the period of selfmanaged, subversive communication, 212; on *Settantasette*, 234; on student protests, 183; *Tape Mark 1* (1961), 56–57. *See also*

Academy, 48, 196, 285n46; *Camera distorta abitabile* (Distorted Living Room, 1970), 174, 196; *Camera stroboscopica multidimensionale* (Multi-Dimensional Stroboscopic Room, 1967), 120–24; and design, 29, 181, 183, 191, 249n3; on designers (as powerless), 228; on the end of Gruppo T, 4; and the 1968 Milan Triennale, 177, 280n2; *Progettazione per l'alabastro* (Design/Plan for Alabaster, 1973), 200–206, 211, 217, 286n55, 286n58; and protest ("Un rifiuto possibile" [A Possible Refusal]), 178; *Spazio + Linee luce + Spettatori* (Space + Light Lines + Spectators, 1964), 98, 100–105, 110, 112; *Lo Spettacolo* (Performance, 1964), 95–96; *Superficie magnetica* (Magnetic Surface, 1960), 57, 60–61; *Tempo libero: Strutturazione temporale in uno spazio urbano* (Free Time: Temporary Structuration in an Urban Space), 198; and the 1970 Venice Biennale, 171; on the work and spectator perception, 62. *See also* Brera Art Academy; Devecchi, Gabriele; *New Tendencies* (exhibitions); Gruppo T; *Volterra '73*

Bourriaud, Nicolas: on the medium of relational aesthetics, 294n25

Brand, Stewart: *Whole Earth Catalog,* 9–10, 226, 278n62. *See also* cybernetics

Branzi, Andrea: on Global Tools, 226. *See also* Archizoom; Global Tools

Brass, Tinto: and the 1964 Milan Triennale, 90. *See also* Milan Triennale

Brera Art Academy, 45, 48, 196–97, 285n46. *See also* Boriani, Davide; Colombo, Gianni; Devecchi, Gabriele; Mari, Enzo

Breton, André, 26, 237. *See also* avant-garde, historical

Burnham, Jack, 132, 164–66, 170; and Bense's theory of art, 135–36; on con-

temporary art, 277n59; on the legacy of computer art, 279n77; on the most important art of the 1970s, 172; and *Software,* 130, 164–66; on systems, 165–66, 277n59. *See also* Bense, Max; computer art; computers; *Software* (1970 Jewish Museum exhibition)

Burri, Alberto: on his painting as "freedom attained," 41. *See also arte informale*; freedom

Burroughs, William: and Giorno's *Dial-a-Poem,* 161, 163; strategic incoherence of, 13. *See also* control societies; Giorno, John

Byars, James Lee: and the Hudson Institute, 17. *See also* Art and Technology Program of the Los Angeles County Museum of Art

Cacciari, Massimo, 188. *See also Contropiano* (journal)

Cage, John: and 9 *Evenings,* 130; and *Cybernetic Serendipity,* 141. *See also Cybernetic Serendipity* (1968 ICA exhibition); Experiments in Art and Technology: 9 *Evenings: Theatre and Engineering* (1966)

Calder, Alexander, 50, 63. *See also* mobiles

Calvino, Italo: on Arte Programmata, 70–71; on being reassured by finite systems, 53

Campo Urbano exhibition, 198–99. *See also* Caramel, Luciano

capitalism: and architecture, 283n27; and art, 87–91, 118, 177–229; and autonomy, 284n34; cognitive, 55; and colonialism, 193; and crisis, 190; critiques of (artistic and social), 293n22; and design, 225; eschewing, 87; and exploitation, 180, 210–211, 233; and free time, 89–93; and identity, 30; and individualism, 42, 75–77; and language, 210–11; and repetition, 42; reproduction of, 266n60;

sual Structure), 108–9; *Strutturazione fluida* (Fluid Structure, 1960), 33–34, 61, 68–69; *Tempo libero: Strutturazione temporale in uno spazio urbano* (Free Time: Temporary Structuration in an Urban Space), 198; *Topoestesia (Tre zone contigue—Itinerario programmato)* (Topoesthesia: Three Contiguous Zones—Programmed Itinerary, 1965–70), 109, 270n87; and the 1968 Venice Biennale, 5, 109. *See also* Gruppo T

Colombo, Joe, 281n9. *See also* Colombo, Gianni; design

Colomina, Beatriz: on the effect of the Eameses, 91, 265n51. *See also* Eames, Charles and Ray

communalism, 9–10. *See also* Brand, Stewart

communication: and art, 62, 63–68, 89, 126, 135–60, 166, 171, 173, 209; and collectivity, 78–79; and community, 8–9, 193, 259n25; and culture, 161; and design, 193, 209, 213; and freedom, 159; as goal, 3, 5, 166; limits of, 154; noncommunication (of abstract art) as, 67; noncommunication (as resistance), 252n25; reevaluation of, 154–55; and spontaneity, 226; subversive, 212, 235, 292n14; symbolic, 82; technology, 3. *See also* clarity; cybernetics; *Information* (1970 MoMA exhibition); information theory; legibility; mass media; radio; RAI (Radiotelevisione italiana); television

communism, 22–25; vs. abstract art, 40, 66; alternative, 237; anti-, 15–16, 22; vs. Hollywood, 80; Italian Communist Party (PCI), 16, 23, 39–41, 52, 66, 80, 181–83, 187, 189, 211–12, 225, 255n40; and Mari, 218–22. *See also* Della Volpe, Galvano; Italian Communist Party (PCI); politics

community, 8–10, 253n32; and communication, 8–9, 193, 259n25; and control, 12, dialogue with, 199; and Global Tools, 226–27; impossibility of, 240; and language, 211. *See also* collectivity; *Volterra '73*

complicity: and art, 178, 198, 227–28; in ecological destruction, 224; with technocracy, 18

computer art, 20, 29, 129–49, 160–71, 278n70; as information processing, 171–72; legacy of, 279n77; and politics, 131, 143–49, 160–70. *See also* automation; CGI; *Computer-Generated Pictures* (1965 Howard Wise Gallery exhibition); computers; *Cybernetic Serendipity* (1968 ICA exhibition); *Generative Computergrafik* (1965 Technische Hochschule exhibition); *Information* (1970 MoMA exhibition); military; mimicry; punch cards; randomness; *Software* (1970 Jewish Museum exhibition)

Computer-Generated Pictures (1965 Howard Wise Gallery exhibition), 137–38, 273n12. *See also* computer art; Noll, A. Michael

computers, 6–13, 33, 53–63; and agency, 57, 139; and choreography, 141; ELEA 9003 (Olivetti), 53–55; as existential threat, 6–7; and freedom, 21, 56; Graphomat Z64, 134, 136–37; vs. human behavior, 91; as humanity's greatest hope, 7–10; and information, 171; and labor relations, 53, 55; as leading to technoanarchy, 8; PDP-8, 167; vs. politics, 172; Programma 101 (Olivetti), 17, 55, 254n33; Stromberg-Carlson S-C 4020, 137–38. *See also* automation; computer art

constructivism, 44, 234; and the "art of protest" (for Tafuri), 283n27. *See also* protest

control, 12–15; abandonment of, 267n66; ambiguity of, 100; as to be avoided, 10, 78, 124–26; and collectivity, 12, 14–15, 70; cybernetic, 12, 77–78, 111, 114, 126; via disorder, 172–73; excess of, 119; and feedback, 12, 77–78, 106–7, 110–11, 126, 132; -freedom (Chun), 14, 252n27; and mass media, 126; and participation, 61; in programmed art, 3–4, 61, 71–127, 158–59, 173–75; regional, 196; resistance to, 13. *See also ambienti*; cybernetics; nationalization

control societies, 12–15, 25, 251n21, 252n22, 252n25; resistance in, 13. *See also* control; Deleuze, Gilles

Contropiano (journal), 30, 182, 188–91, 284n31. *See also* institutions, alternative; Negri, Antonio

conventions: beyond (and pleasure), 135; and complexity, 66; of design, 213; representational, 208; societal, 59. *See also* clarity

corporations: collaborating with artists, 16–18, 130; sponsoring exhibitions, 141–43. See also *Arte programmata* (1962 exhibition); Bell Labs; Boeing; IBM; Olivetti (company)

Costa, Toni, 49, 88–89. *See also* Gruppo N

creativity, 18, 56–57; of the audience, 85; collective, 7; as demanded, 231; and generative aesthetics, 135–36; limits of, 136; of machines, 139–41, 278n70; and randomness, 138; and society, 24; and standardization, 56

Crispolti, Enrico: on Arte Programmata, 70–71; and *Volterra '73*, 197–98. See also *Volterra '73*

Csuri, Charles: and CGI, 144; *Random War*, 142. *See also* CGI; randomness; war

cybernetics, 4, 8–12, 20–21, 131–34, 140–44, 164–69, 239, 268n78, 270n89,

271n93; and *ambienti*, 28, 77–78, 111, 114, 126; "Cybernetics and Ghosts" (Calvino), 53; cybernetic socialism, 21; and democracy, 251n17; and factories, 55; and New Tendency, 106–8, 151; and subjectivity, 114, 270n89; and uncertainty, 114, 154. *See also* communication; *Cybernetic Serendipity* (1968 ICA exhibition); information theory

Cybernetic Serendipity (1968 ICA exhibition), 29, 130, 132–33, 140–44, 147–48, 165. *See also* computer art; cybernetics; Reichardt, Jasia

Dada, 30, 234; "Mao-Dadaism," 234; neo-Dada, 84–85

Dadamaino: *Lo Spettacolo* (Performance, 1964), 95–96

Danese company: and Mari's "Putrella" tray, 46, 213. *See also* design; Mari, Enzo

Debord, Guy, 100. *See also* Situationist International

De Gasperi, Alcide, 16. *See also* Democrazia Cristiana (DC); politics

Deleuze, Gilles, 234, 263n18; on the control society, 12–15, 251n21, 252n22. *See also* control

dell'Arco, Maurizio Fagiolo: on Gruppo T and Gruppo N, 119. *See also* Gruppo N; Gruppo T; *spazio dell'immagine, Lo* (The Space of the Image, 1967 exhibition)

Della Volpe, Galvano: debate with Bobbio, 22–25. *See also* Bobbio, Norberto; freedom; politics

Democrazia Cristiana (DC): anti-communism of, 16; "compromise" with the PCI, 211–12, 225; and corruption, 253n28; and Italian airwaves, 79–80. *See also* Italian Communist Party (PCI); politics

De Palma, Brian: and *The Responsive Eye*,

75–76. See also *Responsive Eye, The* (1965 MoMA exhibition)

design, 44–49, 177–229; and autonomy, 214; basic, 193, 285n43; and capitalism, 225; and communication, 193, 209, 213; counter-, 181, 223–27, 289n89; disappearance of (from 1964 Milan Triennale), 92; industrial, 191; and politics, 216; politics of, 29–30; radical, 216, 223–28; refraining from, 223; self, 213–22; and social change, 4, 177–229; and taste, 214; translation in, 208

Devecchi, Gabriele, 195–206, 213, 222; on his *ambienti*, 126; *Camera distorta abitabile* (Distorted Living Room, 1970), 174, 196; and design, 29, 181, 191, 197, 285n47; and Gruppo T, 48, 89; and politics, 197; *Progettazione per l'alabastro* (Design/Plan for Alabaster, 1973), 200–206, 211, 217, 286n55; *Spazio in strutturazione plasticocromatica* (Space in Plastic–Chromatic Structure), 108–10; *Tempo libero: Strutturazione temporale in uno spazio urbano* (Free Time: Temporary Structuration in an Urban Space), 198. *See also* Boriani, Davide; design; *New Tendencies* (exhibitions); Gruppo T; *Volterra '73*

Dietrich, Frank: on computer art, 278n70. *See also* computer art

Documenta 4 (1968), 4

Dorfles, Gillo: on concrete art, 42–44; on Gruppo T and Gruppo N, 119; on the 1972 *Italy* exhibition, 289n90; on mass media, 82–83, 97; and *Lo spazio dell'immagine*, 118–19; and *Vision 67*, 276n48. *See also* communication; *Italy: The New Domestic Landscape* (1972; MoMA exhibition); mass media; Movimento Arte Concreta (MAC); *spazio dell'immagine, Lo* (The Space of the Image, 1967 exhibition)

Eames, Charles and Ray: and montage, 95; and the 1959 World's Fair in Moscow *(Glimpses of the USA)*, 91, 265n51; and the 1964 World's Fair in New York *(Think)*, 18, 91. *See also* IBM

Eco, Umberto: on *arte informale*, 67–68; as artwork (by Manzoni), 50; and Berio, 79, 293n19; and the *Bompiani Almanac*, 57; on creative Autonomia, 237; and cybernetics/information theory, 107, 159–60; on the 1972 *Italy* exhibition, 289n90; on legible art, 65–66; on Mari's *Modulo 856*, 156–58; on the mass media debate, 82–83; and the 1964 Milan Triennale, 28, 89, 177; and Moles's theory, 65–66, 132, 149; on "open works," 2, 21, 27, 38–39, 53, 63–69, 107, 149; on Pollock's drip paintings, 67–68; on programmed artworks, 2, 36–37, 67–68. *See also arte informale*; *Bompiani Almanac*; information theory; legibility; Milan Triennale: 1964; openness

economic boom (Italy), 4, 15–16, 79; uneven effects of the, 19. *See also* economic planning *(programmazione)*

economic planning *(programmazione)*, 15–17, 25; leftist critique of 19–20. *See also* economic boom (Italy)

Ellul, Jacques: on the technological society, 6–7, 9, 11

emptiness: in Archizoom's work, 223–24; "empty time," 92–93; in Gruppo N's *A porta chiusa*, 50. *See also* Archizoom; Gruppo N; temporality: free/empty time

enjoyment: and critique, 96; and integration, 94; and novelty, 135

environments. See *ambienti*

excess: information overload, 162–64, 256n55; in moderation, 151. *See also* Moles, Abraham

experimentation for experimentation's

statement, 85–86; and the *Bompiani Almanac*, 57; and the 1964 Milan Triennale, 89; Miriorama declaration, 48; *Ossidazioni decorative* (Decorative Oxidations, 1960), 48; *Pittura in fumo* (Picture in Smoke, 1960), 48–49; *A porta chiusa* (Closed Door, 1960), 49–50; as programmers (of audience members), 89, 110; *Lo Spettacolo* (Performance, 1964), 95–96; and *Tendencies 4*, 144–46. *See also* Anceschi, Giovanni; *Arte programmata* (1962 exhibition); Boriani, Davide; collectivity; Colombo, Gianni; Devecchi, Gabriele; Milan Triennale; Varisco, Grazia

Gundle, Stephen: on mass culture, 264n35; on *tempo libero*, 265n50. *See also* mass media; temporality: free/empty time

Guttuso, Renato: on *impegno* and the abandonment of abstraction, 40–41. *See also* abandonment; abstraction; *impegno*

Haacke, Hans, 164, 166–71, 278n68; on information, 132, 166; *MoMA Poll*, 167–68; *News*, 166–67; on systems, 278n64; *Visitors' Profile*, 167–68. See also *Information* (1970 MoMA exhibition); *Software* (1970 Jewish Museum exhibition); surveys; systems

Hamilton, Richard, 20

Han, Byung-Chul: on today's crisis of freedom, 231–32. *See also* freedom; instrumentalization

Hansen, Oskar: and "the open form," 21. *See also* openness

Hardt, Michael: and Negri, 239–40, 243, 293n23, 294n24. *See also* Negri, Antonio

Hayles, N. Katherine: on cybernetics, 270n89. *See also* cybernetics

Hess, Thomas: on op art and consumer culture, 74, 262n7. *See also* op art

horizontality: formal, 38, 44; *Percorsi fluidi orizzontali* (Horizontal Fluid Paths) (Anceschi), 57–59; of political action networks, 234. *See also* Anceschi, Giovanni

Howard Wise Gallery: *Computer-Generated Pictures* exhibition, 137–38; and Haacke's viewer polls, 167. *See also* computer art; Haacke, Hans

Hyde, Gordon: and the Zagreb Manifesto, 278n69. See also *New Tendencies* (exhibitions): *4*

hypothetigraphy, 209

IBM, 18, 56, 141–43; "information machine," 91. See also *Bompiani Almanac*; *Cybernetic Serendipity* (1968 ICA exhibition); Eames, Charles and Ray

identity: and action, 124; and capitalism, 30; collective, 12, 15, 195, 210–11, 232, 239; and language, 210. *See also* action; capitalism; collectivity; language

illusionism, 75; anti-illusionist illusionism (Lippard), 262n10

immediacy: fantasy of, 30, 240; and the historical avant-garde, 234; vs. mediation, 272n110; and metaphor, 238; of op art, 74; of radio, 235; of television, 81

impegno, 39–53, 62, 66, 85–86. *See also* authorship

indeterminacy, 1–2, 28, 62–64, 73, 76, 114, 239. *See also* openness

infinite, the: vs. the finite (in programmed art), 38–39, 45, 211; an infinity of utopias, 223; and the open work, 67; as vertigo-inducing (for Calvino), 53

Information (1970 MoMA exhibition), 29, 130, 132–33, 160–70. *See also* information theory; McShine, Kynaston; politics; *Software* (1970 Jewish Museum exhibition)

information theory, 4, 11, 106, 129–75,

193, 208; and music, 141; and open works, 38, 64–65, 68, 107, 261n54; and politics, 129–75. *See also* aesthetic information; communication; cybernetics; openness; Shannon, Claude

instability: of communication channels, 150; of community, 9; of context, 106, 133, 154, 169; of cybernetic terms, 271n93; economic, 212; and ephemerality, 198; formal, 149; of gestalt art's forms, 85; of the ground, 99; *Instability* (1962 exhibition), 108–9; of meaning, 170, 180; of the modern world, 64, 165–66; and open works, 63–64; of perception, 76; and "the system," 224; of taste, 202; of truth, 63

institutions, alternative, 24, 30, 178–82, 186–87, 190, 199, 212, 222–29. *See also* Autonomia; pragmatism; solutions

instrumentalization: of art (for politics), 178; of freedom, 26, 231; of non-coherence/non-communication, 13–14; of tragedy/crisis (for politics), 172, 188, 212; of uncertainty, 239

interdisciplinarity, 18, 21, 171; and cybernetics, 268n78; and the New Tendencies, 144–48. *See also* New Tendencies

internet, early, 9–10, 14

interpretation, 2–3, 63–68; consistency of, 3; freedom of, 2, 86, 99; machine, 93–94; multiplicity of, 38, 63, 67, 75, 209; narrowing, 150; parody of, 158; reductive, 5. *See also* misunderstanding; openness; perception

Irwin, Robert: and *The Responsive Eye*, 73–74. See also *Responsive Eye, The* (1965 MoMA exhibition)

ISIA (Higher Institute for Artistic Industries), 193. *See also* Anceschi, Giovanni; Argan, Giulio Carlo; Menna, Filiberto

Italian Communist Party (PCI), 66, 187, 255n40; "compromise" with the Christian Democrats, 211–12, 225; defeat of the, 16, 40–41, 52, 212; vs. Hollywood, 80; vs. the left, 183, 211; role of the, 189. *See also* communism; politics

Italy: The New Domestic Landscape (1972 MoMA exhibition), 213–14, 223, 228, 289nn89–90. *See also* design: radical; Mari, Enzo

Jameson, Fredric: on Haacke's work, 168, 278n68. *See also* Haacke, Hans; surveys

Johns, Jasper: and the 1963 San Marino Biennale, 84. *See also* San Marino Biennale

Jorn, Asger: and the 1963 San Marino Biennale, 84. *See also* San Marino Biennale

Joselit, David, 252n25: on Nam June Paik's "viral aesthetics," 13. *See also* Paik, Nam June

judgment, aesthetic. *See* surveys

Julesz, Béla: and *Computer-Generated Pictures*, 137–38. *See also* Bell Labs; computer art; *Computer-Generated Pictures* (1965 Howard Wise Gallery exhibition)

Kaprow, Allan, 8. See also *Medium Is the Message, The* (television program). *See also* television

Kepes, Gyorgy, 18. *See also* Center for Advanced Visual Studies

kinetic art, 20, 38, 149, 171; and Gruppo N, 51–52; and perception (for Massironi), 207. See also *Arte programmata* (1962 exhibition); Gruppo N; Massironi, Manfredo; New Tendencies

kitsch, 149, 200. *See also* op art

Klein, Yves: on emotive gestural painting as capitalist, 42; IKB monochromes (as inspiration for Gruppo T), 48; *Le vide* (The Void, 1958) (as inspiration for Gruppo N), 50

Mack, Heinz: and New Tendencies, 87–88; and *The Responsive Eye,* 73–74. *See also* New Tendencies; *Responsive Eye, The* (1965 MoMA exhibition); Zero Group

Mallarmé, Stéphane: on language and meaning, 63. *See also* language; meaning

management: and politics ("managerialism"), 55; self (and cybernetics), 114; self (in Volterra), 199–202. *See also* cybernetics; politics; *Volterra '73*

Mannucci, Cesare: on mass media, 80–83, 263n25, 264n35. *See also* Lippmann, Walter; mass media

Manzoni, Piero, 86; *Achromes,* 50–51; on emotive gestural painting as capitalist, 42. *See also* Gruppo N; New Tendencies

Marazzi, Christian: on the crisis of meaning, 287n73; on language and capitalism, 210–11. *See also* capitalism; language; meaning

Marcuse, Herbert: on the "one-dimensional society," 6, 9, 11

Mari, Enzo, 1, 3–4, 45–47, 49, 69, 71–73, 76, 86–88, 97, 106–8, 150–51, 213–22, 228, 232, 259nn22–23, 262n15; on *ambienti,* 111; "Art and Freedom" statement, 85–86; on Arte Programmata's works and consumer culture, 76; *The Atlas according to Lenin* (1974), 214, 218–22; and authorship, 37, 45; and communication/collectivity, 52–53, 126–27, 154–55, 159–60; and design, 29, 46–47, 156, 178–81, 183, 191, 213–22, 259n23, 276n47, 288n85; *44 Considerations* (1976), 214, 218–22; and information theory, 159–60; and the 1968 Milan Triennale, 177, 288n79; *Modulo 856,* 155–59; on Munari, 45; *Opera n. 649,* 57–58; and politics, 45–46, 52, 87–88, 131, 148–49, 178–80, 213, 217–22; *Progetto 1059 B* (1964–2001), 47; *Proposta per un'autoprogettazione,* 214–17; and protest ("Un rifiuto possibile" [A Possible Refusal]), 178; on the Sistine Chapel, 45; *Lo Spettacolo* (Performance, 1964), 95–96; *Struttura 301* (Structure 301, 1956), 46; on *Tendencies 4,* 148–49. See also *Arte programmata* (1962 exhibition); Danese company; Milan Triennale; *New Tendencies* (exhibitions); *Responsive Eye, The* (1965 MoMA exhibition)

Marinetti, Filippo Tommaso: "words in freedom" manifestos, 237. *See also* war

Mariscalco, Danilo: on the free radio movement, 235. *See also* radio

Martin, Agnes: and *The Responsive Eye,* 73–74. See also *Responsive Eye, The* (1965 MoMA exhibition)

Marxist theory, 21, 23–25; graphic depiction of, 214, 218–22. *See also* Della Volpe, Galvano; Mari, Enzo

Massironi, Manfredo, 29–30, 49, 52, 88–89, 222, 232, 265n46; *Ambiente cinetico programmato* (Programmed Kinetic Environment, 1967), 112–13, 115; *Ambiente struttura* (Structured Environment), 112, 116; and design/politics, 178, 180–81, 183, 191; on graphic images and visual perception, 181, 206–13, 287n64; *Negativo* (1967), 117; and Negri, 210; on the New Tendency, 106; and protest ("Un rifiuto possibile" [A Possible Refusal]), 178; on *The Responsive Eye,* 73, 76, 79. *See also* design; Gruppo N; New Tendency; pedagogy; *Responsive Eye, The* (1965 MoMA exhibition)

mass media, 74–89, 94–98, 118, 123–27, 264n35; and agency, 123; and alienation, 105, 180; and collectivity, 151; debates in Italy, 79–84; and subjectivity, 126, 151, 154. *See also* capitalism; communication; television

McLuhan, Marshall, 10; on automation, 251n13; on computers, 7–8; on film (as "hot" medium), 95; on Italy's political bent in the late 1940s, 80; on mass media, 83, 251n11; "the medium is the message," 124, 162, 277n54. *See also* computers; mass media

McShine, Kynaston, 130, 132, 160–66, 170. See also *Information* (1970 MoMA exhibition); politics

meaning: against, 235; crisis of, 287n73; and cultural context, 105; and generative aesthetics, 136; and images, 208; and language, 63; as message, 162; and open works, 65–67; as slippery/unstable, 170, 180. *See also* clarity; communication; information theory; legibility

mediation: and action, 118; avoiding, 41, 235–36, 294n24; vs. immediacy, 272n110; limits of, 239–40; technical, 6; for Tronti, 191. *See also* A/traverso; Tronti, Mario

Medium Is the Message, The (television program), 8–9. *See also* television

Melzer, Eve: on systems in post-medium practices, 21. *See also* systems

menabò, Il (journal), 41, 66, 261n59, 276n46

Mendosch, Armin: on the "cybernetic socialism" of the New Tendencies, 21. *See also* New Tendencies

Menna, Filiberto, 193; on the 1972 *Italy* exhibition, 224–25. *See also* Anceschi, Giovanni; ISIA (Higher Institute for Artistic Industries); *Italy: The New Domestic Landscape* (1972 MoMA exhibition); utopia

Meštrović, Matko: and the *New Tendency/ Tendencies* exhibitions, 86, 105–6, 265n41. *See also* New Tendencies; *New Tendencies* (exhibitions)

Metropolitan Indians: protests of, 234. *See also* politics; primitivism; protests

Metzger, Gustav: on the military as the true avant-garde, 171, 279n71; and the Zagreb Manifesto, 278n69. *See also* computer art; military; *New Tendencies* (exhibitions): 4

Milan Triennale: 1964, 28, 89–98, 177; 1968, 177–79, 280nn2–3, 288n79. *See also* Gruppo T; Mari, Enzo

military: and computers, 142–43, 171, 279n71; U.S. Air Force (as sponsor of *Cybernetic Serendipity*), 142–43. *See also* Art Workers' Coalition: *And Babies* (1969); computer art; politics; war

mimicry: of the artistic process (by computers), 137–38. *See also* computers; mirrors; repetition

mirrors, 118, 120–25; in Boriani's *Camera stroboscopica multidimensionale*, 120–24, 156; in Mari's *Modulo 856*, 156–57; in Pask's *Colloquy of Mobiles*, 142; in Pistoletto's *Cinque pozzi* (Five Wells, 1967), 121–25; in Pistoletto's mirror paintings, 121–22, 156, 272n105. *See also* Boriani, Davide; mimicry; Pistoletto, Michelangelo; repetition

misinformation, 132, 173, 212, 280n80. *See also* control; fake: news; politics

misunderstanding: of Arte Programmata works, 28, 73, 76, 118, 154, 158; and complex communication, 150. *See also* interpretation

mobiles: of Calder, 50; of Munari (useless machines), 43, 45, 50; of Pask (*Colloquy of Mobiles*), 142. *See also* Calder, Alexander; Munari, Bruno; Pask, Gordon

Moles, Abraham; on art and information theory / cybernetics, 65–66, 107–8, 131–32, 135, 149–53, 270n85, 265n29; and *Cybernetic Serendipity*, 141; on the New Tendencies, 144, 274n28; and *New Tendencies 3*, 151; and *Tendencies 4*, 144–46. *See also* aesthetic information;

cybernetics; *Cybernetic Serendipity* (1968 ICA exhibition); information theory; New Tendencies; rationality; Ulm School of Design

Molnar, François, 87. *See also* GRAV (Groupe de recherche d'art visuel)

MoMA, 28, 29; *MoMA Poll* (Haacke), 167–68; on *The Responsive Eye*, 75. See also *Information* (1970 MoMA exhibition); *Italy: The New Domestic Landscape* (1972 MoMA exhibition); *Machine as Seen at the End of the Mechanical Age, The* (1968 MoMA exhibition); *Responsive Eye, The* (1965 MoMA exhibition)

Mondrian, Piet: computer imitations of, 138–39. *See also* computer art; Noll, A. Michael

Monnet, Gianni, 42. *See also* Movimento Arte Concreta (MAC)

Moorman, Charlotte, 20

Morales, Cildo: *Insertions into Ideological Circuits: Coca-Cola Project* (1970), 161. See also *Information* (1970 MoMA exhibition)

Morandi, Corinna: *Progettazione per l'alabastro* (Design/Plan for Alabaster, 1973), 200–206, 211, 217, 286n55. See also *Volterra '73*

Moravia, Alberto: as against Hollywood and *Carosello*, 80. *See also Carosello*; cinema; mass media

Morellet, François, 267n66; and *Labyrinth*, 99; and *The Responsive Eye*, 73–74. *See also* GRAV (Groupe de recherche d'art visuel); *Responsive Eye, The* (1965 MoMA exhibition)

Moro, Aldo: and the Democrazia Cristiana (DC), 16. *See also* Democrazia Cristiana (DC); politics

Moroni, Primo: on the period of self-managed, subversive communication, 212; on *Settantasette*, 234; on student protests, 183. *See also* Autonomia; Balestrini, Nanni; protests

Movimento Arte Concreta (MAC), 42–44, 258n17. *See also* Dorfles, Gillo; Munari, Bruno

Mumford, Lewis: on the "megamachine," 6–7, 10–11

Munari, Bruno, 42–45, 57, 62, 258n17, 259n22–23; and authorship, 37; and the *Bompiani Almanac*, 57; and communication/collectivity, 52–53; and design, 29, 42, 44–45, 259n23; and futurism, 42, 258n16; *Negative-Positives* (1951), 44; *Nove sfere in colonna* (Nine Spheres in a Column), 35, 58; on programmed art, 1–3, 36–37; useless machines of, 43, 45, 50, 258n16. *See also* futurism; Movimento Arte Concreta (MAC); Olivetti (company)

Musatti, Riccardo: and the *Arte programmata* exhibition, 57. See also *Arte programmata* (1962 exhibition); Olivetti (company)

Museum of Modern Art. *See* MoMa

music: and *Cybernetic Serendipity*, 140–41; and Eco's "open work," 38; and information theory, 141. *See also* Berio, Luciano; Cage, John; Powell, Specs; sound; Xenakis, Iannis

Mussa, Italo: on Gruppo N's environments, 112–13. *See also ambienti*; Gruppo N

mutability, 21, 33–39; of the world, 48, 51, 62. *See also* adaptability; openness

myth: appropriation of, 287n73; of artistic creation, 50, 66; of free time, 28, 89, 92; and ideology, 132; of individual autonomy, 77, 100; of middle-class mediocrity, 95; of Narcissus, 158

Nake, Frieder, 131–32, 136–38, 141, 170, 275n37; abandonment of computer art,

171, 275n37, 279n73; on digital art, 137; and rationality, 147–48; and *Tendencies 4*, 144, 147–49; and the 1970 Venice Biennale, 171. *See also* Bense, Max; CGI; computer art; *Cybernetic Serendipity* (1968 ICA exhibition); information theory

nationalization: of the electricity industry (Italy), 16; of oil resources (Algeria), 192, 212, 284n37. *See also* RAI (Radiotelevisione italiana); Sonatrach

Nees, Georg, 131–32, 134, 136–39, 141, 170–71; and *Cybernetic Serendipity*, 141; *8-corner graphic*, 134; and *Generative Computergrafik*, 134, 136–37; on information and innovation, 139; and the 1970 Venice Biennale, 171; and *Tendencies 4*, 144. See also *Cybernetic Serendipity* (1968 ICA exhibition); *Generative Computergrafik* (1965 Technische Hochschule exhibition); information theory

Negri, Antonio, 187–93, 254n38, 284nn33–34; on autonomy, 190, 284n34; and *Contropiano*, 188–89, 284n31; on Gruppo N, 210; and Hardt, 239–40, 243, 293n23, 294n24; and Massironi, 210; and Potere Operaio, 187, 189, 193; and *Quaderni rossi*, 182; vs. Tronti, 189–91, 203–6, 233. *See also* autonomy; collectivity; *Contropiano* (journal); Potere Operaio; Tronti, Mario

Negroponte, Nicholas, 9–10, 171; on the digital age, 10

Nelson, Ted, 165. See also *Software* (1970 Jewish Museum exhibition)

Nespolo, Ugo: and *Volterra '73*, 199. See also *Volterra '73*

New Tendencies, 20–21, 86–88, 108, 144–49, 271n99, 274n28; New Tendency, 99–111; and "research," 87–88, 106, 151, 155, 262n15. *See also* cybernetics; information theory; *Nouvelle tendance* (New Tendency, 1964 exhibition)

New Tendencies (exhibitions): *1*, 86; *2*, 86–88; *3* (*New Tendency*), 105–11, 151, 270n85; *4* (*Tendencies 4*), 144–49, 278n69. *See also* New Tendencies; *Nouvelle tendance* (New Tendency, 1964 exhibition)

Nicolin, Paola: on the occupation of the 1968 Milan Triennale, 280n3. *See also* Milan Triennale: 1968

Nixon, Richard: Kitchen Debate, 91; referenced in Haacke's *MoMA Poll*, 167. *See also* Haacke, Hans; politics

Noland, Kenneth: and *The Responsive Eye*, 73–74. See also *Responsive Eye, The* (1965 MoMA exhibition)

Noll, A. Michael, 131–32, 141; and *Computer-Generated Pictures*, 137–38, 273n12; and *Cybernetic Serendipity*, 141; *Gaussian-Quadratic* (1963), 137–38, 142; and *Tendencies 4*, 144. *See also* Bell Labs; computer art; *Computer-Generated Pictures* (1965 Howard Wise Gallery exhibition); *Cybernetic Serendipity* (1968 ICA exhibition); information theory

Nouvelle tendance (New Tendency, 1964 exhibition), 98–105. *See also* New Tendencies: New Tendency; *New Tendencies* (exhibitions)

novelty: vs. clarity, 46, 65–67, 131–133, 135, 149–60, 170, 211; as problematic for some, 143. *See also* clarity

Nuovi Argomenti (journal), 22–25. *See also* Bobbio, Norberto; Della Volpe, Galvano

O'Beirne, T. H.: and *Cybernetic Serendipity*, 141. See also *Cybernetic Serendipity* (1968 ICA exhibition); music

obsolescence: planned (of consumer society), 82; of traditional political organization and concepts, 233

Olivetti (company), 81; and the *Arte programmata* exhibition, 33, 57; ELEA 9003, 53–55; "enlightened corporatism" of, 16–18; and Munari, 44–45; Programma 101, 17, 55, 254n33; and Sottsass Jr.'s "visual jukebox," 161; "wildcat strikes" at, 184, 186. See also *Arte programmata* (1962 exhibition); *Bompiani Almanac*; computers; Munari, Bruno; Olivetti, Adriano; Olivetti, Camilio; Olivetti, Roberto; Zorzi, Renzo

Olivetti, Adriano: on managerialism, 55; and social programs, 16–18, 253n32. *See also* Olivetti (company)

Olivetti, Camilio, 16. *See also* Olivetti (company)

Olivetti, Roberto: and new technologies, 17, 55. *See also* computers; Olivetti (company)

Ono, Yoko, 20

op art, 74–77, 149, 261n2; and consumer culture, 74–76, 262n7, 262n9. See also *Responsive Eye, The* (1965 MoMA exhibition)

openness, 28; and computers, 140; "fields of possibilities," 38, 60, 70, 149, 153, 209; of interpretation, 209; as obstacle, 86; open forms, 21; open works, 2, 12, 21, 27, 33–71, 107, 149; and surveys, 108, 153; and typography, 194. *See also* Eco, Umberto; indeterminacy

operaismo (workerism), 88, 182, 184–91, 210, 227, 237; as against planning, 19, 188–90; feminist critiques of, 233–34; and refusal, 30, 290n101. *See also* agency; Autonomia; collectivity; Potere Operaio; refusal

optimism: about Algerian national identity, 192; of *Cybernetic Serendipity,* 143; economic, 16; of Haacke's surveys, 168; about science and technology, 147, 170; about social programming, 16–17. See

also *Cybernetic Serendipity* (1968 ICA exhibition)

Paik, Nam June, 8–9; and *Cybernetic Serendipity,* 141; "Participation TV," 9; viral aesthetics of, 13. See also *Cybernetic Serendipity* (1968 ICA exhibition); *Medium Is the Message, The* (television program); participation; television

Pansera, Anty: on the 1964 Milan Triennale, 90, 92. *See also* Milan Triennale: 1964

Paolozzi, Edoardo, 20

participation: of artists, 198; and element-manipulation, 100; forced, 267n69; without guarantee, 62; of the people, 25, 185; as refused, 49–50; as submission, 94, 231; total, 267n66; of the user, 225; of the viewer, 8–9, 12, 27–28, 35–37, 42, 48–49, 59–63, 68–69, 93–127, 142, 156–58, 161, 198, 267n66. *See also* viewer, the

Partito Socialista Italiano (PSI): and the Democrazia Cristiana, 16, 52. *See also* Democrazia Cristiana (DC); politics

Pascali, Pino, 118–20; and *Lo spazio dell'immagine,* 118–19; and the spectator, 120. *See also* Arte Povera; *spazio dell'immagine, Lo* (The Space of the Image, 1967 exhibition)

Pask, Gordon, 271n93; *Colloquy of Mobiles,* 142; and *Vision 67,* 276n48. *See also* cybernetics; *Cybernetic Serendipity* (1968 ICA exhibition); mobiles

Pasolini, Pier Paolo: on mass culture, 80, 82, 264n35. *See also* capitalism; mass media; television

Patterson, Benjamin, 20

PCI. *See* Italian Communist Party (PCI)

pedagogy: after abandoning art, 4; of Anceschi, 193; of Boriani, 196; and computer art, 148; of Devecchi, 197; of

Massironi, 29–30; self-teaching, 234. *See also* Anceschi, Giovanni; Boriani, Davide; Devecchi, Gabriele; Massironi, Manfredo; Ulm School of Design

Pepsi Pavilion, 17–18. *See also* Experiments in Art and Technology

perception: and *ambienti,* 99; and gestalt art/psychology, 85–86, 110, 156, 206; instability of, 76; and (flashing) light, 102, 118, 120; limits of, 208; for Massironi, 181, 206–13; and op art, 74–77; as productive, 85, 156; self, 118, 120–21; variability of, 156–58. *See also* gestalt art; instability; interpretation; Massironi, Manfredo; op art

Pesce, Gaetano, 223–24; *Project for an Underground City in the Age of Great Contaminations,* 224. *See also* design: radical; Gruppo N

Petri, Elio: *The 10th Victim* (1965), 249n4. *See also* cinema; computers

Pias, Claus: on Bense's work, 136. *See also* Bense, Max

Pickering, Andrew: on cybernetics and uncertainty, 114, 271n93

Piene, Otto: and New Tendencies, 87–88. *See also* New Tendencies; Zero Group

Pistoletto, Michelangelo, 118–21; *Cinque pozzi* (Five Wells, 1967), 121–25; mirror paintings of, 121–22, 156, 272n105; on mirrors in his artworks, 122–24; and *Lo spazio dell'immagine,* 118–19; and the spectator, 120. *See also* Arte Povera; mirrors; *spazio dell'immagine, Lo* (The Space of the Image, 1967 exhibition)

poetry: and algorithms, 56–57; and computers, 141; concrete, 140

politics, 129–241; and abstraction, 5, 18, 40–42; art and, 3–5, 18, 26, 28–31, 39–46, 135–37, 231–41; of authorship, 39–52; and design, 216; and distortion, 172–73; of form, 5; and freedom, 22–26;

and information, 129–75; and management ("managerialism"), 55; and media, 77; and misinformation, 132, 280n80; and New Tendencies, 87–88; and technology, 10–11, 18, 142–43; and television, 79–81. *See also* Autunno caldo (Hot Autumn); Avanguardia operaia; communism; Democrazia Cristiana (DC); Italian Communist Party (PCI); Lotta Continua; military; Potere Operaio; protests; strikes; war

Pollock, Jackson, 67–68; in Italy, 42–43; as symbol of the capitalist West, 42

pop art, 74, 85, 89, 283n27

Popper, Frank: on participation in art, 267n66, 268n39

Portoghesi, Paolo: on the 1964 Milan Triennale, 94. *See also* Milan Triennale: 1964

Potere Operaio, 182, 187, 189, 193–95. *See also operaismo* (workerism); politics

Powell, Specs, 75. *See also Responsive Eye, The* (1965 MoMA exhibition)

pragmatism, 178–81, 197, 217, 222. *See also* institutions, alternative; self-design; solutions

Preiss, Anne: and design, 192–93, 285n40. *See also* Anceschi, Giovanni; Sonatrach

primitivism, 223, 225–27, 234; "pastoral," 225. *See also* Archizoom; design: -counter; Metropolitan Indians; Sottsass Jr., Ettore; Superstudio

progettazione (design/planning), 177–229. *See also* design

protests: 24, 29, 129–30, 172–91, 197, 213, 216, 234, 254n37, 279n78, 280nn2–3; art of, 283n27; *Ciclo della protesta n. 3* (Cycle of Protest No. 3, 1956) (Vedova), 257n7; Mari's *Modulo 856* as (?), 158. *See also* Autunno caldo (Hot Autumn); Milan Triennale: 1968; politics; strikes

punch cards, 134, 136–37. *See also*

computer art; computers; *Generative Computergrafik* (1965 Technische Hochschule exhibition)

Quaderni rossi (journal), 55, 88, 182. *See also* Asor Rosa, Alberto; Tronti, Mario

radio, 24, 77, 132, 293n19; alabaster-encased, 202; and autonomy, 236; and censorship, 236; and collectivity, 236; and creative Autonomia, 234–36; free, 212, 235–37; *Guerrilla Radio* (Giorno, 1968), 165; and immediacy, 235. *See also* RAI (Radiotelevisione italiana)

RAI (Radiotelevisione italiana), 79, 82, 235–36, 264n30. *See also* radio

randomness, 1; and innovation, 139–41, 148; *Random War* (Csuri), 142; within structure/systems, 36, 136–42

rationality, 6–7, 70, 151, 249n4; as amoral, 6; of Bauhaus, 84; of Bense, 135–36; vs. fascism, 136; and freedom, 7; of GRAV, 267n67; of Gropius, 84; of Gruppo N, 51; hyper-rationalism, 70; of Nake, 147–48; vs. social ills, 147

Rauschenberg, Robert: Earth Day poster, 161; and *9 Evenings*, 130; and the 1963 San Marino Biennale, 84. *See also* Experiments in Art and Technology: *9 Evenings: Theatre and Engineering* (1966); *Information* (1970 MoMA exhibition); San Marino Biennale

Rebentisch, Juliane: on democracy and the rejection of the aesthetic, 26

referentiality, 42–44

refusal: and Autonomia, 30, 181, 292n15; of legibility, 214; of meaning, 66; and *operaismo*, 30, 290n101; as political resistance, 13, 30, 177–81, 184, 186, 199, 290n101, 292n15; positive dimensions of, 233; "Un rifiuto possibile" (A Possible Refusal), 178; of waged labor, 30,

235, 290n101, 292n15. *See also* Autonomia; institutions, alternative; solutions; strikes

Reichardt, Jasia, 130, 140–41. See also *Cybernetic Serendipity* (1968 ICA exhibition)

repetition: and capitalism, 42; of forms (in Klein's monochromes), 48; and gestural painting, 50; via reflection, 120–25; unrepeatability, 51. *See also* mimicry; mirrors

representation: and abstraction, 208–9; and Arte Programmata, 30, 229, 232, 238–39; multiplicity of, 209; and objects, 287n65; refusal of, 206, 235–36, 238

resistance: constructive, 3; refusal as, 13, 30, 177–81, 184, 186, 199, 290n101, 292n15; and technology, 3. *See also* protests; strikes

Responsive Eye, The (1965 MoMA exhibition), 28, 73–79, 98–99, 105. *See also* Seitz, William

Riley, Bridget: computer imitations of, 138–39; and *Cybernetic Serendipity*, 141; and *The Responsive Eye*, 73–74. *See also* computer art; *Cybernetic Serendipity* (1968 ICA exhibition); mimicry; Noll, A. Michael; *Responsive Eye, The* (1965 MoMA exhibition)

Roggero, Gigi: on class composition, 186, 282n13, 283n19. *See also* class composition

Rose, Barbara: on op art, 74, 262n9. *See also* op art

Rosen, Margit: on the New Tendencies, 146, 262n15. *See also* New Tendencies; *New Tendencies* (exhibitions)

Rossellini, Roberto: as against Hollywood and *Carosello,* 80. See also *Carosello*; cinema; mass media

Rossi, Catherine: on pastoral primitivism, 225. *See also* primitivism

netic notion of, 114, 270n89; dissolving of, 3, 78, 85, 111–12, 120, 270n89; and integration, 105; and interactivity, 103–4, 107, 111; and mass media, 126, 151, 154; production of, 2, 77, 210; and (shared) materiality, 31, 71, 105, 110, 185, 210; and technology, 181. *See also* agency; viewer, the

Superstudio, 181, 223–26; *Cultura materiale extraurbana* (Extra-Urban Material Culture), 225. *See also* design: counter-

surrealism, 30, 203, 234, 237

surveillance, 3, 252n25. *See also* control societies; voyeurism

surveys, 196; in Anceschi and Boriani's *Ambiente sperimentale,* 108–9, 151–54, 158, 160, 168–69, 196; in the "decompression room" of the 1964 Milan Triennale, 93; earnest, 153, 169; in Haacke's work, 166–69, 196; in Mari's *Modulo 856,* 155–60, 168–69; and openness, 108, 153. See also *Volterra '73*

Sutton, Gloria: on immersive environments and global community, 9. *See also* community

systems: consciousness, 277n59; end of, 224; as real, 278n64; and the subject, 181; as unsystematic, 11; theory, 165–66, 168

Tafuri, Manfredo, 181, 188, 283n27. *See also* architecture; constructivism; *Contropiano* (journal)

Tambellini, Aldo, 8. See also *Medium Is the Message, The* (television program)

Tanga, Martina: on *Volterra '73,* 199. *See also* institutions, alternative; *Volterra '73*

taste, 75–76, 86; aesthetics without, 136, 168; and communication, 150; and design, 214; public, 106, 202; as socio-historically determined, 28, 89; and surveys/research, 158, 202

Taylor, Grant D.: on the reception of computer art, 138–39. *See also* computer art; *Computer-Generated Pictures* (1965 Howard Wise Gallery exhibition)

technocracy, 3, 5, 7, 254n34; complicity with, 18; submission to, 24, 182

technology: and agency, 181; and freedom, 8–11, 25, 124, 230–31; and the individual, 8–9; neutrality of, 146–47; ontology of, 10–11; vs. op art, 74; and society, 16–18

television, 77–85, 91, 131, 265n50; and art, 81, 264n30; and capitalism, 79–81; and connection/collaboration, 8–9, 79; and consumerism, 79–81; in La Pietra's *Domicile Cell,* 224. *See also* RAI (Radio-televisione italiana)

temporality: and adaptability, 109; and automation, 251n13; and collectivity, 227; free/empty time, 28, 89–95, 265n50; the future (as having already begun), 53–54; the future (imagined), 217; and Gruppo T, 48; and radio, 235; "Tempo libero" (Free Time), 28, 89–90, 93–94; *Tempo libero: Strutturazione temporale in uno spazio urbano* (Free Time: Temporary Structuration in an Urban Space) (Boriani; Colombo; Devecchi), 198; vs. unity, 253n32. *See also* Gruppo T

Terranova, Tiziana: on the abstract machine of soft control, 14. *See also* control

textiles: frayed (in Burri's assemblages), 41; light-defusing (in Anceschi's *Ambiente a shock luminosi*), 102; moiré-patterned, 74; motorized (in *Lo Spettacolo*), 95–96; and worker uprisings, 282n10

Tinguely, Jean: *Metamatic* painting machines of, 141. See also *Cybernetic Serendipity* (1968 ICA exhibition)

Togliatti, Palmiro: on figurative realism

and *impegno*, 40. See also *impegno*; Italian Communist Party (PCI)

Toti, Gianni: on free time, 90. *See also* capitalism; temporality

Touraine, Alain: on "the programmed society," 6–7, 250n9

Trigon 67, 109, 111

Tronti, Mario: on anger and political change, 190–91; on Della Volpe's *La libertà comunista,* 23; on economic plans, 19, 187; vs. Negri, 189–91, 203–6, 233; and the PCI, 189, 211; on the working class, 184–85, 187. *See also* capitalism; Italian Communist Party (PCI); Negri, Antonio; *operaismo* (workerism); politics; within and against: capitalism

Trotsky, Leon, 26

Turner, Fred: on Brand's *Whole Earth Catalog,* 9–10; on cybernetics ideas in the 1930s, 251n17; on McLuhans's media theories, 251n11. *See also* cybernetics

Tzara, Tristan, 237. *See also* avant-garde, historical

Ulm School of Design, 107, 192, 226, 269n84, 285n43. *See also* Anceschi, Giovanni; Bill, Max; Preiss, Anne

uncertainty: and cybernetics, 114, 154; and Gruppo N and Gruppo T, 51; instrumentalization of, 239

unknown, the: and action, 114–17; and culture, 178. *See also* unpredictability

unpredictability: and action, 114–17, 126, 150; and information, 131; of the subject, 51; within a system/program, 36, 111, 160. *See also* unknown, the

uselessness: of city festivals, 198; of positions on mass culture (Eco), 82–83; useless goods, 180; useless machines (Munari), 43, 45, 50, 258n16

Usselman, Rainer: on *Cybernetic Serendip-*

ity (as out of touch), 143. See also *Cybernetic Serendipity* (1968 ICA exhibition); military: and computers

utopia, 223–25, 237; infinity of utopias, 223; negative, 224; techno, 5, 7, 18

Valéry, Paul: on freedom vs. rigor, 1–3. *See also* freedom

Valsesia, Stanislao: on the idea of a digital library, 56. *See also* computers

VanDerBeek, Stan: *Movie-Drome,* 9–10. *See also* cinema

van Eesteren, Cornelis, 49. *See also* Gruppo N

Vanoni, Ezio: and economic planning, 16. *See also* Democrazia Cristiana (DC); economic planning *(programmazione)*; politics

Varisco, Grazia: and Gruppo T, 48. *See also* Gruppo T

Vasarely, Victor: and *The Responsive Eye,* 73–74. See also *Responsive Eye, The* (1965 MoMA exhibition)

Vedova, Emilio: *Ciclo della protesta n. 3* (Cycle of Protest No. 3, 1956), 257n7; on the political potentiality of abstract art, 40. *See also* abstraction; politics

Venice Biennale: 1964, 89; 1968, 4–5, 109, 177–78; 1970, 171; 1976, 218–19

Verucchio Congress: and Arte Programmata, 84–86, 88. *See also* collectivity

viewer, the, 84–97; agency of, 11–12, 15, 38–39, 52–53, 85, 92–94, 105, 114–20, 267n66; assaulting (the senses) of, 92, 120, 126; as an assemblage of nerves, 75; as automated, 70; as (effectively) blinded, 101, 109–10; as bust, 156–57; as co-creator, 35–37, 109; constraining/controlling/manipulation of, 2–4, 27–29, 78, 86–97, 110–12, 117; contingency of, 78; creativity of, 85, 267n66; desire of, 75; disorientation of, 12, 100–101,

LINDSAY CAPLAN is assistant professor of art history at Brown University.